THE CAMBRIDGE COMPANION TO
Vermeer

Johannes Vermeer (1632–75) has long been heralded as one of the greatest Dutch painters of the Golden Age. As the spectacular success of recent exhibitions on this artist confirms, Vermeer's work continues to fascinate specialists and laypersons alike. *The Cambridge Companion to Vermeer* offers a systematic overview of the artist's life and work that will be useful to specialists, students, and the general public. Its eleven essays include studies of the artist's development and approach to painting, women as a subject in Vermeer's work, the role of Catholicism in Vermeer's life and art, and the artist's reputation during the nineteenth and twentieth centuries, among other topics. Collectively, these essays provide a balanced and enlightening examination of many different aspects of Vermeer's art.

Wayne E. Franits is Associate Professor of Fine Arts at Syracuse University. A scholar of Dutch painting, he is the author of *Paragons of Virtue: Women and Domesticity in Seventeenth-Century Dutch Art* and editor of *Looking at Seventeenth-Century Dutch Art: Realism Reconsidered.*

THE CAMBRIDGE COMPANION TO

Vermeer

Edited by

Wayne E. Franits
Syracuse University

CAMBRIDGE
UNIVERSITY PRESS

PUBLISHED BY THE PRESS SYNDICATE OF THE UNIVERSITY OF CAMBRIDGE
The Pitt Building, Trumpington Street, Cambridge, United Kingdom

CAMBRIDGE UNIVERSITY PRESS
The Edinburgh Building, Cambridge, CB2 2RU, UK
40 West 20th Street, New York, NY 10011–4211, USA
10 Stamford Road, Oakleigh, Melbourne 3166, Australia
Ruiz de Alarcón 13, 28014 Madrid, Spain
Dock House, The Waterfront, Cape Town 8001, South Africa

http://www.cambridge.org

First published 2001

Printed in the United States of America

Typeface Fairfield Medium 10.5/13.5 pt. *System* QuarkXPress^R [GH]

A catalogue record for this book is available from the British Library.

Library of Congress Cataloguing in Publication Data

Franits, Wayne E.
 The Cambridge companion to Vermeer / Wayne E. Franits.
 p. cm. – (Cambridge companion to the history of art)
 Includes bibliographical references and index.
 ISBN 0-521-65330-4 (HB) – ISBN 0-521-65331-2 (PB)
 1. Vermeer, Johannes, 1632–1675 – Criticism and interpretation. I. Title. II. Cambridge.
companions to the history of art.

ND653.V5 F73 2001
759.9492 – dc 21
 00-052953

ISBN 0 521 65330 4 hardback
ISBN 0 521 65331 2 paperback

For Aidan

Contents

List of Illustrations

FIGURES

Acknowledgments

As is customary with publication ventures of this nature, many colleagues and friends assisted me in bringing *The Cambridge Companion to Vermeer* to fruition. First, I must acknowledge Beatrice Rehl, the Cambridge University Press fine arts editor who conceived of the project (and the Cambridge Companion series as a whole) and invited me to serve as its editor. Next, I must extend my gratitude to all of the authors who participated either by allowing me to reprint their essays or by enthusiastically preparing newly commissioned ones. After all, this book is much more the result of their labors than of mine. Moreover, I wish to thank the editors who granted permission to reproduce studies that had previously appeared in the following publications: *Konsthistorisk Tidskrift*; *Rembrandt och hans tid*, Stockholm, National Museum, 1992–3; and *The Scholarly World of Vermeer*, The Hague, Museum Meermanno-Westreenianum/Zwolle, Waanders Uitgevers, 1996. At various times during the editorial process friends and colleagues provided much needed assistance in various capacities: therefore a debt is owed to Paul Archambault, Marten Jan Bok, Ton Brandenbarg, Jeff Carnes, Rudolf Dekker, Laurinda Dixon, Quint Gregory, Walter Liedtke, Frank Macomber, Donald Mills, Gary Radke, Dennis Romano, Herman Roodenburgh, Leonard Slatkes, Lisa Vergara, Herbert H. Westphalen III, and Arthur Wheelock. The William Fleming Educational Trust Fund provided much needed financial support for the production of a foldout map to accompany the text, a task expertly executed by Kees Kaldenbach. Lastly, I thank my wife, Linnéa, and son, Aidan, for cheerfully enduring an often weary husband and father who continually struggled to balance his familial, scholarly, and administrative responsibilities.

Vermeer and His Age: A Chronology

1632	Baptism of Johannes Vermeer in the New Church in Delft, 31 October. Second and youngest child of Reynier Jansz. Vermeer (alias Vos; ca. 1591–1652), caffa worker, innkeeper, and art dealer, and Digna Baltens (ca. 1595–1670).
1641	Vermeer's father, Reynier Jansz. Vermeer, buys a large house on the *Markt* square in Delft called the *Mechelen*, 23 April. This became an inn where Vermeer would spend the remainder of his childhood.
ca. 1645–53	Vermeer receives his artistic training with an as yet unknown master or masters, either in Delft or possibly in another city.
1652	Reynier Jansz. Vermeer buried in the New Church in Delft, 12 October.
1653	Vermeer marries Catharina Bolnes (ca. 1631–88) in the village of Schipluy, outside Delft, 20 April. Vermeer and the prominent Dutch genre painter and portraitist Gerard ter Borch (1617–81) jointly sign a notarial document in Delft as witnesses, 22 April. Vermeer registers with the Delft Guild of St. Luke as a master painter, 29 December.
1654	The accidental explosion of Delft's municipal powder arsenal destroys one quarter of the city and claims many lives, including that of the painter Carel Fabritius (1622–54), 12 October.
1655	Vermeer's earliest signed and dated work is completed, the *St. Praxedis* (Plate 1).
1656	Vermeer paints *The Procuress* (Plate 4).
1657	Vermeer's likely patron Pieter Claesz. van Ruijven (1624–74) lends the painter and his wife 200 guilders, 30 November. The death inventory of the Amsterdam-based art dealer Johannes de Renialme lists "een graft besoeckende van der Meer . . ." (a *Visit to the Tomb* by Van der Meer [Vermeer]), 27 June.
1660	Vermeer and his wife bury a child in the Old Church in Delft, 27 December. The document reveals that by this time, the artist and his growing family were living in the house of his mother-in-law Maria Thins (ca. 1593–1680), on the Oude Langendijk in Delft.
1662	Vermeer appointed one of the headmen of the Delft Guild of St. Luke.

1663 The Frenchman Balthasar de Monconys visits Vermeer's studio in
 Delft, 11 August.

1664 Death inventory of the English sculptor Jean Larson, formerly resid-
 ing in The Hague, is composed; it lists "een tronie van Vermeer" (a
 head by Vermeer), 4 August.

1665 Pieter van Ruijven and his wife, Maria de Knuijt (d. 1681), draw up
 their last will and testament. In a separate section of the will de
 Knuijt bequeaths 500 guilders to Vermeer, 19 October.

1667 Vermeer is mentioned twice in Dirck van Bleyswijck's *Beschryvinge der
 stadt Delft* (*Description of the City of Delft*). Maria Thins, Vermeer's
 mother-in-law, legally empowers him to collect various debts owed to
 her and to reinvest the money according to his discretion, 10 May.
 Another child of Vermeer and his wife is buried, this time in the New
 Church in Delft, 10 July.

1668 Vermeer paints *The Astronomer* (Plate 27).

1669 Vermeer paints *The Geographer* (Plate 28). Digna Baltens, Vermeer's
 mother, leases his boyhood home, the inn *Mechelen*, to a local shoe-
 maker for a term of three years, 1 February. Pieter Teding van Berck-
 hout, scion of a prominent family from The Hague, twice visits Ver-
 meer's studio and records his impressions in his diary, 14 May, 21 June.
 Vermeer and his wife bury another child in the Old Church in Delft,
 16 July.

1670 Vermeer is appointed for a second term as one of the headmen of the
 Delft Guild of St. Luke. Vermeer's mother, Digna Baltens, is buried in
 the New Church in Delft, 13 February. Gertruy Reyniersdr. Vermeer,
 the painter's sister, is buried in the New Church in Delft, 2 May. Ver-
 meer inherits the *Mechelen* from the estate of his deceased mother, 13
 July.

1672 Vermeer leases the *Mechelen* to an apothecary for a period of six
 years, 14 January. Vermeer is summoned to The Hague (along with
 several other painters) to appraise a collection of twelve Italian paint-
 ings at the source of a dispute between the art dealer, Gerrit van
 Uylenburgh, and their prospective buyer, Friedrich Wilhelm, the
 Grand Elector of Brandenburg, 23 May.

1673 Yet another child of Vermeer and his wife is buried in the Old Church
 in Delft, 27 June. Vermeer travels to Amsterdam where he sells two
 bonds to Hendrick de Schepper, amounting to 800 guilders, 21 July.
 One of them, worth 500 guilders, had been previously issued in the
 name of Magdalena Pieters van Ruijven (1655–82), the daughter of
 Vermeer's likely patron, Pieter Claesz. van Ruijven.

1674 Vermeer's name appears in the register of members of the Delft mili-
 tia. Vermeer travels to Gouda in order to settle some of the affairs of
 Reynier Bolnes, his recently deceased father-in-law, 4 May. Maria Ver-
 meer, eldest daughter of the artist, is married to Johannes Gillisz.
 Cramer, a merchant, 10 June.

1675 Maria Thins empowers Vermeer to collect and administer monies

owed her son, Willem Bolnes, 5 March. Vermeer borrows 1,000 guilders from the Amsterdam merchant Jacob Rombouts, 20 July. Vermeer is buried in the Old Church in Delft, 16 December. He leaves a widow and eleven children, ten of whom are minors.

1676 An inventory of the moveable goods from Vermeer's estate is compiled, 29 February.

POLITICS AND DIPLOMACY

1634 Dutch capture Curaçao from the Spanish.

1642–51 English Civil War.

1643 Accession of Louis XIV to the throne of France, succeeding Louis XIII.

1648 Treaty of Münster ending the war between the Netherlands and Spain. Peace of Westphalia ending the Thirty-Years War in Europe.

1649 Charles II of England executed for treason. Oliver Cromwell, eventually taking the title Lord Protector of the Commonwealth, assumes leadership of the nation until his death in 1658.

1652–4 First Anglo-Dutch War.

1660 Restoration of Charles II (Stuart) to the throne of England.

1664–7 Second Anglo-Dutch War.

1664 The Dutch town of New Amsterdam, at the foot of Manhattan Island, is seized by the English and renamed New York.

1665 Accession of Charles II (Bourbon) to the throne of Spain, succeeding Philip IV.

1672 Invasion of The Netherlands by the armies of Louis XIV and his allies, 12 June.

VISUAL ARTS

1624–33 Bernini, Baldacchino for St. Peter's, Rome.

1632 Rembrandt, *The Anatomy Lesson of Dr. Tulp.*

1632–4 Rubens, The Banqueting House Ceiling, Whitehall, London.

1633 Hals, *Officers and Sergeants of the St. Hadrian Civic Guard.*

1633–5 Hals, *Malle Babbe.*

1635 Velázquez, *The Surrender of Breda.* Poussin, *Rape of the Sabines* (version in New York, the Metropolitan Museum of Art). Van Dyck, *Charles I on the Hunt.*

1640 Death of Rubens.

1641 Death of Van Dyck in London.

1642 Rembrandt, *The Nightwatch.*

1645–52 Bernini, *Ecstasy of St. Theresa.*

1648 Poussin, *Landscape with the Burial of Phocion.*

1656 Velázquez, *The Maids of Honor (Las Meninas).*

1660 Death of Velázquez.

1662 Rembrandt, *The Sampling Officials of the Amsterdam Draper's Guild* (*The "Staalmeesters"*).

1664 Hals, *Regents of the Old Men's House; Regentesses of the Old Men's House.*

1665 Death of Poussin in Rome.

1666 Death of Hals.

1669 Death of Rembrandt.

LITERATURE AND MUSIC

1633 Birth of Pepys.

1635 Calderon, *La vida es sueño.*

1637 Vondel, *Gijsbrecht van Aemstel.* Descartes, *Discours de la méthode.* Corneille, *Le Cid.* Death of Jonson.

1641 Monteverdi, *Il ritorno d'Ulisse in patria.*

1642 Hooft, *Nederlandsche historien.*

1643 Death of Monteverdi. Death of Frescobaldi.

1645 Death of Grotius.

1651 Hobbes, *Leviathan.*

1653 Birth of Corelli.

1654 Vondel, *Lucifer.*

1655 Cats, *Alle de wercken.*

1658 Huyghens, *Koren-bloemen.*

1659 Birth of Purcell.

1664 Schütz, *Christmas Oratorio;* Molière, *La Tartuffe, ou l'imposteur.*

1667 Milton, *Paradise Lost.* Birth of Swift.

1668 Birth of Couperin.

1670 Spinoza, *Tractatus theologico-politicus.*

1671 Milton, *Paradise Regained; Samson Agonistes.*

1672 Death of Schütz.

1673 Death of Molière.

1674 Lully, *Alceste.*

Contributors

Klaas van Berkel Professor of History, Groningen University, Groningen, The Netherlands

Wayne Franits Associate Professor of Fine Arts, Syracuse University, Syracuse, N.Y.

Marguerite Glass Assistant Professor of Art History and Museum Studies, Gallaudet University, Washington, D.C.

Elise Goodman Professor of Art History, University of Cincinnati, Cincinnati, Ohio

Valerie Hedquist Independent Art Historian and Adjunct Assistant Professor of Art History, University of Montana, Missoula, Mont.

Christiane Hertel Associate Professor of the History of Art, Bryn Mawr College, Bryn Mawr, Pa.

Kees Kaldenbach Independent Art Historian, Amsterdam, The Netherlands

Walter Liedtke Curator of European Paintings, The Metropolitan Museum of Art, New York, N.Y.

H. Rodney Nevitt Jr. Associate Professor of Art History, University of Houston, Houston, Tex.

Lisa Vergara Associate Professor of Art History, Hunter College of the City University of New York, New York, N.Y.

Arthur K. Wheelock Jr. Curator of Northern Baroque Painting, National Gallery of Art, Washington D.C., and Professor of Art History, University of Maryland, College Park, Md.

Vermeer Geography

Homes of Artists and Patrons in the Age of Vermeer

Kees Kaldenbach

This reprint of a historic map (see the foldout map following page xxiv) known as the *Kadastrale Minuut* map, depicts the precise topography of Delft as it existed in 1832. The original use of this map was to help register the ownership of building lots and real estate. For the purpose of identifying sites associated with Vermeer and the extended circle of artists and patrons around him, we prefer this 1832 map to seventeenth-century examples. This map is also suitable because so little had changed in the layout of Delft between 1650 and 1832.

The numbers and symbols on the map show the locations of artists and patrons living in Delft in the seventeenth century. A few present-day street names have been added for reference.

Legend

Buildings in the *View of Delft* (Plate 11) and Other Monumental Structures in Delft

1. Triangular side facade, possibly part of the *De Papegaey* (Parrot Brewery) at **Oude Delft.**
2. **Kethel Street.**
3. Large roof of a building, possibly part of the *De Papegaey.*
4. *Oude Kerk* (Old Church) at **Oude Delft** and **Heilige Geest Kerkhof.**
5. Slender tower of the *De Papegaey,* at **Oude Delft.**
6. *Armamentarium* (Armory) between **Oude Delft** and **Korte Geer.**
7. Kethel gate at **Zuidwal.**
8. Schiedam gate at **Zuidwal.**
9. Houses shown by Vermeer at **Lange Geer.**
10. *Nieuwe Kerk* (New Church) at **Markt** Square.
11, 12. Rotterdam gate, main building and barbican, at **Zuideinde.**

13, 14. Sites of the tow barge and standing burghers in the *View of Delft*.

15. Delft shipyard at **Zuideinde**.

16. *Stadhuis* (Town Hall) at **Markt** Square.

Homes of Artists and Craftsmen in the Age of Vermeer

A1. Leonard Bramer (1596–1674), painter and possibly one of Vermeer's teachers. He lived in a house called the *Wapen van Dantzig* (Dantzig Coat-of-Arms) at **Koornmarkt** 48. He probably rented the house before 1638, purchased it in 1643, and lived there until his death in 1674.

A2. Carel Fabritius (1622–54), painter, initially lived at **Oude Delft** and then moved to the **Doelenstraat.** Though the exact location of his house is unknown, it was most certainly near the gunpowder arsenal, which exploded on October 12, 1654, taking the artist's life in the process.

A3. Pieter de Hooch (1629–84), painter, lived in a house with an enclosed courtyard that could be reached through an alleyway between **Oude Delft** 145–7. De Hooch had arrived in Delft in or shortly before 1652 and departed permanently for Amsterdam around 1660–1.

A4. Egbert Lievensz. van der Poel (1621–64), painter (and relative of Vermeer's father through marriage), resided at various addresses in Delft before moving to Rotterdam around 1654–5. In 1652, for example, he lived on the **Doelenstraat,** close to Carel Fabritius. Van der Poel made a specialty of paintings of spectacular conflagrations and like disasters, including the explosion of Delft's gunpowder arsenal in 1654.

A5. Jan Steen (1626–79), one of the most beloved seventeenth-century Dutch painters, moved to Delft from The Hague in the fall of 1654. Shortly before he relocated there, Steen leased the brewery *Inde Slange* (In the Snake), also known as *De Roscam* (The Currycomb), located at **Oude Delft** 74. Steen gave up brewing in 1657 and moved to Leiden.

Vermeer in Delft

V1. Johannes Vermeer was born in 1632 in *De Vliegende Vos* (The Flying Fox), an inn leased by his father Reynier Jansz. Vermeer, on the **Voldersgracht.** This inn stood two houses east of the Old Men's House, which later became the headquarters of the Guild of Saint Luke. The present-day location is **Voldersgracht** on or near no. 23.

V2. In 1641, Vermeer's father, Reynier Jansz., bought a large house on the **Markt** square called the *Mechelen*. This became an inn where Vermeer spent the remainder of his childhood and possibly his teenage years (unless he received his artistic training at a city outside of Delft, in which case he would have been away from circa 1645–7 until 1653). After his marriage in 1653 to Catharina Bolnes, the young couple might have

resided at the inn, though they were certainly living at his mother-in-law's house by December 1660 (see no. V3). After Jansz.'s death in 1652, the inn was operated by his widow, Digna Baltens, until she leased it to a local shoemaker in 1669. Vermeer himself would rent the property to an apothecary in 1672. Though rented, the property was still in the possession of Vermeer's family when the artist died in 1675. The inn was demolished in 1885; the site today is a vacant lot, next to **Markt** 52.

V3. This is the site of the house of Maria Thins, Vermeer's mother-in-law, in the Catholic quarter of Delft. The artist and his wife were living in the house by December 1660. Most of Vermeer's paintings were created here and many of his children were born here as well. The house was later demolished and today there is a large Roman Catholic church on the site, at the corner of **Oude Langendijk** and **Molenpoort.**

V4. Vermeer was buried in the *Oude Kerk* (Old Church) on December 16, 1675. The commemorative stone marker in the church today does not lie on the actual spot where Vermeer's remains were interred.

S1. The viewpoint of Delft's South Harbor and Schiedam and Rotterdam Gates that Vermeer adopted for his *View of Delft* (Plate 11).

S2. The viewpoint of **Nieuwe Langendijk** 22–6 that Vermeer adopted for *The Little Street* (Plate 10).

Homes of Patrons and Officials Associated with Vermeer

P1. Hendrick van Buyten (?–1701) was a baker who lived on the **Koornmarkt** – the exact location of his house is unknown. Van Buyten probably owned one of Vermeer's paintings by 1663. He acquired two more shortly after Vermeer's death from his widow in lieu of a huge debt owed for bread.

P2. Pieter Claesz. van Ruijven (1624–74) and his wife, Maria de Knuijt (?–1681), were major patrons of Vermeer's who between circa 1665 and 1674 lived on the east side of **Oude Delft** near **Nieuwstraat** in a house called the *Goude Adelaar* (The Golden Eagle). Van Ruijven loaned Vermeer 200 guilders in 1657, which might have been meant as an advance toward the purchase of one or more paintings. Eventually this wealthy couple would own a sizable number of the artist's paintings. In her will, De Knuijt instructed that 500 guilders be left to the painter, a rare if not unique example of a seventeenth-century Dutch patron bequeathing money to an artist.

P3. Jacob Dissius (1653–95) lived at *Het Vergulde ABC* (The Golden ABC), a printing establishment owned by his father at **Markt** 32. Dissius married the daughter of Pieter Claesz. van Ruijven and Maria de Knuijt, Magdelena, in 1680. After her death in 1682, Dissius eventually inherited Van Ruijven's and De Knuijt's Vermeer paintings, which in turn were auctioned in 1696, several months after Dissius's own death.

P4. Anthony van Leeuwenhoek (1632–1732; Fig. 52), the renowned inventor
 of the microscope, lived at *Het Gouden Hooft* (The Golden Head), a no
 longer extant house at **Hippolytusbuurt** 7 that he purchased around
 1653. In 1676 the city of Delft appointed Van Leeuwenhoek as trustee of
 Vermeer's estate.

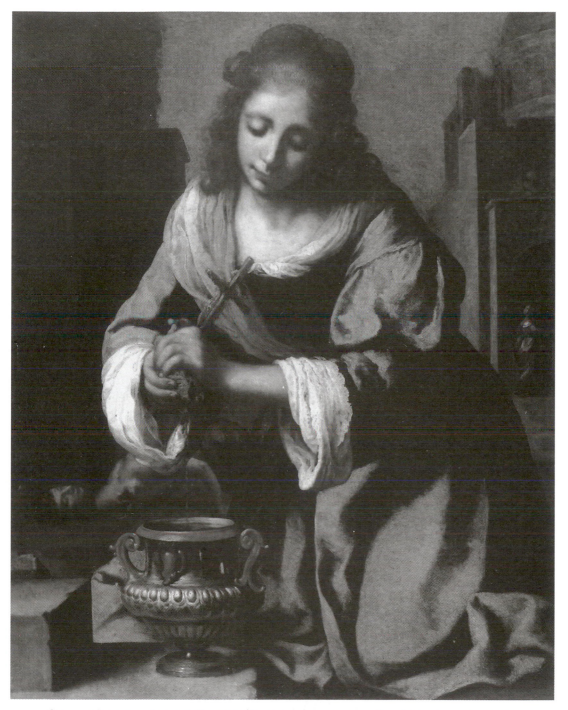

Plate 1. Johannes Vermeer, *Saint Praxedis,* 1655 (oil on canvas, 105.4 × 85.1 cm). The Barbara Piasecka Johnson Collection Foundation. Photo: foundation.

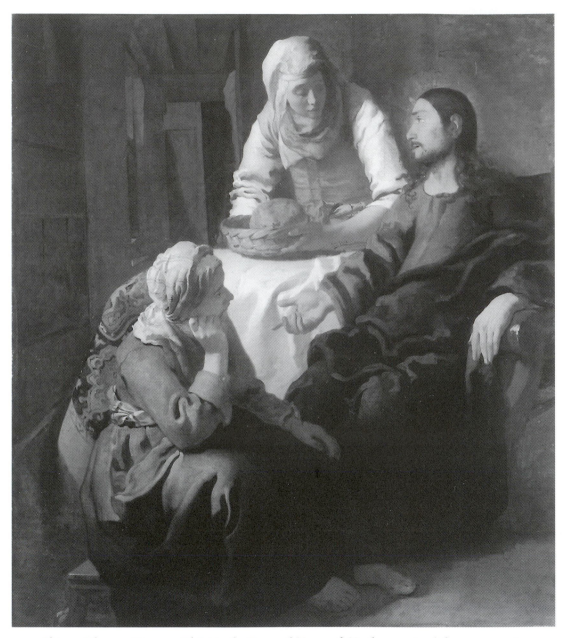

Plate 2. Johannes Vermeer, *Christ in the House of Mary and Martha,* ca. 1655 (oil on canvas, 160 × 142 cm). Edinburgh, National Galleries of Scotland. Photo: museum.

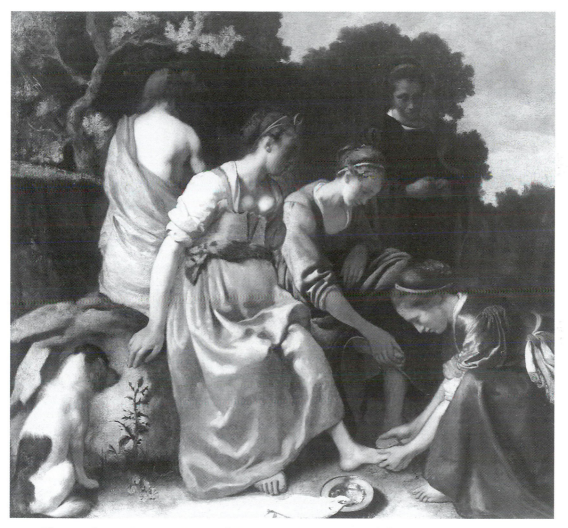

Plate 3. Johannes Vermeer, *Diana and Her Companions,* ca. 1655–6 (oil on canvas, 98.5 × 105 cm). The Hague, Mauritshuis. Photo: copyright Stichting Vrienden van het Mauritshuis.

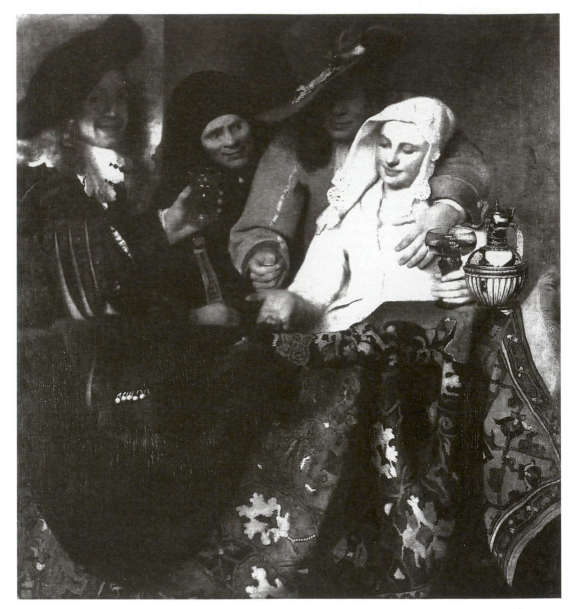

Plate 4. Johannes Vermeer, *The Procuress,* 1656 (oil on canvas, 143 × 130 cm). Dresden, Staatliche Kunstsammlungen. Photo: museum.

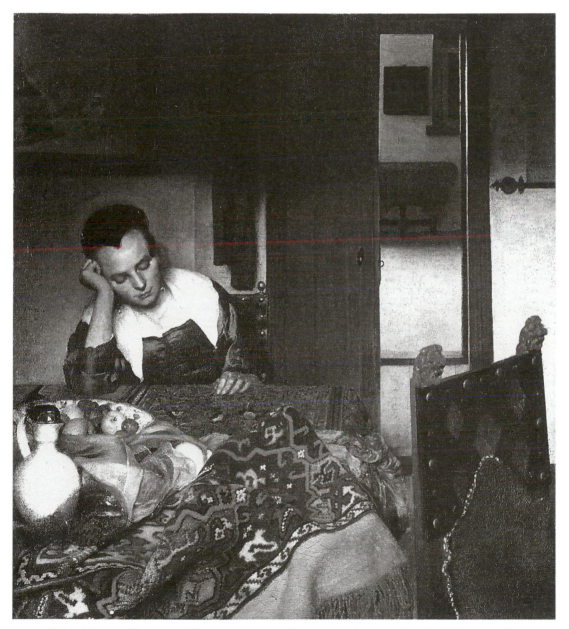

Plate 5. Johannes Vermeer, *A Woman Asleep at a Table,* ca. 1657 (oil on canvas, 87.6 × 76.5 cm). New York, The Metropolitan Museum of Art, Bequest of Benjamin Altman, 1913. Photo: museum.

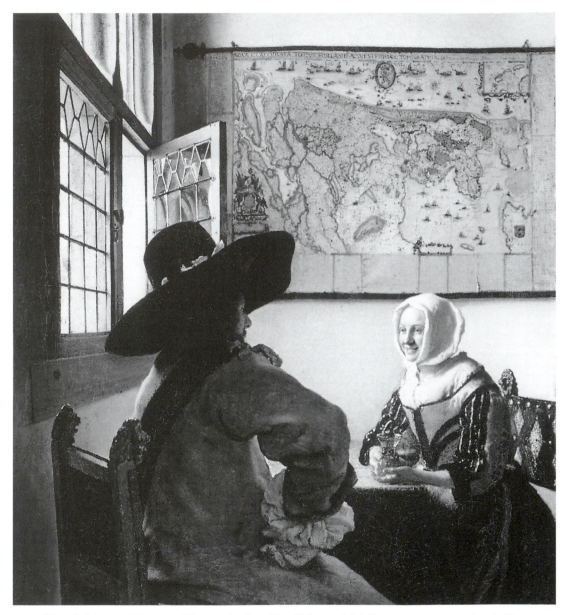

Plate 6. Johannes Vermeer, *Officer and a Laughing Girl,* ca. 1658 (oil on canvas, 50.5 × 46 cm). New York, The Frick Collection. Photo: The Frick Collection.

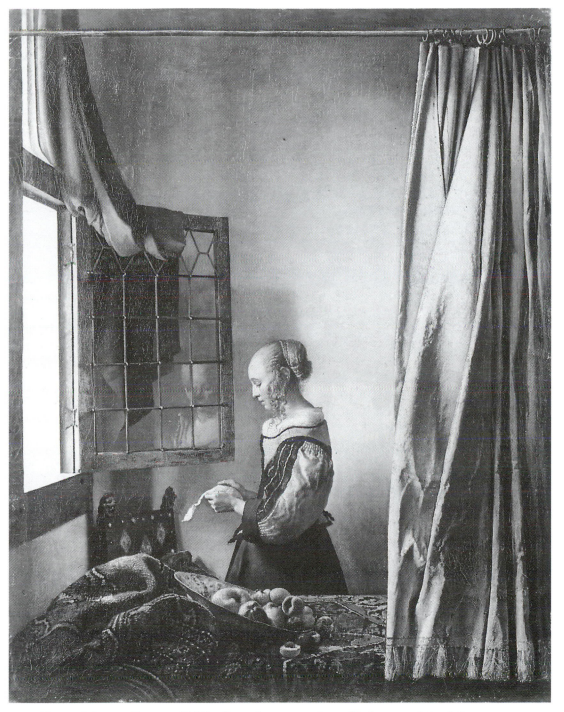

Plate 7. Johannes Vermeer, *Girl Reading a Letter at an Open Window*, ca. 1658–9 (oil on canvas, 83 × 64.5 cm). Dresden, Staatliche Kunstsammlungen. Photo: museum.

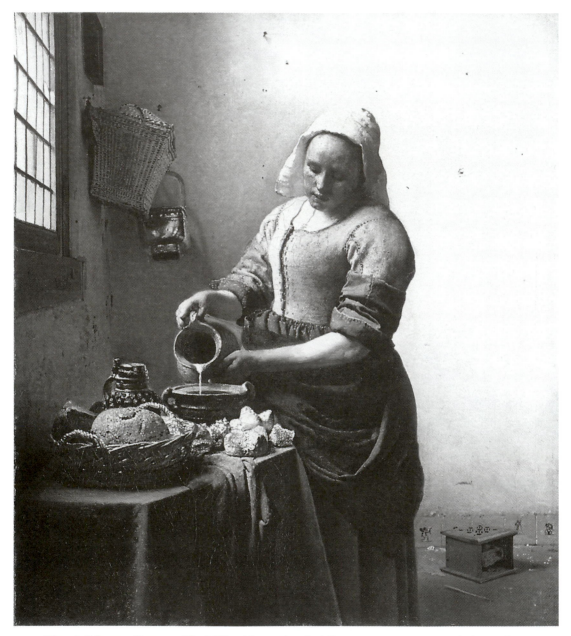

Plate 8. Johannes Vermeer, *The Milkmaid*, ca. 1659–60 (oil on canvas, 45.5 × 41 cm). Amsterdam, Rijksmuseum. Photo: Rijksmuseum-Stichting.

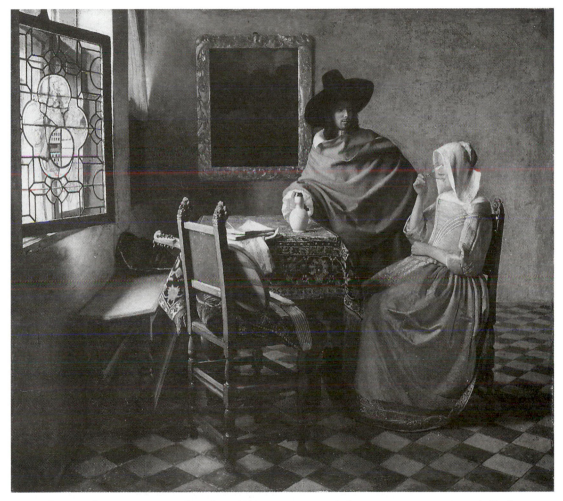

Plate 9. Johannes Vermeer, *The Glass of Wine,* ca. 1659–60 (oil on canvas, 66.3 × 76.5 cm). Berlin, Staatliche Museen zu Berlin; Preußischer Kulturbesitz Gemäldegalerie. Photo: Jörg P. Anders.

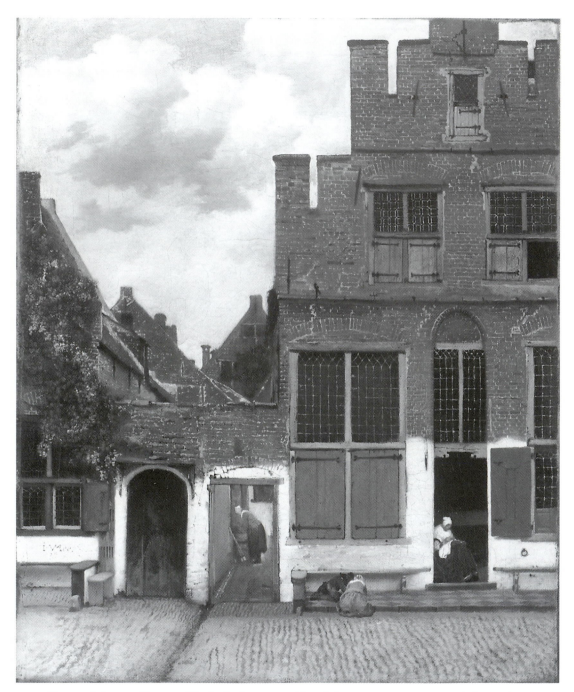

Plate 10. Johannes Vermeer, *The Little Street,* ca. 1660–1 (oil on canvas, 54.3 × 44 cm). Amsterdam, Rijksmuseum. Photo: Rijksmuseum-Stichting.

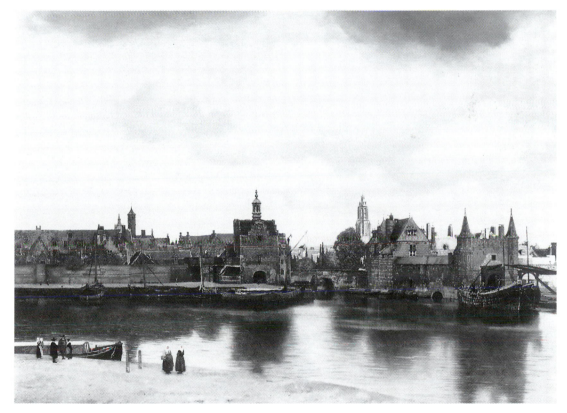

Plate 11. Johannes Vermeer, *View of Delft,* ca. 1660–1 (oil on canvas, 96.5 × 115.7 cm). The Hague, Mauritshuis. Photo: copyright Stichting Vrienden van het Mauritshuis.

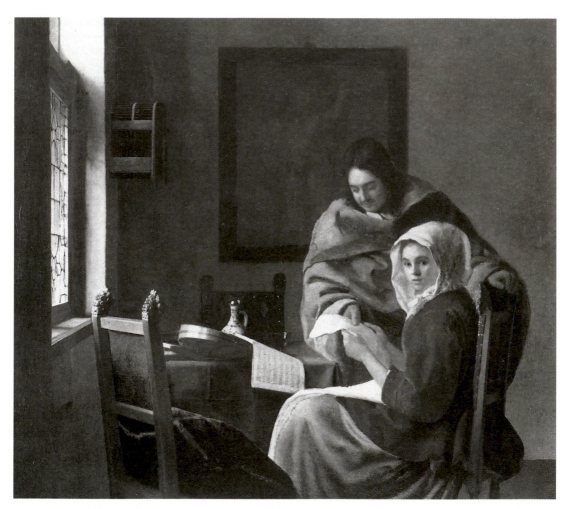

Plate 12. Johannes Vermeer, *Girl Interrupted at Her Music*, ca. 1660–1 (oil on canvas, 39.3 × 44.4 cm). New York, The Frick Collection. Photo: The Frick Collection.

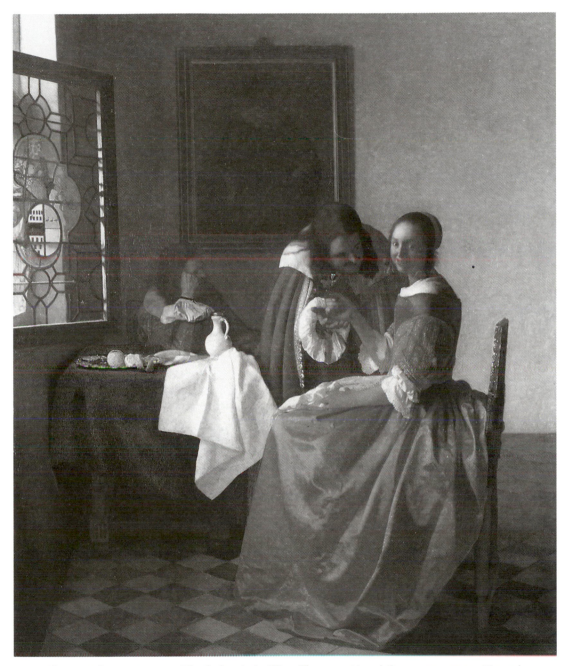

Plate 13. Johannes Vermeer, *The Girl with the Wine Glass,* ca. 1661–2 (oil on canvas, 77.5 × 66.7 cm). Brunswick, Herzog Anton Ulrich-Museum. Photo: Bernd-Peter Keiser.

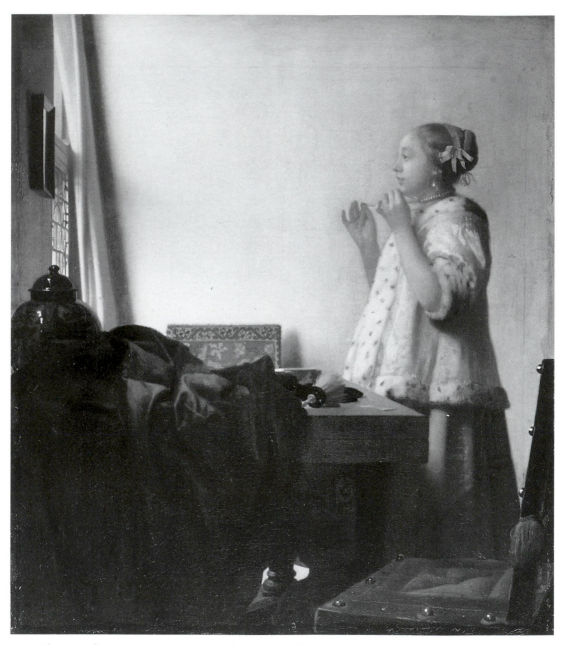

Plate 14. Johannes Vermeer, *Woman with a Pearl Necklace,* ca. 1662–4 (oil on canvas, 51.2 × 45.1 cm). Berlin, Staatliche Museen zu Berlin; Preußischer Kulturbesitz Gemäldegalerie. Photo: Jörg P. Anders.

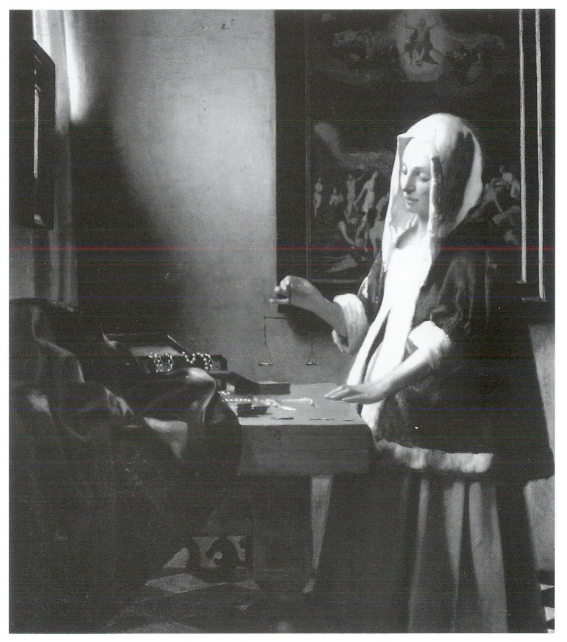

Plate 15. Johannes Vermeer, *Woman Holding a Balance,* ca. 1662–4 (oil on canvas, 42.5 × 38 cm). Washington, D.C., National Gallery of Art, Widener Collection. Photo: museum.

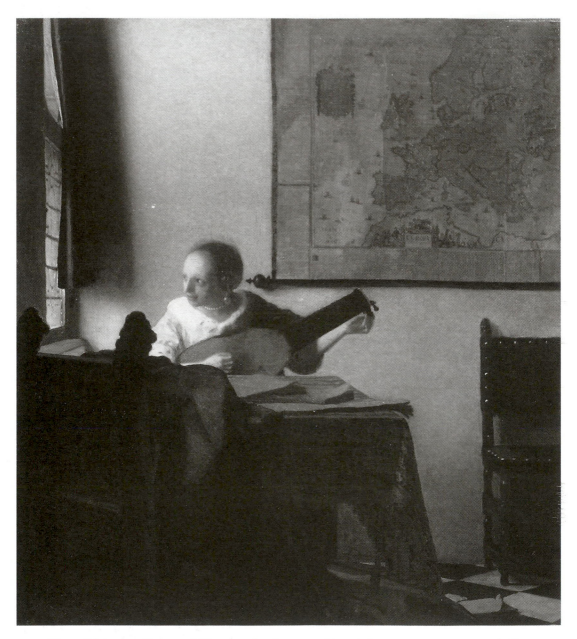

Plate 16. Johannes Vermeer, *A Woman with a Lute,* ca. 1662–4 (oil on canvas, 51.4 × 45.7 cm). New York, The Metropolitan Museum of Art, Bequest of Collis P. Huntington, 1900. Photo: museum.

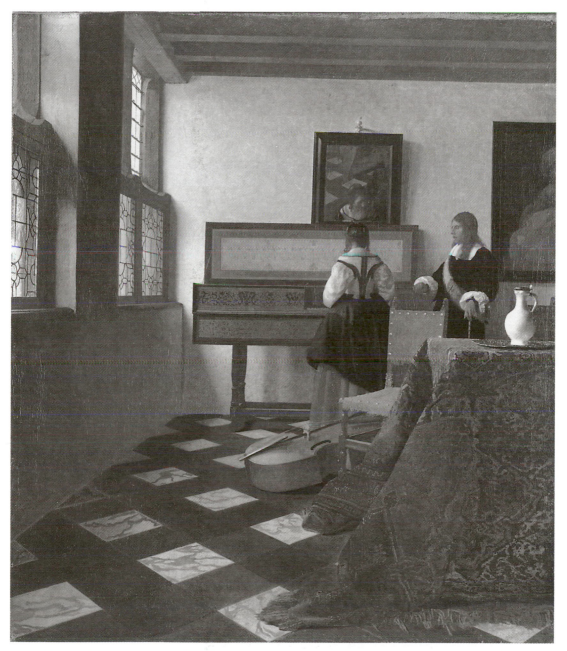

Plate 17. Johannes Vermeer, *The Music Lesson,* ca. 1662–4 (oil on canvas, 74 × 64.5 cm). London, The Royal Collection Copyright HM Queen Elizabeth II. Photo: Royal Collection Picture Library.

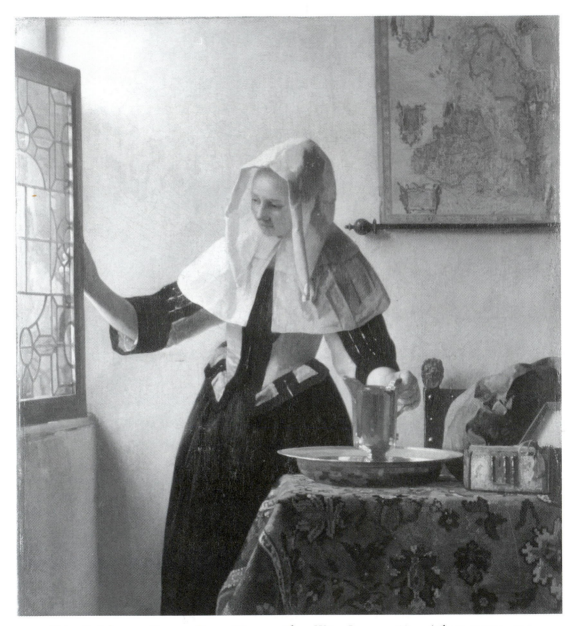

Plate 18. Johannes Vermeer, *Young Woman with a Water Jug,* ca. 1663–5 (oil on canvas, 45.7 × 40.5 cm). New York, The Metropolitan Museum of Art, Gift of Henry G. Marquand, 1889. Photo: museum.

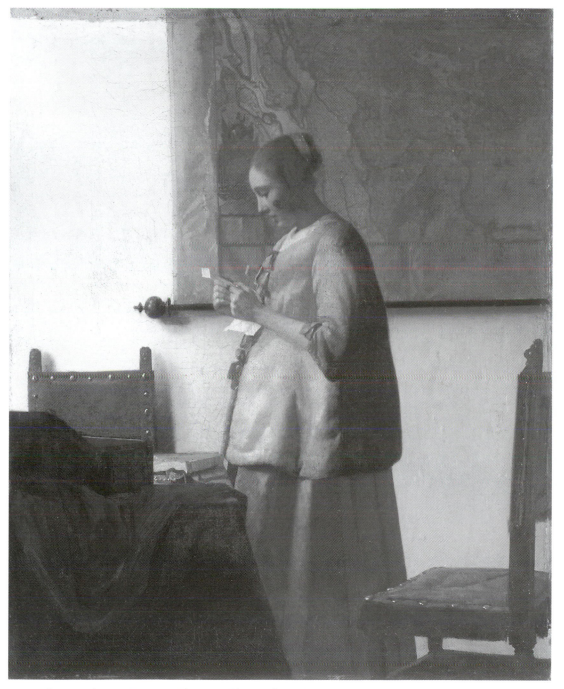

Plate 19. Johannes Vermeer, *Woman in Blue Reading a Letter,* ca. 1663–5 (oil on canvas, 46.5 × 39 cm). Amsterdam, Rijksmuseum. Photo: Rijksmuseum-Stichting.

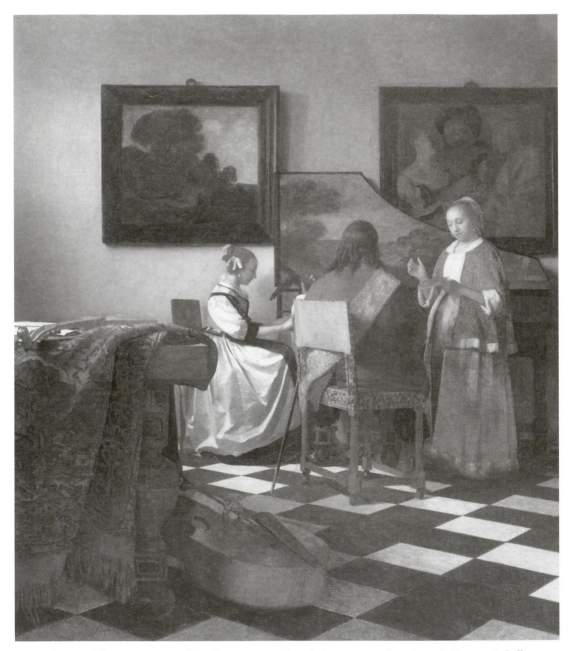

Plate 20. Johannes Vermeer, *The Concert,* ca. 1664–5 (oil on canvas, 69 × 63 cm). Boston, Isabella Stewart Gardner Museum. Photo: museum.

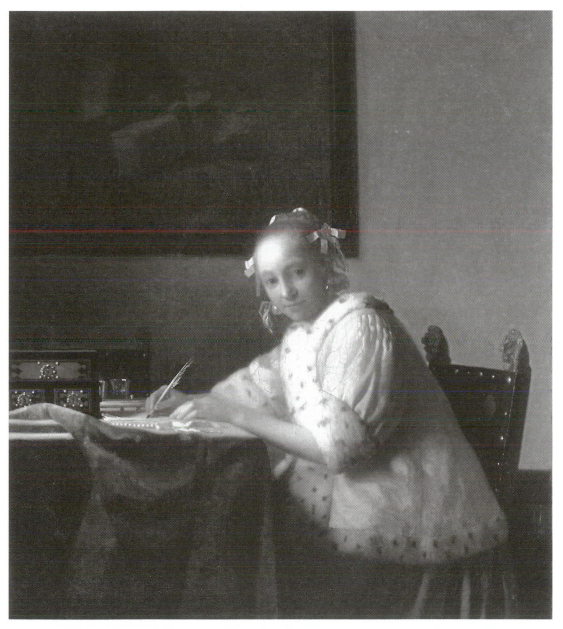

Plate 21. Johannes Vermeer, *A Lady Writing*, ca. 1665 (oil on canvas, 45 × 39.9 cm). Washington, D.C., National Gallery of Art, Gift of Harry Waldron Havemeyer and Horace Havemeyer Jr., in Memory of Their Father, Horace Havemeyer. Photo: museum.

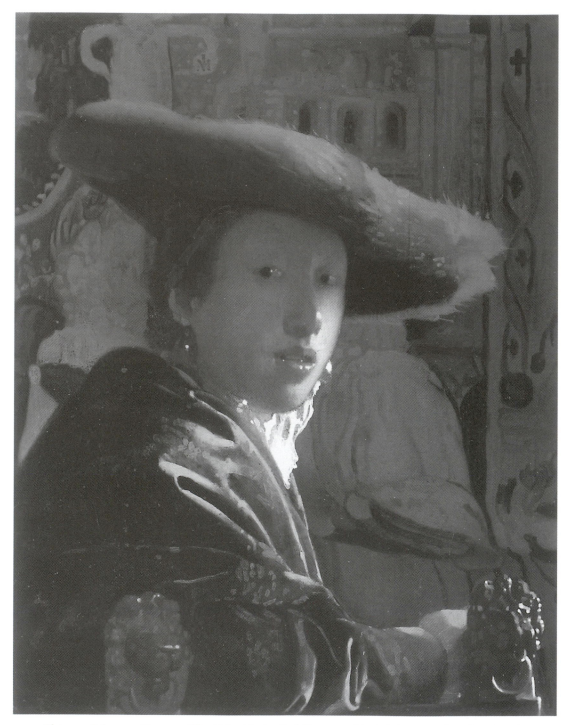

Plate 22. Johannes Vermeer, *The Girl with the Red Hat,* ca. 1665–6 (oil on panel, 22.8 × 18 cm). Washington, D.C., National Gallery of Art, Andrew W. Mellon Collection. Photo: museum.

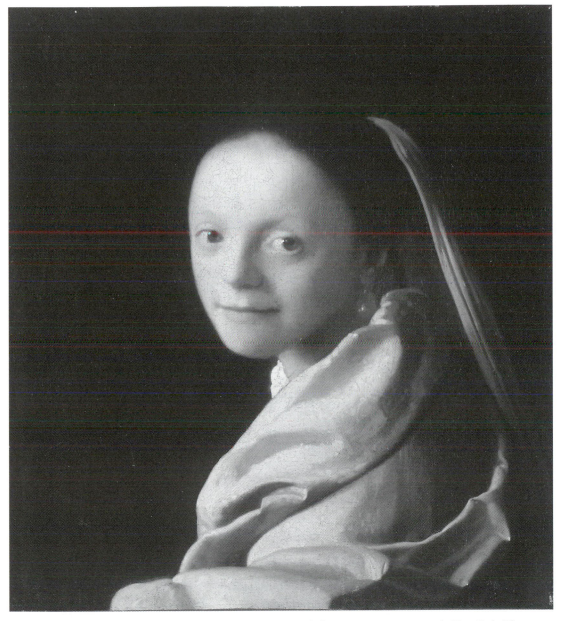

Plate 23. Johannes Vermeer, *Head of a Girl,* ca. 1665–6 (oil on canvas, 44.5 × 40 cm). New York, The Metropolitan Museum of Art, Gift of Mr. and Mrs. Charles Wrightsman, in Memory of Theodore Rousseau Jr., 1979. Photo: museum.

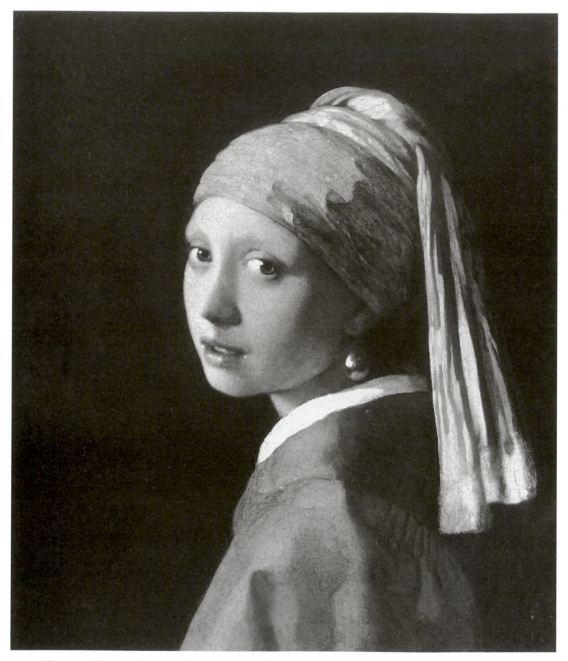

Plate 24. Johannes Vermeer, *Girl with a Pearl Earring*, ca. 1665–6 (oil on canvas, 44.5 × 39 cm). The Hague, Mauritshuis. Photo: copyright Stichting Vrienden van het Mauritshuis.

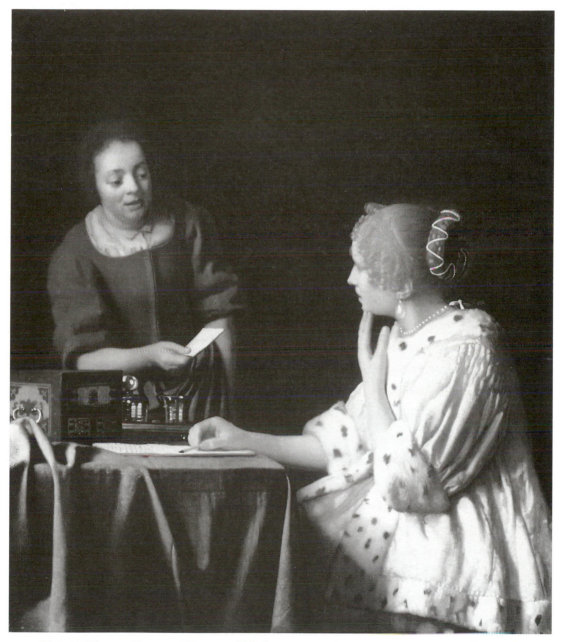

Plate 25. Johannes Vermeer, *Mistress and Maid*, ca. 1666–7 (oil on canvas, 92 × 78.7 cm). New York, The Frick Collection. Photo: The Frick Collection.

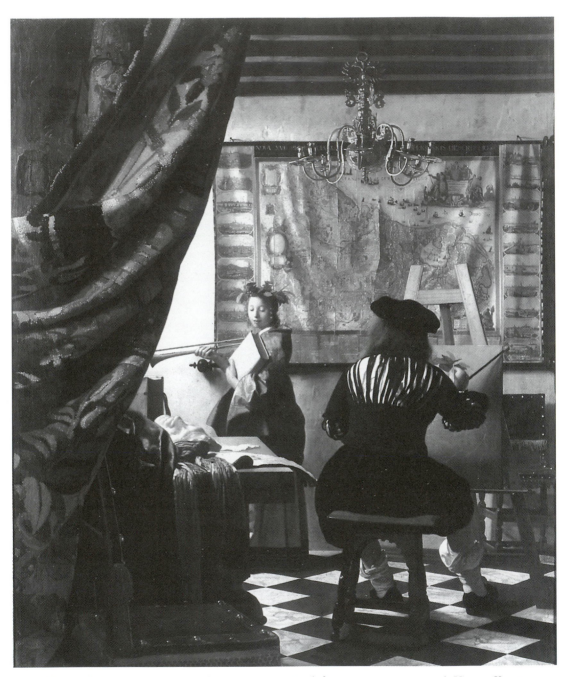

Plate 26. Johannes Vermeer, *Art of Painting*, ca. 1666–7 (oil on canvas, 120 × 100 cm). Vienna, Kunsthistorisches Museum. Photo: museum.

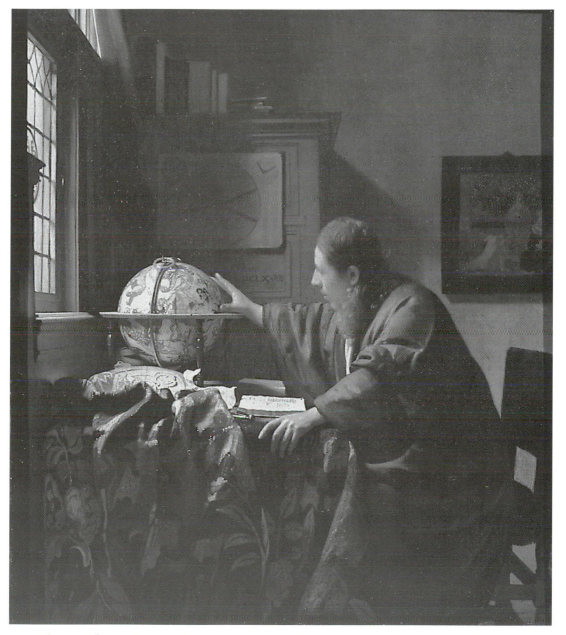

Plate 27. Johannes Vermeer, *The Astronomer*, 1668 (oil on canvas, 51.5 × 45.5 cm). Paris, Musée du Louvre. Photo: Art Resource.

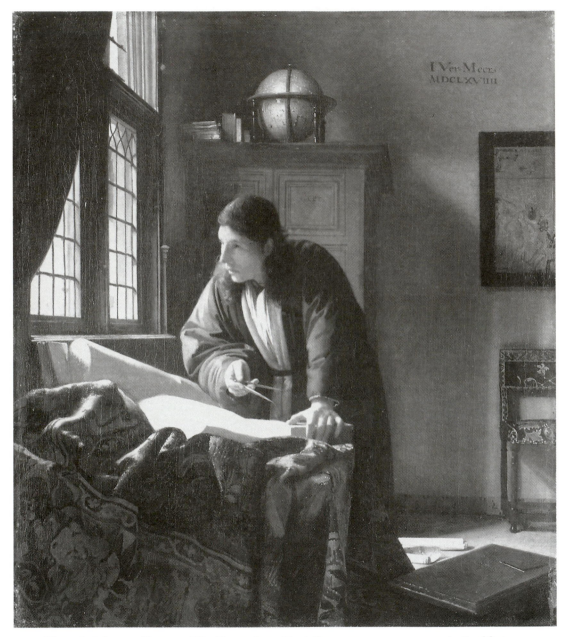

Plate 28. Johannes Vermeer, *The Geographer*, 1669 (oil on canvas, 52 × 45.5 cm). Frankfurt am Main, Städelsches Kunstinstitut. Photo: museum.

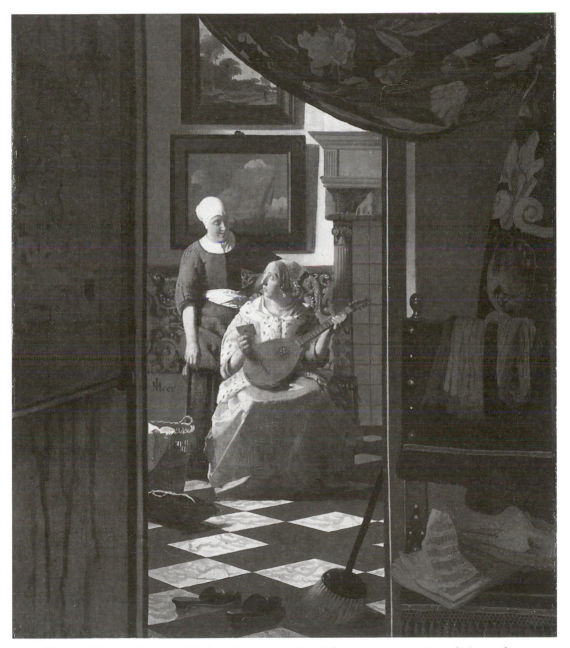

Plate 29. Johannes Vermeer, *The Love Letter*, ca. 1668–9 (oil on canvas, 44 × 38.5 cm). Amsterdam, Rijksmuseum. Photo: Rijksmuseum-Stichting.

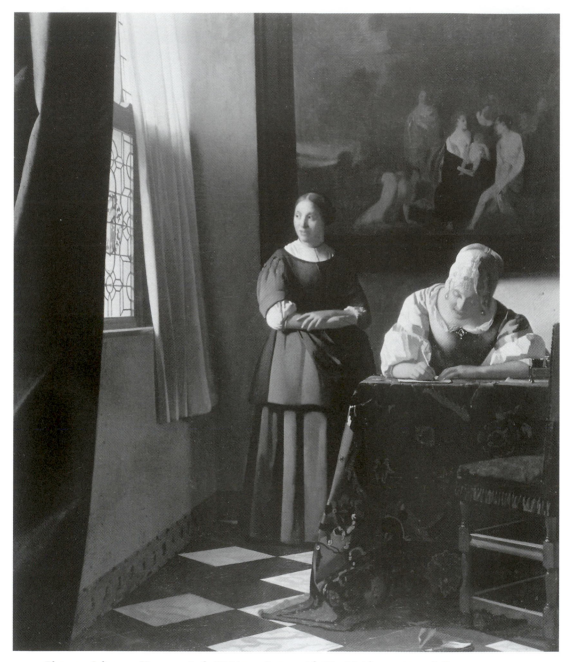

Plate 30. Johannes Vermeer, *Lady Writing a Letter with Her Maid,* ca. 1670–1 (oil on canvas, 72.2 × 59.7 cm). Dublin, National Gallery of Ireland. Photo: museum.

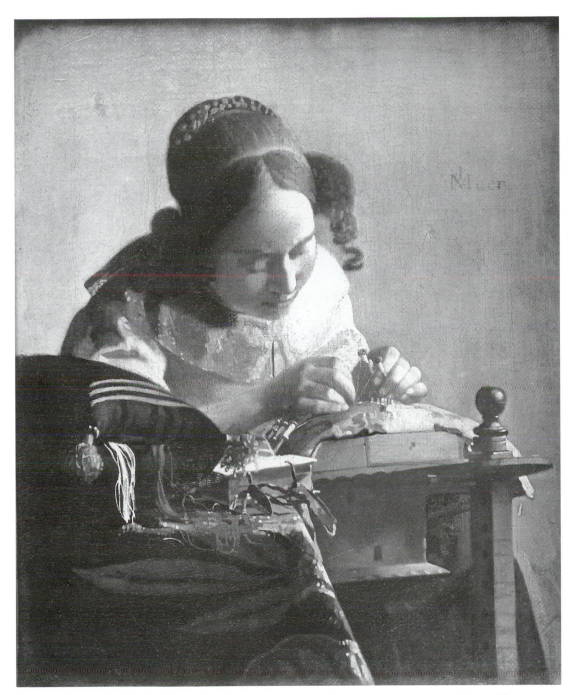

Plate 31. Johannes Vermeer, *The Lacemaker*, ca. 1671–2 (oil on canvas, 23.9 × 20.5 cm). Paris, Musée du Louvre. Photo: Art Resource.

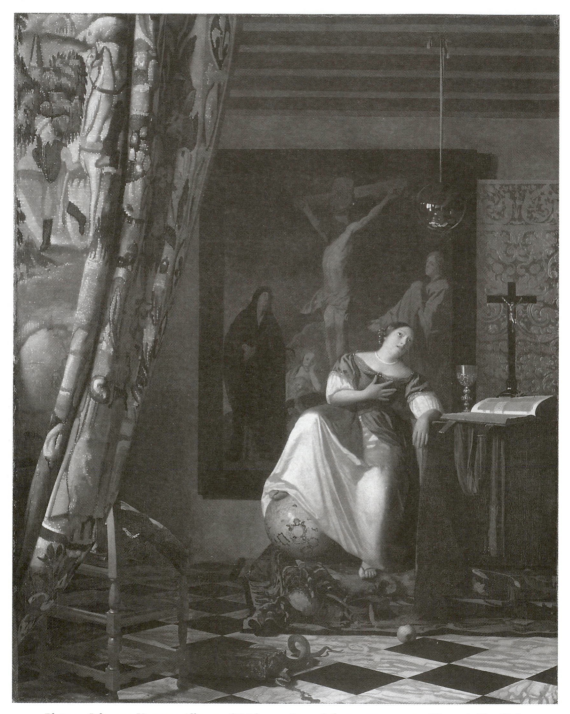

Plate 32. Johannes Vermeer, *Allegory of Faith,* ca. 1672–4 (oil on canvas, 114.3 × 88.9 cm). New York, The Metropolitan Museum of Art, The Friedsam Collection, Bequest of Michael Friedsam, 1931. Photo: museum.

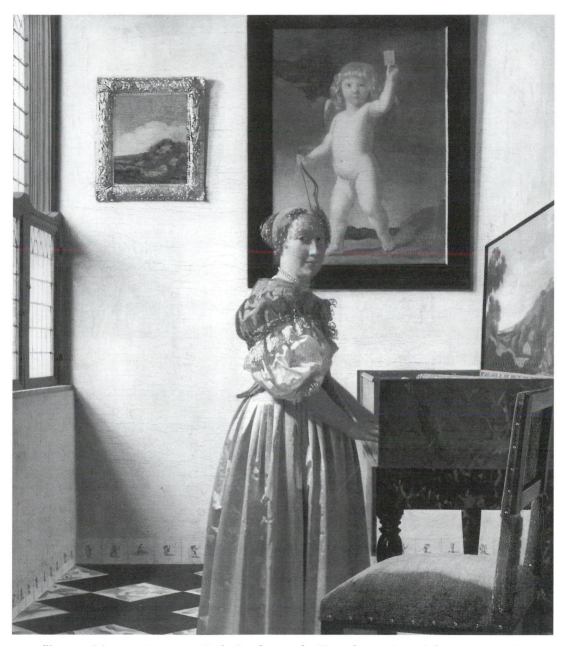

Plate 33. Johannes Vermeer, *A Lady Standing at the Virginal,* ca. 1672–4 (oil on canvas, 51.8 × 45.2 cm). London, The National Gallery. Reproduced by courtesy of the Trustees, The National Gallery, London.

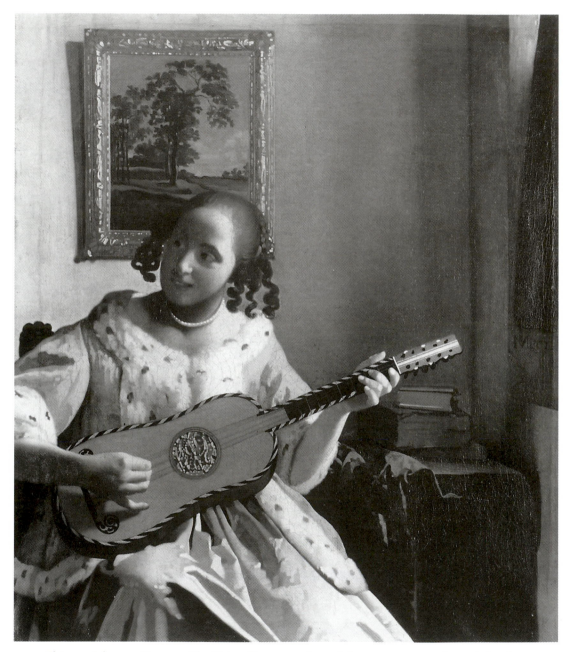

Plate 34. Johannes Vermeer, *The Guitar Player*, ca. 1672–5 (oil on canvas 53 × 46.3 cm). London, Iveagh Bequest, Kenwood (English Heritage). Photo: copyright Iveagh Bequest.

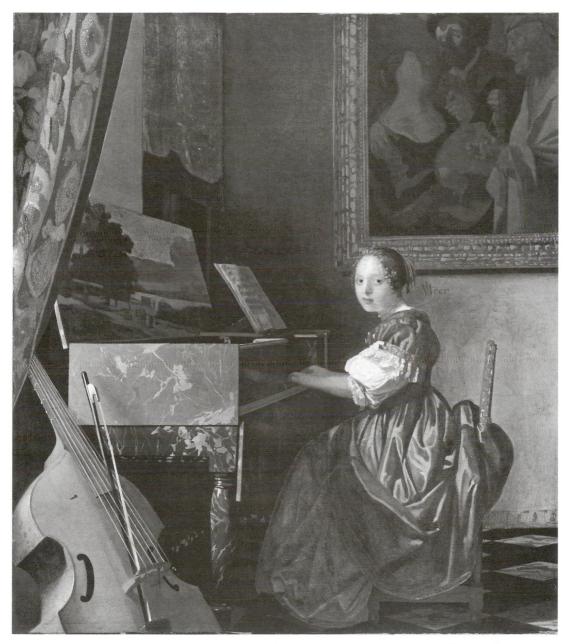

Plate 35. Johannes Vermeer, *A Lady Seated at the Virginal*, ca. 1675 (oil on canvas, 51.5 × 45.6 cm). London, The National Gallery. Reproduced by courtesy of the Trustees, The National Gallery, London.

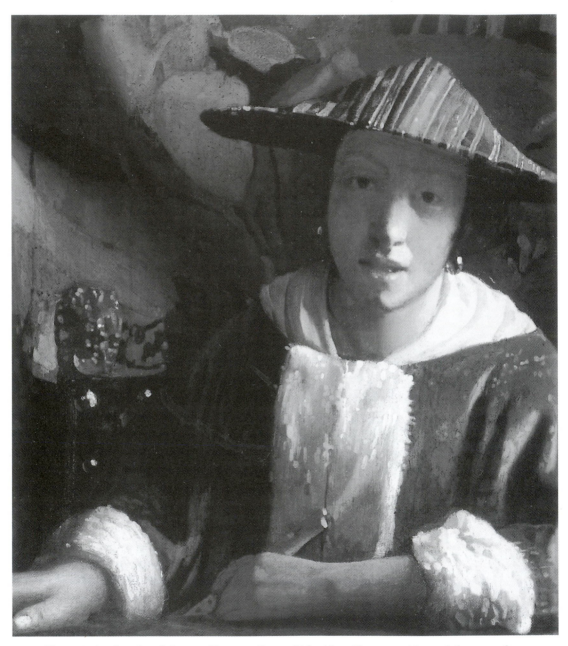

Plate 36. Attributed to Johannes Vermeer, *Young Girl with a Flute*, ca. 1665–70 (oil on panel, 20 × 17.8 cm). Washington, D.C., National Gallery of Art, Widener Collection. Photo: museum.

THE CAMBRIDGE COMPANION TO
Vermeer

Introduction

Wayne Franits

Johannes Vermeer (1632–75) has long been heralded as one of the greatest Dutch painters in what was arguably the greatest century in the history of Dutch painting: the seventeenth century, otherwise known as the Golden Age. The propitious confluence of various economic, political, cultural, and religious factors enabled Vermeer's country, The Netherlands, to become one of the leading European centers of art during this period. The Netherlands was born of a long and bloody war of independence against Spain.[1] Although decades of hostilities between the two nations only ended with the ratification of the Treaty of Münster in 1648, a twelve-year truce declared in 1609 had all but confirmed the de facto status of The Netherlands as an independent nation.

Despite the war with the Spanish the Dutch economy flourished through much of the seventeenth century. Indeed, its outstanding transportation networks, successful industries, specialized agrarian sector, and booming, international trade made the economy the envy of many nations. Equally enviable was the economy's impact on the heavily urbanized Dutch society, one in which wealth was dispersed far down the social ladder as evidenced, for example, by the country's huge and thriving middle class. The robust Dutch economy and prosperous citizenry provided an extremely favorable environment in which artists could work, even if their principal patrons were no longer the small aristocratic class and the much-reduced Roman Catholic church in this now officially Protestant land.

For whom did artists paint in the mercantile republic that was The Netherlands?[2] Essentially, artists worked in an open and highly competitive market. Guild restrictions within individual cities helped to ease this situation, for example, by limiting the sale of pictures by painters who were not citizens of a particular municipality, but for the most part, competition was very keen. Regardless of whether an artist was selling his or her work to a private patron; a public institution; an art dealer; or, without a dealer intermediary, directly on the open market, success could only be guaranteed by the production of art consistent with the expectations of the buyer. And generally, the greater the wealth, social

status, and sophistication of that buyer, the higher the quality of the art demanded.

In light of the economic and cultural conditions under which painters labored, it should come as no surprise to learn that they tended to specialize in particular subjects that sold well. Thus, some artists restricted their repertoire to painting still lifes while others specialized in landscapes. And within these individual genres existed even further specialization. For example, some still-life painters depicted only floral still lifes whereas others concentrated on breakfast pieces, namely, depictions of food. Moreover, certain landscape painters had a preference for night scenes while other landscapists depicted dunes or winter vistas.

There were also an extraordinarily large number of painters whose specialty was genre painting, or, as they are commonly known, scenes of everyday life. This was the category of art in which Vermeer specialized, after some initial forays into the field of history painting (that is, representations of biblical, mythological, or historical subjects). Vermeer, who began to produce genre paintings in the late 1650s, could not have embarked upon a career in this specialty at a more auspicious moment. The Dutch economy virtually exploded with the cessation of hostilities with Spain in 1648; indeed, the nation's economic strength would reach its apogee within a few short years after that event. Equally dramatic developments in genre painting surfaced concomitant with the flourishing economy (and perhaps related to it in as yet unclear ways) fostered by artists of Vermeer's generation. Masters such as Gerrit Dou (1613–75) and Gerard ter Borch (1617–81) introduced certain stylistic devices, including a hitherto unseen level of refinement in the renderings of textures and stuffs, and subtle yet sophisticated evocations of light and shadow on figures and objects placed in carefully constructed spaces, often vertical in format (Fig. 1). Their superbly balanced and visually striking works contrast strongly with the more evenly lit and semimonochromatic products of their predecessors.

During his extended career as a genre painter Vermeer would participate in these developments by producing pictures that display an unprecedented level of artistic mastery in their consummate illusion of reality. As the reader will discover in the ensuing essays, Vermeer enjoyed great notoriety in his lifetime, only to sink gradually into semioblivion during the eighteenth century. He was, finally, recompensed by his rediscovery and seeming deification in the nineteenth and twentieth centuries. As numerous publications attest and the spectacular success of the Vermeer exhibition held in Washington, D.C., and The Hague during 1995–6 confirms (see Fig. 56), the art of Vermeer continues to fascinate art historians and laypersons alike. *The Cambridge Companion to Vermeer* is meant to bridge the gap between experts on one hand and students and general art lovers on the other. It consists of ten chapters by scholars of Dutch art that examine the art and life of Vermeer from a variety of perspectives. These chapters are written in an easily accessible style that will appeal to nonspecialists.

The book opens with a survey of Vermeer's art and life as it is generally

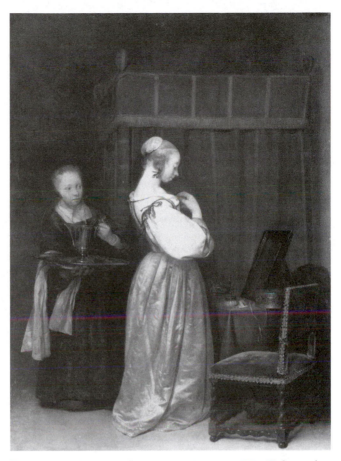

Fig. 1. Gerard ter Borch, *A Young Woman at Her Toilet with a Maid* (oil on canvas, 47.6 × 34.6 cm). New York, The Metropolitan Museum of Art, Gift of J. Pierpont Morgan, 1917. Photo: museum.

understood by scholars today. This provides the reader with a foundation for the chapters that follow. The ensuing contributions can be divided between the next two, which examine Vermeer's development as an artist and his approach to painting, and the following five chapters, which explore Vermeer's pictures within the broader context of contemporary Dutch culture. The volume concludes with two surveys of Vermeer's reputation in subsequent eras, especially our own.

Vermeer's formative years are the focus of the chapter by Walter Liedtke. The identity of Vermeer's principal teacher remains a mystery today; nevertheless his earliest pictures, dating between roughly 1655 and 1660, reveal much about his response to the work of other artists. As Liedtke argues, "the main element in [a] painter's program of self-training was the discovery of an effective approach to compositional design. In this respect Vermeer proceeded from painting to painting with exceptional care." By charting Vermeer's progress in this regard, the artists who influenced him, and his development as a figural painter, Liedtke establishes convincing connections between Vermeer's early

paintings of biblical and mythological subjects and the more familiar genre paintings of his maturity for which he is principally celebrated today.

As was already noted, Vermeer devoted much of his energy in his early years to the creation of history paintings. It was only during the late 1650s that he would turn permanently to genre paintings, the type of work that secured his reputation both in his own day as well as in ours. The approaches and techniques that Vermeer employed to produce these latter pictures are as varied as they are remarkable. Arthur Wheelock, a leading authority on Vermeer, has contributed a chapter on precisely this aspect of Vermeer's art, drawing upon his vast knowledge of the artist's working method. As Wheelock observes, "Vermeer was an extraordinary craftsman who carefully conceived and structured his compositions to achieve the purity of expression he sought to convey. . . . He mastered a wide range of painting techniques to allow his vision to take visual form, which, when analyzed, provide extraordinary insights into Vermeer's pictorial ideas." Using Vermeer's *Woman in Blue Reading a Letter* (Plate 19) as his principal example, Wheelock goes on to present intriguing evidence drawn from recent technical studies of the multiple changes that the painter wrought in this and other pictures to enhance their clarity and mood. Wheelock closes his study by linking the compellingly realistic appearance of Vermeer's paintings to broader seventeenth-century aesthetic ideals of artistic accomplishment.

Vermeer's paintings are arresting for their general lack of narrative, for their eternalization of seemingly inconsequential moments. Therefore, attempts to decipher the iconographic complexities of the artist's work have often proved elusive. In other words, art historians have addressed the question of the meaning of Vermeer's art with only limited success – a reflection no doubt of the evocative, yet enigmatic nature of his imagery. It is precisely this aspect of Vermeer studies that is the most captivating (even if it is sometimes the most frustrating). For this reason, *The Cambridge Companion to Vermeer* devotes five interpretive studies to the themes that comprise Vermeer's art.

Women form the single largest subject in Vermeer's work: of the approximately thirty-six works considered authentic, twenty focus exclusively on either one female or two. To these can be added six paintings featuring men and women engaged in various activities. Consequently, three of the five interpretive essays explore various facets of Vermeer's female imagery. Lisa Vergara's contribution is perhaps the most general of the three as she examines the artist's representation of women in genre paintings as well as in his highly personal, allegorical *Art of Painting* (Plate 26). Vergara's essay is noteworthy for her exceptionally close scrutiny of the surfaces of Vermeer's paintings of women. This approach reveals the artist's habit of guiding the viewer's reading of a picture by coordinating forms on the surface and in depth in order to yield further dimensions of meaning. Vergara simultaneously recognizes a personal dimension in Vermeer's renderings of females, one in which the salient themes of the artist's life overlap with those of his pictures – his wife's frequent pregnancies, for example, and the pregnant figure in the *Woman Holding a Balance* (Plate 15).

Vergara also investigates the underlying reasons for Vermeer's interest in the female figure: "the growing market for pleasing images of youthful femininity, the identification of high-class burgher households with women in Dutch paintings of domestic life, and the aesthetic appeal to Vermeer of ordered, sunlit spaces associated with such households; . . . this combination of factors makes Vermeer's attention to women in his art easier to understand."

The focus of Elise Goodman's article is more narrow than that of Vergara's but it, too, offers insights into seventeenth-century perspectives on women and femininity. Specifically, Goodman studies the seemingly problematic presence of landscape paintings in the background of many of Vermeer's genre paintings of women and courtship. By linking this imagery with contemporary lyrics, poetry, and prints, Goodman argues that these landscape paintings contribute significantly to the principal theme of the artist's work: the celebration of love and beauty. Potential literary associations also form the basis of H. Rodney Nevitt's contribution on love and courtship in the art of Vermeer. Nevitt provides a close reading of a number of Vermeer's paintings of women in relation to a variety of popular (and in some cases, scarcely known) literary genres from this period, including love poems, courting guides, prose romances, and related anthologies of love stories. Like other scholars, Nevitt articulates such features in Vermeer's paintings as "the delicate emotional tone, the role of the viewer, the thematics of privacy, order, and purity. . . ." However, Nevitt places these features more squarely within a seventeenth-century Dutch context that in effect enriches them and, more important, our appreciation of them today.

The contributions of Vergara, Goodman, and Nevitt expand our appreciation of Vermeer's depictions of women, love, and courtship. The two remaining chapters dedicated to the cultural context of Vermeer's art address other issues, namely, his depictions of "scientists" and the ramifications for his work of the artist's immersion in Catholicism. Valerie Hedquist's contribution on religion in the life and art of Vermeer provides a helpful overview of the state of Catholicism in the largely Protestant Dutch Republic, a significant faith for many people in the seventeenth century that is easily overlooked today. Hedquist assesses the evidence for Vermeer's devotion to his adopted faith – he presumably converted in 1653 – and its consequences for some of the pictures by the artist with unequivocally Catholic content, including *Saint Praxedis* (Plate 1) and the *Allegory of Faith* (Plate 32) and others that are ostensibly less straightforward, for example, *Christ in the House of Mary and Martha* (Plate 2) and the mysterious *Woman Holding a Balance* (Plate 15). In sum, Hedquist persuasively argues that a more thorough cognizance of "the Roman Catholic religious ambiance of his home and neighborhood enriches our understanding of Vermeer's artistic themes, stylistic characteristics, and iconographic decisions."

With Klaas van Berkel's chapter, we enter the world of seventeenth-century science as it is reflected in Vermeer's paintings *The Astronomer* (Plate 27) and *The Geographer* (Plate 28). Van Berkel's contribution deliberately follows that by Hedquist, since as he points out, seventeenth-century science remained perme-

ated by moralizing and religious tendencies. Scientific inquiry of this period exhibited other paradoxical traits such as the tendency to attempt to reconcile observed fact with the collective wisdom of ancient civilizations. Thus, Van Berkel considers Vermeer's two depictions of scientists idealized representations of men who calculate the parameters of the cosmos with the assistance of instruments and books as they simultaneously ponder its deeper moral significance.

The Cambridge Companion to Vermeer concludes with two chapters devoted to the vicissitudes of Vermeer's reputation during the more than three centuries since his death. Vermeer was an artist who had enjoyed considerable notoriety in his native Delft and beyond during his lifetime. Yet during the century following his demise, Vermeer fell into semiobscurity. The principal reason for this was the rather limited size of his oeuvre. Before the invention of photography, the degree of recognition of works by a particular artist often hinged upon the quantity produced. Large numbers of paintings guaranteed familiarity since these would appear with some frequency in private collections and at auctions. Thus artists like Nicolaes Berchem (1620–83) and Philips Wouwermans (1619–68) enjoyed great prestige among eighteenth- and early nineteenth-century connoisseurs while the names of Vermeer and others with comparatively small outputs were often forgotten. It is not surprising then that paintings now considered authentic Vermeers were earlier occasionally attributed to other, more widely known artists, among them, Nicolaes Maes (1634–93) and Pieter de Hooch (1629–84). Yet confusion over attributions worked both ways: paintings by Vermeer were misattributed, but his name was sometimes erroneously attached to works by other artists.

Vermeer's reputation grew enormously during the nineteenth and twentieth centuries. The revolutionary social and political developments that affected Europe during the 1830s and 1840s led to renewed appreciation of many Dutch artists. The rise of the Realist school of painting in France coincided in particular with a growing interest in the works of seventeenth-century Dutch painters, whose views of daily life were mistakenly considered precedents for the socially and politically informed paintings of such realists as Gustave Courbet (1819–77). Vermeer himself was rediscovered as an artistic entity during the formative stages of the Impressionist style when followers of Courbet began to depict scenes of contemporary life with great sensational immediacy. Naturally, Vermeer's art – with its seemingly bold tactility, its extraordinary optical fidelity, and its eternalization of supposedly inconsequential moments – appealed greatly to these artists. Perhaps equally significant, Vermeer's art and name enjoyed increasing recognition at approximately the same time that photography was invented.

Indeed, as the chapters by Christiane Hertel and Arthur Wheelock and Marguerite Glass demonstrate, the enthusiastic response to Vermeer's pictures during the last 150 years is as remarkable as it is complicated. Although Hertel's study charts the reception of Vermeer's work from the decades after his death onward, much emphasis is placed upon the nineteenth and twentieth centuries.

Among other things, her fascinating account reveals the biases of writers of the latter nineteenth century who curiously viewed Vermeer's art through their Western European perceptions of the Far East. Moreover, in taking into account the powerful responses that Vermeer's paintings have evoked, Hertel demonstrates how these responses have often built upon and reinforced one another. Her chapter concludes by examining Vermeer's inspiration for the American painter George Deem, as well as for poets of the late twentieth century, many of whom were responding to the monumental exhibition of the artist's work held in Washington, D.C., and The Hague during 1995–6.

Arthur Wheelock and Marguerite Glass's contribution focuses upon Vermeer in the twentieth century as they carefully investigate the broad appreciation of Vermeer in America during this period. The American mania for all things Dutch around the turn of the twentieth century nurtured an already growing interest in Vermeer and "coincided with the rise of an extraordinary breed of American collectors intent upon enriching their lives with masterpieces of European art." Authors of Vermeer studies from this period were profoundly moved by the aesthetic qualities of the artist's pictures while simultaneously perceiving them as emotionally detached. Through the course of the twentieth century this perception was dramatically reversed, as witnessed by the outpouring of sentiment in response to the emotional appeal of Vermeer's pictures on display in the aforementioned exhibition of 1995–6. Wheelock and Glass also chart the phenomenon of Vermeer's truly remarkable popularity in the late 1990s as his work inspired artists, novelists, filmmakers, and even an opera. Their apt conclusion that Vermeer's works "engage the viewer with their beauty and serenity, and open worlds of imagination that continually enrich and ennoble the human spirit," is certainly a statement with which every contributor to *The Cambridge Companion to Vermeer* would agree.

1 Johannes Vermeer

An Overview of His Life and Stylistic Development

Wayne Franits

Vermeer's rightful place among the greatest seventeenth-century Dutch painters belies the fact that his paintings were to some extent forgotten and only occasionally associated with his name in the decades following his death up until the nineteenth century.[1] Likewise, the events of Vermeer's life were largely shrouded in obscurity; much of what is now known about the artist's life was only discovered by diligent archivists laboring in the late nineteenth and especially the twentieth centuries.[2] In light of these curious circumstances, it makes sense to begin *The Cambridge Companion to Vermeer* with an overview of Vermeer's art and life as it is generally understood by scholars today. This will provide the reader with a foundation for the essays that follow.

Vermeer's Early Career

Johannes Vermeer was born in 1632, the second and youngest child of Digna Baltens (ca. 1595–1670) and Reynier Jansz. Vermeer (alias Vos; ca. 1591–1652), both Reformed Protestants. Vermeer's father was trained in Amsterdam to weave caffa, a fine, patterned fabric of satin, silk, or velvet. Eventually, Reynier Jansz. Vermeer took on the occupations of innkeeper and picture dealer; he registered for the latter profession with the Guild of Saint Luke in Delft in 1631. Jansz.'s activities as a picture dealer necessarily provided him with many contacts among local painters and collectors.[3] Jansz. was also related by marriage to Egbert van der Poel (1621–64), a Delft native and prolific painter of peasant interiors and conflagration scenes, who resided in the city until 1654.[4] The circumstances under which Vermeer was raised therefore seem likely to have affected his career choice. Presumably, the young Vermeer would have begun his artistic training sometime around 1645–7. In this regard, the identity of his teacher or teachers has long been debated.

Vermeer's admittance as a master to the Guild of Saint Luke on December 29, 1653, sheds further light on this problem. According to guild regulations, any

painter who enrolled as a master had to have served at least six years as an apprentice with a recognized artist (or artists), either in Delft or elsewhere.[5] Equipped with this knowledge, scholars have thus turned to Vermeer's immediate artistic milieu to try to identify his teacher. Vermeer is described as the artist who trod masterfully in the path of "the Phoenix," the painter Carel Fabritius (1622–54), in one version of the frequently quoted poem by Arnold Bon published in Dirck van Bleyswijck's *Beschryvinge der stadt Delft* (Description of the City of Delft; 1667).[6] The poem alludes to the explosion of the municipal arsenal in Delft in 1654, a catastrophe that leveled a large portion of the city, tragically claiming many victims, including Fabritius, an artist who had arrived in the city around 1650 and become its leading master.[7] On the basis of this poem, it was once argued that Fabritius was Vermeer's teacher, even though Bon merely implied that Vermeer succeeded Fabritius as the foremost painter in Delft. Although the two artists' similar subjects and style, along with their common interest in perspective and optics, have been adduced to support this hypothesis, it is extremely unlikely that Fabritius served as Vermeer's teacher since the former only enrolled in the Guild of Saint Luke in October 1652, in other words, approximately one year before Vermeer.

The Delft painter Leonard Bramer (1596–1674) is another contemporary artist who could have been Vermeer's teacher. When he returned to his native city in 1628 after a lengthy stay in Italy, Bramer quickly established himself as one of the principal painters in Delft. Given his prominence it is possible that he taught Vermeer, even if his surviving work consists largely of easel paintings depicting luminous, energetic figures frequently posed within dark, cavernous settings, a style that has little in common with Vermeer's art.[8] While Bramer may not have been Vermeer's teacher there is strong evidence that he was a friend of the artist's family. A document dated April 5, 1653, reveals Bramer's presence during an attempt to persuade Vermeer's future mother-in-law to sign the act of consent for the registration of the marriage banns between Vermeer and her daughter.[9] Moreover, Bramer also served as a witness at a deposition made by Vermeer's mother, Digna Baltens, concerning her brother's questionable business practices in the town of Brouwershaven in the Province of Zeeland.[10]

More recently, John Michael Montias has hypothesized that Vermeer, after spending the first four years of his apprenticeship in Delft, concluded his training in Amsterdam or Utrecht or possibly both cities in succession.[11] The influence of painters from Amsterdam and Utrecht on Vermeer's early work has long been noted.[12] Moreover, Montias's archival discovery that the prominent Utrecht artist Abraham Bloemaert (1566–1651) was a distant relative of Vermeer's future wife's family supports his hypothesis.[13]

On April 20, 1653, several months before his aforementioned enrollment in Delft's Guild of Saint Luke, Vermeer married Catharina Bolnes (ca. 1631–88). Catharina's mother, Maria Thins (ca. 1593–1680), initially had some reservations about the marriage, possibly on social and financial grounds – Maria descended from a distinguished family from the city of Gouda – and also because she and

her daughter were practicing Catholics while Vermeer was, at least nominally, a Reformed Protestant.[14] As was noted earlier, Vermeer's fellow artist and presumed family friend Leonard Bramer was among those who tried to convince Maria Thins to consent to the registration of the marriage banns of the fledgling painter and her daughter. In any event Vermeer must have converted to Catholicism sometime between the couple's betrothal and the wedding ceremony, the latter occurring in the village of Schipluy (present-day Schipluiden) outside of Delft, where Catholicism remained well entrenched.

By December 1660, if not earlier, Vermeer and his growing family were living in his mother-in-law's house on the Oude Langendijk (see no. V3 on the foldout map following page XXIV), situated in the so-called Papists' Corner, the Catholic quarter in Delft.[15] In fact, this house stood right next to the Jesuit Church. The couple's likely decision to destine their eldest son Johannes for the priesthood and to baptize their second youngest child Ignatius after St. Ignatius, the renowned founder of the Jesuit order, might be construed as evidence of their zeal for Catholicism.[16] However, with respect to Vermeer himself, one must be cautious in assessing his enthusiasm for the faith despite these decisions and the existence of the *Allegory of Faith* (Plate 32) with its overtly Catholic iconography.[17]

As we have seen, Vermeer enrolled as a master painter in the Delft Guild of Saint Luke on December 29, 1653. This act granted him the right to sell his work in Delft, to take on pupils, and even to sell paintings by other artists as his father had done before him, an occupation in which he would eventually engage.[18] Vermeer's first surviving paintings date to shortly after this event. During this early period of the artist's career (ca. 1655–7) he experimented with various techniques and subjects. His very earliest works are history paintings. Such paintings, which illustrate episodes from the Bible, mythology, or classical and modern history, were most highly reverenced by seventeenth-century art theorists.[19] Clearly at this stage in his career, Vermeer aspired to be a history painter for reasons undoubtedly tied to the general esteem in which this genre was held at the time.[20]

One of Vermeer's earliest surviving pictures is *Christ in the House of Mary and Martha* (Plate 2), which was painted around 1655. Like all of those produced during this initial stage in the artist's career, it is of much larger dimensions than any of his later paintings and includes large-scale figures placed in the foreground of the composition. It is a broadly painted work and reveals the artist's knowledge of contemporary developments in history painting in Utrecht and perhaps Flanders, as it is related to a picture of the same subject (Fig. 2) by the Flemish painter Erasmus Quellinus the Younger (1607–78).[21] Quellinus's work resembles Vermeer's in motifs such as the open door in the background and in the pose of Christ with Mary at his feet. The figure of Christ is also dependent on prototypes from Italian art.[22] The sensitivity to light in this painting and especially its cool effects are reminiscent of pictures produced in the 1620s by the Utrecht Caravaggisti, Dutch painters who resided in Utrecht (a city in which, as we have seen, Vermeer might have trained) who were followers of the renowned Italian artist Caravaggio (1571–1610).[23] Yet the painting's subtle utilization of light and shadow and even the table covering anticipate later developments in Vermeer's art.[24]

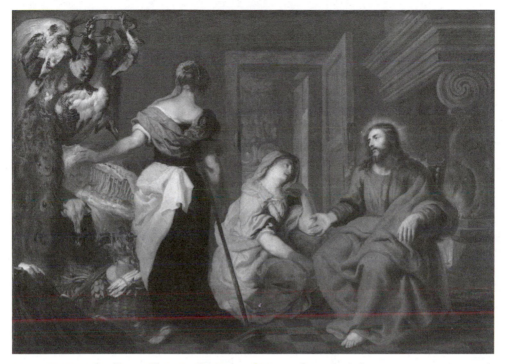

Fig. 2. Erasmus Quellinus, *Christ in the House of Mary and Martha* (oil on canvas, 172 × 243 cm). Valenciennes, Musée des Beaux-Arts. Photo: museum.

Vermeer's knowledge of contemporary trends in history painting in Amsterdam is demonstrated by his only surviving painting with a mythological subject, *Diana and Her Companions* (Plate 3). This picture was completed around the same time as *Christ in the House of Mary and Martha* (Plate 2). It has long been noted that Vermeer's figures resemble those in the background of a painting of the same subject (Fig. 3) by the Amsterdam artist Jacob van Loo (ca. 1614–70). Moreover, Diana herself and the kneeling attendant cleaning her foot recall Rembrandt van Rijn's (1606–69) contemporaneous painting of *Bathsheba* (Fig. 4), both in its figures and in the subtle use of chiaroscuro for expressive purpose.[25] However, the rich palette and facture of *Diana and Her Companions* – which differs markedly from *Christ in the House of Mary and Martha* – has long been compared to that of sixteenth-century Venetian paintings, particularly those by Titian. And its composition derives from representations of Diana and Acteon by Titian (ca. ?1485-90–1576) and Rubens (1577–1640).[26] Despite Vermeer's early dependence on artistic developments in Amsterdam, Utrecht, and to a lesser extent, Flanders and Italy, his work, as is true of all great artists, remains somewhat distinctive, even if connoisseurs of the nineteenth century were confused about the authorship of *Christ in the House of Mary and Martha.*[27]

Vermeer's lofty ambition to become a history painter may also explain his interest in Italian art. Since he presumably did not travel to Italy,[28] his knowledge of Italian art might possibly have been acquired in Amsterdam, which had more important collections of Italian painting than did his native Delft. Moreover, Johannes de Renialme, the owner of a now lost composition by Vermeer,

identified in a document of 1657 as the *Visit to the Tomb* (namely, the visit of the three Marys to Jesus's tomb), was an important dealer-collector of Italian art who was primarily based in Amsterdam but was also active in Delft.[29] Vermeer's potential contacts with this leading figure in the art market might have exposed him to Italian paintings of high quality. In any event, the artist was eventually acknowledged as an expert in Italian art: in May 1672, Vermeer was summoned to the nearby city of The Hague (along with several other painters) to appraise a collection of twelve Italian paintings at the source of a dispute between another art dealer, Gerrit van Uylenburgh, and their prospective buyer, Friedrich Wilhelm, the Grand Elector of Brandenburg.[30]

The controversial *Saint Praxedis* (Plate 1), if it is indeed a genuine Vermeer, also testifies to the artist's exposure to Italian art during the early stages of his career. This work, a copy of a painting by the contemporary Florentine master Felice Ficherelli, is signed and dated 1655 in the lower left, and it also carries an additional inscription in the lower right corner: *Meer N . . . R . . . o . . . o,* which has been interpreted as *Meer N[aar] R[ip]o[s]o* (Vermeer after Riposo), the latter being Ficherelli's nickname.[31]

The last painting ascribed to Vermeer's early period is *The Procuress* (signed and dated 1656; Plate 4), which reveals his continued ties to the Amsterdam and Utrecht schools. The warm colors and chiaroscuro effects recall paintings by Rembrandt and his pupils of the late 1640s and 1650s, for example, Nicolaes Maes (1634–93).[32] The subject was probably inspired by pictures by the Utrecht Caravaggisti; Vermeer's mother-in-law owned a work of a closely related, if not identical subject (Fig. 5) by Dirck van Baburen (ca. 1595–1624) that later appeared in the background of two of Vermeer's genre paintings (Plates 20, 35). At first glance, *The Procuress* could be categorized as a genre painting; however, the costume of the smiling man on the left – a possible self-portrait of the artist – was at least twenty years out of date when this picture was completed.[33] Since the presence of anachronistic clothing and accoutrements in figural scenes in Dutch art sometimes indicates that the painting in question is actually a history painting, Vermeer might have intended it as such, particularly at this point in his career. If this hypothesis is correct, then *The Procuress* could represent an episode from the New Testament parable of the Prodigal Son in which the unruly youth dissipates his inheritance, a subject occasionally rendered in contemporary guise by Dutch artists.[34]

Vermeer's Middle Period: Part One

The Procuress (Plate 4) can be considered a crucial transitional work as its subject shares many features with Vermeer's genre paintings, that is, so-called scenes of everyday life, the type of work that is most frequently associated with him. Most of the paintings of the middle period (ca. 1657–67), along with those of the late period, are genre paintings.[35] Vermeer's first unequivocal genre paint-

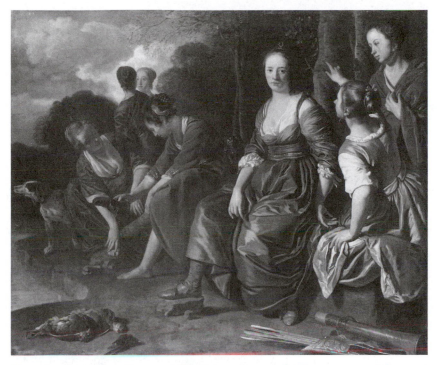

Fig. 3. Jacob van Loo, *Diana and Her Companions,* 1648 (oil on canvas, 136.8 × 170.6 cm). Berlin, Staatliche Museen zu Berlin; Preußischer Kulturbesitz Gemäldegalerie. Photo: Jörg P. Anders.

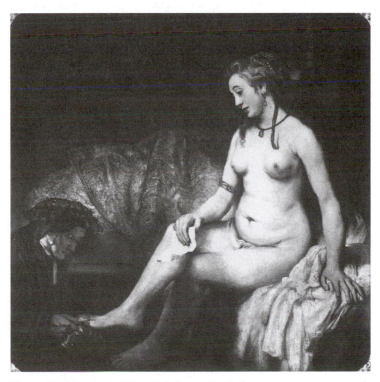

Fig. 4. Rembrandt van Rijn, *Bathsheba,* 1654 (oil on canvas, 142 × 142 cm). Paris, Musée du Louvre. Photo: Art Resource.

ing is his *Woman Asleep at a Table* (Plate 5). Its comparatively large scale, spatial ambiguities, and palette recall *The Procuress,* suggesting that it should be dated circa 1657. This picture and subsequent ones reflect Vermeer's response to the innovative formal and thematic developments that began to exert an impact upon Dutch genre painting around 1650.[36] The raucous scenes (such as pictures of unruly peasants) so frequently depicted by artists in earlier decades gradually began to decline in popularity in favor of more tempered and often more wholesome subjects featuring elegantly attired figures engaged in a wide variety of activities.[37] Accompanying this shift in subject matter were stylistic changes as well: individual paintings started to exhibit reduced numbers of figures whose dimensions were enlarged in relation to overall space. A younger generation of artists, such as Gerrit Dou (1613–75), Gerard ter Borch (1617–81), and Pieter de Hooch (1629–84), began to produce superbly balanced, visually dramatic works that contrast strongly with the evenly lit, semimonochromatic pictures by artists of an earlier generation (see Fig. 1).

Vermeer was certainly familiar with Ter Borch's work and probably with the artist himself, even though the latter lived in Deventer (a sizable town that was some distance from Delft): they had both signed a notary document in Delft in April 1653.[38] The stimulus of De Hooch, on the other hand, who resided in Delft between approximately 1652 and 1661, likely explains Vermeer's growing interest in the placement of figures within solidly constructed, light-filled spaces.[39] Vermeer's next four paintings, a closely related group, all differ considerably from the artist's previous work and reflect the influence of De Hooch in varying degrees. The *Officer and a Laughing Girl* (Plate 6), the *Girl Reading a Letter at an Open Window* (Plate 7), *The Milkmaid* (Plate 8), and *The Glass of Wine* (Plate 9) were probably painted, respectively, between 1658 and 1660.[40]

De Hooch had previously perfected the compositional schema evidenced in these four paintings, namely, the depiction of the corner of a fairly spacious room illuminated by a window or windows positioned along the left side of the canvas (Fig. 6). However, in contrast to the figures depicted in De Hooch's interiors, those in Vermeer's are proportionally larger and are placed closer to the foreground. Nevertheless, when compared to the size of the figures that Vermeer painted during his early period, these are reduced in scale in relation to the overall space. The artist's paint application in these pictures has become much thicker as he powerfully models the figures and objects to exude a tremendous tactility. Indeed, the forcefulness of Vermeer's touch has long been commented upon; for example, when *The Milkmaid* (Plate 8) was auctioned in 1701 it was described as being "krachtig gegeschildert" (powerfully painted).[41] Lastly, like those by De Hooch, but much more intensely, Vermeer's paintings evidence the artist's scrupulous attention to the brilliant naturalistic effects of light within the interiors. Yet in this painting and in others such effects have been carefully manipulated for expressive purposes.[42]

The *Officer and a Laughing Girl* (Plate 6) is considerably accomplished in this respect: the superb rendition of the myriad effects of sunlight and shadow

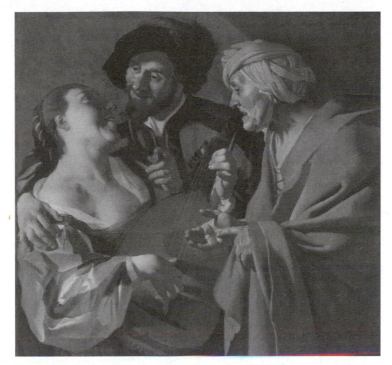

Fig. 5. Dirck van Baburen, *The Procuress,* 1622 (oil on canvas, 101.5 × 107.6 cm). Boston, Museum of Fine Arts, M. Theresa B. Hopkins Fund. Photo: museum.

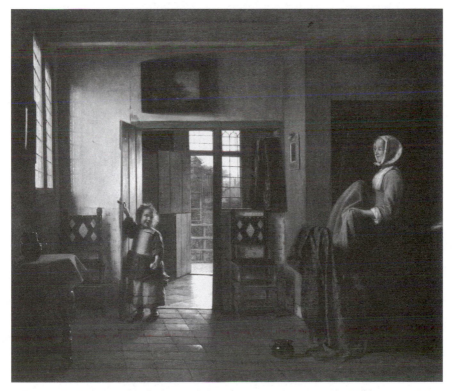

6. Pieter de Hooch, *The Bedroom* (oil on canvas, 51 × 60 cm). Washington, D.C., National Gallery of Art, Widener Collection. Photo: museum.

within this radiantly illuminated interior reveal Vermeer's great technical mastery and introduce a rarely matched intensity of vision into seventeenth-century Dutch art. The distortions in size and scale between the soldier starkly silhouetted in shadow in the foreground and the woman seated in the middle ground, along with the unfocused look of such motifs as the lion-headed finial on her chair, her hands, and the wine glass she is holding, provide the earliest evidence of Vermeer's interest in optical devices.

That Vermeer employed an optical device or devices in some connection with his art is undeniable. Consequently, scholars have often argued that Vermeer utilized a camera obscura, a contraption invented in the Renaissance as a perspective aid for artists, mathematicians, scientists, and generally interested amateurs.[43] In essence the camera obscura is a precursor of our modern camera. In its earliest and most elemental form, it was simply a darkened chamber with an extremely small opening in one of its walls. Rays of light pass through this small opening and project an image with uncanny fidelity (though inverted and reversed) on the back wall. By Vermeer's day, the camera obscura was available in a mobile form as a transportable box (Fig. 7). The image the device created was sharpened and intensified by a converging lens placed in the small hole through which the rays of light passed. Additionally, the image was now projected onto a screen composed of frosted or ground glass, oil paper, or some similar translucent material. To early modern Europeans who, unlike us, were never jaded by television, movies, and computer games, the image must have been absolutely startling, even if a substantial part of its perimeter was blurred on account of the crudity of the lens with its very limited depth of field.[44] This was especially true for projections of metallic objects or those with hard surfaces: their peripheries would be literally dissolved into broken contours of light called halations. A further drawback of the device was its reduction of the scale of objects but not the amount of color or light that reflected off of them so color accents and light contrasts subsequently gained in intensity.

The general enthusiasm among contemporary Delft artists such as the aforementioned Leonard Bramer and Carel Fabritius for complex perspective as well as optical phenomena may have stimulated Vermeer's interest in the camera obscura.[45] A number of scholars have conjectured that in several instances, most prominently in the renowned *View of Delft* (Plate 11), Vermeer actually aimed the camera obscura at a site that he intended to paint (see no. S1 on the foldout map) and then actively used the device during the production process.[46] However, other specialists have rightly contested such claims for the *View of Delft* as well as other pictures by the artist.[47] There is no evidence, for example, that Vermeer either traced or copied his compositions directly from the projected image of the camera obscura (an image that could be righted with a mirror built into the box). A recent essay by Jean-Luc Delsaute makes the most persuasive argument to date against Vermeer's direct use of the camera obscura in the creation of his paintings. On the basis of his careful reading of contemporary art theory books and treatises on the camera obscura, Delsaute convinc-

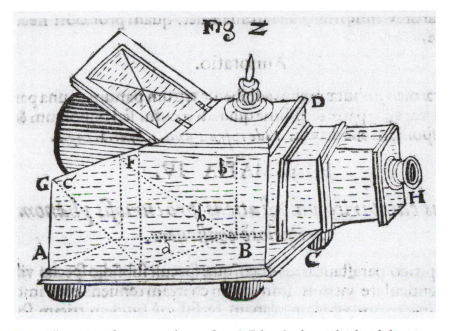

Fig. 7. Illustration of a camera obscura from J. Zahn, *Oculus artificialis teledioptricus*, 2d ed., Nuremberg, 1702. The Hague, Koninklijke Bibliotheek. Photo: Koninklijke Bibliotheek.

ingly asserts that painters did not use the device as a tool in the actual creative process until the eighteenth century.[48]

The question remains of the significance of the camera obscura for Vermeer's art. The enchanting ocular effects produced by the apparatus no doubt stimulated his aesthetic interest to such an extent that he often replicated them in his art. Yet at the same time Vermeer modified these effects to suit his artistic vision, often, surprisingly, exaggerating them. This is especially true of Vermeer's famous *pointillés*, little dots of impasto (thick lumps of paint) applied to the surfaces of his pictures in order to imitate the halations inherent to the peripheries of gleaming objects projected by the camera obscura. Although Vermeer likely used *pointillés* initially to duplicate what commonly could be seen through the camera obscura, he soon realized their independent aesthetic potential. For instance, he could not have observed them on the bread depicted in *The Milkmaid* (Plate 8) because the camera obscura will, as we have seen, only cause halations on projected objects that reflect light (such as metal or polished wood).[49] Likewise, in the *View of Delft* (Plate 11) Vermeer applied *pointillés* to the shadowy hulls of the boats moored in the water in an effort to suggest flickering reflections. Had these boats been viewed through a camera obscura, reflections would not have been present, as they were only visible in direct sunlight.[50] It would thus be reductive to consider the *View of Delft* — or, for that matter, any painting by Vermeer — a simple transcription of the projected image seen by the artist through the camera obscura.

Vermeer's signature *pointillés* became a prominent feature of his art during

his middle period and, in fact, would continue to be present, in a much modi-
fied form, in his late works. In *The Milkmaid* (Plate 8), for example, *pointillés*
are used to impart an extraordinary tactile quality to such objects as the chunks
of bread. In fact, the chunks are encrusted with so many *pointillés* that these
dots of paint seem to exist independently of the forms they describe. An impos-
ing tactility is also detected in other works of this phase: the carpets on the
tables of the *Girl Reading a Letter at an Open Window* (Plate 7) and *The Glass of
Wine* (Plate 9), for example, have a palpable nubby quality that is completely
different from the broad, general planes of the carpet in the early *Christ in the
House of Mary and Martha* (Plate 2).

Vermeer's rapid mastery of the depiction of forms in space probably stimu-
lated his interest in townscape painting, a genre in which he produced at least
three paintings, as is known from the catalogue of the auction in 1696 of Jacob
Dissius's collection, which included the following lots: "A view of a house stand-
ing in Delft," "A view of some houses . . . ," and "The town of Delft in perspec-
tive, to be seen from the south. . . ." Two of them survive, *The Little Street*
(Plate 10) and the famous *View of Delft* (Plate 11), both painted around 1660–1.[51]
The titles in the old sale catalogue suggest that Vermeer might have completed
the three paintings in sequence, working from the simplest composition of a
house in Delft to the most complicated one, a view of the city itself. Vermeer
took liberties for aesthetic effect with the dimensions of buildings in his *View of
Delft,* but it is nonetheless an extraordinary document of the seventeenth-
century appearance of the city, rendered with astonishing physical presence.
This picture is also a tour de force in the rendition of the natural effects of light
filtering through heavy cloud formations.

Despite his comparative youth, Vermeer had reached great artistic heights by
the early 1660s. His colleagues elected him one of the headmen of the Guild of
Saint Luke in the autumn of 1662 (a two-year position to which he was reelected
in 1670). He was the youngest artist to be chosen for the post since the guild
was reorganized in 1611, a reflection certainly of the esteem of his fellow artists,
though by 1662 many other possible candidates had either died or left the city.[52]

Vermeer's Patrons and Contemporary Reputation

Clearly, Vermeer had become a well-respected member of the Delft artistic com-
munity and in this capacity must have enjoyed the patronage of contemporary
collectors, particularly those in his native town. This in turn assured him, at
least to some extent, of a steady income. There is strong circumstantial evidence
that Vermeer enjoyed the patronage of a man who possibly had first right of
refusal to purchase his paintings, the affluent Delft citizen Pieter Claesz. van
Ruijven (1624–74).[53] Van Ruijven loaned Vermeer and his wife 200 guilders in
1657. According to Montias, who has written extensively on Vermeer's possible
patrons, this loan, given the amount and its short duration, may have been an
advance toward the purchase of one or more paintings. Vermeer possibly had

more than a professional association with Van Ruijven and his wife, Maria de Knuijt. On October 19, 1665, the couple signed their last will and testament. Perhaps the most fascinating part of this entire document is the arrangements they made for the guardianship of their surviving child or children if both parents should predecease them; among the guardians' responsibilities after their deaths was the disposal of works of art according to the stipulations made in a certain book marked A (unfortunately now lost), on which would be written "Dispositions of my *Schilderkonst* (works of art) and other matters." In 1665, De Knuijt had her own, separate section of the couple's last will and testament drawn up in case her husband and child or children predeceased her. In it, De Knuijt bequeathed 500 guilders to the painter, the only nonrelative to be singled out for a special bequest. This is a rare if not unique example of a seventeenth-century Dutch patron bequeathing money to an artist.

The bulk of the Van Ruijven and De Knuijt estate — including their collection of paintings — was indeed inherited by their only surviving child, Magdelena.[54] Several months before the death of her mother in 1681, Magdelena had married Jacob Abrahamsz. Dissius, who became the heir of the estate when Magdelena died childless in June 1682. In May 1696, seven months after his death, his art collection, including twenty-one paintings by Vermeer (many of which survive today), was auctioned. This sale is well documented, which led to the widely held view that Dissius had been a patron of Vermeer. However, this seems highly improbable because Dissius was just twenty-two years old and destitute when Vermeer died.[55] On the basis of Montias's archival discoveries concerning Van Ruijven, De Knuijt, and their daughter, it can be postulated that Dissius had ultimately inherited his Vermeer paintings via his wife's parents.[56]

Despite the near steady income that Vermeer possibly depended upon from Van Ruijven, this arrangement could also have been injurious. If indeed a significant proportion of Vermeer's works remained in the family collection until twenty-two years after Van Ruijven's death, the question can be legitimately raised as to whether this limited the spread of the artist's reputation beyond his native city. There is, however, increasing evidence that Vermeer's circle of buyers and devotees, albeit limited, stemmed from the very upper echelons of society in Delft and beyond. For example, two other members of the patrician class (one of the wealthiest and most august social groups in The Netherlands) in Delft, Gerard van Berckel and Nicolaes van Assendelft, likely owned paintings by Vermeer.[57]

In 1991 Montias published excerpts from the fascinating diary of Pieter Teding van Berckhout, a member of a very prominent family in The Hague who was active in cultured social circles both there and in Delft.[58] Van Berckhout traveled to Delft by boat on May 14, 1669, and visited Vermeer, whom he called "un excellent peijntre" (an excellent painter) who showed him "quelques curiositez de sa maijn" (some curiosities made by his own hand). Van Berckhout had arrived in Delft that day in the company of three of his distinguished friends and colleagues. One of them was Constantijn Huygens (1596–1687), a truly legendary figure in seventeenth-century Dutch art and culture. Huygens was an artistic authority in his own day, maintaining contacts with the famous Flemish

painters Peter Paul Rubens and Anthony van Dyck (1599–1641) and recording in his own diary some remarkably insightful comments about the art of, among others, Rembrandt van Rijn.[59] Although Van Berckhout explicitly stated in his diary that "je vis un excellent peijntre nommé Vermeer" (I saw an excellent painter named Vermeer), it is likely that his traveling companions, including Huygens naturally, accompanied him to the artist's studio that day.[60] Several weeks later, namely on June 21, 1669, Van Berckhout returned to Delft and once again sought out Vermeer. This time he called the artist "un celebre peijntre" (a famous painter) and related that Vermeer "me monstra quelques eschantillons de son art dont la partie la plus extraordinaijre et la plus curieuse consiste dans la perspective" (showed me some examples of his art, the most extraordinary and most curious aspect of which consists in the perspective). Van Berckhout's obvious admiration for the rendering of perspective in Vermeer's pictures is fascinating; one wonders what paintings in particular he had seen.[61]

Among the other noteworthy owners of Vermeer paintings is Hendrick van Buyten, another inhabitant of Delft and a baker by trade, though he accrued substantial wealth through a large inheritance.[62] An inventory drawn up at his death in July 1701 listed the possessions that Van Buyten had brought into his second marriage in 1683 (but kept separate by mutual agreement with his bride), including three paintings by Vermeer.[63] Two of these paintings, "one representing two persons one of whom is sitting and writing a letter and the other with a person playing a cittern," were acquired shortly after Vermeer's death from his widow in lieu of a huge debt owed for bread.[64] The other painting was probably already in Van Buyten's possession by 1663, as can be inferred from remarks made by the Frenchman Balthasar de Monconys in his diary (which was published in 1666). De Monconys visited Delft on August 11, 1663, in the company of a Catholic priest, a certain Father Léon, and another Catholic, Lieutenant Colonel Gentillo.[65] The three men went to Vermeer's studio, but since there were no paintings to be seen – perhaps the artist was working on commission at this time – they were sent to the shop of a baker who owned one. This baker, who has long been identified as Hendrick van Buyten, showed them his painting of a single figure by Vermeer, boasting that 600 livres (probably 600 guilders) had been paid for it. Van Buyten's quotation of such an exorbitant price might be construed as a feeble attempt to impress a well-to-do foreigner; De Monconys himself commented that he considered the painting overpaid for if it had been bought for "six pistoles" (60 guilders).

Paintings by the artist also appear occasionally in collections in other Dutch cities. Mention has already been made of the presence of Vermeer's now lost *Visit to the Tomb* in the death inventory of the Amsterdam art dealer Johannes de Renialme, composed in June 1657. In that very same city, between the years 1669 and 1678, the surgeon Jan Sysmus compiled a list of "present day" painters and their subjects that included Vermeer.[66] A "face by Vermeer" was listed in the death inventory (composed in August 1664) of Johannes Larson, an English sculptor who lived in The Hague, where he worked for both the Dutch and Eng-

lish courts.[67] A wealthy Amsterdam banking official and postmaster named Hendrick van Swoll also owned a painting by Vermeer, which was auctioned in April 1699, along with other works in his collection. In the auction catalogue it was described as "a seated woman with several meanings, representing the New Testament."[68] This painting, which fetched the then substantial price of 400 guilders, can most assuredly be identified as the *Allegory of Faith* (Plate 32).

Outside of the Dutch Republic, the Antwerp jeweler and banker Diego Duarte owned a large collection of paintings that included a work by Vermeer. In an inventory drafted in July 1682, the picture was valued at 150 guilders and described as "a piece with a lady playing the clavecin with accessories. . . ."[69] Far from being a socially insulated figure living in the Papist's Corner in Delft, whose production was largely destined for one principal client, Vermeer, as the evidence presented here reveals, was held in great esteem as an artist and as a citizen of some social prominence.[70] Indeed, the recent discovery that Vermeer was a member of Delft's militia confirms his status for membership in these municipal organizations of citizen soldiers presupposed a certain level of affluence and social standing among their participants.[71]

Vermeer's Middle Period: Part Two

Questions of patronage and reputation aside, Vermeer was at the zenith of his career during the 1660s. Nevertheless, he continued to modify his style throughout this decade. The artist introduced an unprecedented level of refinement in such works as *The Girl with the Wine Glass* (Plate 13) and the so-called pearl pictures (a group of paintings, usually dated between 1662 and 1665, of women that share a common motif of pearls and a luminous, silvery tonality), among them, the *Young Woman with a Water Jug* (Plate 18), *Woman in Blue Reading a Letter* (Plate 19), *Woman with a Pearl Necklace* (Plate 14), and the *Woman Holding a Balance* (Plate 15). At this stage in his development, Vermeer no longer relied on pasty modeling with thick impasto, and consequently, his use of *pointillés* became less obtrusive. The paint surfaces are smoother and less tactilely detailed, and the lighting effects, though at times retaining their brilliance, are generally less bold. Vermeer created the wonderfully luminous sheen of the pearl pictures by deliberately utilizing the underpaint as an interactive agent with the paint layers above it. In the *Young Woman with a Water Jug,* for example, he applied a darker tone over the light ocher ground followed by a thin glaze to delineate shadowed yellows, such as those on the right side of the girl's jacket. In the lower right a layer of reddish brown has been applied over the ground; it enhances the reddish glow of the reflections on the brass basin and also serves as the base color for the tablecloth.[72]

The pearl pictures convey an air of reticence and introspection, qualities so highly esteemed in Vermeer's art in our own era. Vermeer's stylistic shift toward greater refinement is best explained as a response to contemporary develop-

ments in pictures by the *fijnschilders* or "fine painters," a group of artists work-
ing in the city of Leiden from about 1640 onward. In particular, the unprece-
dented polish and sophistication now witnessed in Vermeer's art is analogous to
that encountered in the works of such Leiden artists as Frans van Mieris the
Elder (1635–81; Fig. 8).[73]

Vermeer's renowned *Girl with a Pearl Earring* (Plate 24) was also painted
during this phase but toward the end of it, perhaps in 1665 or 1666. All the con-
tours of this small canvas are created with delicately modulated tones of paint in
place of outlines. Even the bridge of the young woman's nose is delineated not
by line but by a subtle, barely perceptible application of impasto. The edge of
the nose is not even distinguishable from the right cheek – the two features sim-
ply blend together.[74] The resultant visual effects are stunning, as the girl's fea-
tures are refined and purified to the extent that it is difficult to identify this
work as a portrait of a specific person.[75]

During his middle period Vermeer also produced two paintings with compar-
atively deep spatial recessions: *The Music Lesson* (Plate 17) and *The Concert*
(Plate 20), which were probably painted at about the same time as the "pearl
pictures" (ca. 1662–5). Although these pictures are related to *The Glass of Wine*
(Plate 9) and *The Girl with the Wine Glass* (Plate 13), they represent Vermeer's
most spatially complex works to date.[76] In both pictures the figures are placed in
the background in an effort to exploit the volumetric qualities of the scene as a
whole. *The Music Lesson,* probably the earlier of the two, displays a rigorous
spatial construction with carefully orchestrated arrangements of light, colors,
and forms as evidenced, for example, by the parallel beams of the ceiling and
the white, gray, and black pattern of the lozenge-shaped floor tiles.

Vermeer also adjusted the shapes of objects within the composition. For
instance, he made the lid of the clavecin wider on the girl's right than on the left
in order to reduce the viewer's visual propensity to connect the two halves of the
lid through the girl, which, in effect, would have lessened the painting's con-
vincing illusion of reality. Furthermore, the artist subtly changed the hues that
define objects in relation to the amount of light that strikes them. For example,
the inscribed letters on the cover of the virginal are painted in ocher to the left
of its player and in lilac to her right, where there is more shadow. The windows
at the left display similar color changes as Vermeer captured the play of sunlight
and shadow on the glass. In essence, the painting reveals (as do all of Vermeer's
paintings) the artist's deliberate manipulation of its formal elements to enhance
its mood and subject.[77]

Despite Vermeer's near continual manipulation of formal elements for
expressive purposes, it is striking that in many instances the rooms in his paint-
ings closely resemble one another as can be seen by comparing, among others,
The Glass of Wine (Plate 9) and *The Girl with the Wine Glass* (Plate 13) or the
Girl Reading a Letter at an Open Window (Plate 7) and the *Officer and a Laugh-
ing Girl* (Plate 6). This resemblance has led to several unsuccessful attempts to
associate the spaces depicted in the paintings with those that actually existed in

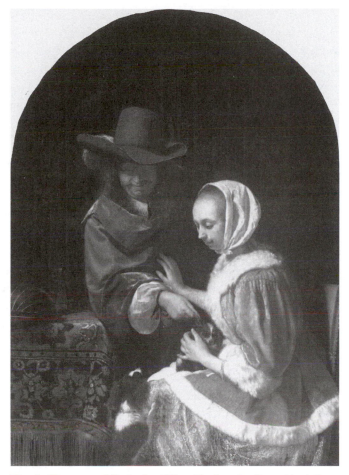

Fig. 8. Frans van Mieris the Elder, *Teasing the Pet*, 1660 (oil on panel, 27.5 × 20 cm). The Hague, Mauritshuis. Photo: copyright Stichting Vrienden van het Mauritshuis.

his mother-in-law's house.[78] Vermeer also resorted to an impressive array of "studio props" ranging from paintings (which he reproduced so faithfully that their authorship can often be determined) to costumes, musical instruments, furniture, and wall coverings, including maps, which are generally rendered with great fidelity.[79] While many of these objects are identifiable thanks to the discovery of an inventory of the deceased artist's movable goods drafted in 1676,[80] we must acknowledge that Vermeer continually varied their appearance along with the rooms in which they are depicted. From this standpoint, the variations from painting to painting are seemingly inexhaustible: the famous chairs with lion-headed finials are often shown with different upholstery, the patterns of tiles on the floors change, the pictures on the walls vary in scale and have different frames, the placement of windows are modified with respect to the back walls, and so on. Vermeer's ceaseless alterations of existing objects and spaces in his work once again underscore his habit of structuring his paintings to maximize their potential to evoke ambience.

The crowning achievement of Vermeer's middle period is the highly ambitious *Art of Painting* (Plate 26) executed circa 1666–7 and still in the artist's possession at the time of his death in 1675.[81] In it, Vermeer harmoniously integrated a variety of exquisitely painted figures and objects within a carefully constructed, light-suffused room. The result is an unsurpassed masterpiece of luminosity and spatial illusion, one that is also characterized by the quintessential detachment and reticence so often associated with Vermeer's art. The artist in this picture paints a model who can be identified as Clio, the muse (that is, the creative spirit) of history. Therefore, the *Art of Painting* was long thought to embody Vermeer's supposed convictions concerning the artistic primacy of history painting (see the earlier discussion). Yet if this were the case, then why did Vermeer abruptly abandon the depiction of history paintings after some initial experiments in the genre some ten years earlier? Eric Jan Sluijter has recently offered a more compelling interpretation of this renowned painting.[82] Sluijter subtly corrects long-standing misconceptions concerning the significance of Clio and, in doing so, argues convincingly that far from extolling history painting, Vermeer's picture expresses the fame, glory, and honor that artists accrue through their work, concepts easily corroborated in contemporary art-theory books. For Sluijter, female beauty, embodied by the muse, was also Vermeer's paradigm and the inspiration for his art.

Vermeer's Late Period

Various details in the *Art of Painting* (Plate 26) anticipate the style that characterizes Vermeer's late period (ca. 1667–75). The material lying on the table beside the mask is so unfocused and abstract that it resembles melted wax. The chandelier exhibits similar abstract qualities, its diffuseness enhanced by *pointillés* that, compared to those in earlier works, have been reduced to small, flat rectangular planes. The abstraction evident in these objects became a dominant feature in Vermeer's late paintings as he tended to concentrate on patterns of colors on objects at the expense of describing their textures. The increased stylization and refinement of the painter's late work was not unique to him; such tendencies are broadly seen in Dutch art during the 1670s and beyond. The reasons that underlie this phenomenon are complicated; it entailed, among other things, widespread cultural changes in the direction of French paradigms and, inextricably tied to this, shifting aesthetic conventions within Dutch painting itself.[83]

The Love Letter of circa 1668–9 (Plate 29) is Vermeer's first painting to display on a wide scale those stylistic features commonly associated with his late style. The mistress and maid are viewed through a vestibule, an unusual device possibly influenced by a painting by the Dordrecht artist Samuel van Hoogstraten (1627–78; Paris, Louvre).[84] The architectonic features of the vestibule and back room are sharply linear. Such details as the right doorjamb in

the vestibule are delineated by single, vertical bands of color. The ensuing sense of geometric purity extends to the figures themselves. Vermeer's earlier interest in the depiction of subtle nuances of light has now disappeared, having been replaced by crisp, clear divisions of light and shadow.

These crystalline, refined features are especially strong in paintings executed around 1670–1, such as the *Lady Writing a Letter with Her Maid* (Plate 30), which displays the very same linear precision. The refinement and abstraction of forms toward geometric ends is now complete. The garments of the maid looking out the window are so sharply defined in terms of light and shadow that they actually resemble the fluting on classical columns. Even the carpet on the table on which the mistress is writing shares these abstract features; unlike the broad general planes of the carpet in the early *Christ in the House of Mary and Martha* (Plate 2) and the nubby quality of the carpets in such middle period works as *The Glass of Wine* (Plate 9), it hangs in a most artificial, boxlike manner.

The purity and abstraction conveyed by the paintings produced around 1670–1 intensifies in those executed during the artist's last years (1672–5), as can be seen, for example, in the *Allegory of Faith* (Plate 32) and *The Guitar Player* (Plate 34).[85] The composition of the latter is unusual, as the artist placed the young woman so far to the left that her arm is partly cut off. The forms are again abstractly rendered and the girl's fingers, the head of the guitar, and the frame of the picture on the wall in the background are highlighted with the *pointillés* of Vermeer's late period: extremely flat, geometric touches of impasto.

Although it is tempting to posit links between the overly stylized and abstract qualities of Vermeer's late paintings and his personal circumstances during this period it is perhaps wisest to refrain from doing so. Nevertheless, marked changes in his art did occur at a time when Vermeer was suffering great financial hardship exacerbated by the responsibilities of having to provide for a large family – upon his death in 1675, he left a widow and 11 children, 10 of whom were minors. The source of the artist's pecuniary difficulties, as well as those of many of his countrymen at this time, undoubtedly stemmed from the great economic crisis that engulfed The Netherlands in the wake of the invasion by the armies of France and its allies in 1672.[86] Insights into Vermeer's financial problems, related familial concerns, and their ultimately calamitous impact on his health were dramatically provided by none other than his widow, Catharina Bolnes. In 1677, a year and a half after the artist's death – he was buried in the Old Church in Delft on December 16, 1675 – Bolnes, still saddled with formidable debts, testified that "during the long and ruinous war with France [her late husband] not only had been unable to sell any of his art but also, to his great detriment, was left sitting with the paintings of other masters that he was dealing in. As a result and owing to the very great burden of his children, having no means of his own, he had lapsed into such decay and decadence, which he had so taken to heart that, as if he had fallen into a frenzy, in a day and a half had gone from being healthy to being dead."[87]

The economic turmoil induced by "the long and ruinous war with France,"

as Bolnes put it, evidently affected the production and sale of art everywhere, but in Vermeer's case his problems were worsened by his laborious approach to his craft and, related to this, his relatively low rate of production and somewhat restricted clientele.[88] These latter factors, which go far in explaining the high prices that the artist seems to have commanded for his pictures, were in the end detrimental not only to his career but, if his widow is to be believed, to his very health as well.

2 Vermeer Teaching Himself

Walter Liedtke

Vermeer's development from the last days of 1653, when he became a master in the painters' guild of Delft, to about 1660, when he arrived at his mature style (Plates 16, 18), is an extraordinary example of a great artist teaching himself. Independence from a particular master is not unusual in the career of a young and gifted painter, and it was more common, of course, in those countries where there was an open art market and freedom from official academies. Rembrandt van Rijn (1606–69) in Leiden is comparable with the early Vermeer in the balance he achieved between willfully learning from other artists and learning from direct observation. But Johannes Vermeer's temperament was very different from Rembrandt's, which seems reflected in the Delft painter's much narrower range of subjects and expressive qualities; in his even more selective survey of current artistic ideas; and in his fascination with light for its own sake rather than for its usefulness, in an arbitrary manner, as a dramatic device. These inclinations are linked by one aspect of Vermeer's personality, which might be considered reticence or preoccupation, but was described more simply by an eminent conservator: few artists were ever so careful.[1]

This is not to say that Vermeer was cautious or overly methodical, which would imply a lack or distrust of imagination. Vermeer's deliberation was rather like Pieter Saenredam's (1597–1665) in that both painters of light-filled interiors used their sophisticated command of stylistic conventions to transform visual observations into exquisite works of art. The painter of church interiors was even more concerned with relationships of space, and Vermeer with those of light, but both artists found new ways of recording these two fundamental aspects of visual experience. It may be said, however, that the main element in each painter's program of self-training was the discovery of an effective approach to compositional design. In this respect (what some writers today would call patterns of "picture-making") Vermeer proceeded from painting to painting with exceptional care.

Rembrandt fills the more familiar role of an impetuous prodigy who pores over all the available models and absorbs, with a visual hunger, everything in the

environment. In his sheer inventiveness he took risks that occasionally justify Constantijn Huygens's remark that the even younger Jan Lievens (1607–74) had a stronger grasp of composition.[2] Vermeer's compositions, by contrast, are only open to criticism when they are too conventional (for example, Plate 3).

The history paintings with which Vermeer began his career are sometimes seen as signs of misplaced ambition, a prelude to the Vermeer who had found himself (Plate 5). One of the artist's most astute interpreters finds the *Christ in the House of Mary and Martha* (Plate 2) surprising, its style difficult to explain, and P. T. A. Swillens's rejection of the attribution (and signature) understandable.[3] However Vermeer's early paintings seem indispensable to his later work when they are considered as exercises in composition, in painting techniques, and in one essential aspect of his development: he was one of the finest figural painters in Delft. The point is doubly underscored by the fact that some Delft artists made figure painting their professional domain (for example, Leonard Bramer [1596–1674] and Christiaen van Couwenbergh [1604–67]),[4] and that no other Delft painter of interiors, whether of churches, inns, or private homes, was particularly talented in this area. The most comparable genre painter, Pieter de Hooch (1629–84), is often noted for his wooden articulations of drapery and the human form.

To place an emphasis on Vermeer's program of self-teaching one need not neglect his signs of genius, even the early ones. Like many prodigies (which Vermeer was not) he often saw great potential in minor works of art, a gift that some scholars, being blessed with less vivid imaginations than their subjects (for example, Diego Velázquez [1599–1664]), occasionally consider implausible.[5] A perhaps related phenomenon is the brilliant beginner's rejection, radical revision, or temperamental appropriation of an established artist's ideas. A broad range of artistic reactions is found among Rembrandt's followers, in Anthony van Dyck's (1599–1641) response to Peter Paul Rubens (1577–1640), and perhaps even in Vermeer's constant shifting, in his early paintings, from one model to the next. But the very mention of these relationships, like the search for Vermeer's master,[6] betrays the historian's dependence upon available types and models; we shop in the convenience store of "sources" to explain what is rarely explicable in logical terms, the rise of an individual style from the surf of talent, inspiration, fortuitous opportunities, and the elusive factor of personality.

Nonetheless, conventions of style and meaning must be constantly considered in order to understand how an artist of any talent incorporated them into his own work. This is especially important for an appreciation of Vermeer because of his bewildering ability to absorb technical and compositional ideas and to renew them substantially, usually by testing the borrowed convention against the evidence of actual appearances. For example, the silhouetted figure in the *Officer and a Laughing Girl* (Plate 6) is a device ultimately (and perhaps immediately) derived from genre paintings by Gerrit van Honthorst (1592–1656),[7] but "done over from nature" in the light of the studio.[8] Vermeer thereby arrived (as did Rembrandt, when he borrowed the same idea)[9] at

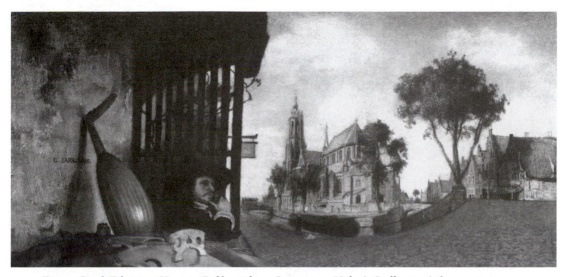

Fig. 9. Carel Fabritius, *View in Delft, with an Instrument Maker's Stall*, 1652 (oil on canvas, 15.4 × 31.6 cm). London, The National Gallery. Reproduced by courtesy of the Trustees, The National Gallery, London.

unprecedented descriptive and expressive qualities.[10] Similarly, the intimate corner of space found here for the first or second time (compare Plate 7) was by this date (ca. 1657) routinely employed by other genre painters in the South Holland area (for example, Quiringh van Brekelenkam [after 1622–69?], Ludolf de Jongh [1616–79], Hendrick Sorgh [1609–70], and De Hooch),[11] but the closeness of view and the consequently abrupt recession reveal that Vermeer was not content with a standard artistic formula.

Scholars have suggested that the use of a camera obscura or even "a wide-angle lens or convex mirror" produced the photographic look of this composition, with its "contrast of scale between the two figures."[12] Vermeer may have learned more about actual appearances from the camera obscura and some of his stylistic peculiarities could depend upon that experience. However, the rushed recession of space in Plate 6 is similar to that found in other Delft paintings of the 1650s, such as Carel Fabritius's (1622–54) *View in Delft* (Fig. 9) of 1652,[13] Gerard Houckgeest's (ca. 1600–61) first views inside the Delft churches (Fig. 10),[14] and several other examples.[15] Vermeer was probably more prepared to see the connections than we are, for example, the resemblance between two receding columns (the near one perhaps in shadow) and the figures of the cavalier and young woman,[16] or to see her similarity to another vibrant figure set against a white wall, *The Goldfinch* (The Hague, Mauritshuis) that Fabritius painted about three years earlier.[17] This kind of comparison has nothing to do with artistic sources but with similar interests in observation, so that in some cases it hardly matters – that is, there are reasons one cannot determine – whether Vermeer first saw something in another artist's painting or in reality.

Much of the mystery that has been perceived in Vermeer by writers from Marcel Proust to Edward Snow,[18] and by other amateurs, comes from their

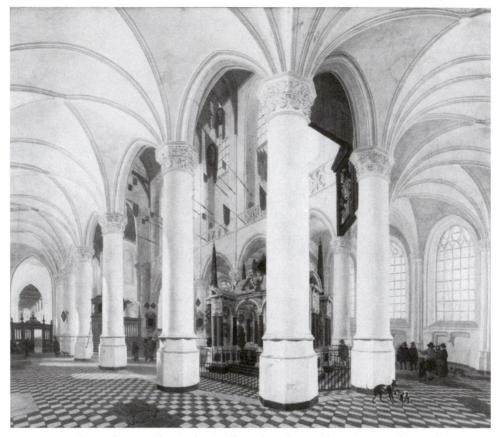

Fig. 10. Gerard Houckgeest, *The Tomb of William the Silent in the Nieuwe Kerk in Delft*, 1651 (oil on panel, 65.5 × 77.5 cm). The Hague, Mauritshuis. Photo: copyright Stichting Vrienden van het Mauritshuis.

unfamiliarity with the formal and iconographic conventions of Dutch painting at the time, which are made more obscure by Vermeer's subtle steps away from anything commonplace. His profound interest in optical effects compounds the sense of wonder, since his figures, no matter how conventionally arranged (there are historical reasons why Vermeer's *Young Woman with a Water Jug* [Plate 18] is posed like Rembrandt's *Aristotle* of 1653 [Fig. 11]),[19] are treated in terms of light, color, and definition (or "focus") as if they were still-life objects slowly transferred to canvas by some automatic means. Contemporary examples of remarkable verisimilitude, as in figures by Frans van Mieris the Elder (1635–81; Fig. 8), may by comparison look like routine passages in the surface layer of seventeenth-century Dutch painting. And yet very little in Vermeer, apart perhaps from some qualities of color and effects of light, can be credited to his possible use of the camera obscura,[20] and in my view nothing is due to convex mirrors or wide-angle lenses other than those he had in his head. When one compares Vermeer's luminous motifs to passages in the contemporary church interiors by Emanuel de Witte (ca. 1616–91/92) and in still lifes by Willem Kalf (1619–93), to name two of several sympathetic painters, one is brought back to the realization

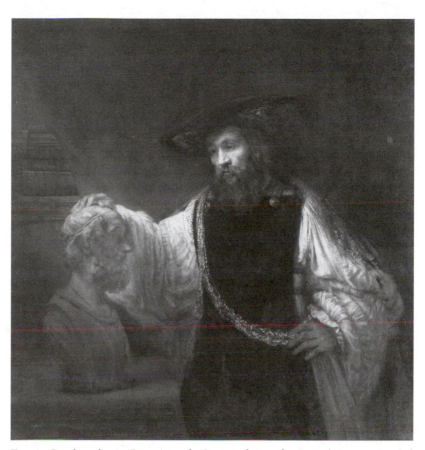

Fig. 11. Rembrandt van Rijn, *Aristotle Contemplating the Bust of Homer*, 1653 (oil on canvas, 143.5 × 136.5 cm). New York, The Metropolitan Museum of Art. Photo: museum.

that Vermeer's individual manner of recording visual experience was not a science but a style — and a style of the period, however rare an example it might be.

That sophisticated forms of realism in painting depend upon a mastery of artistic conventions and not on an innocent eye is one of the main lessons of Ernst Gombrich's *Art and Illusion* and related studies.[21] Vermeer's own review of current artistic ideas had much to do, of course, with intangibles like taste and opportunity (what did he know of Utrecht, Amsterdam, Italian art?), but also was conditioned by two practical considerations: his teacher, if any, made no obvious impression on him; and the art market, with all its realities of efficient production and popular appeal, was not one of his immediate concerns. The security provided by his late father (who died in 1652) and his mother-in-law (he married in 1653), and above all the support of a highly sympathetic patron, Pieter van Ruijven (who acquired at least twenty-one of Vermeer's paintings more or less as they were completed between 1657 and Van Ruijven's death in 1674), allowed Vermeer to develop somewhat in the manner of a dilettante, with time for exceptional refinements of style and meaning, and some assurance that they would be recognized.[22]

A similar level of involvement is required of Vermeer's admirers today. Modern writers are more prepared for this than were predecessors such as Etienne Joseph Théophile Thoré alias William Bürger, because they can now (perhaps like Van Ruijven) sketch out the context of other Delft painters and cite some connections with artists in other towns.[23] All this has not discredited the most informed kind of subjective remarks, for example, those of the painter and critic Lawrence Gowing,[24] nor does it alleviate the need to give each of Vermeer's paintings, in the original, a great deal of time. Arthur Wheelock properly faults the textbook analyses offered by Albert Blankert because he appears to have "neglected close examination of the paintings and analysis of technical information about Vermeer's painting techniques and artistic procedure."[25] But even here one discerns, in the insistent use of clinical terms, an attempt to objectify more than is warranted. The scientific tone serves as a refuge from the mists of aesthetic experience.[26]

The academic approach to Vermeer's stylistic development has dominated in recent discussions of his two earliest undisputed works: *Christ in the House of Mary and Martha* and *Diana and Her Companions* (Plates 2, 3). Scholars follow each other in placing the religious picture earlier (ca. 1654) essentially because it seems less Dutch and less Vermeer-like than the other painting. This does not imply that the seemingly Italian or Flemish qualities of color and texture in the *Diana and Her Companions* or the international flavor of Vermeer's presumed source of inspiration, paintings of the same subject by the Amsterdam artist Jacob van Loo (ca. 1614–70; Fig. 3), have been neglected.[27] Most writers, however, look back from *A Woman Asleep at a Table* (Plate 5) and see *Diana and Her Companions* (Plate 3) as similar in the transparent shadows of the (much abraded) faces and in the coppery highlights of the figure to the lower right. Leonard Slatkes, by contrast, looks back from the *Diana* to find Van Dyck-like qualities in the same drapery and strong recollections of Hendrick ter Brugghen (1588–1629) in the treatment of light.[28]

From whichever viewpoint *Diana and Her Companions* is analyzed, its values of light and texture may be considered tentative signs of brilliance in an immature and derivative work of art. The suggestions of daylight in both the highlights and shadows are achieved with all the enthusiasm of a new discovery. Vermeer could not have found these qualities in Jacob van Loo but perhaps saw them in Carel Fabritius, whose *Self-Portrait* (Rotterdam, Museum Boijmans Van Beuningen), along with certain figures in his early history pictures, anticipates the handling here. But whatever virtues one might detect in the *Diana and Her Companions* (Wheelock sees the mood as tragic, rather than as pastoral in a sleepy way), one cannot ignore the inexpressiveness of the figures or the composition's naïveté. The triangular arrangement in the foreground, which the dog faithfully obeys, is buttressed symmetrically by the two farther figures and then surrounded by landscape elements that convey almost no sense of space. A basin and towel fill the foreground, the dog fills the corner, the plant fills the gap in front of him, which is part of a rock that looks like a lavender bedspread

piled up on the floor. The slope to the left and a tree fill in the space above, and like the trees to the right arch obligingly over the uninvolved figures in the background. All this is the work of a novice who spent his best efforts on the skirt of Diana and the drapery of the figure to the lower right.[29]

Christ in the House of Mary and Martha (Plate 2), when viewed in the original, is clearly a far more accomplished work of art.[30] The kind of historical logic that has Vermeer proceeding from foreign to domestic, from painterly to precise, and from rhetorical to evocative cannot overrule the objection that this painting is more mature. This is not plain in reproduction, where the picture's space looks disjunctive and the areas of color reflect and go flat. In the actual object the sense of space is striking, especially on the left where the downward view of Mary foils the rapid recession of the corridor. That deeper space is introduced by the open door on the left and by the wall to the right, where Martha casts a shadow and a rectangular object to the right of her head defines the receding plane.[31] Mary's stool, with the highlight just above Vermeer's signature, and the arm of Christ's chair thrust the space forward without making it clear in plan (the changed window ledge and the open door in the corridor are signs of struggle in Vermeer's earliest known application of linear perspective). But the emphatic modeling of the figures,[32] which is drastically reduced in photographs, makes the close view, the sense of volume, and the space intensely felt at a normal viewing distance. The drapery throughout is beautifully painted, with thick, fluid highlights contrasting to the deep, absorbent shadows in the folds. A superb passage is the colorful carpet, which adds greatly to the visual weight of Mary; the pattern continues in her scarf, like bass and treble lines of music, and blends effortlessly into the sash at her waist.[33] The rhythms throughout Mary's drapery lend emphasis to the focus on Christ, whose gesture and voice seem to animate his robe and sleeve and the cascading folds in the white tablecloth. Martha leans well forward, the space under her forearm and the basket (which casts a strong shadow) suggesting the tabletop's rapid recession to her. She seems to serve and bow at once, her lovely face demurely responding to Christ's rebuke. His profile was modified by Vermeer to more obliquely turn the head.[34] All three faces, but especially Mary's, recall the evocatively turned and shaded faces in Ter Brugghen's oeuvre (Fig. 12).[35]

It is a measure of Vermeer's progress in this painting that while its formal qualities are skillfully resolved, the subject is effectively realized. The interplay between the three figures never comes to rest: Christ seems to speak to Mary, and she reflects on his words, even as he answers Martha's complaint. The general design of the painting, even the setting's subordinate treatment in tones of brown, is Flemish, Van Dyck–like, and of course reminiscent of the often cited picture of the same subject by the contemporary follower of Rubens and Van Dyck, Erasmus Quellinus the Younger (1607–78; Fig. 2).[36] Anyone who has seen that large canvas in Valenciennes will realize that its manner of execution could have been of no more than superficial interest to Vermeer. However, Christ's pose and the recession from him to a room in the background, beyond Mary,

suggest that this or some version of the painting was known to the Delft artist. The background view in Vermeer anticipates that in *A Woman Asleep at a Table* (Plate 5), and in its more complex perspective and greater sense of depth already seems like a Dutch painter's revision of the Flemish master's motif.

Christ in the House of Mary and Martha marks such an advance beyond *Diana and Her Companions* that one imagines them separated by more than a year within the period 1654–5. There is no space here to discuss the controversial copy after Ficherelli's *Saint Praxedis,* which appears to be signed by Vermeer and dated 1655.[37] Direct comparisons with *Diana and Her Companions* and *Christ in the House of Mary and Martha* must be made to support the attribution,[38] but the brushwork in *Saint Praxedis* (Plate 1) recalls both pictures (the later work, Plate 2, especially) and, to a lesser extent, that of the Florentine painter himself.[39] Saint Praxedis's face and pose could have inspired the figure of Martha (Plate 2).

John Michael Montias suggests that Vermeer may have studied not in Delft but in Utrecht because of family ties there, which through marriages extended to the famous teacher of Van Honthorst and Ter Brugghen, Abraham Bloemaert (1566–1651), and to his son Hendrick (ca. 1601–72).[40] Amsterdam connections might be deduced from the apparent influence of Jacob van Loo and perhaps of Quellinus, who worked on the new Town Hall's decorations around 1655–6.[41] A lost painting by Vermeer, the *Visit to the Tomb,* was cited in the 1657 estate of the Amsterdam dealer and collector Johannes Renialme, who was earlier in Delft and probably was in contact with Vermeer's art-dealing father and with Vermeer himself.[42] Wheelock sees similarities in style between the early Vermeer and Rembrandt, but he more persuasively recalls that Carel Fabritius and Nicolaes Maes (1634–93) were Rembrandt pupils and that several Delft artists, for example, De Witte (two or three of whose church interiors were in Van Ruijven's collection), moved to or had business in the big city during the early 1650s.[43]

One is still left with the impression that Vermeer was essentially resident in Delft, where there were opportunities to study the Utrecht painters, but that he occasionally traveled and in any event saw a wide range of pictures (he also traded in paintings, according to his wife).[44] This is borne out by Vermeer's early compositions (1654–7), each of which seems to take a different model from outside Delft as a point of departure and then, with reference to other sources, evolves into something remarkably new. From the *Christ in the House of Mary and Martha* (Plate 2) onward this was done with originality and flair; Vermeer was not producing hybrids from just a few seeds[45] but was carefully selecting what he found most sympathetic from a broad range of artistic styles.

In this short chapter Vermeer's further progress can be described but schematically. His first genre painting, *The Procuress* (Plate 4), is very much his own version of a bordello scene in the vein of Van Honthorst (Fig. 13) and Van Baburen. The latter's *Procuress* (Fig. 5) was owned by Vermeer's mother-in-law and features an offered coin and embrace, but Van Baburen's *Loose Company*

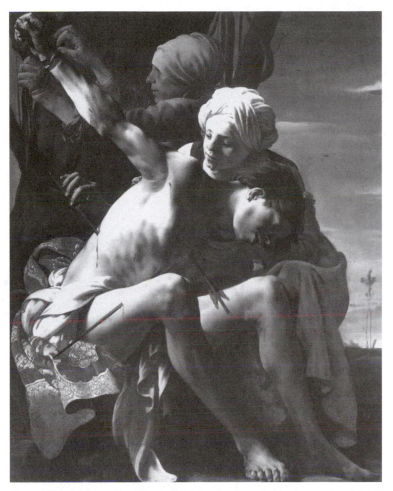

Fig. 12. Hendrick ter Brugghen, *St. Sebastian Attended by Irene,* 1625 (oil on canvas, 149.5 × 120 cm). Oberlin [OH], Allen Memorial Art Museum, Oberlin College, R. T. Miller Jr. Fund, 1953. Photo: museum.

(Fig. 14) is much closer in subject and in its four-figure composition.[46] The inclusion of a table is more reminiscent of Van Honthorst, who had an enormous reputation at The Hague, where he was court painter from about 1630 and well known for his portraits, mythologies, and genre scenes. Blankert sees his influence on Bramer in the 1640s, and on Christiaen van Couwenbergh, whose *Bordello* of 1626 (Fig. 15) features a figure on the left (as does Van Baburen's *Loose Company* [Fig. 14] on the right), which anticipates Vermeer's "prodigal son" looking at the viewer (Plate 4).[47] Van Honthorst also piled up carpets on tables, but the wall of fabric here recalls the parapets and tables in concert scenes by the Van Bronchorsts of Utrecht, who in the early 1650s lived in Amsterdam.[48] Vermeer's new emphasis on realistic light and textures has been related to Rembrandt's pupils, principally to Carel Fabritius in Delft and to Nicolaes Maes in Dordrecht.[49] It is the figure on the left, of course, that testifies to Vermeer's optical interests in a manner dissimilar to anything in Utrecht

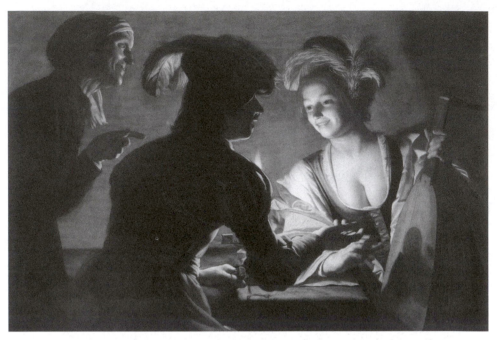

Fig. 13. Gerard van Honthorst, *The Procuress,* 1625 (oil on panel, 71 × 104 cm). Utrecht, Centraal Museum. Photo: museum.

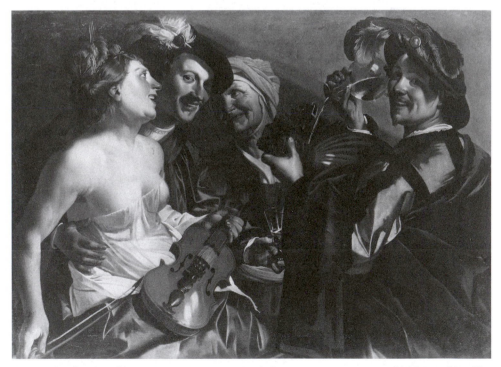

Fig. 14. Dirck van Baburen, *Loose Company,* 1623 (oil on canvas, 110 × 154 cm). Mainz, Gemälde-galerie. Photo: museum.

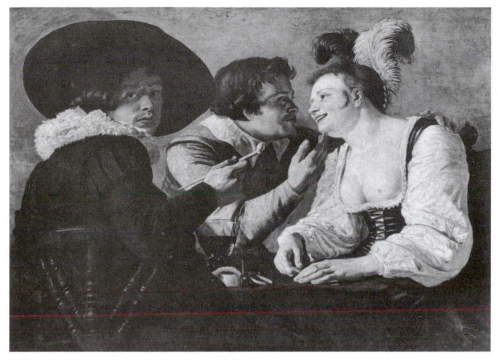

Fig. 15. Christiaen van Couwenbergh, *Bordello Scene*, 1626 (oil on canvas, 78 × 110 cm). Present location unknown. Photo: Rijksbureau voor Kunsthistorische Documentatie, The Hague.

(even in Ter Brugghen); this corner of the composition looks like a mirror propped up in front of a canvas by one of Van Honthorst's followers.

Indeed, the whole work is divided into parts, with the coat to the lower left, the carpet to the right, and the background revealing Vermeer's discomfort with corners again. This seems consistent with his beginning as a painter of large-scale figure groups, which in his pictures preceding *The Procuress* rise pyramidally in the foreground. With this work Vermeer brings in carpeted tables and tableware to occupy the foregrounds, like parapets or barriers (compare Plates 4, 5, 7). Each use is more successful than the last, until the use of perspective and the De Hooch–type (or South Holland–type) of interior taught Vermeer how to invent spaces that stand on their own (Plates 6, 8, 18).

A Woman Asleep at a Table of circa 1656–7 (Plate 5) is to some extent a revision of *The Procuress* (Plate 4), where the woman in yellow is an off-center focus likewise approached by the folded carpet, a pitcher, and a glass. In design and technique Vermeer's first two genre paintings reveal greater continuity than his earlier works, which is more remarkable when one considers the shift to a very different model, that of Nicolaes Maes's genre interiors of about 1655–6 (Fig. 16).[50] Perhaps his and De Hooch's examples (not to ignore Ter Borch and others) and possibly even Van Ruijven – this is the earliest Vermeer that we know he owned[51] – turned the artist's attention to contemporary genre scenes. It is well known that Vermeer modified *A Woman Asleep at a Table* extensively,

replacing a dog in the nearest doorway with the chair, a man in the background with the mirror, and making changes in the now abraded still life, in the painting to the upper left, and to the size of the whole composition.[52]

A logical next step in terms of design is the *Girl Reading a Letter at an Open Window* (Plate 7), but from about 1657 onward Vermeer's compositions become more complexly interrelated and the concept of linear development more implausible. Like *A Woman Asleep at a Table* (Plate 5), the *Girl Reading a Letter at an Open Window* is a comparatively large canvas with a small figure behind a table that supports a pyramidal carpet and a bowl of fruit. The open window and the angled chair (again with a pillow), and perhaps even the space outside and the curtain to the upper left, would for an artist like Vermeer be formal analogies to the open door and chair, the second room, and the hanging cloth in *A Woman Asleep at a Table*. Radiographs reveal a large *roemer* (a Dutch drinking glass) in the lower right corner,[53] which was replaced by the green curtain. This illusionistic motif must have been adopted from the Delft painter of church interiors Hendrick van Vliet (ca. 1611–75),[54] but it also serves, like the wall on the right and even the door in the earlier composition (Plate 5), to simultaneously create space and crop the view toward the figure.[55] When one considers that a painting of a cupid was also on the wall in the *Woman in Blue Reading a Letter* (Plate 19), and that a reflection (if not a mirror) again plays a symbolic part, then the two paintings appear to be intimately related in motifs and theme as well as in design. However, two aspects of the *Girl Reading a Letter at an Open Window* (Plate 7) are different from *A Woman Asleep at a Table* (Plate 5), and they are both strongly reminiscent of Ter Borch: the lovely lady in profile; and the meticulous description of surfaces (Fig. 1).[56]

The changes made by Vermeer during work on *A Woman Asleep at a Table* and the *Girl Reading a Letter at an Open Window* have rightly been appreciated as a kind of editing in which conspicuous cues to meaning are eliminated to enhance a poetic mood.[57] Here, too, one finds hints of sympathy with Ter Borch, above all in Vermeer's two paintings of a woman reading a letter (Plates 7, 19). Unlike Ter Borch, however, Vermeer can sometimes seem slightly self-conscious, even witty or coy.[58]

This side of Vermeer's sensibility links the *Officer and a Laughing Girl* (Plate 6) to *The Procuress* (Plate 4), while the silhouetted cavalier recalls the figure of Mary (Plate 2) and antecedents in Utrecht. In the *Officer and a Laughing Girl* the young woman with a wine glass smiles again (compare Plates 4, 5), but as in Ter Borch's social encounters she plays a knowing part. The intimate scale of the picture and the close corner of space announce Vermeer's arrival in a realm shared not only with Ter Borch and occasionally with De Hooch, but also with Gabriel Metsu, Van Mieris, and other contemporaries. The issue now for scholars is not how well known their paintings could have been to Vermeer but whether we could ever know them as well as he did.[59]

Looking back over Vermeer's early attempts to place everyday figures in domestic interiors (Plates 5, 6, 7), one can see that *The Milkmaid* (Plate 8) and

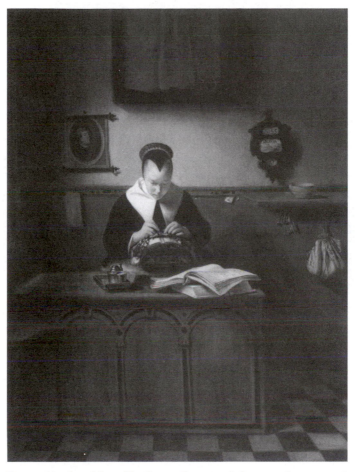

Fig. 16. Nicolaes Maes, *The Lacemaker,* 1655 (oil on panel, 57.1 × 43.8 cm). Ottawa, National Gallery of Canada. Photo: museum.

other paintings of about 1658 or slightly later still use solid forms such as tables to build back into the space (this is still evident, if less conspicuous, in the *Woman with a Lute,* Plate 16).[60] When one adds the laundry basket that Vermeer originally painted in the right background, the entire space, as in the three preceding pictures, is crossed diagonally by a continuous sequence of forms. In the next few years the artist gradually overcame this dependence upon figures and props in the foreground and resolved his motifs toward the middle ground (Plate 18). At the same time his touch became thinner and softer, describing not so much surfaces as patterns of light. These changes recall those made by De Witte in his progress away from the other architectural painters of Delft, and may in Vermeer's case also be understood as an evolution from a tactile to an optical, that is, to a more exclusively visual approach. Vermeer's mature compositions, such as the *Young Woman with a Water Jug* (Plate 18) and the *Woman in Blue Reading a Letter* (Plate 19), are remarkable for the poise and simplicity of their compositions, in which figures and inanimate objects are given equal emphasis within the field of view.

Vermeer's mature style was, for the former figure painter, an extraordinary achievement, arrived at after seven or eight years of painting, and above all looking, with the most curious care. That Vermeer also achieved a new level of meaning in the same years is a tribute not to his astonishing talent but to his character. His closely valued colors and gently balanced shapes convey a sense of harmony that wonderfully suits the subject of peaceful private life (Plate 18). How much of this may be related to Vermeer's own home is hard to say, as it would be for any great artist who was in his twenties at the time. It is intriguing, nonetheless, that the only early painting by Vermeer with an emotional depth comparable to that of his finest pictures is *Christ in the House of Mary and Martha* (Plate 2), an image of domestic tranquillity.

3 Vermeer's Craft and Artistry

Arthur K. Wheelock Jr.

Vermeer was an extraordinary craftsman who carefully conceived and structured his compositions to achieve the purity of expression he sought to convey. He had great sensitivity to optical effects found in the world about him, and he translated these in his paintings through his use of light and color. He mastered a wide range of painting techniques to allow his vision to take visual form, which, when analyzed, provide extraordinary insights into Vermeer's pictorial ideas. Vermeer's craftsmanship was not an end in itself, however, but rather a means toward creating a work of art that conveyed a mood, introduced abstract ideas, or otherwise reflected upon some aspect of the human experience. Many of the scenes he chose to depict are those encountered in daily life, passing moments seemingly of little consequence. In his hands they take on almost metaphysical significance. Other paintings have explicit allegorical connotations, where ideas about human endeavor are introduced through complex emblematic and symbolic elements. Finally, his representations of biblical and mythological subjects are forceful far less for their narrative than for the mood that they project. The study of the structure and execution of his paintings must likewise not remain an end unto itself but rather be understood as a means for exploring the emotional and intellectual framework within which each of his works was created.[1]

Vermeer's artistic approach varies subtly from painting to painting throughout the course of his career, but its essential characteristics are found in a beautiful yet characteristic work from the mid-1660s, *Woman in Blue Reading a Letter* (Plate 19). In this painting one encounters an image so radiantly pure and simple in its elements, and so familiar in its subject, that one immediately accepts her world as one's own. Yet the viewer is also aware that this woman and her realm are not exactly like reality. One approaches the work with a certain reverence, partly because Vermeer painted it, but also partly because the image demands that response. It is a quiet world without sound and without movement. One is drawn to the painting by the warmth of the light and the serenity of the scene, but is kept at a distance as well.

The woman is so totally absorbed in her letter that she has no awareness that

anyone has intruded upon her privacy. Seen in pure profile against a flat wall that is decorated only with a map of The Netherlands, neither she nor her environment welcomes the viewer into her physical or psychological space. Her pyramidal form, which is centrally placed in the composition, is partially concealed by the dark form of a table on the left and by a chair, turned slightly away from the viewer, on the right. The physical barriers thus created effectively isolate her even though she is quite close to the viewer. A subtle tension exists in the viewer's relationship to the scene, a tension that pulls one back and forth as one subconsciously tries to reconcile these conflicting signals.

By creating this psychological tension Vermeer emotionally involves the viewer in the painting and prepares him or her for the central focus of his work, the emotional response of the woman to the letter she reads. He suggests her intense concentration subtly, without dramatic gesture or expression. The depth of her response, however, is clear in the way she draws her arms up tightly against her body, clasps the letter, and reads it with slightly parted lips. Vermeer was interested in revealing neither the contents of the letter nor its origin, merely in that quiet moment when communication between the writer and the woman is at its fullest.

Although Vermeer provides little context for the letter, it appears to have come unexpectedly, since she has interrupted her toilet to stop and read it. Her pearls lie unattended on the table, with another sheet of the letter partially covering them. Significant, undoubtedly, is the map, which may allude to an absent loved one, as does perhaps the empty chair in the foreground. The woman's shape also adds to the sense of expectancy. It is decidedly matronly, perhaps as a result of fashion, but more likely because she is pregnant. Vermeer, however, remains entirely circumspect about the circumstances of the woman's life, allowing each viewer to ponder the image anew in his or her own way.

Vermeer captured the privacy of that moment by creating an environment that echoes and reinforces it. A subtle light playing across the woman and the objects surrounding her helps locate her in the corner of a room. By falling most sharply in the upper left, it implies the presence of a wall and window just outside the picture plane. Vermeer even includes the breath of a blue shadow cast by the window's frame near the picture's edge. The rectangular shapes of the table, chairs, and map surrounding her, their colors of blue and ocher, and their inner design patterns both complement the static nature of the woman's pose and act as a foil for her intense concentration on the letter. The blue-black rod stabilizing the bottom of the map passes directly behind the woman's hands and provides a visual accent that draws the viewer's attention to the letter she is holding. The map, its muted ocher tonalities echoing the flesh tones of the woman's head and browns of her hair, forms a field against which her emotions are allowed to expand. Although Vermeer separates the head from the map by juxtaposing the woman's highlighted forehead with the dark tones of the cartouche, the patterns of rivers and inlets seem to flow from her own form.

Finally, the clearly articulated shapes of the white wall defined by the objects

in the painting visually bind together the various compositional elements. Vermeer has established three basic blocks of wall, balanced though not symmetrical: the upper left, the area adjacent to the woman's stomach, and the area between the woman and the chair. These distinct shapes take an active role in the composition. Their bold and simple shapes read as positive elements, help provide a framework for the figure, and enhance the quality of stillness and tranquillity that pervades the scene.

Vermeer's *Woman in Blue Reading a Letter* seems so harmonious in color, theme, and mood that it is hard to imagine any other compositional solution. Indeed, as in others of his paintings, one has difficulty in imagining Vermeer at work, as an artist who had to somehow compose and make tangible a concept he had conceived in his mind. Part of the problem in visualizing Vermeer's working procedure stems from a lack of available information. No drawings, prints, or unfinished paintings – indeed, no records of commissions – offer clues as to his intent or aspects of his working process. No contemporary accounts comment on his work or his ideas. Our entire appreciation of Vermeer's achievement is focused on his thirty-six extant paintings.

In recent years, however, it has been possible to look far more closely at the artist behind these paintings than ever before.[2] Although little has been discovered about Vermeer's attitudes toward painting, new information about artistic procedure has been gathered through a variety of technical examinations of the works themselves.[3] Some of Vermeer's paintings have been restored, so that discolored varnish and old repaints have been removed. Pigment analyses have been made. Many of his works have now been examined with a microscope to determine more about the types and the layering of the paints Vermeer used.[4] Further technical examinations have been undertaken with the use of ultraviolet light, infrared light, and x-radiography. Infrared reflectography has been utilized in a number of instances, and at the Metropolitan Museum of Art and at the Staatliche Museen in Berlin, Vermeer's paintings have been studied with neutron autoradiography.[5] Although the availability of technical information varies greatly from painting to painting, which rules out any truly systematic assessment of Vermeer's working process, a wealth of information exists about Vermeer's working methods that can be used in assessing the character of his images.

Vermeer conceived and executed his paintings with exceptional care. His final compositional solutions often only came after he had modified his initial design. Understanding the nature of Vermeer's changes and the ways in which he adjusted the proportion and placement of his compositional elements to achieve his results helps determine those qualities he wished to emphasize in his work. In the *Woman in Blue Reading a Letter*, for example, Vermeer made two compositional modifications that are visible in x-radiographs of the painting. X-radiographs record the various densities of materials and help determine the patterns of the use of lead-bearing paint, particularly lead white and lead-tin yellow-white (Fig. 17). One alteration occurs along the left edge of the map of the

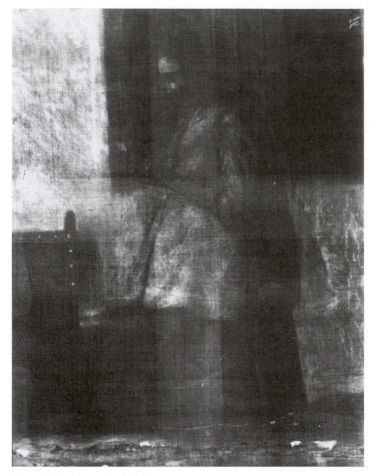

Fig. 17. X-radiograph of Plate 19.

back wall, where the lead white of the wall color extends about three to four centimeters under the left edge of the map as it now exists. Whether Vermeer altered the position of the map or decided to enlarge it cannot be determined, but it may be the latter case. The map, which is based on an actual prototype, is proportionally larger in the painting than it is in actuality. It is also larger than it appears in his earlier painting, *Officer and a Laughing Girl* (Plate 6).

Another compositional change evident in the x-radiograph is that the woman's jacket once flared out in the back, and perhaps also slightly in the front. The shape of the earlier design is visible in the x-radiograph because Vermeer started painting the white wall with lead white around an earlier form of the jacket. An infrared reflectogram shows many of these same changes (Fig. 18) but also gives additional information. Because the reflectogram works on the principle of heat absorption and picks up patterns of black or gray applied over a light ground, the underlying jacket seen in the reflectogram must have been blocked in in grays over the light ocher ground. In the reflectogram one can see that this original jacket had a fur trim along its bottom edge. As fur-trimmed

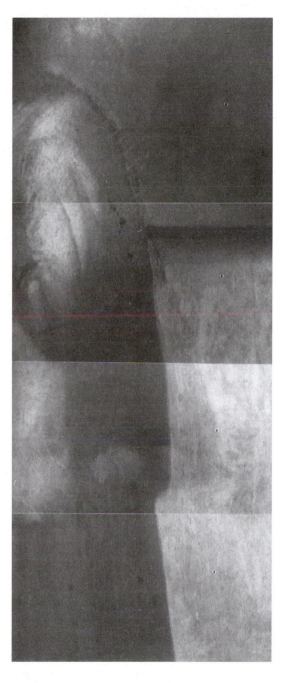

Fig. 18. Infrared reflectogram of woman in Plate 19.

jackets found in other of Vermeer's paintings are either deep blue or yellow one might well imagine that Vermeer originally had a different color harmony in mind when he conceived his work.

Paintings can also be examined technically to determine whether or not an artist has changed a color. With microscopic examinations one can occasionally see the various layers of paint used by the artist. Other means are also possible. X-ray fluorescence and neutron autoradiography can provide information about

the various chemical elements present in specific areas of paintings. Because chemicals are almost always pigment specific, their identification can often provide information about the artist's buildup of his images. This type of analysis can be confirmed and often made more specific by taking paint samples and cross sections in areas where confusion exists. Since these two examination methods require removing small particles of paint, they are considered destructive examination methods and undertaken only in extreme circumstances when art-historical questions seem particularly important. Usually such samples are taken at the edges of preexisting losses or along the edges of paintings where their impact is minimal.[6]

In the *Woman in Blue Reading a Letter*, microscopic examinations give added information about the changes found in the X rays and reflectograms. The white that underlies the left edge of the map consists of a white layer on top of a layer in which white is mixed with blue. Because both of these layers lie under the map, it would seem that Vermeer had completed his wall color before changing the contour edge of the map. Microscopic examination also provides more information about the jacket. For the blue of the jacket, Vermeer applied a thin layer of natural ultramarine, an expensive and particularly radiant blue that he frequently used in his paintings. In the microscope it is thus easy to see the underlying paint layer. No additional colors underlie the woman's jacket, which means that the shape visible in the x-radiograph and reflectogram must represent a preliminary compositional stage before Vermeer began introducing local color.

Such technical examinations can also reveal the ways in which Vermeer accommodated light effects within his paintings. In the *Woman in Blue Reading a Letter*, the light, which comes in from the upper left, passes gently over the image, catching highlights and casting shadows in a variety of ways. The brass nails in the back of the blue chair on the left, for example, have specular highlights facing the upper left. The effect seems quite simple, but an infrared reflectogram demonstrates how carefully Vermeer worked to create this effect. The reflectogram reveals that Vermeer initially painted each nail at its full size with a light color, which from microscopic examination appears to be lead-tin yellow. He then reduced the intensity of the nails by adding shadows with a dark thin glaze that is heavier on the right side of each of the nails than on the left. Finally, he added a small dot of lead-tin yellow paint over the glaze to create the accent. Vermeer used similar specular highlights to enliven the painting in a number of places, including the hair band and the map.

Vermeer's depiction of shadows as light plays across the surfaces of objects in the *Woman in Blue Reading a Letter* is particularly remarkable. His sensitivity to light effects is evident on the wall beside the back chair: the darkness of the chair's shadow varies from a soft bluish tint near the finial to a deep blue-black at its lower extreme (Fig. 19). The shadow is made even more complex by the presence of a secondary shadow from another light source, presumably the window closest to the back wall. This secondary shadow, which again has a light blue tinge, falls across the primary shadow and softens its rather sharp outer

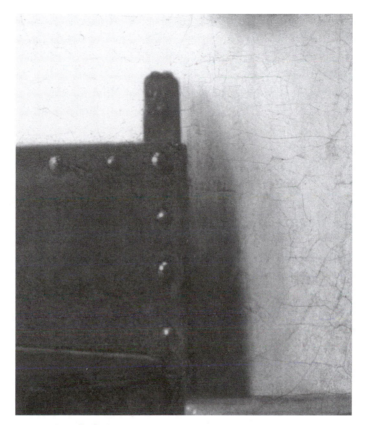

Fig. 19. Detail of Plate 19.

edge. An examination of this area with microscopy and x-radiography indicates how Vermeer established the transparent character of the shadows. He created the deepest shadow by applying this blue-black layer over the ochre ground. The wall color, which appears to be a mixture of lead white, light ocher, and light blue, stops at the shadow's edge. The light blue tones of the secondary shadow and of the top of the primary shadow appear lighter because in these instances Vermeer painted a thin blue glaze over the wall color. The artist indicated shadows under the rod at the bottom of the map in a similar way.

Vermeer's use of glazes to suggest shadows approximates the transparent qualities of the natural phenomenon. He employed these same techniques in a variety of ways throughout the painting. In the woman's jacket, for example, he created the midtone of blue by applying thin glazes of natural ultramarine over the ocher ground. In the deep shadows along the back of the jacket Vermeer painted a thin black layer over the ground, which was either mixed with or served as the base for small traces of blue pigment. Very little blue paint actually exists either in the highlights or deep shadows. Indeed, Vermeer suggested the jacket's overall tonality with a minimum of blue and relied on the eye to combine the various tonalities into a whole.

Vermeer's sensitivity to the optical effects of light and color and his ability to

transmit them in paint is one of the primary reasons why his images have the visual impact they do. Light effects in his paintings, however, are not always consistent. As with his choices of colors and modifications in the scale of objects, he also used light and shade selectively for compositional reasons. As previously indicated, in the *Woman in Blue Reading a Letter,* the chair near the wall casts a shadow, or, more accurately, two shadows. A pronounced shadow also falls just below the map. The woman, however, who also stands near the wall, casts no shadow at all. Indeed, Vermeer emphasized her separateness by giving the wall immediately behind her a brighter tonality, as though her form radiated rather than obstructed light. He even accentuated this effect by purposely softening the juncture of her form and the wall, diffusing the contour of her jacket with a light blue (see Fig. 20).

Although the woman exists within a recognizable interior space where shadows of the objects in the room will change as the sun moves in its orbit, by not casting a shadow she exists in a different spatial and temporal framework. The viewer can more or less determine where the woman is standing but cannot measure her precise location. Similarly, the absence of a shadow provides this moment of great privacy and intense concentration with a permanence that strengthens the psychological impact of the woman as she gazes at her letter. The viewer is drawn to her image and held by it in ways that are not totally explicable but that clearly have much to do with the way Vermeer has handled light, color, and composition.

Vermeer achieved this sense of permanence in the *Woman in Blue Reading a Letter* through many means. The moment he chose to depict was carefully considered, as was the way in which he related the woman to her surroundings through his careful compositional arrangement. Vermeer, however, also manipulated reality to achieve his effects. He modified the shape and character of the woman's jacket, adjusted the scale and color of the map, and only selectively represented the flow of light as it passes through the scene. In a painting where the figure, her attitude, her accoutrements, and the light that encompasses her seem so real, these adjustments come as a surprise, for they call into question the notion that Vermeer accurately described the physical reality of the world about him. Vermeer, however, consistently altered the character of objects and light effects for his own artistic purposes. Indeed, it would be surprising if he did not adapt reality in these ways, for the Dutch concept of realism was far more complex than is generally recognized today.

Vermeer never wrote about his art, so no certain understanding of his attitudes about pictorial representation is possible. It is evident from his work, however, that somewhere in the course of his training he learned the fundamental principles of artistic practice and theory. To judge from paintings like the *Woman in Blue Reading a Letter* he was remarkably adept at layering his paints to create textural and optical effects that would both simulate reality and enhance the mood he wanted to achieve. He had a sophisticated awareness of the importance of perspective not only as a means for creating the illusion of a

Fig. 20. Detail of Plate 19.

three-dimensional space on a flat surface but also for affecting the psychological impact of the scene. From other paintings in his oeuvre it appears that in his search for new ways to enlarge his artistic vision, he also examined the expressive possibilities of the camera obscura.[7]

Before being able to determine the unique characteristics of Vermeer's manner of depicting the world about him, however, it is important to understand, in a broader fashion, the theoretical framework of realism in the seventeenth century.[8] The closest that one can come to an assessment of the theoretical approach of his contemporaries toward realism is Samuel van Hoogstraten's *Inleyding tot de hooge schoole der schilderkonst* (Introduction to the Lofty School of Painting), published in Rotterdam in 1678, some thirteen years after Vermeer completed his *Woman in Blue Reading a Letter*. Van Hoogstraten (1627–78), who, along with Carel Fabritius (1622–54), had been a pupil of Rembrandt van Rijn's (1609–69) in the mid-1640s, may also have known Vermeer since he lived in Dordrecht, not far from Delft. Van Hoogstraten was a multifaceted artist who painted biblical subjects in the style of Rembrandt, genre scenes, portraits, and trompe l'oeil still lifes. As a consequence, his theoretical treatise, which is an amalgamation of many ideas drawn from the classics, Italian art theory, and his own practical experience, provides a relatively reliable glimpse into the intellectual concerns that must have been shared by many of his contemporaries.

Van Hoogstraten defined the artistic ideals to be sought by a painter as follows: "I say that a painter, whose work it is to fool the sense of sight, also must

have so much understanding of the nature of things that he thoroughly understands the means by which the eye is deceived."[9] According to Van Hoogstraten, then, the artist's task is to fool the eye, to make the viewer believe that the image he or she is seeing is an entirely different reality. The success of such an undertaking is not determined by a quick wit and fluid brush but by a thorough understanding of the laws of nature and "the means by which the eye is deceived." For Van Hoogstraten the "means" explicitly include the workings of vision and the theories of perspective, but also implicitly include an understanding of the psychological expectations of a viewer encountering an illusionistic image.

It is clear from the fascination with trompe l'oeil in Dutch art that Van Hoogstraten's contemporaries shared in his enthusiasm for works that deceived the eye. In 1641, for example, Jan Orlers described the wonderment of viewing Gerrit Dou's (1613–75) careful technique for depicting figures, animals, insects, and other objects from life.[10] In the following year Philips Angel also cited the wonder invoked by Dou's remarkable technique for recording the smallest details in a lifelike manner, for, according to Angel, the most admirable of painting is that which comes closest to nature.[11] Angel stressed that it was important to delight the viewer's eye with illusionistically conceived representations of materials and textures of natural objects.[12] Careful observation of nature, such as that which allowed the painters Jan Brueghel the Elder (1568–1625) and Jan Davidsz. de Heem (1606–83/84) to produce convincing images of flowers, was essential to any artist who sought to create an illusionistic painting. By studying the shapes and colors of petals, the rhythms of leaves and stems, and the delicate translucency of their forms, artists could translate their qualities into paint and elicit the admiration of their patrons. Cornelis de Bie, writing in 1662, admired the still-life painter Daniel Seghers (1590–1661) because he created flowers so real that live bees would want to settle on them. De Bie continued, "Life seems to dwell in his art."[13] Van Hoogstraten perhaps best expressed the ideal that painted images should appear so real that they could be confused with nature itself: "A perfect painting," he wrote, "is like a mirror of Nature, in which things that are not there appear to be there, and which deceives in an acceptable, amusing and praiseworthy fashion."[14]

Van Hoogstraten's recommendation that an artist should deceive the eye is advice he followed in a number of his own paintings. One such work was a life-size view through a doorway into an interior space (Fig. 21) that was displayed in such a way as to fool the spectator into believing that the "doorway" led to another part of the house. The response to such works must have been similar to the excitement that greeted the small triangular perspective box that the Englishman John Evelyn described in the entry in his diary from February 5, 1656: "so rarely don, that all the artists and painters in towne flock'ed to see and admire it."[15] The admiration for the illusionistic qualities of the view of the "greate Church of Harlem" in the perspective box noted by Evelyn is also felt in the delightful story recounted by Roger de Piles about an illusionistic image of a

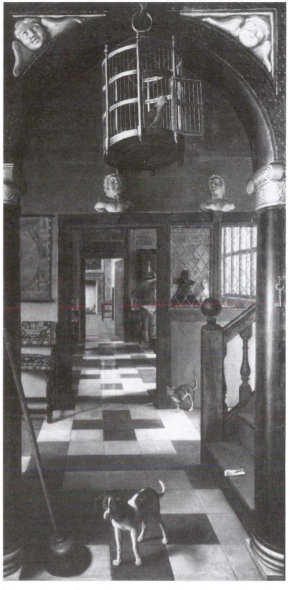

Fig. 21. Samuel van Hoogstraten, *View Down a Corridor*, 1662 (oil on canvas, 264 × 136.5 cm). Dyrham Park, The Blathwayt Collection (The National Trust). Photo: Courtauld Institute of Art.

servant girl that Rembrandt placed in his window. "Everybody who saw it was deceived, until the painting had been exhibited for several days, and the attitude of the servant being always the same, each one finally came to realize that he had been deceived."[16] The illusion worked because of the scale, colors, and textures of Rembrandt's image, but also because the expectation of those passing by Rembrandt's window was that a real person would be leaning out – not an imitation of one. The success of a trompe l'oeil painting was due not only to the

careful application of the laws of perspective and detailed technique but also to the ability to engage the viewer in the work of art itself.

In its broadest respect, then, such illusionistic ideals are sympathetic to Vermeer's approach in the *Woman in Blue Reading a Letter* (Plate 19). Vermeer not only created a believable space with recognizable textural and lighting effects, he also engaged the viewer in the scene with his empathetic portrayal of the woman. One could hardly imagine, however, that Vermeer's scene would be mistaken for reality in the way that was so frequently commented upon in the work of other artists, even those whose paintings were not conceived as trompe l'oeil works of art. Although Vermeer studied nature and tried to emulate its textures and light effects in his paintings, he did so with an eye and an intent unlike that of a still-life painter. The primary difference is that an illusionistic painter tries to deny the reality of the two-dimensional surface of the painting by making the viewer accept the reality of the objects in the scene. Vermeer, on the contrary, purposely establishes a distance between the viewer and the image. The painting always maintains its independent reality, even though the elements seem real and the psychological characterization is powerful. In this respect, Vermeer's artistic interests and approach in paintings like the *Woman in Blue Reading a Letter* are fundamentally different from the illusionistic one advocated so enthusiastically by Van Hoogstraten and others.

Illusionism, however, is only one of the artistic ideals espoused by Van Hoogstraten. Although he delighted in visual deceptions, Van Hoogstraten also stressed that "the highest and most distinguished level in the Art of Painting, which is above all others, is the representation of the most memorable histories."[17] For Van Hoogstraten, as for the early-seventeenth-century Dutch painter and art theorist Karel van Mander (1548–1606), depictions of biblical, mythological, or allegorical subjects demonstrated both the artist's imaginative genius and his ability to portray human figures interacting at moments of great historical and moral consequence.[18]

How Dutch artists dealt with these contradictory recommendations – trompe l'oeil realism and idealized, imaginatively conceived history paintings – is a complex problem, but one that is fundamental to coming to terms with Vermeer's artistic career. Van Hoogstraten's artistic solution was to execute his history paintings and trompe l'oeil images in totally different styles, the one with generalized forms and chiaroscuro effects derived from Rembrandt van Rijn's style of painting, the other with specific details and natural light. The types of images he created in these two styles are so different that it is hard to imagine that they were painted by the same master. Vermeer, who began his career as a painter of large-scale histories, accommodated his new subject matter with a change of style, but perhaps uniquely among Dutch artists, he sought to incorporate the fundamental moral seriousness of history painting into his genre scenes.

This seriousness comes from the fact that despite the specific concerns for textures and light effects in his genre scenes, Vermeer chose the reality he wanted to depict with the same concerns as those evident in history painting.

Much as history paintings evoked images and moods that enlarged one's perception and understanding of self, Vermeer infused his scenes of daily life, such as the *Woman in Blue Reading a Letter,* with comparable fundamental human concern. Whether he sought to convey the timeless bond between two individuals, the bounty of God's creations, the need for moderation and restraint, the vanity of worldly possessions, the transience of life, or the lasting power of artistic creation, his works invariably transmit important reminders of the nature of existence and provide moral guidance for human endeavors.

4 Perspectives on Women in the Art of Vermeer

Lisa Vergara

Vermeer's artistic devotion to women is one of the most striking features of his extraordinary oeuvre; only a third of the surviving works picture a man. But quantity is the least of the phenomenon. The very concept, "women in the art of Vermeer," takes us into every aspect of his production, from professional aspirations to personal predilections, from broad cultural norms to private meditations, from mundane working conditions to exquisite pictorial adjustments. Surely no two specialists, restricted to a dozen pages, would approach so vast a subject in quite the same way.

The present chapter examines Vermeer's perspectives on the female figure in just four works: the *Art of Painting, Woman Holding a Balance, Officer and a Laughing Girl,* and *The Music Lesson.* In the *Art of Painting* (Plate 26), Vermeer's notion of the female model is highly original, offering insight into why women play such an important role in his professional self-definition. In *Woman Holding a Balance* (Plate 15), many of the values that the painter's culture cherished are crystallized in a householder, her gesture, and her place within a shrinelike domestic setting. In *Officer and a Laughing Girl* (Plate 6), Vermeer, with great spirit, plays up the differences between the sexes as well as their mutual attraction. Lastly, in the artist's subtlest staging of an amatory scene, *The Music Lesson* (Plate 17), everything is conceived as depending upon the woman. A number of forces that likely shaped the unusual degree and kinds of attention that Vermeer pays to women in his art are examined here in a final section. But first, some preliminaries.

Figuration

The qualities that we attribute to Vermeer's works as a whole apply equally to the women they picture: paintings and personages share dignity, equilibrium, and an exceptional measure of both vivid presence and abstract purity. The figures range from girlish to maternal, yet all are youthful, with high curved fore-

54

heads, features that evenly balance the individualized and the classical, and simple, believable postures. Their costuming – its colors, shapes, and associations – contributes so much to bodily construction and expression that the absence of nudes from Vermeer's oeuvre hardly seems surprising.[1]

Apart from a few early works with religious or mythological subjects, all of them depicting women, Vermeer fashioned his figures to evoke his own time and place, "The Netherlands, now." Clothing and settings usually signal the world of prosperous burghers, the urban elite, a world where women enjoyed sufficient space and leisure to cultivate private moments within the home.[2] In three of the paintings, a maidservant appears in the company of a lady, emphasizing the latter's higher social position and evoking the conventions of courtship (Plates 25, 29, 30). But these servants also command interest in their own right, and one of the artist's most popular paintings is devoted entirely to a sturdy, wholesome-looking kitchenmaid (Plate 8). Vermeer's compelling depictions of socially humble women signal his sensitivity to class distinctions. As for housewives in ordinary workaday situations, they appear only in his two surviving hometown views, a close-up and a panorama of Delft (Plates 10, 11). There, although small in scale, these figures convey the artist's complete familiarity with such women as representative social types.

Vermeer's women often seem familiar to us, too, because his concept of significant human activity embraced habitual, universal ways of engaging the world. Most often, he depicts female figures gazing downward in careful concentration upon an object at hand (Plates 1, 3, 4, 7, 8, 10, 15, 19, 20, 30, 31). But they may also smile fetchingly at the viewer (Plates 21, 33); confront us directly with more ambiguous expressions (Plates 12, 13, 24, 35); withdraw their attention in a state of reverie (Plates 3, 5, 18); cast a wide-eyed glance through a window (Plates 16, 30); or catch and hold the look of a man (Plate 6). These ways of regarding, and their accompanying gestures, are crucial to Vermeer's constructions of femininity.

Despite his focus on women, the gender implications of Vermeer's works are rarely considered. This is understandable, given the enormity and difficulty of what gender studies seek to know; the expectations around art at the time; and not least, the artistic complexity of the paintings themselves. Even "gender *in* Vermeer's art" would have to address, minimally, his qualities of imagination and means of expression in relation to conditions specific to the women in his milieu, and thus in comparison with those of men. At least we can state with confidence that the pervasive structures of patriarchy faced no serious opposition in Dutch society. Direct participation in politics, institutions of higher learning, and many economic spheres, for example, were for all practical purposes closed to women. As for art, it was expected to manifest an ethical dimension, and so it is important to know that within prosperous, respectable burgher society, the class that Vermeer most often painted, the virtues most valued in women included charity, industry, modesty, submissiveness, and piety, all of which were to be exercised in the important familial realm of the home. Writ-

ings produced by the more urbane members of that class sometimes reveal an enthusiastic regard for women, including spouses, who combined the standard feminine virtues with affection, beauty, learning, and wit. A good family and a good dowry always added to a woman's value as well.[3]

Regarding social constructions of femininity, the discussions that follow may help to establish a foundation for further study by identifying some of the interpretative terms that the images themselves propose. In recognition of this painter's singular artistry as the chief reason his female figures compel interest even today, pictorial qualities and relationships receive particular emphasis here. First and foremost, "women in the art of Vermeer" refers to the products of a consummate professional painter, one whose expressive language turns out to be very much his own.

Model and Muse in the *Art of Painting*

The magisterial *Art of Painting* (Plate 26) offers a fruitful starting point for our investigation. Vermeer's sole description of a painter at work, it provides at the same time a comprehensive summary of his own special skills, interests, allegiances, and ambitions. In the history of art it counts as one of the most complex meditations by a painter on what his vocation meant to him. So it should go without saying that Vermeer ordained the depicted painter (henceforth, the Painter) to be his surrogate, and that the presence and meaning of the female model signal ideas integral to his art as a whole. Working from that premise, we can begin by examining some of the connections between the picture's two personages – and just as important, between each of them and ourselves as viewers.

First, however, it is important to recall that Vermeer's style stems from that of the great fifteenth-century Netherlandish innovators in the art of painting, who combined breathtaking realism with intricacy of design. More specifically, the *Art of Painting* domesticates and secularizes an earlier Netherlandish subject, St. Luke portraying the Virgin and Child. Rogier van der Weyden's version (Fig. 22), a masterpiece from some 230 years earlier, is credited with having "devised pictorial means of articulating ideas about art, artists and artistic tradition that were addressed elsewhere primarily in literary writings and allusions."[4] Rogier depicts the belief, already centuries old at the time, that St. Luke had been a painter, and that he had made the first icons of the Madonna and Child. Because of this belief, artist's guilds throughout Europe, including Delft's, were named the Guild of St. Luke. As Eric Jan Sluijter observes in his recent study of the *Art of Painting*, it was through this guild tradition that the representation from life of a beautiful young woman came to stand for the highest goals of painting.[5] So, whatever Vermeer's perspectives on real women, he had a professional investment in those that his art represents.

By the seventeenth century, the subject of St. *Luke Portraying the Virgin*, demoted to a legend, had gone out of style. Yet Vermeer clearly was attracted to

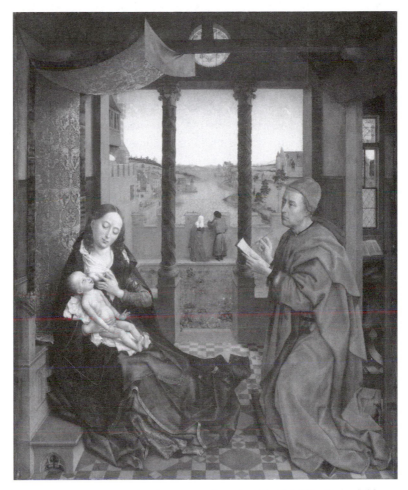

Fig. 22. Rogier van der Weyden, *St. Luke Drawing the Virgin and Child*, ca. 1435 (oil on panel, 137.5 × 110.8 cm). Boston, Museum of Fine Arts. Photo: museum.

it. Like Van der Weyden's *St. Luke Drawing the Virgin and Child*, his *Art of Painting* is a large work that describes, with concerted virtuosity, a rich interior in which a female model poses before an artist. In Vermeer's scene, the large map with a border of city views – a fashionable domestic decoration in his day – substitutes for the prominent landscape background in the earlier work, and a more dynamic, asymmetrical form of pictorial balance replaces Van der Weyden's old-fashioned, bilaterally symmetrical composition. If Vermeer did not study Van der Weyden's painting, he must have seen one of the many copies or variants it inspired, or perhaps only a more recent artistic descendant, and he was surely familiar with the tradition of placing a painting of its subject on the altar endowed by a town's Guild of St. Luke. We know that he kept the *Art of Painting* at home, and it is reasonable to assume that he used it to demonstrate to visitors his special mastery. Vermeer must have conceived this modern adaptation of the guild's former trademark production to fit the private, "home stu-

dio" context in which he defined his art – a new and particularly appropriate idea.[6]

As a deeply intelligent transformation of an illustrious subject from the Netherlandish past, the *Art of Painting* should express a rich set of relationships between the painter and model. The primary one was expressed by Lawrence Gowing in his classic study of Vermeer, written in 1952: Gowing felt that the dominant theme in Vermeer's work as a whole was "the attention man pays to woman."[7] Thanks to Vermeer's pictorial ingenuity, the nature of this attention can be recognized as it shifts from painting to painting. For example, in establishing a psychological situation, he often creates systematic, dialogical relationships between two figures, as we see here: male and female; seated and standing; near and far; large and small; back and front; oriented right and oriented left. Further: he very deliberately aligns sets of related motifs throughout multiple spatial planes, a skill that Van der Weyden and his contemporaries had already developed to a high degree. And of course, he typically employs perspective as a technical device to create form, but also to convey his attitudes – his perspectives – on women. The specific application of these devices in the *Art of Painting* helps us to understand the key role that the young model plays in the scene.[8]

So, to proceed. Although the Painter's eyes are not visible to us, we can feel from the pose that his gaze is fixed on the model. Strengthening this effect, the lower edge of the map's internal frame runs between him – at the level of his eyes – and the girl posing. Note, too, that the bar at the bottom of the map lines up the model with the tip of his brush.[9] The Painter's right hand, strangely bulbous and unfocused (especially in comparison with the model's), suggests that his sense of touch, in the service of manually applying paint to canvas, is for the moment subordinated to sight, to staring intently at her. Moreover, she looks down, her eyes almost shut, increasing our sense of her as the object of his gaze. Finally, Vermeer did not sign his name just anywhere in this work, but rather in that same area of the map, between the two horizontals joining the figures, right next to the girl. The placement of his signature in this connecting zone confirms his personal identification with the Painter and acknowledges that an intense relationship with the female figure lies at the heart of his art.

This relationship, according to Vermeer, is to some extent private as well. His surrogate turns his back on us as he takes in an unobstructed view of the girl. His physical bulk, and the table next to him, create a special space in the painting for his – and only his – act of looking. Yet Vermeer contrives the model to attract us as well as the Painter. She becomes irresistible through one of his happiest color combinations: the icy blues of her shawl and the bright yellow of her book. And the perspectival vanishing point, strategically situated for our benefit, falls right before her, under the knob of the lower map rod and her delicately drawn right hand.[10] Vermeer even paints a path of white tiles leading directly to the hem of her skirt.

Looking closely at the model's sunlit features, we might identify her as sim-

ply "the girl next door." But substituting for the Virgin and Child of the St. Luke pictures, Vermeer's model takes on an appropriately prestigious identity. For this occasion, as has long been realized, she impersonates Clio, the first of the nine classical Muses, who inspires the writing of history. In a handbook of images by Cesare Ripa that Vermeer presumably consulted, the Muse of History appears twice, the second time as "Clio, Honor-Fame."[11]

We can deduce this second identity, Clio, through the model's attributes: a crown of laurel leaves, a trumpet, and a book. In Vermeer's studio context, Ripa and other sources allow us to interpret these motifs as follows. Clio's trumpet signifies that she will "sound" the Painter's mastery throughout the world; she holds a history book in which to record his artistic triumphs; and her crown is made of ever-green laurel leaves because, as Ripa states, "through History, past as well as present things live forever." The point, then, is that Clio's presence in the studio fuels the Painter's ambitions. She prompts him to excel at his art in order to gain what he most desires, eternal respect and renown.[12]

So far, the painting seems to be more about the man, the artist, than about the woman-as-Clio. But with great wit Vermeer reveals that the relationship between the two personages is reciprocal. That is, he invites us to peer over the Painter's shoulder at the canvas-in-progress, and there we see but a single motif: a representation of a laurel crown. The crown that Clio wears and the crown on the Painter's canvas together epitomize the give and take between her and the artist. The two crowns symbolize at once *her* power to inspire; *his* mastery; and the honor and fame that *she* will confer on *him*. (By placing their heads at nearly the same level, Vermeer adds to the impression of their equality.)

But to return to the St. Luke pictures, the *Art of Painting* actually espouses the same essential goals as had the old guild subject, namely, of dignifying the profession of painting, partly through its association with a special woman; of displaying virtuoso feats of pictorial skill; and of gaining immortality – although now more weight is placed on eternal life in History than in Heaven. The youthfulness of Vermeer's female model reminds us of this. Like her, his art was designed to defy growing old, and indeed generation after generation rediscovers it anew.

Clio plays such an important role in the *Art of Painting* because in it Vermeer visualizes his historical role, namely, of constantly revitalizing the Netherlandish artistic past by fusing it with the local Dutch present. The prominent map on the wall specifically places the Painter, and thus Vermeer, within The Netherlands, with its great centuries-old artistic traditions that still enlivened the present. Equally important in conveying the picture's themes is the Painter's special clothing. A unique blend of then current fashion and decidedly retrospective elements, this hybrid costume is topped by a beret – an item that was considered old-fashioned by the later sixteenth century but which became a characteristic attribute of painters in the seventeenth century. Through the Painter's costume as a whole, then, Vermeer specifically refers to painting's illustrious past as well as its vital present.[13]

Often overlooked, however, is the model's modern dress showing beneath her antique mantle.[14] Her combination of old and new prompts us to reconsider the two sides of her dual identity, both everyday painter's model and the first of the classical Muses. The *Art of Painting* illustrates through this duality the picture's central idea: that Vermeer hopes to go down in history by depicting the lovely young women of his own time and place. It is they who embody his art's ambitions. Clio, therefore, can guide us toward understanding Vermeer's more typical images of women.

Vermeer's Modern Icons: *Woman Holding a Balance*

It is important to recall that in the *Art of Painting* the Painter sees Clio from a different angle than we do. From our perspective, she immediately recalls the motif that, as Edward Snow puts it, is most intimately Vermeer's own: a woman standing alone, in whom "a sense of life's meaning, its affirmative core, is made manifest."[15] The *Woman Holding a Balance* (Plate 15) has always counted as a brilliant exploration of this motif. Only one-third the size of the *Art of Painting*, the *Woman Holding a Balance* focuses solely on the female figure in her world, but here too she stands next to a table, a few select props enrich her characterization, and light plays actively over her still, solid form. Vermeer enshrines this stately figure between a table's small array of treasures and a painting of the *Last Judgment*.

In a sale list of 1696, the *Woman Holding a Balance* was described as "A Lady weighing gold . . . extraordinarily artful and vigorously painted."[16] The categories singled out in that brief entry are the essential ones: the depicted person; her action; and the quality of the artistic rendering. Each component can be fruitfully examined in turn. First, the Dutch term used for Lady – *Juffrouw* – had strong class connotations.[17] And indeed, a number of motifs identify the woman as belonging to the ranks of prosperous burghers: her fur-trimmed jacket; the gold and pearl necklaces spilling forth from a jewel box; gold coins on the table; a marble-tiled floor; and on the wall, a large painting, framed in partially gilt ebony. Second, the sale catalogue describes the action as "weighing gold." It is not surprising that whoever wrote the notation, being accustomed to thinking in conventional terms, overlooked the woman's precise gesture. It is in fact unique in the art of this time. She is studying a slender set of scales to determine if it is perfectly calibrated. That is, she is "testing its accuracy" before she begins the weighing.[18]

Next term: "extraordinarily artful." In the painting, nearly square in shape, the woman stands at the right, so that her hand holding the balance is illuminated at the exact center of the canvas. At this same spot lies the perspectival vanishing point. In a bold move, the artist designed the left upright of the internal picture frame to set off and stabilize the hand before it. Then, with contrasting delicacy, he refined the gesture: the woman extends her little finger so that it

exactly parallels the crossbar of the scales, the lower edge of the depicted frame, and a series of horizontals formed by the table and the objects on it.

The centrality of the woman's gesture, and the care with which Vermeer coordinated the composition around it, signals its special importance. Clearly, the large painting that frames her and its connection with that gesture are crucial for any understanding of female personhood in his art. Gowing's opinion on this matter seems precisely right, namely, that the *Last Judgment* serves to characterize the figure, to give "a quality of the universal, a cosmic balance, to the fact of womanly judiciousness." And Snow, taking a different interpretative route, concludes that Vermeer's woman embodies "a sense of well-being predicated on balance, on equanimity, and on pleasure in making the finest distinctions."[19] Her judiciousness and sense of well-being have many dimensions. For example, the *Last Judgment* marks her as pious by referring to an imagined ultimate reality, the knowledge of which is meant to help one live an upright life.

Keeping in mind Vermeer's habit of guiding the viewer's interpretation by coordinating forms on the surface and in depth, we can discover further dimensions of meaning. Note, for example, that from our vantage point it is the Saved who rise in the space of the *Last Judgment* visible in front of the woman. This cannot be insignificant in the case of an artist as careful as Vermeer. Further, he draws attention to the woman's pregnant shape: a bright orange ribbon caresses the illuminated volume that curves outward where her jacket parts. The figures of the Saved, striving toward Jesus above the womb's growing life, suggest in more remote terms the blessing that Vermeer's light always seems to confer. "The light so long beloved to me/Now I give, dear child, to thee." This saying has been cited in relation to the painting, and it seems most apt.[20] That is, a proverb referring to the light – to the spiritual values a mother is charged with passing on to her child, or some other expression of that idea – must have played into Vermeer's conception. As a result of all these artistic choices, the painting celebrates a life that balances worldly and spiritual things. The woman indeed makes manifest "life's affirmative core." From a historical perspective, then, she embodies a broad range of positive ideals: piety, prosperity, fertility, foresight, conscientiousness, and judiciousness.[21]

Vermeer's *Woman Holding a Balance* also conveys a feeling of spirituality that is unusual in Dutch scenes of domestic life. As has often been remarked, the veil-like treatment of her head covering and the iconic solemnity of her presentation evoke associations with the Virgin Mary. A painting of *The Holy Family* (Fig. 23) from the previous century represents the kind of Marian image that comes to mind: the Blessed Mother stands at a table within a shallow interior, looking down at the Christ Child with a smile of contentment. Pictures like this were produced in great quantity, attesting to their immense appeal.[22] In the *Woman Holding a Balance* Vermeer conveys the personage's spirituality in yet another way. He makes the prospect of the Last Day properly fearsome – in contrast to the woman's firm, reassuring shape, the religious painting teems with agitated, spectral forms, yet she links up visually with the scene behind her as if

to suggest its inescapable relevance. The jagged little figure of Christ, his arms raised in right angles, echoes in reverse the pendant lines of her set of scales, and the pale, oval-shaped nimbus around him floats above the oval of her beautifully modeled head. Despite this dramatic tension, she remains serene, as if assured that her kind will prevail, even at the end of time.[23]

Regarding the concept of figuration in the *Woman Holding a Balance*, it is useful to consider some remarks made by Vermeer's fellow painter, Samuel van Hoogstraten (1627–78). In his long treatise on art, Van Hoogstraten writes that if a painting is to reach the highest level (the third level, in his scheme), then it must show the noblest emotions and desires of rational human beings. The talent needed to depict more than "mere animal passions," Van Hoogstraten feels, is spread very thin. Interesting in this context is the fact that he cites painters of "the loveliest young women in every town." He writes (abruptly turning to portraiture): "Indeed, those portrait painters who make reasonable likenesses, and imitate eyes and noses and mouths all prettily, I would not wish to place . . . above the first grade, unless they make their faces overflow with the quality of the intellectual soul. . . ."[24] The *Woman Holding a Balance* demonstrates that Vermeer's achievement is of the highest rank, because through his figure's display of womanly judiciousness, her seemingly blessed maternal state, her visual associations with Mary, her confidence in the face of Judgment, we do indeed get a sense of what Van Hoogstraten called "the noblest emotions and desires of rational human beings." Further, as in all of Vermeer's paintings (and this separates them from works by his contemporaries), here the window reveals no view outside. The woman's resulting privacy within the enclosed interior becomes a metaphor for her own interiority, her own soul within.

Reviewing his cast of female characters, we can easily see how often Vermeer suggests through them the workings of the mind and the cultivation of the spirit that come together in the course of commonplace yet highly civilized activities. Not surprisingly, his women express habits of mind, hand, and heart akin to those we imagine the artist himself exercising as he planned and painted his pictures. This certainly pertains to the *Woman Holding a Balance*. For example, Edward Snow, prompted by the fact that the pans of the scale are empty except for gleams of light, observes of the woman's action: "It seems appropriate that a gesture so paradigmatic of Vermeer's art, should appear concerned with the weighing and balancing of light itself."[25] Indeed, the gesture requires precise coordination of delicate physical and mental calculations – the same capacities that Vermeer's art demanded from him. In *The Milkmaid* (Plate 8), the figure's act of directing a stream of liquid straight downward brings to mind one of Vermeer's own most distinctive pictorial habits: the assured, mimetic application of paint (here representing milk) over carefully plotted straight lines. No wonder his perspectives on women tend to strike viewers as sympathetic; consistently, the figures' gestures refer back to the very processes of his art. Even in the case of male characters, Vermeer avoids actions more readily associated with masculinity, those requiring physical exertion, vigorous motion, forceful contention.

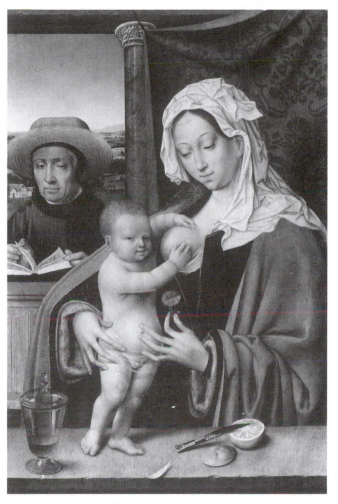

Fig. 23. Workshop of Joos van Cleve, *The Holy Family* (oil on panel, 54.9 × 36.2 cm). New York, Metropolitan Museum of Art, Robert Lehman Collection. Photo: museum.

Instead, he situates his men in quiet domestic spaces, whether a scholar's study, an artist's studio, or a salon where courtship takes place.

She Shines, and Makes Everything Shine

Vermeer's paintings often express quiet fulfillment, as in the *Woman Holding a Balance* (Plate 15). But his numerous paintings with amatory subjects – nearly half his oeuvre – are more varied in tenor. In Dutch art, literature, and music, themes around love were among the most common, attracting a wide audience of both women and men. One of Vermeer's earliest paintings of this kind, already a tour de force, was described in the late seventeenth century as "A soldier and a laughing girl, very beautiful" (Plate 6).[26] Paintings of soldiers and

young women had been popular for decades, and they became more numerous with time. Vermeer must have intended to appeal, then, to a firmly entrenched taste for such subjects by painting one in his own "very beautiful" style. Men dressed in a vaguely military fashion – there was no standard uniform at the time – occur frequently in Dutch courtship scenes.[27] In Vermeer's painting, the sword belt strapped across the man's back is enough for us to identify him as a soldier; it enhances his masculinity, as does his typically male pose of one arm akimbo. In contrast, the young woman wears the tight bodice of the time, minus a separate collar, which makes her seem even more ingratiating as she leans forward in her chair. Like the later *Art of Painting*, the *Officer and a Laughing Girl* (Plate 6) conceives of male and female personages according to sets of terms, both pictorial and gendered, that contrast all the way down the line: to his large size is opposed her smallness; to his back, her front; to the masculine expansiveness of his pose, her traditionally feminine closure; to his silhouetted obscurity, her radiant light; to his flat, smooth rendering, her glittering impasto. Yet the two figures are perfectly balanced. As always with Vermeer, precise pictorial calculation establishes the scene's emotional thrust. Here, the young woman's visual and psychological self-sufficiency, in the face of her looming companion, results as much from the composition as from her famously engaging smile.

The *Officer and a Laughing Girl* brilliantly conveys the psychic currents transmitted through an exchange of glances; now Vermeer's theme is the attention that women and men pay each other. He expresses this theme with his usual mastery, fixing the picture's horizon line exactly at the level of the young woman's eyes. Further, the vanishing point of the perspective falls on that line, like a visual spark, in the prominent wedge of wall space between the two figures.[28] This makes us perceive all the more strongly that the girl is an autonomous beholder, no mere passive object of the soldier's regard. And the painting's rightward progression from the man's dark silhouette, to the gray wall, to her colorful luminosity, emphasizes the force of her light. The flamelike red feathers on his hat, and the vanishing point's near electrical charge, convey that he indeed responds to her glow.

Turning to *The Music Lesson* (Plate 17), made a few years after the *Officer and a Laughing Girl,* we see that the stage has widened into a spacious, sunlit salon, inhabited by a well-to-do couple engaged in a refined form of music making. The man again prominently wears that especially masculine item of clothing, a baldric (sword belt). But now, in conjunction with his elegant black costume, accented by snowy white cuffs and collar, it endows him with a seignorial air that is absent from the earlier work. This exemplifies Vermeer's increasing investment in burgher respectability. The description of *The Music Lesson* in the 1696 sale actually refers to the male figure as a Gentleman, and applies to the woman the title Lady.[29]

This painting is one of Vermeer's most ambitious and personal. Artistically, it manages to balance a full-blown drama of space with a very finely nuanced interaction between two figures. In the foreground, an immense-seeming table,

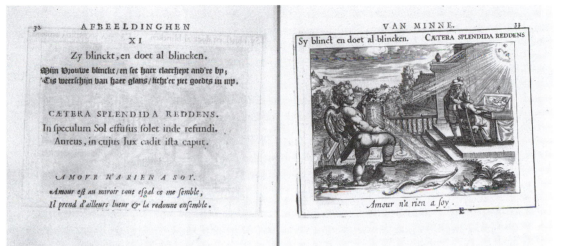

Fig. 24. Emblem from Pieter Cornelisz. Hooft, *Emblemata amatoria*, Amsterdam, 1611. New York, Rare Book and Manuscript Library, Columbia University. Photo: Columbia University.

behind it a blue chair turned at an angle, and then a large viol on the floor at first seem to have been arranged solely to create a private space for the couple within the depths of the room. But these objects also suggest a narrative. Some time before, the gentleman might have sat in that chair and played the stringed instrument, but then set it aside to approach the lady. Once again, Vermeer draws special attention to the woman through the location of the vanishing point: on her left sleeve, emphasizing the area where her unseen hands touch the keyboard of an instrument, a virginal, its very name implying a female musician.

In *The Music Lesson*, Vermeer presents yet another version of femininity. An emblem by the high-class, highly cultivated Dutch poet of love, Pieter Cornelisz. Hooft, may help elucidate the situation in which she appears (Fig. 24).[30] One of the emblem's mottoes states: "She shines, and makes everything shine." "She shines" refers both to the power of the sun ("sun" being gendered as feminine in seventeenth-century Dutch) and to the power of a woman. This idea is illustrated through two related sets of images. In the background scene, a gentleman gazes at a lady playing at the keyboard next to him. Decorous as this vignette is, the reclining nude Venus on the lid of the virginal makes clear that the musician's shine has an erotic dimension. The emblem's main scene shows the sun, whose rays strike and reflect off a mirror held by Cupid, making its target (Cupid's bow) shine and, we understand, become very hot indeed. On the opposite page, the two-line poem below the motto explains: "My lady shines, and illuminates others with her brightness/It can only be the reflection of her glow if anything good is shining in me."

Hooft compares the mirror to love, the medium through which the radiance is transmitted. In *The Music Lesson*, Vermeer actually stationed a prominent mirror over the head of the woman, where it reflects her face. If we apply the

emblematic analogies to the scene, then her power to captivate is reflected in and off the "mirror of love," "lighting up something good" in the man. He depends on his lady for his own shine, for his whole sense of fulfillment.

Vermeer stages this scene to create a tension between desire and restraint. The image in the mirror is surprising, showing the musician's face turning toward the gentleman, a turning we would hardly guess from her not-quite-matching pose. He, open-mouthed, must be speaking or singing. But in contrast, her reflected face is silent, her lips left undescribed. The man's large right hand rests on the corner of the instrument, midway between the space separating him from the lady. But his left presses down on a cane, perfectly straight, as if to repress understandable wants. The gap between the figures now seems more fraught than in the *Officer and a Laughing Girl* (Plate 6), suggesting that Vermeer had become more receptive to the conventions of refined, literary love that shape emblems and poems of the kind that Hooft wrote.

Among those conventions is the notion that amorous involvement is essentially conflicted, involving such opposites as hope and fear, safe harbors and storm-tossed seas.[31] Or take the inscription on the lid of the virginal here: "MVSICA LETITIAE CO[ME]S MEDICINA DOLOR[VM]" (Music, Companion of Joy, Balm for Sorrow). Given the picture's evident subject, the joys and sorrows of love are meant.[32] Contributing to the tension in the couple's interaction is the sizable painting-within-the-painting hanging next to the gentleman. It depicts the popular subject known as Roman Charity: Cimon, an old man starving in prison, is visited by his faithful daughter Pero, who out of filial devotion gives him her own milk to suck. The image is cropped nearly in half by the right edge of Vermeer's canvas, so that only the captive Cimon remains visible, his hands tied behind him. In his book on Vermeer, Gowing intimated that the inset picture refers to the gentleman's state of being captivated by the lady, and indeed his "abject dependence" on her. (To which we might add: his need to draw near.)[33] In other words, the picture of the bound captive Cimon allows us to infer what could not be outwardly expressed in the dignified figure of the suitor himself.

Vermeer frequently conceives of a room and its contents as emotional extensions of the painted figures, as when he literally writes the words "joy" and "sorrow" into this picture. The saying that contains those words for contrasting feelings proclaims the comforting role of music. Vermeer's couple, then, is bracketed by an image of abject dependence at right, and at left by the inscription's gentle, elevated sentiment. A pivotal moment, the beginning of the lady's turn toward the gentleman, is suspended forever in the mirror of love.

Gowing observed that here Vermeer pursued his goals in "a more private, more oblique direction, the direction that was properly his own."[34] An example of this obliqueness is the way he connects the gentleman with the figure of the bound Cimon through the intersecting black picture frame. And then, he connects himself with both male figures by placing his signature on the lower hori-

Fig. 25. Detail of Plate 17.

zontal of that frame, below Cimon and next to the gentleman. His name, typically, can only be read at very close range. It makes no great public announcement. In fact, just the opposite, as if to instruct us to take perception a step or two further than usual if we wish to discern the "private," "oblique" dimensions of Vermeer's authorial mind at work. After noticing that various inventive forms of self-projection constitute a recurring feature of his art, it is inviting to recognize even in the virginal's repeated decoration, of seahorses and tendrils, the form of Vermeer's monogram: ᴍ (to which he would add "eer"; Fig. 25). The decoration actually appears on existing virginals. Vermeer, understanding its personal relevance, presumably contrived to incorporate its shapes into this painting. And he placed one of these puns on his monogram directly beneath the gentleman's hand.[35]

The situation and even the setting that Vermeer depicts in *The Music Lesson* are surely fictional. But further hints of self-projection appear. For example, the bottom of an easel is reflected in the mirror. According to a later inventory, in the room presumed to be Vermeer's own workplace, where he kept his canvases, easels, palettes, and folio of prints, there was also the accessory that the gentleman has in the painting, namely a cane (Vermeer's had an ivory knob). Finally, a painting of Cimon and Pero inherited by his mother-in-law likely hung in his home at one time.[36] This assemblage of motifs, then, might prompt us to ask: Does the depicted gentleman represent Vermeer himself? After all, Dutch paintings of artists in their studios often included scenes of music making, and occasionally hints of love.[37] We should not be too literal, of course. But it cannot be denied that the painter marks this domain of polite yet ardent homage to a lady as his special imaginative world, stimulating the exercise of his finest talents. In fact, Vermeer's attention to the woman at the virginal, and the prominence of her devotee's viol, are meaningful in relation to the aims of painting, since musical harmony often provided an analogy to pictorial perfection. As Van Hoogstraten wrote, using the Dutch term *houding* (a term associated with the confluence of abstract harmony and realistic illusion that could only be achieved in painting):

Which secret of art we usually express with the word *Houding* . . . corresponding also to concord and charming melody in Music. Because the concept contains within itself a pure assembly of powers tuned together: the fine arrangement of colors . . . and the ordered arrangement of chiaroscuro: together with advancing, receding, curvature and foreshortening; and finally, comprises everything . . . that goes into the making of a perfect painting.[38]

The Music Lesson represents a superb example of *houding;* its arrangement of forms within a cubic space, the multiple effects of shadow and light on the contours of objects and on textured surfaces, and the equilibrium achieved among the three primary colors plus black, white, and gray, have never been equaled. Realizing the importance that painters placed on this quest for pictorial harmony, and seeing its full attainment here, we can easily believe that this time Vermeer invoked a music-making Muse.

Seigneur Johannes Vermeer, Artful Painter

Now we must turn to Vermeer himself, and ask why he so often focuses on women. From an art-historical perspective, several factors come to mind as having encouraged this direction. His earliest known paintings, of religious and mythological subjects, already announce his predilection for the female figure (Plates 1, 2, 3). Eventually, having observed the outstanding artistic results and widespread success of such painters as Gerard ter Borch, who had turned to subjects in which attractive, modern young women play the starring role, Vermeer set out along a similar path.

His own first essay of this kind, *A Woman Asleep at a Table* (Plate 5), was bought by a well-to-do Delft couple, Pieter Claesz. van Ruijven and Maria de Knuijt.[39] Eventually, they owned as many as twenty-one of Vermeer's rare paintings, nearly half his estimated lifetime production, probably acquiring each piece as soon as the oil was sufficiently dry. Van Ruijven and de Knuijt owned the *Woman Holding a Balance* (Plate 15), for example, as well as an *Officer and a Laughing Girl* (Plate 6) and *The Music Lesson* (Plate 17). Their distinguished art collection consisted entirely of depictions of nativist Dutch subjects, painted by masters who were associated with Delft.[40] Van Ruijven had reason to bolster his social prestige, and it seems plausible that in patronizing Vermeer he was following the example of his high-class relative, Pieter Spiering Silvercroon. The latter was the patron of Gerrit Dou (1613–75), one of the best-remunerated Dutch painters of the century.[41] Spiering had an arrangement to pay Dou 500 guilders a year, apparently for the right of first refusal on this sought-after master's works (whose subjects were mostly modern). Philips Angel, in his *Praise of Painting* of 1642, writes of Spiering's arrangement with Dou. In his account, within the ranks of such fabled patrons of antiquity and the Renaissance as King Attalus, Alexander, Caesar, the Emperor Maximilian, Julius II, and Francis I, the only Dutchman named is Spiering.[42] By emulating him, Van Ruijven must

have hoped to improve his social luster by linking his name to that of an out-standing local talent – Vermeer – and more generally, by assembling a choice art collection.

As John Michael Montias has shown, Vermeer had a close relationship with Van Ruijven. As for Van Ruijven's wife, we know that in her will she bequeathed to Vermeer 500 florins. This sum was comparable to the cost of from one to three expensive cabinet pictures. Such a bequest, made to a painter who was not a family member, was possibly unique. It thus counts as a gesture of special esteem and commitment to the painter's well-being.[43] Maria de Knuijt might have been acting on behalf of her husband, but she evidently had brought the far greater share of money to the marriage, and her taste must have been taken into account. Indeed, Dutch domestic scenes as well as many other subjects were designed to appeal to a woman's gaze at least as much as to a man's. That is, in conceiving female figures, Vermeer needed to include among his concerns (to paraphrase Gowing) the attention that woman pays to woman.[44] As a sup-porter of the Orthodox wing of the Reformed church, De Knuijt might have found particularly appealing the chaste dignity that informs Vermeer's interpre-tations of femininity.

When it came to the burgher household, Dutch scenes of ideal domesticity tended to identify its presiding spirit as female.[45] So we may partially explain Vermeer's focus on burgher women through their association with the clearly ordered spaces of an ideal home. Artistically, Vermeer felt comfortable with such spaces, with the perspective needed to construct them, and with the quiet demeanor expected of women. Encouragement by faithful, sympathetic patrons to explore domestic subjects no doubt nourished his artistic perfectionism as well as his sense of self.

Let us examine this relationship a little more closely. People such as Van Ruijven and De Knuijt required cultural symbols to help define their identity, and among those symbols, their paintings meant a great deal. So the link between them and Vermeer would have involved a sharing of respective visions. An artist well equipped to provide appropriate symbols needed to stand on familiar ground with his elite audience. But on what social ground did Vermeer stand? It has been especially difficult to identify his position in Delft society, because that position was atypical and unstable. He died young, and deeply in debt, but throughout much of his life he experienced upward mobility, and it is evident that he, too, placed importance on sociocultural status symbols. The image of a burgher woman at home and at leisure itself signified wealth.[46]

Yet another reason for Vermeer's focus on women may be found in the theo-retical notion that paintings of modern burgher subjects should reflect the artist's own world.[47] Vermeer led a relatively private life, and he painted private life almost exclusively, so we should not be surprised if his art engages his per-sonal circumstances in various ways. Keeping in mind his artistic project of exploring femininity, it seems reasonable to make some connections. The visible pregnancy of the woman holding a balance (Plate 15) inevitably reminds us of

the fact that his own wife was almost continually with child, giving birth fifteen times in twenty-two years of marriage. So, too, Vermeer's invocation of Marian associations here and in several other works seems bound up with his adoptive religion, Catholicism. And many items in his death inventory find close correspondences in his paintings.[48] Finally, returning to the *Art of Painting* (Plate 26), Vermeer's most fully articulated professional statement, we are reminded that although it *symbolizes* the significance that his artistic world held for him, to some extent it also *describes* that world. That is, the painter works alone before a model within an ostensibly domestic interior, which indeed corresponds to Vermeer's practice of painting at home without assistants or pupils. The girl looks like an amateur model at most, perhaps a neighbor posing as a favor or to make a little pin money. Still, it is unthinkable that Vermeer's upstairs studio – or even a more formal ground-floor room – was as luxurious as the one described in the painting; the richness of the decor, like the painter's costume, is largely rhetorical in nature, meant to dignify the artist's profession.[49]

It is nonetheless significant that some of the salient themes in Vermeer's biography overlap with those of his paintings. Vermeer's marriage, outside his family's religion and social class, was exceptional. It entailed a move from the lower, artisan class of his Reformed parents to the higher social stratum of his Catholic in-laws, and from Delft's Market Square to its "Papists' Corner," the Catholic quarter in the city. Vermeer lived with his wife Catharina Bolnes, and eventually many children, in the house of her strong-willed mother Maria Thins; it was what we might describe as a matriarchal household. The theme of female autonomy, which Gowing stressed, is conceivably linked to this fact.

Vermeer's situation was unusual, in that very few married men in The Netherlands lived with a parent or parent-in-law for an extended period of time.[50] But the house was substantial. Indeed Maria Thins, although a divorced woman, had a handsome income, and in her words, she "frequented in a familiar way and had good acquaintance with" highborn people.[51] Vermeer's own mother continued to run the family's nearby inn after her husband's death, but the artist must have deemed it an unsuitable place to paint and to raise a family.

Women and social class, then, are recurring themes in Vermeer's biography, just as they are in his art. As early as 1655, there are hints that he had achieved some degree of social standing. That is, only two years after he joined the guild, when he had little income or fame, he was referred to in a document as "S[r] [Seigneur] Johannes Reijnersz. Vermeer, master painter." The S[r] indicates his rise in social status. His higher-born mother-in-law and his wife were already referred to with the high-class title *Juffrouw*, so possibly the S[r] was an extension of the honor bestowed on them, as the social historian Donald Haks has surmised.[52] Later, in the artist's death inventory, we find listed "a drawn coat of arms of . . . S[r] Vermeer, with a black frame." Did Vermeer invent these heraldic bearings to match the legitimate arms belonging to his wife's family, as Haks suggests?[53] If so, that would count as one of several instances in which the painter relied on his wife's and his in-laws' social distinction for his own.

Further, the financial assistance of his mother-in-law Maria Thins was crucial. Vermeer could not have supported his family by employing the painstaking methods that one can deduce from both the quality and rarity of his paintings; he would have had to work faster, produce in greater quantity, and market his output more aggressively. At the same time, by becoming "man of the house" as well as a notable artist, Vermeer added to the respectability of Catharina Bolnes and her mother. It is worth adding that his sole sibling, an older sister, maintained ties with him until the end of her life, as did her frame-maker husband. In other words, a pattern of biographical facts raises the question of whether Vermeer's personal relationships nourished the respectful interest in women that so strongly characterizes his art.

Vermeer's early predilection for the female figure; the growing market for pleasing images of youthful femininity; the identification of high-class burgher households with women in Dutch paintings of domestic life, and the aesthetic appeal to Vermeer of ordered, sunlit spaces associated with such households; the likely attraction of those subjects to women such as Maria de Knuijt, whose husband set out to build a choice collection of modern subjects painted by living masters associated with Delft: this combination of factors makes Vermeer's attention to women in his art easier to understand.

The conditions of the painter's life nevertheless produced considerable strain. The testimony of his widow concerning the cause of his early death is dramatic: worrying about his inability to sell his art in a poor market, lacking "any means of his own," and charged with the support of so many children, the artist fell into a frenzy, from which he quickly died.[54] It is perhaps no mere coincidence that Van Ruijven had died the year before. And indeed, Vermeer's paintings reveal the tight control that he asserted in transforming real life into transcendent art. Sometimes tensions in his paintings seem to emerge from that impulse. Consider, for example, the posture of the model in the *Art of Painting* (Plate 26): standing in profile to keep the trumpet parallel to the picture plane, she uncomfortably turns her head to make it fit the sharp right angle of the map's internal border. One cannot escape the impression of her servitude to the rigors of Vermeer's sense of design. But the artist's perspective shifts from one painting to the next. Does he not, after all, present as an alter ego the gentleman in his scene of music making, who is captive to and dependent upon a woman? In the poetic tradition, the theme of a gentleman's amorous enthrallment to a lady – his utter need for her, his whole self-definition through her – was well understood as a fiction. Yet in Vermeer's painting, which so concretely describes that situation, the sincerity seems real.

The *Art of Painting* (Plate 26), the *Woman Holding a Balance* (Plate 15), the *Officer and a Laughing Girl* (Plate 6), and *The Music Lesson* (Plate 17) offer a few of Vermeer's perspectives on women, women who are always, at the same time, artistic constructions: "female figures." By their very nature, they are also ideological constructions. Vermeer's women do not challenge gender stereotypes in any obvious ways, and this no doubt contributes to the timeless feel of his

images. Yet the depiction of anonymous, burgher women within domestic interiors, such as Vermeer and a small contingent of his fellow Dutch painters produced, represents a novelty in European art of the period. The phenomenon was in fact dependent on unfolding and sometimes highly fraught social realities, which need to be studied in greater detail.[55] Vermeer's versions of womanhood subtly register complex social forces, but they often do so by countering gender instabilities: recall the *Woman Holding a Balance* (Plate 15), with its perfect formal equilibrium, and its theme to match.

Imaginatively positioning himself in relation to women, Vermeer opens up perspectives on himself. We see this in the way he integrates his own belongings – and by extension, I think, his longings – into the scenes he invents. To encompass such references, Gowing wrote of Vermeer contriving, "almost secretly, his own mythology."[56] "Secret mythology": as good a term as we are likely to find for Vermeer's stories in paint about certain kinds of women, and about himself, as a hidden yet ever present participant in the vision of the world thus evoked.

5 The Landscape on the Wall in Vermeer

Elise Goodman

Vermeer is the most enigmatic of painters. It is difficult to be altogether certain about his iconographic intentions, although it is evident that he had intellectually demanding programs. Little interpretive help is provided by his contemporaries. The few seventeenth-century references to his pictures are cursory and iconographically unenlightening; thus the complex *Guitar Player* (Plate 34) was described merely as "A person playing a cittern" and "A lady playing on a guitar. . . ."[1] The difficulties in understanding the meaning of Vermeer's work stem mainly from his intriguingly subtle and lyrical approach to his subjects; Arthur Wheelock rightly characterizes it as "poetic" rather than "narrative."[2] And poetically allusive rather than factually assertive our interpretations must be.

My concern here is with the landscapes depicted on the walls of his paintings, specifically *The Glass of Wine* (Plate 9), *The Love Letter* (Plate 29), *The Guitar Player* (Plate 34), *A Lady Standing at the Virginal* (Plate 33), and *The Concert* (Plate 20), inset pictures that are integral elements of the tableaux themselves. Recent art-historical scholarship has demonstrated that the enframed figural paintings and maps placed in the paintings relate iconographically to the scenes transpiring in front of them.[3] The landscapes hung on the walls, however, have escaped discussion, presumably because they have been seen as decorative fillers, paintings merely imitative of the style of contemporaneous pictorial landscapes,[4] rather than as iconographically charged emblems that contribute to and expand on the meanings of the pictures. If the other paintings on the wall have meaning, then why should not the landscapes?

Their symbolism becomes apparent when one examines their analogues in literary landscapes, specifically some of the kind appearing in period love lyrics that were set to musical accompaniment. I believe that the meaning of the enframed landscapes lies in what I take to be the artist's major and "poetic" theme, the celebration of love and beauty.[5] Their contexts can be established in some manner by love songs (called airs in the seventeenth century) and love poems, and by the courtesy literature of the period. Vermeer provided subtle clues to the meaning of his inset pictures by the fashionable performers with

their musical instruments he placed in several of his paintings. Vermeer's land-
scapes are "poetic," and even "melodic," in a very direct sense, paralleling and
perhaps imitating, as they do, the natural landscapes in many contemporaneous
lyrics and songs that dealt with wooing, courtship, and beauty.

Vermeer's prominent characters represent the kind of people who would
have known the musical lyrics through Dutch, French, and even English song-
books and part-music. The performers who appear in the paintings are members
of the haute bourgeoisie, people who read, wrote, and often spoke several lan-
guages and who collected European poetry in which the latest love conventions
appeared.[6] Although we know nothing about the specific ways in which Vermeer
himself was stimulated, since we have no information about his literary and
musical predilections, the enframed landscapes (and inset emblematic figural
paintings) show that he was sensitive to what was in his air. Many of the topoi
to which he alludes also occur in multilingual expository verses appended to the
amatory emblems with which he must have been familiar.[7] His paintings in gen-
eral betray a knowledge of musical instruments and point to his interest in and
fascination with the musical scene of his day.

For fully assessing this scene, we must realize the European, particularly
French-oriented, climate of the Holland of Vermeer's time. It has recently been
demonstrated that the entire range of ideas about nature expressed in Nether-
landish literature of the Baroque stemmed from landscape conventions in
French lyrics of the sixteenth and the seventeenth centuries.[8] It was to France
that the Dutch, from the nobility down to the middle class, turned, not only for
literary but also for musical models.[9] Because Dutch music was mostly uninven-
tive and undistinguished, Dutch songbooks contained as many French as native
airs.[10] Amateur musicians of the kind depicted in many of Vermeer's paintings
collected these. For example, Gesina ter Borch, the sister of the famous genre
painter Gerard, whom Vermeer knew, owned at least one book of keyboard
music (ca. 1661) with several French tunes.[11] Other Dutch songbooks that fea-
tured the *gezelschapslied* (a social lyric set to musical accompaniment) con-
tained French, and to a lesser degree, English and Italian pieces.[12] The most
popular songbooks in Holland were filled with French love lyrics, and the Dutch
burghers took to them with a passion.

The ultimate inspiration for Dutch lyrics, and for European love poetry in
general, came of course from Petrarch.[13] Dutch poets were deeply influenced
by Petrarchan conventions of nature and love, which reached them via the
French Pléiade (a prominent group of sixteenth-century French poets) and
their contemporaries. The better-known Dutch writers such as Pieter Cor-
nelisz. Hooft, Constantijn Huygens, Daniel Heinsius, and Joost van den Vondel
were nourished in France on Petrarch, Pierre de Ronsard (1524–85), Joachim
du Bellay (ca. 1525–60), and Philippe Desportes (1546–1606).[14] Huygens
(1596–1687), a talented composer of songs as well as lyric poems, imported to
his native country some of the latest French Petrarchan airs for musical accom-
paniment on the lute and harpsichord.[15] And nonprofessional Dutch poets and

Fig. 26. Detail of Plate 9.

amateur musicians sometimes composed their own Petrarchan-style lyrics in French.

The pictures on Vermeer's walls emphasize the amorous themes of the paintings themselves and their varying mood and tone. In the relatively early *The Glass of Wine* (Plate 9), the relationship appears fairly simple and the touch light. The wooded landscape in the style of Allart van Everdingen (1621–75), which hangs conspicuously on the wall behind and to the left of the couple in the room (Fig. 26), is emblematic of their amorous connection, which is suggested with delicacy and subtlety. In the painting itself, the elegant cavalier's gallant intention is alluded to by his intense gaze at the lady, for whom he is about to pour another glass of wine. A preceding music making, presumably for the purpose of wooing, is hinted at by the songbooks on the table and by the cittern on the chair, which we may assume to have been used by the gentleman to serenade the young woman. He may be thought to have intoned a love song, perhaps like one of Hooft's, whose lyrics in the tradition of Petrarch and De Ronsard were often set to musical accompaniment. Some of these lyrics

appeared in Hooft's noted *Emblemata Amatoria* (Emblems of Love), which has been drawn upon for interpreting the symbolism of Dutch genre paintings by other scholars.[16] To our purpose, Hooft warbles seductively:

> But one should ask what the singing means,
> This wistful tune that charms:
> It aims by these fanciful strains
> To lure into mine arms
> That one whose gentle waxen hands can mould
> My hot and melting heart, which they enfold.[17]

In *The Glass of Wine* (Plate 9) all the orthogonals in Vermeer's linear perspective system significantly converge in the area of the landscape on the wall. It reinforces the delicate scene of the amorous proposition in the painting itself quite in the manner of many seventeenth-century literary landscapes. If it is exceptionally dark, it is perhaps because Vermeer wished to allude to the privacy of love. "Love's shadows are so rich in joy," as Shakespeare has it. But not only joy. Landscapes in literature could be settings for innocent amorous dalliance as well as physical delights. In contemporaneous love poems, such as Joost van den Vondel's "Koridon" (1665), a swain persuades his lady to seize the moment and accompany him to the forest, where he may kiss her mouth, cheeks, and ear with fond desire: "Through love will grow / The tree and bushes."[18] A similarly seductive carpe diem melody is entoned in an *air de cour* – a lyrical melody whose major subject was love – for voice and lute accompaniment in *Het luitboek van Thysius* (The Lute Book of Thysius), published in Amsterdam in 1620. An eager lover here bids his belle to go to the "sacred shades" and recline on the grass while their young spring lasts.[19] Likewise, but more explicitly, Hooft exhorts his Rosemund to join the carnival of nature, which "is straightway roused to full-blooded love-making."[20] We may well imagine Vermeer's cavalier, already dressed in his cape and hat, to be intent on departing to a grove that will shelter his amour. But the darkness of the landscape behind him may well be a danger signal for his beloved; the carpe diem may become a *carpe florem*. That Vermeer intended at least lightly to caution the pair against immoderate behavior is indicated by the coat of arms on the partially opened window at the left. It is primarily an indication of the high status of the elegant couple in the room, but it also contains a vague figure of a woman with a bridle in her hand, apparently the figure of Temperance, an emblem of moderation and a warning signal against excess.[21] The short diagonal of the window containing the personification of Temperantia leads directly back to the enframed painting with its lush, seductive scenery, suggesting the need to react moderately to the call of nature's delights, no matter how beguiling.

The mood is no less lyrical, but it appears to have a nostalgic rather than an anticipatory thrust in the two paintings on the wall of *The Love Letter* (Plate 29). A solitary wanderer appears in the idyllic landscape in the mode of Adriaen van de Velde (1636–72) hung above a seascape with a ship (Fig. 27). The wanderer in the forest forms a vertical with the female lutenist below in Vermeer's painting

Fig. 27. Detail of Plate 29.

itself. This arrangement probably reflects the double motif of the separation of lovers and their desire for reunion. Vermeer seems to have portrayed their relationship through the topos, widespread in poetry and songs, of the exiled lover who confides to nature his wish to return to his lady. In love lyrics of the Petrarchan tradition and in the lute songs they inspired, nature was depicted as a sympathetic witness to the lover's pains and hopes during his absence from the beloved. This motif of the exiled suitor's sufferings in nature (about which an entire book has been written)[22] appeared, for example, in Constantijn Huygens's air for solo voice and lute entablature, published in the *Pathodia Sacra et Profana* (Sacred and Profane Songs of Suffering) of 1647:

> Grave witnesses of my delights,
> Bushy oaks, lovely precipices,
> For so many summers,
> Jealous and proud of my happiness.
> .
> Do not expect me any longer to go
> Anywhere except where Love beckons me . . .[23]

In a similar melancholy tenor, the exiled lover in Hooft's "Sang" (1612) intones his frustrations:

Does anyone wonder who makes my voice ring?
'Tis one without whose grace
No impulse within my frame grows strong,
For whom my voice I raise
Till the level sands and the streams around
And the hills reverberate and resound.[24]

The theme of absence and the desire for reunion is underscored by the seascape below the solitary peregrinator. As art historians have noted, the ship in the picture is associated with the emblematic motif of the suitor as a ship on the sea of love searching for the safe harbor of his lady's arms. Jan Harmensz. Krul's emblem (Fig. 28), which has been connected to *The Love Letter* (Plate 29), is superscribed by a motto that reinforces the theme of exile from love: "Even Though You Are Far Away, You Are Never Out of My Heart."[25] Vermeer supports the topos by the letter, presumably a love letter, that has been delivered to the lady with the lute.

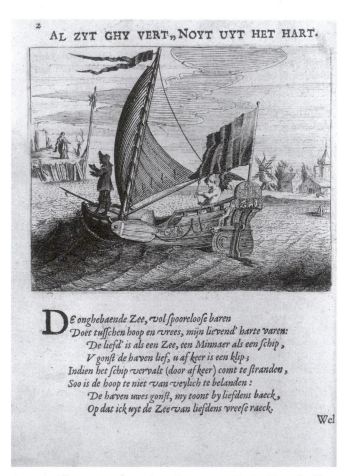

Fig. 28. Illustration from Jan Harmensz. Krul, *Minnebeelden: toe-ghepast de lievende ionckheyt*, Amsterdam, 1634. Washington, D.C., Folger Shakespeare Library. Photo: courtesy Folger Shakespeare Library.

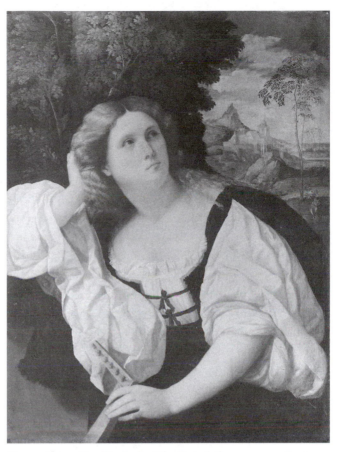

Fig. 29. Palma Vecchio, *Lady with a Lute* (oil on canvas, 96.5 × 73.7 cm). Alnwick, Alnwick Castle, Collection of the Duke of Northumberland. Photo: Country Life Picture Library.

The slightly later *Guitar Player* (Plate 34) ingeniously uses another theme, celebratory rather than nostalgic. It may be called the construct of the "lady and the landscape," which was a popular, international convention for glorifying female beauty in seventeenth-century paintings, prints, and literature. In its design using a female musician seated in front of an idyllic landscape, it was not new in painting, appearing, for instance, in Palma Vecchio's *Lady with a Lute* of the early 1520s (Fig. 29).[26] Since Vermeer was reputed to be a connoisseur of Italian art, particularly Venetian art, he may have known this iconographic type through similar pictures in the Dutch art market. As A. B. de Vries noted, "Italian models, in particular those of the Venetian School, were directly accessible to the young Vermeer,"[27] and the facture of such an early work as his *Diana and Her Companions* (Plate 3) betrays indeed his knowledge of the painterly Venetian technique. Like Palma's lutenist, Vermeer's guitar player sits in front of an idyllic pastoral landscape fashioned asymmetrically. Both women are similarly protected by the leafy foliage that rises above their heads. That Palma's lady gazes in reverie off to the right while Vermeer's musician is distracted by something or someone at the left is only a minor difference.

The Guitar Player (Plate 34) also recalls French engravings of modes and manners of the 1630s that depict a lutenist in front of a garden, field, or park. Two examples of the genre are an anonymous print of 1630[28] and another entitled *Omnia vincit Amor nec Musica vincit Amorem* (Love Conquers All but Music Does Not Conquer Love; Fig. 30), designed by the expatriot Fleming Pieter van Mol (1599–1650), engraved by the popular French master Charles David (ca. 1600–36), and published by the prolific Jean I[er] Leblond.[29] The *Omnia vincit Amor* (Love Conquers All) recalls particularly Vermeer's composition: both open-mouthed musicians are placed on a diagonal in the foreground of a shallow space; they are flanked by a table with a book or books. In the French engraving, this space is a balcony separated from the garden and landscape by a drapery, while in the Vermeer, the area is a room with a curtain at the right. With consummate skill, Vermeer distilled the landscape into the painting hung deliberately and directly behind the musician's head; he related it visually

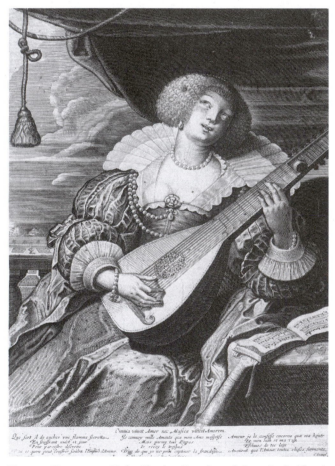

Fig. 30. Pieter van Mol, Charles David, and Jean Ier Leblond, *Omnia vincit Amor nec Musica vincit Amorem*. Paris, Bibliothèque Nationale, Département des Estampes. Photo: cliché Bibliothèque Nationale de France.

Fig. 31. Detail of Plate 34.

to and made it reflect her beauty (Fig. 31). The landscape seems lovingly to con-
tinue and recapitulate her brown hair: the rightward tilt of her head and her
ringlets are suggestively restated in the arching foliate branches of the tree
above her. As Lawrence Gowing puts it, "her bell-like shape is compared with
the round head of a tree against the sky, painted in the style of Wynants behind
her."[30] Her music weaves, as it were, a civilizing magic into plain and forest. She
may be thought to recall a beautiful guitarist named Uranie in an air for guitar
entablature of 1629, whose "divine voice animates these fields and these
woods."[31] The baroque guitar held by Vermeer's musician is a piece of fashion-
able accoutrement for this purpose; in the later seventeenth century it was
rapidly supplanting the lute as the most popular solo instrument to accompany a
singer.[32]

 The general subject of *The Guitar Player* (Plate 34) is also paralleled in *Jouis-
sance* (Pleasurable), Countryhouse, and Promenade lyrics of the period, in
which poets delicately intertwined the woman with features of her natural envi-
ronment, thereby heightening her attractiveness and intimating that she reflects

and even produces the beauty of the landscape. At times she turns into a metaphorical tree or a verdant meadow. This metamorphosis was popular in English and French literature of the sixteenth and the seventeenth centuries.[33] It also appeared in the Dutch poems and songs of Hooft, Huygens, and Vondel, all of whom lived abroad and were greatly influenced by European literary trends.[34] In a spirit similar to Vermeer, Nicholas Hookes in 1653 poeticized the effects of his Amanda's beauty on the tree under which she sits: "The broad-leav'd *Sycomore,* and ev'ry tree / Shakes like the trembling *Aspe,* and bends to thee, / And each leaf proudly strives with fresher aire, / To fan the curled tresses of thy hair . . ."[35]

In fact, female arborescence, as we may call it, was an international convention of the period and appeared in several courtesy books. It is discussed in André du Chesne's *Figures mystiques du riche et precieux cabinet des dames . . .* (Mystical Figures of the Rich and Precious Cabinet of Ladies; Paris, 1605). Here woman is the epitome of nature, metaphorized as the Tree of Life that assimilates all the perfections and virtues of the other plants. The sweetest charms of earthly love find refuge under the shady foliage of her womanhood.[36] Jacques Corbin's panegyric *La royne Marguerite* (Queen Margaret) asserts hyperbolically in the tradition of the biblical book the *Song of Solomon* that the lady is higher than an alder tree, more noble than an apple tree, and lovelier to behold than the highest plane tree.[37] Abraham Darcie, in his *Honour of Ladies* (London, 1622), generalizes that the comeliness of women "remains as a Character and patterne, which makes it exteriorly known, as the beauty of blossomes of Trees bear witnesse of the Goodnesse of the fruit which grows thereof."[38]

The ubiquitous idea that the lady was the "masterpiece of nature," to be admired, possessed, and displayed, appeared in countless poems, songs, and tracts on beautiful women in the seventeenth century. From the Chevalier de l'Escale's *Le champion des femmes* (The Champion of Women) through the Sieur de Saint-Gabriel's *Le mérite des dames* (The Merit of Ladies) to Constantijn Huygens's "Sur le portraict" (On the Portrait; 1673), the ideal woman was variously labeled the masterpiece and miracle of nature and the ornament of the earth.[39]

This motif also manifested itself in the attempts to portray trendsetting women in many prints of the period. In Crispijn de Passe II's famous book of fashions, *Les vrais pourtraits de quelques unes des plus grandes dames de la Chrestienté, desguisées en bergères* (True Portraits of Some of the Grandest Ladies of Christendom, Disguised as Shepherdesses), a lovely princess of Poland, cryptically named "Bova P. P.," who stands before a pastoral landscape (Fig. 32), is lauded as "Un miracle de nature" (A Miracle of Nature).[40] Wenceslaus Hollar's etchings of young women personifying Spring (London, 1641, 1644), who are placed in a room overlooking a formal garden, are hailed respectively as nature's "cheefe" and "Natures Darling."[41] Using the same baroque poetic convention of the comparison of the lady's beauty to that of nature, the subscribed verses of Jeremias Falck's and Jean I[er] Leblond's *L'Atouchement/May* (Touch/May), part of an allegorical series of the senses and months, claim that

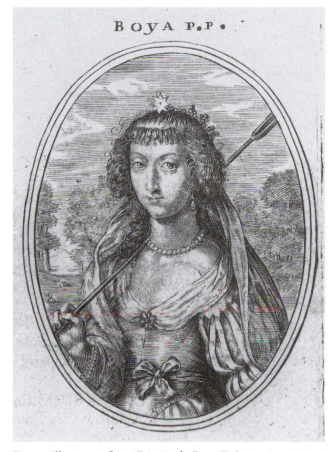

Fig. 32. Illustration from Crispijn de Passe II, *Les vrais pourtraits de quelques unes des plus grandes dames de la Chrestienté, desguisées en bergères,* Amsterdam, 1640. Washington, D.C., Folger Shakespeare Library. Photo: courtesy Folger Shakespeare Library.

the luster of the earth cannot compare to the least splendor of the fecund beauty of the woman in front of it.[42]

The theme of the epitomization of nature in women was a common feature of French allegorical engravings of female musicians in front of landscapes, fashioned in the 1630s and 1640s. For example, the four-line poem of *Adolessence* (Fig. 33), engraved by Jean Humbelot and published by Jean I[er] Leblond, asserts hyperbolically that the earth becomes barren or fertile according to whether the musician's face is sad or amiable.[43] In a similar tenor, the lovely lutenist's playing and singing in Falck's and Leblond's *L'Ouye/Avril* (Hearing/April) animate the nerves of the forest that she enchants and cause the trees to change their leaves into ears in order to hear her.[44] Imaginatively employing what the noted literary critic J. B. Leishman called the "pastoral hyperbole," Vermeer, engravers, and their near contemporary, the renowned Flemish portraitist Anthony van Dyck (1599–1641), eloquently paid homage to beautiful women by alleging that they wielded a magical power over nature.[45]

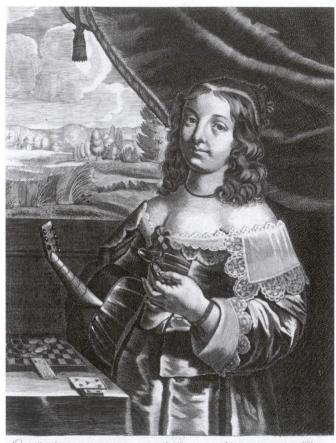

Fig. 33. Jean Humbelot and Jean Ier Leblond, *Adolessence*. Paris,
Bibliothèque Nationale, Département des Estampes. Photo: cliché
Bibliothèque Nationale de France.

The hitherto undiscussed arcadian landscape in the manner of Jan Wijnants
(ca. 1631–84) on the wall of Vermeer's late *Lady Standing at the Virginal* (Plate
33) also projects a female musician's beauty into nature, adding to the theme of
ideal beauty the acclaim of ideal love. As in *The Guitar Player* (Plate 34), the
painter sets up analogies between the virginal player and the pastoral landscape
behind her. Like her body, the landscape is formed with gently curving contours;
the blue sky, white clouds, and yellowish brown tones of the earth are in some
measure restated in the corresponding three layers of her dress. Her projecting
chignon is reflected in the outcropping at the summit of the hill. As specialists
have noted, the enframed Cupid holding the card aloft above the musician's
head almost certainly embodies the emblematic concept of pure and faithful
love, since the motif is based on the emblem with the motto "Perfectus Amor
non est nisi ad unum" (Love is not perfect except to one) in Otto van Veen's
Amorum Emblemata (Emblems of Love; 1608).[46] The arcadian landscape next to
the inset figural painting can be read as an extended metaphor for the lady's

beauty, symbolizing her innocence, as nature often does in contemporaneous poetry and music.[47] Lawrence Gowing has noted that the rocky landscape on the virginal lid supports this concept by underscoring the "challenging" female nature of its player.[48] At any rate, the nature iconography does not appear to have the complexity of the previously discussed paintings.

By contrast, the two landscapes in *The Concert* (Plate 20) are the most enigmatic examples of inset landscapes in Vermeer's pictures. I have lifted *The Concert* out of its chronological sequence as a mature work in the artist's oeuvre to discuss it last because it presents a particularly challenging task to the iconographer. The problem of interpretation is created by the difficulty of relating the different components of the painting to one another. It is not merely a matter of tracing the connection between the musicians in the room and the wall painting of the landscape at the left but also of relating these elements to the landscape on the harpsichord lid and most of all to the genre scene on the right wall. Interpretations have generally seen the crux here, and we must begin with the latter relationship. This genre scene (Fig. 34) is a reduced replica of Dirck van Baburen's (ca. 1595–1624) *The Procuress* (Fig. 5). *The Procuress* evidently had a special significance for Vermeer since he owned it and used it again in *A Lady Seated at the Virginal* (Plate 35).[49]

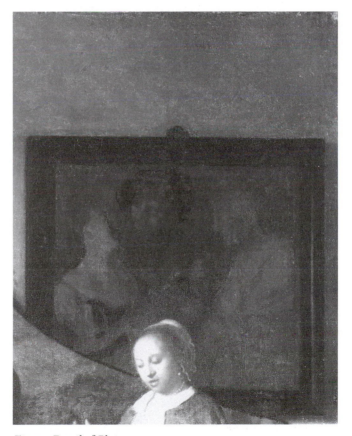

Fig. 34. Detail of Plate 20.

Because the compositional arrangement of Van Baburen's painting parallels
that of Vermeer's group in the room, some scholars have claimed that the sub-
ject of *The Concert* (Plate 20) is an elegant brothel scene. Then the older
singing woman at the right would be the procuress; the male lutenist in the cen-
ter, a client; the lovely harpsichordist at the left a courtesan.[50] However, others
have contradicted this interpretation; rightly, to my mind, they have seen a con-
trast between the group's decorous and concentrated music making and the
licentiousness of the procuress scene above.[51] Ignacio Moreno suggests that
what we see is a domestic interior that provides a setting for the amateurs per-
forming their music. So far, so good. But Moreno is hardly correct in reading
the older singer at the right who raises her hand as an emblem of temperance.
He believes that she is an amalgam of a musical and moral conductor, guiding
the younger musicians not only in keeping time but also in staying on the path
of virtuous moderation. By parallel and contrast, the procuress on the wall is
then a leader toward temptation and vice.[52] But Moreno's explication of the
singer's gesture is not supported by the musical practices of Vermeer's time. Two
trained musicians, neither then nor now, require no conductor to set the pace
for an informal performance. Rather, it is more likely that the singer is merely
underscoring the expressive effects of the text of her song, which she probably
sight-reads; it is an informal copy, probably written for her by the lutenist.[53]

I, too, believe that Vermeer's mixed group of musicians presents a scene of
nonvenal devotion to the pleasures of love, and that he included *The Procuress*
in order to hint at a contrast with the cruder, venal species, but with subtle allu-
siveness rather than heavy-handed, demonstrative gesture. Gentility and good
manners rather than meretriciousness predominate in the painting itself, but
love as a socialized and civilized entertainment is in the air. The performers are
affluent and observe upper-bourgeois decorum in their richly arrayed room. The
male lutenist in the center wears a sword, the well-known attribute of a gentle-
man. The Flemish harpsichord, probably manufactured by the famous Ruckers
family in Antwerp, which the young woman plays, was found only in the draw-
ing rooms of the very wealthy during Vermeer's time.[54] Because of the presence
of the particular musical instruments and the female singer at the right, we may
assume that Vermeer's group is performing a standard seventeenth-century
chamber piece for voice and musical accompaniment. The harpsichord, viola da
gamba, lute, and cittern, all displayed in Vermeer's room, are designed to
accompany the singer, probably a soprano. She must be thought to entone what
was called an *air de cour,* a lyrical melody whose major subject was love.[55]

In *The Concert* (Plate 20), as in *The Glass of Wine* (Plate 9), *The Love Letter*
(Plate 29), and *The Guitar Player* (Plate 34), nature is again associated with this
celebration of affection and beauty. As specialists have noted, the landscape on
the harpsichord, with which the lutenist's head is juxtaposed, is arcadian and
peaceful. In contemporaneous amatory poems and songs for chamber perfor-
mance, a calm, pastoral landscape often stimulates a gallant to enter it so as to
guide his beloved through nature. In Hooft's lyric "Rosemund, hoordij speelen

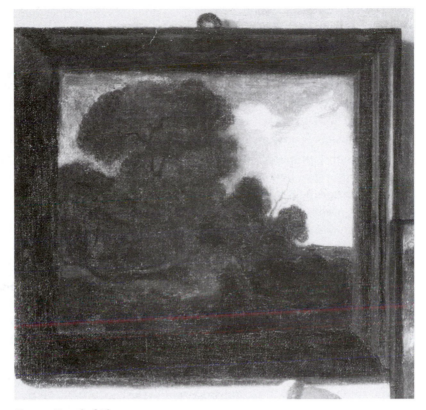

Fig. 35. Detail of Plate 20.

noch singen?" (Rosemund, do you hear neither playing nor song?; 1621) and the
airs de cour "Aminte approche-toy de ce plaisant boccage" (Aminte, approach
this pleasant grove) and "Bois, ruisseaux, aymable verdure, lieu charmant &
délicieux," (Woods, brooks, pleasant greenery, charming and delicate place), dat-
ing respectively to 1661 and 1662, a gentleman persuades his lady to enter the
pastoral setting to taste the sweet pleasures of love.[56] Such an amorous prome-
nade is depicted on the lid of the virginal in Jan Miense Molenaer's (ca.
1610–68) *Interior with a Lady at the Virginal* (ca. 1640; Amsterdam, Rijksmu-
seum).[57] Vermeer, typically, is not as direct and obtrusive as Molenaer, who on
the lid of the virginal most likely alludes to an amorous liaison between his
female musician and his eager cavalier, who enters her room through a door
behind her. Undoubtedly, like the similarly dressed couple painted on the lid of
the musical instrument, the pair in the room will eventually join hands on a
promenade amoureuse. But the mere allusion to an idyllic landscape on the
harpsichord lid of *The Concert* (Plate 20) very likely directed the seventeenth-
century viewer to make an association between the lutenist and the harpsichord
player, both of whom are seated, in contrast to the older, standing performer at
the right. They are engaged, as it were, in a duet of love.

The rugged enframed landscape above the harpsichordist's head (Fig. 35)
appears to relate to her alone, and seems of the woman-as-masterpiece type.

During Vermeer's time composers frequently opposed somber landscapes to the gentle beauty of their ladies. Thus Hooft's "Natuur, die daar schijnt in droeve damp begraven" (Nature, which seems to be buried in a sad cloud over there) entones the difference between dismal nature and the glow of a beautiful woman who gave it its richest gifts. Further, Jean Boyer's air "Sombres forests, noires vallées" (Somber forests, dark valleys; 1621) in a similar tenor asserts that "This sun whom I love so well, / Has so much beauty and grace, / Than [that which is] absent from your divine face" [that is, from the landscape].[58] In other lyrics, the lady's presence "can civilize the rudest place" and imparts order and beauty to nature.[59] Reversely, love poets and composers were wont to compare their ladies' hardness and lack of feeling to the woods and craggy rocks.[60] Altogether, the modes of the inset landscapes and their placement in *The Concert* may be taken to indicate the cavalier's honorable intentions and the decorous character of the harpsichordist next to him; its subject, I believe, is domesticized, civilized, and civilizing love.

Vermeer's enframed pictures of nature, as I have argued, should be paralleled and compared with musical pieces about landscapes that his performers may be thought to be playing. The insets furnish some clues to the general meaning of the paintings themselves and they help us to better understand their themes of love and beauty. Like the versifiers and composers of the seventeenth century, Vermeer uses landscapes anthropocentrically and gives them social and amorous overtones. As in period songs and lyrics, nature is conventionalized and reconstituted in a closed room and is brought into rapport with good society, ringing variations on courtship and love.[61] Macrocosmic nature does not contain human nature; rather, the desires and emotions of the human microcosm create the macrocosmic evocations within the enframed works of art. Vermeer varied and modulated his landscapes on the walls in his paintings to suit the nature and mood of the human drama he portrayed in the foreground.

6 Vermeer on the Question of Love

H. Rodney Nevitt Jr.

Elegant young men and women converse, drink, or play music together in domestic settings. Alone in their rooms, other women play musical instruments. Still others receive, read, or write letters, either alone or in the company of their maidservants. The thoughts of all, it seems, turn to love. In this chapter, I relate such paintings by Vermeer to a variety of literature of the period: moralizing books, love poems, songbooks, guides to courting etiquette, plays, as well as the prose romances and collections of love stories that were becoming increasingly popular in The Netherlands during the seventeenth century. Several of these texts were printed in Vermeer's Delft but many more in the publishing center of Amsterdam. Most could have been known to Vermeer. Even those that postdate him by a few years, however, have something to say about the frame of reference that a contemporary audience likely brought to a viewing of his paintings.

The Turn to Narrative

The imagery of courtship in early seventeenth-century Dutch art is typified by Esaias van de Velde's (ca. 1590–1630) paintings of garden parties, for example, his *Party on a Terrace* of circa 1620 (Fig. 36), which descend from the iconography of the garden of love.[1] Similarly stylish, amorous youth populate the texts and illustrations in the books of love songs – many illustrated with prints of similar subjects – that had been eagerly consumed by Dutch young people since the beginning of the century, Delft's only example being the tiny volume *Delfs Cupidoos schighje* (Delft's Little Boat of Cupid) of 1652 (Fig. 37).[2] Songbooks played a conspicuous role in the social rituals of courtship, and musical themes are common in both the garden parties and Vermeer's paintings. Closer to Vermeer's time, the visual formulae change. By the 1630s, painters more often represented companies of youth in indoor settings, and there is a shift to focused compositions of two or three figures, or even a single figure, in contrast to the larger

groups in the garden parties. These trends converge in Gerard ter Borch's (1617–81) paintings of the 1650s, which were an important source for Vermeer's work in the next decade.

In terms of subject matter, representations of courtship form a continuous tradition. Like the garden parties, Vermeer's paintings were called "modern" pictures, that is, images of figures in contemporary dress.[3] The same words were used for the figures in his scenes, *juffers* and *jonkers* (ladies and gentlemen), which reflected their elegant dress and high social status.[4] Certain motifs continue. In Vermeer's *Girl with the Wine Glass* (Plate 13), the man, probably having just offered the woman the glass, bows graciously to steady her hand. The offer of wine as a prelude to love was a literary convention.[5] The other man seated at the table with his head in his hand has been seen either as overcome by the narcotic effects of smoking (a rolled paper of tobacco lies on the table) and wine (from the white ceramic pitcher), or as the rejected suitor who has lost the girl to the other man.[6] In fact, both are probably true, for these vices were thought typical of those suffering from lovesickness, which is his real malady.[7] Vermeer contrasts his unhappy state with the amorous exchange of the other figures. The lonely lover whose melancholy is intensified by the merrymaking of those around him is a recurring literary type and also appears in Van de Velde's *Party on a Terrace* (Fig. 36) in the form of the solitary pipe-smoking man on the right.[8] Vermeer's painting (Plate 13) sums up the story in a circuit of whites: the rolled paper of tobacco, the pitcher of wine, the tablecloth that overlaps the handkerchief in the young lady's lap, and finally, the man's right cuff, which encircles their touching hands.[9] She turns to us and laughs, nervously perhaps; as one Dutch poet of the time wrote, ". . . A sweet tongue, and a lovely laugh,/ Have more power [over men] than beauty's brilliance."[10]

<div align="center">✳ ✳ ✳</div>

The genre paintings that appeared in The Netherlands around midcentury, however, reshaped the imagery of courtship. Their more focused compositions bring us closer to Gerard de Lairesse's comment (1707) about finding "little dramas" in genre paintings that are comparable to the grand narratives of historical scenes.[11] Such qualities evoke plays and other prose texts like the romances and story collections, the number of which printed in The Netherlands increased markedly after about 1630, and especially from the 1640s through the 1660s.[12] Vermeer's reduction of the number of figures to three (Plate 13) encourages us to connect them into a narrative – a love triangle, in fact. More than the garden parties, the image then is reminiscent of stories like that from *De schouburg der verliefde* (The Theatre of the Lovestruck), which begins: "Once in Burgundy there were two young gentlemen who were in love with the same lady. . . ."[13] The plot that follows need not concern us. What is noteworthy is the capacity of prose texts, in contrast to songs and shorter poems, to develop characters (however stereotyped) and concentrate on their exchanges with each other. The

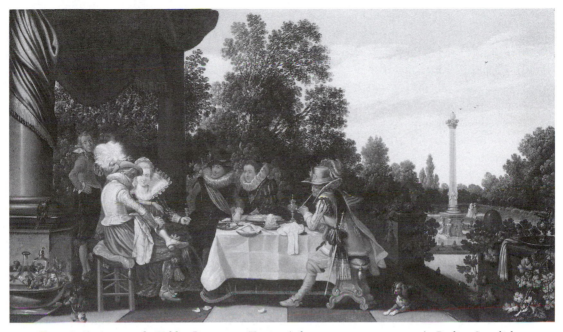

Fig. 36. Esaias van de Velde, *Party on a Terrace* (oil on canvas, 43 × 77 cm). Berlin, Staatliche Museen zu Berlin; Preußischer Kulturbesitz Gemäldegalerie. Photo: Jörg P. Anders.

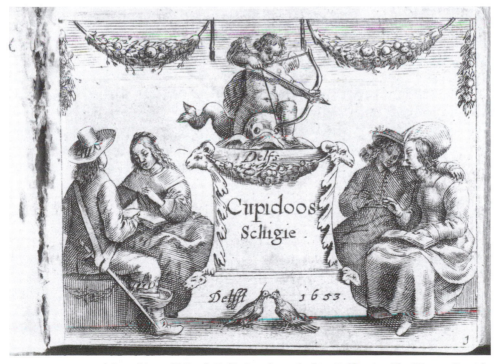

Fig. 37. Frontispiece from [Aernold Bon], *Delfs Cupidoos schighje,* Delft, 1652. The Hague, Koninklijke Bibliotheek. Photo: Koninklijke Bibliotheek.

engraved title page (Fig. 38) to Jean Puget de La Serre's novel of a young lady of the French court, translated into Dutch in 1641 as *De hoofse Clitie* (The Courtly Clitie), reflects the narrative focus of the text. Unlike songbook title pages with their generic couples (Fig. 37), this image tells a story: Clitie watches in distress as her lover walks off with another woman. Prose romances, like songbooks, were marketed to courting youth, though their actual readership was probably broader.[14] Perhaps the new mode of genre painting appealed to viewers who were increasingly attuned to conventions of narrative in images as well as in texts.

By juxtaposing the unhappy lover with the amorous pair (Plate 13), Vermeer constructs a fairly clear narrative, but other of his paintings are more enigmatic. His *Glass of Wine* (Plate 9) also includes the offer of wine. In a painting by Ter Borch of the same subject, the man touches the woman's shoulder affectionately as she drinks.[15] In Vermeer's scene, the presence of wine and musical instruments – the traditional accompaniments of love – suggests an amorous relationship between the figures, yet the lack of any emotional exchange between them also allows other readings.[16] Similarly, in *The Music Lesson* (Plate 17), the man listening to the woman play the virginal might be her music tutor (as the traditional title implies) or her suitor. In paintings by other Dutch artists, the theme of a man listening to a woman play music often took on a more forthrightly amatory tone.[17] Technical examination of Vermeer's painting shows that the man was initially closer to the woman; his repositioning leaves us with a less intimate pair.[18] Wine is again present in the white pitcher, but its spatial relationship to the two figures only indicates the interpretive problem. From our viewpoint, the pitcher seems to be juxtaposed with them, but within the "real" space of the room it is at a considerable distance. Both the inscription on the virginal (Music: Companion of Joy, Balm of Sorrow) and the painting to the right depicting the ancient theme of "Roman Charity" might or might not refer to matters of love.[19] Few of Vermeer's figures offer clues in facial expression or body language about the nature of their relationship to each other. The markers of love – music, wine, and the interaction among the figures – seem to be deliberately stretched, pulled apart, to precisely the point at which connecting them into a narrative of courtship becomes problematic.

The Ambiguities of Love

Vermeer's allusiveness is frequently bound up in pictures-within-the-picture that suggest meaning rather than determine it, or rather, deliver a range of possible meanings.[20] One example reads as a vestige of the garden party. As the imagery of courtship moves indoors, the outdoor setting, which had linked it to the garden of love with its amatory meanings, reappears in the form of landscape paintings hanging on the wall or adorning the lids of keyboard instruments.[21] Such

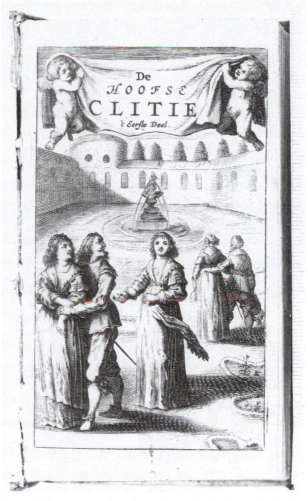

Fig. 38. Frontispiece from Jean Puget de La Serre, *De hoofse Clitie,* Amsterdam, 1641. The Hague, Koninklijke Bibliotheek. Photo: Koninklijke Bibliotheek.

instruments were, in fact, often decorated with landscapes because of the traditional association of love, music, and nature. In *The Concert* (Plate 20), the back of the gentleman's head surrounded by the landscape on the inner lid of the virginal eloquently figures his absorption into an imaginary image of nature. Yet a fictive landscape, if we accept the scene itself as "real," is in some sense an accidental presence, its iconographic significance in relation to the theme of the picture a matter of artifice. It thereby calls attention to the artifice of the larger painting of which it is a part, somewhat like the leg of Vermeer's easel in the mirror in *The Music Lesson* (Plate 17). Both point outside the world of the painting and imply that some aspect of its meaning lies in the interpreting eye of its audience.

The Concert (Plate 20) includes another picture-within-the-picture, Dirck

van Baburen's (ca. 1595–1624) *The Procuress* (Fig. 5), hanging on the wall to the right, a painting once owned by Vermeer's mother-in-law, which shows a prostitute playing a lute; a man offers her a coin while the old procuress demands payment. (Vermeer also included the painting in his *Lady Seated at the Virginal*, Plate 35.) One critic has maintained that the presence of Van Baburen's painting in *The Concert* means that Vermeer's scene is a high-class brothel.[22] Others have argued that Vermeer opposes Van Baburen's bawdy scene of venal love to the proper courtship of his own figures.[23] It seems unlikely that Vermeer's refined and dignified group is enacting a scene of prostitution. On the other hand, must such qualities be taken as evidence of their virtue? La Serre's *Clitie*, for example, is a model of social grace but certainly no moral paragon. At one point in the novel, we read of a musical company consisting of Clitie, a man, and another woman, a situation reminiscent of Vermeer's *Concert*. The man, however, is Clitie's extramarital lover.[24] Perhaps Vermeer is drawing neither a contrast nor an equation with Van Baburen's figures but a whimsical analogy along the lines of Jacob Westerbaen's remark in his *Avond-school voor vryers en vrysters* (Evening-School for Courting Men and Women) that women should learn to sing to attract men, for "The voice has served for some as a *koppelaer* (matchmaker)."[25] (Westerbaen's text is one of the *vryerijboeken,* or "courtship books," adapted from Ovid's *Art of Love* that served as etiquette guides for courting youth.)[26] *Koppelaer* was also a common euphemism for a procurer of sexual liaisons: in fact, its feminine form was used in reference to Van Baburen's painting in the seventeenth century.[27] Without an adequate context, the word, like Vermeer's citation of Van Baburen, leaves more questions than answers.

Ambiguities were inextricable from the discourse on love in The Netherlands during the seventeenth century. The Dutch word *vrijen* often meant "to court," that is, to woo honorably; thus a young man of courting age was a *vrijer* and a young woman a *vrijster*. But it could also refer to illicit relationships.[28] In his widely read moralizing book *Houwelyck* (Marriage), Jacob Cats describes adolescent *vrijen* as a confusing maze of "beautiful deception," "outward show," and "loose dreams," which nevertheless must be negotiated to achieve a virtuous marriage.[29] One aspect of this confusion is moral, for courtship, according to Cats, is a perilous enterprise in which the temptation to sin is ever present.[30] Another is emotional, to court being, in some measure, to dissemble. Cats counseled young women to conceal their emotions from their suitors. In a different spirit, but with similar effect, poets in the Petrarchan tradition praised the remote, icy lady.[31] Young men, however, could be equally opaque: Dutch songs often speak of the bashfulness of the male lover, tongue-tied in the presence of his beloved.[32] By its very nature then, courtship is a zone of ineluctable mystery and uncertainty, in which both men and women hide their own feelings even as they seek to discern those of others, and in which the potential for sin lurks beneath the surface of seemingly polite activities. The moral and emotional enigmas we encounter in Vermeer's paintings seem only commensurate with such a vision of love.

Youth, Fashion, and Dutch Simplicity

Like the artists of the garden parties, Vermeer pictures courtship as a self-enclosed world of youth, from which parents and older guardians are excluded. It is an imagery that accords well with the desire of contemporary young people in The Netherlands for their own social and emotional space apart from adult supervison. In Cats's *Houwelyck,* for example, when the wise, married woman Sibille (who serves as Cats's mouthpiece) advises young women not to go off with their suitors unchaperoned, the headstrong *vrijster* Rosette protests: "It appears that you begrudge us the free time of our sweet youth."[33] Generational conflicts can also be inferred from *vryerijboeken,* which took the side of youth. Westerbaen advises his female readers that if their parents forbid them to receive a certain suitor, they can still arrange to meet him secretly "in the salons of [their] friends."[34] This was not an adolescent counterculture, for most Dutch young people seemed to share the moral code of their elders.[35] The prospect, however, that they would face the moral temptations and emotional trials of courtship alone – which they embraced, and moralists like Cats fretted about – is part of what accounts for the quiet drama of Vermeer's paintings.

The youth culture we encounter in Dutch love songs and romances is a decidedly elite one, composed of the nobility and high-burgher class; in turn, the relationship of wealth, rank, and fashion to the moral life of youth was a bone of contention for Dutch writers. In his emblem book *Sinne-poppen* (Meaningful Little Figures) of 1614, Roemer Visscher draws unfavorable comparisons between the spoiled upper-class youth of his era and the heroic generation that had fought the war against Spain. He heaps scorn on the new fashions in dress and manners among Dutch youth, which he ascribes to foreign (mostly French) influence. Instead, he proposes *botticheyt* (simplicity or bluntness) as an authentically Dutch virtue, enjoining his readers to be *slecht en recht* (simple and upright).[36] Visscher's mordant view of the younger generation, however, was by no means universally shared. In his *Minne-kunst* (Art of Love), a *vryerijboek* published in 1626, Johan van Heemskerck reverses Visscher's system of values, poking fun at the simplicity of his ancestors and praising the elegant courting youth of his day:

> If in the past century the young ladies were not very well made up, the young men, just like them, were simple and upright *[slecht en recht]*. For if she was not clothed in silk and velvet, what did it matter? Neither were her sweet suitors. . . . Some may praise the old [ways], but as for me, I agree with those who love our own, and I am well satisfied to have been born in our time . . . because today one sees a fine gracefulness in everything, and the crudeness of that inept era has in our time been replaced by the art of good living.[37]

For Van Heemskerck, the flowering of love in poetry, fashion, and manners among Dutch upper-class youth was a natural result of peace and prosperity, and indeed a mark of national prestige.[38]

Closer to Vermeer's time, perhaps inspired by the Treaty of Münster (1648), Dutch poets were still driving home this point, as in one of the dedicatory poems from Samuel van Hoogstraten's romance *Schoone Roseliin* (Fair Roselijn):

> Batavian lovemaking in the pure Mother's tongue,
> Through the fearful sounds of the Guns and Trumpets,
> Till now was unheard: even though other folks –
> Greeks, Romans, and French – with very sweet poetry
> Challenged our Writers; but hardly had Peace
> Placed her holy foot in Holland's smart Halls,
> Than the cream of Poetry displays to us all what [once] was hidden.[39]

Peace gives rise to love, in all of its elite cultural forms. Vermeer's *Officer and a Laughing Girl* (Plate 6) enacts a similar meditation on national history, warfare, and love, in which a modern Mars and Venus perhaps, the latter holding a glass of wine, chat amiably before a map of the provinces of Holland and West-Friesland.[40] In Pieter Cornelisz. Hooft's emblem book *Emblemata amatoria* (Emblems of Love), written during the earlier Twelve Years' Truce (1609–21) between the Dutch and their Spanish adversaries, we read of "stern Mars . . . tempered, that bridle and bright spear drop from his hands, when [Venus] gives him a wink to come into her."[41]

In some sense, the discourse on love in the Dutch Republic was conflicted on the subject of class, wealth, and fashion. The Dutch translator of *De hoofse Clitie* dedicated the first volume of his edition to a long list of young women from the best families of Amsterdam; he assures them that Clitie wishes to "keep company with those who are most like her in class, clothing, adornment and style of living, and has chosen you [ladies] . . . as her most special companions."[42] Other amatory texts, however, identified such things as enemies of true love. One print from *De schouburg der verliefde* shows Cupid fleeing from a pile of treasure and a coat of arms, the latter representing genealogical prestige.[43]

Perhaps these issues are raised by the coats of arms in the windows of Vermeer's *Girl with the Wine Glass* (Plate 13) and *The Glass of Wine* (Plate 9), as well as the ancestral portrait in the latter painting, the fashionable dress of these and other of Vermeer's figures, and the rich furnishings of his interiors.[44] It is worth recalling that Vermeer's own social sphere was probably not far removed from that shown in his paintings.[45] While the artist himself came from the lower ranks of the middle class, his wife Catharina Bolnes was of patrician birth.[46] After his marriage, Vermeer assumed the upper-class title *seigneur;* similarly, his wife and her mother Maria Thins were called *Juffrouw.*[47] The "great hall" of the latter's home, where the couple lived, was hung with ten ancestral portraits of her family. Vermeer owned a "drawn coat-of-arms" of his family, perhaps a modest exercise in social climbing.[48]

Despite the rich material culture they contain, Vermeer's scenes do not at all suggest excess, like images of *Opulentia* (Opulence) and other Dutch moralizing themes; nor do his women have the obvious eroticism of the figures in these scenes.[49] His domestic interiors also seem the antithesis of Jan Steen's (1626–79)

comic-moralizing paintings of disorderly households, the chaotic surfeit of which clearly expresses an underlying moral disorder.[50] De Lairesse described the "burgerlyke of cierlyke Modern" (*burgerlijk* or refined Modern) as a type of genre painting that took its subjects from the upper ranks of the Dutch middle class, which despite its aristocratic airs, differed essentially from the nobility. Rather than the *pracht* (ostentation) and *overdaad* (excess) of the nobility, the *burgerlijk* mode displayed *zedigheid* (modesty) and *matigheid* (moderation).[51] Indeed, the patrician world of Vermeer's paintings is peculiarly austere, its elements clean, polished, and locked into an immaculate geometry, as if the vaunted orderliness of Dutch housekeeping had been transmuted into a pictorial sense of order.[52]

To modern eyes, one aspect of Vermeer's austerity or "purity" is his white walls, raked by light, which have so formed our image of Dutch domestic culture.[53] That Dutch viewers in the seventeenth century may also have found a native reference in these pristine spaces is suggested by a curious passage from Johan van Heemskerck's *Batavische Arcadia* (Batavian Arcadia), a pastoral romance about a group of courting youth from The Hague. As they trade stories, one young man tells of his travels in the Pyrenees, where he stumbled on an inn run by an expatriot Dutchman:

> . . . I was amazed to find there a neatness (in whitewashed walls and in other examples of Dutch cleanliness) *[een nettigheydt (soo in ghewitte muren, als andere Hollantsche puntigheydt)]* to which my eyes had almost grown unaccustomed, for I had been a long time abroad.[54]

Nettigheydt (neatness) and *puntigheydt* (cleanliness) hark back to Visscher's ideal of *botticheyt*. What seems noteworthy about Vermeer, however, is his reconciliation of this conception of the Dutch character with an elite and elegant culture of love. It is this notional alloy that, in *A Lady Standing at the Virginal* (Plate 33), materializes in the unified yet subtly differentiated whites of the walls, the lady's dress, her pearls, and indeed her own skin. In one song from *Delfs Cupidoos schighje*, Venus is "de blanke Moeder van de Min" (the white Mother of Love).[55] Pale skin was an attribute of feminine beauty. "Haer hals, witter dan sneeuw" (her neck, whiter than snow) writes La Serre of Clitie.[56] When put into practice, such ideals became an object of satire from moralists like Cats and Visscher. One Dutch satirical text declares that a young lady soaked her arms in urine every night to acquire pale skin, which the author presents as an example of female folly and slavery to fashion.[57] Vermeer's painting, however, like the Dutch word *schoonheid,* seamlessly marries beauty with purity, high fashion with Dutch cleanliness.

Cupid and the Viewer

A Lady Standing at the Virginal (Plate 33) addresses us directly; so too does Cupid in the painting on the wall, which reappears in Vermeer's *Girl Interrupted*

at Her Music (Plate 12) and was initially included in the background of the *Girl Reading a Letter at an Open Window* (Plate 7) before Vermeer painted it out. It has been compared to a print from Otto van Veen's emblem book, *Amorum Emblemata* (Emblems of Love; 1608), of Cupid holding a tablet inscribed with a "1" and stepping on several tablets with other numbers to show that true love is directed to only one.[58] Other scholars have noted that the object held by Vermeer's Cupid is, in fact, blank and furthermore that there are no tablets visible on the ground.[59] What is represented in *A Lady Standing at the Virginal* then is perhaps nothing more specific than a Cupid who greets us, to frame the woman's gaze as amorous. Vermeer's Cupid does fit into a system of references within the painting. Among the tiles at the bottom of the wall is at least one Cupid: the figure just to the left of the woman's gown (Fig. 39), which is similar to the fishing Cupid in a print (Fig. 40) from Hooft's *Emblemata amatoria*. Hooft's emblem plays on the conventional comparison of courtship to fishing.[60] In Vermeer's Cupid tile, the fishing rod is visible, the proportions of the figure are consistent with Cupid, and the dark shape on his back can only be his stubby wings. (The same figure may be repeated on a tile to the right, partially obscured by the virginal's leg.) Prints like that from Hooft's book often served as patterns for tiles. Contemporary viewers who were familiar with these recurring designs on their own walls would readily have identified the Cupid in Vermeer's tile.[61] The fishing Cupid, moreover, is part of a broader aquatic theme in the painting. Another clearly legible tile, one to the left of the Cupid, depicts a sailboat (Fig. 39). Water appears in all three pictures-in-the-picture. A blue patch in the lower right corner of the landscape on the wall denotes a sea or lake; so too does the blue-gray area behind the Cupid in the painting. Finally, the landscape

Fig. 39. Detail of Plate 33.

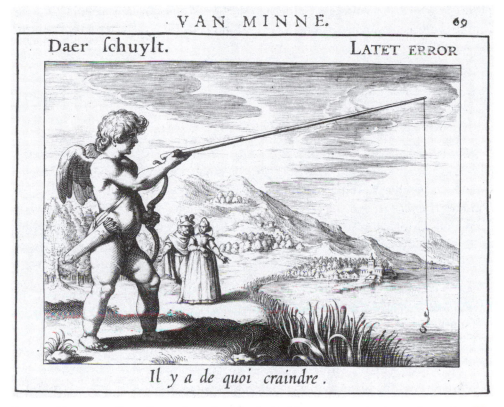

Fig. 40. Illustration from Pieter Cornelisz. Hooft, *Emblemata amatoria,* Amsterdam, 1611. The Hague, Koninklijke Bibliotheek. Photo: Koninklijke Bibliotheek.

on the inner lid of the virginal includes a waterfall in the right foreground. The analogy between fishing and love, as well as the myth of Venus born from the sea, pervades Vermeer's painting, perhaps even to the extent of the pearls around the lady's neck. Watery motifs also feature prominently in *Delfs Cupidoos schighje,* on the title page of which (Fig. 37) Cupid aims his bow at two lovers while seated on a dolphin.

Vermeer's *Lady Standing at the Virginal* (Plate 33) fishes for us, we fish for her, or Cupid fishes for us both. One *vryerijboek* advises young women: "Learn . . . to steal hearts/ With Clavecimbel-playing."[62] The empty chair is for us, like the viola da gamba in *A Lady Seated at the Virginal* (Plate 35). These two paintings are merely confrontational versions of the theme of the woman with a musical instrument, whose outward gaze in other paintings (Plates 16 and 34) is probably no less amorous. The figure in *A Lady Standing at the Virginal* looks down at us slightly and invites us to take a position of even greater subservience – to look up at her from the chair as she plays. We approach her then as a supplicant, a Petrarchan lover. From the chair, she would be silhouetted against the glare of the window.[63] A song from the *Tweede Delfs Cupidoos schighje* (a sequel to the original songbook) poses a similar contest of lights: ". . . how your God-like eyes/ seek to draw hearts in/ By your bright brilliance, which conquers all:/

Through which Apollo's rays stand blinded."[64] Vermeer's lady seems to wear
Cupid's bow as an ornament; the intersection of the bow with her gaze conjures
the metaphor:

> And you, Cupid . . .
> . . . must not live unarmed,
> For the little EYES of my ROSELIJN:
> They will provide little arrows for you again.[65]

She is perhaps both a woman to be courted and Venus herself, to whom the
beloved is often compared in poetry (the "white Mother of Love," as noted pre-
viously).[66] Vermeer's faintly comic tone, with his cross-eyed Cupid looming tri-
umphantly above us and the trace of a smile on the woman's face, recalls a song
from *Delfs Cupidoos schighje* in which the foolish *vrijer* Pietje is confronted by,
as he says, "a small little man with a bow."[67] Pietje's female companion Trijntje
warns him that he is in danger. The song ends with Pietje pleading for mercy:

> Ay, ay, ay, dear Cupid
> You must not slay me,
> Your little arrow will hurt me so,
> Stop, I will kneel before you . . .[68]

Cupid reappears in Vermeer's *Milkmaid* (Plate 8) on the tile between the
maid's skirt and the foot warmer, preparing to shoot his bow (Fig. 41). (Another
tile to the right seems to contain a figure with a walking stick.) We can confirm
the identity of the Cupid here by comparing it to a seventeenth-century Dutch
tile that was clearly made from the same design (Fig. 42). The Cupid tile in Ver-
meer's painting may be deliberately juxtaposed with the foot warmer, the
wooden box containing a ceramic bowl for hot coals. Arthur Wheelock has
called attention to a *pictura* entitled "Mignon des Dames" (Servant of Ladies)
from Visscher's *Sinne-poppen* in which a foot warmer becomes a symbol of the
attention paid by courting men to their ladies.[69] Such metaphoric uses of the
foot warmer occur in other genre paintings.[70] An illustration from *Scoperos
satyra ofte Thyrsis minnewit* (Scopus's Satire or Thyrsus' Wit of Love), a *vryeri-
jboek* published in 1668, shows a young man kneeling to attend to his lady's foot
warmer; the accompanying text compares men who are open about their desires
to women who cloak them: "The burning of maidens can be hidden,/ The coals
exist in the heart. . . ."[71]

Similarly, Vermeer's *Milkmaid* is absorbed in her work, a paragon of domestic
virtue without any overt amatory meaning. Cupid, however, is the peripatetic
messenger of love, mischievously cropping up where one least expects him. Thus
his understated presence here may be precisely the point. For both servants and
mistresses, household work was often set in opposition to more pleasurable activ-
ities. In the popular *kluchten* (farces), maids regularly seek to evade their chores
for amorous pursuits, like Jannetje in *Klucht van de koeck-vreyer* (Farce of the
Cake-*Vrijer*), who wishes to go out "to the *vrijers*'s path, to see and be seen."[72]

Fig. 41. Detail of Plate 8.

Fig. 42. *Cupid with His Bow and Arrow,* ca. 1675 (Dutch blue and white tile). Private collection.

This stereotype was grounded in a social reality; in the Dutch Republic, maids were often young women who hoped to marry rather than make a lifelong profession of domestic work.[73] A similar dynamic of work and play obtained for their mistresses. The preface to *Delfs Cupidoos schighje,* addressed to "the Delft song-loving young ladies," focuses on lacemaking as a duty: "Don't throw this book away,/ When with your fingers/ You weave nice, dense little laces." Put it in your lap, the author suggests, and enjoy it later.[74] We do not know what book lies next to Vermeer's *Lacemaker* (Plate 31), but certainly it represents another contemplative pursuit that will occupy her when the lacemaking is done.[75]

In *The Love Letter* (Plate 29), a basket of clothes to be mended and a sewing cushion sit beside the lady. She has exchanged her domestic chores for music, an activity evocative of love.[76] The broom perhaps refers to the similarly neglected chores of her maid who has just handed her the letter, the amatory content of which, in turn, seems to be indicated by the seascape, as the poet Jan Harmensz. Krul wrote in 1640: "Love may rightly be compared with the sea, in view of her changes, which one hour cause hope, and the next fear. . . ."[77] In *The Milkmaid* (Plate 8), Vermeer had initially included a basket of clothes in the lower right, which he later painted out in favor of the Cupid and the foot warmer.[78] Rather than reiterate the theme of domestic duty, he suggests what may lie beyond it in the life of the maid. Whether such marginalia point to the maid's own proclivities, or solicit them from the viewer, is an open question – if indeed they mean anything, for the linkage of maid, Cupid, and foot warmer amounts to a less conclusive reading than what the mutually reinforcing references in *A Lady Standing at the Virginal* (Plate 33) allow.[79] In both paintings, the iconographic significance of the Cupid tiles is somewhat clouded, as it were, by the other tiles with their only slightly less legible figures.

Who, more precisely, is this viewer? Issues of class, gender, and age vary from one painting to the next. Viewers of *The Milkmaid* (Plate 8) would often have been of a higher class than the depicted figure, whom we can identify as a *keuken-meid* (kitchen maid), one of the lower orders of houseservants.[80] Most of Vermeer's paintings accommodated viewers of both sexes, with male viewers perhaps seeing the women in the scene as objects of desire, and female viewers identifying with them as compatriots in the game of courtship, as Alison Kettering has suggested of Ter Borch's paintings.[81] On the other hand, both *A Lady Standing at the Virginal* (Plate 33) and *A Lady Seated at the Virginal* (Plate 35) seem to assume specifically male viewers, probably of about the same age and class, who are to be enticed into these narratives of love. Of course, Vermeer could not control who would come before, for example, the *Lady Standing at the Virginal,* to be the object of her gaze and that of Cupid. Cupid's aim was famously arbitrary, and the painting's constantly changing audience is perhaps one of its deliberately comic aspects. Though Vermeer drew much of his meaning and wit from the culture of courting youth in seventeenth-century Holland, his actual audience must always have been more varied. We might take our cue in this regard from Johan van Heemskerck, who wrote that his *Minne-kunst* was

intended not only for courting young people but for those "who under cover of a stately old age still possess a youthful heart."[82]

Separation, Privacy, and the Epistolary Theme

One context for examining our role as viewers of these women and their private spaces is the literary convention of the rejected suitor who pines for entry to his beloved's dwelling, as in a song from Gerbrandt Adriaensz. Bredero's *Groot lied-boeck* (Great Songbook) of 1622.[83] The accompanying print (Fig. 43) shows the *vrijer* standing before the door and the young lady peeking through the shutters on the second floor. It could also serve as an illustration to the play by the Delft-born Adriaan van Steyn, *Den volstandigen minnaer* (The Persistent Lover), printed in Delft in 1662, in which Karel addresses his beloved Brandyne's home:

> Here I stand before the dear building,
> In whose vaults, and closed walls
> My captured soul, in bonds,
> Continually sighs for the return of her love.
> Closed entrance, keep me outside
> In case my beloved still hates me,
> And with that stinging purpose goes
> To close her soul before me.[84]

Fig. 43. Illustration from Gerbrandt Adriaensz. Bredero, *Boertigh, amoreus, en aendachtigh groot lied-boeck*, Amsterdam, 1622. The Hague, Koninklijke Bibliotheek. Photo: Koninklijke Bibliotheek.

Later, after Karel has gained Brandyne's favor, she hears a false rumor that he loves another. When she asks him to leave, his reply shows how laden with memories her home had become for him: he cannot bear to leave ". . . the dear hall where we so often sat."[85] Just as the settings of the garden parties evoked the conventional meanings of the garden of love, so Vermeer's audience might have invested his interior scenes with associations of emotional intimacy, and of access to the private space of the beloved.[86]

Privacy and separation are thematized in Vermeer's paintings of women reading, writing, and receiving letters (Plates 7, 19, 25, 29, 30). Such paintings by Vermeer and other Dutch artists of the time reflect the contemporary vogue for letter writing, which also took the form of epistolary manuals that included model love letters, among other types of correspondence.[87] Letters could play an important role in courtship; most prose romances of the time, in fact, are epistolary novels, replete with letters between lovers.[88] In the paintings, of course, we cannot read the letters, but artists often drop hints: Ter Borch depicts a pensive young man writing a letter while a playing card with a heart lies prominently on the floor.[89]

Vermeer, characteristically, is less inclined to give clues. Even the seascape in *The Love Letter* (Plate 29), which seems to function as an amatory reference, is less starkly juxtaposed with the letter than is the same motif in paintings by Dirck Hals (1591–1656) and Gabriel Metsu (1629–67).[90] Other women in Vermeer's paintings correspond with whomever we wish: suitors, husbands, friends, or family.[91] If the *Woman in Blue Reading a Letter* (Plate 19) is identifiably pregnant, as some believe, we could probably exclude the first of these. In fact, I am inclined to think she is not, for many of Vermeer's women seem to wear dresses that would give the same impression were they viewed in profile.[92] We must accept the polyinterpretability of these paintings as a deliberate artistic choice. Vermeer's original inclusion of the Cupid painting in the *Girl Reading a Letter at an Open Window* (Plate 7), for example, posits the lady as reading a love letter, but the removal of the Cupid just as clearly produces a more generalized image of privacy, absorption, and communication with an indeterminate other.[93] At the same time, the option to read an amatory theme into it remains very much in play.[94] The prose romances offer one context for thinking about Vermeer's epistolary paintings, albeit a specifically amatory one. They may yet prove illuminating, however, even if – like the artist himself, apparently – we are not exactly sure what his letters are about.

Before letters are read, they are delivered in Vermeer's *The Love Letter* (Plate 29) and *Mistress and Maid* (Plate 25). In the latter, the maid interrupts her mistress as she writes her own letter (lines of writing are visible on the sheet before her).[95] The letter's arrival is unexpected. The maid seems to be telling her mistress who it is from; the lady raises her hand to her mouth in a gesture of surprise or reflection. The coincidence of writing one letter while receiving another suggests a narrative of rival suitors.[96] In *The Love Letter,* the lady holds the letter that the maid has just delivered. She looks at her maid, who smiles. The exchange suggests that both women know the author's identity and can guess at

the significance of his communication. In both scenes, the maid may have been handed the letter by its author, or may have been given it by a servant who told her who it was from. That merely the authorship of the letters sparks the drama in these scenes in itself perhaps hints at an amatory theme.

These maids are to be distinguished from common houseservants like Vermeer's *Milkmaid*; rather, they are probably the *kameniers* (ladies' maids) that are described in a facetious diatribe on the purported evils of maidservants, *Zeven duivelen, regerende en vervoerende de hedendaagsche dienst-maagden* (Seven Devils, Ruling and Seducing Contemporary Maidservants), as attending to the personal needs of women in upper-class families.[97] Both the wife and each of the daughters in such a family might have her own *kamenier*. *Zeven duivelen* portrays young ladies and their maids as equally foolish creatures, constantly hatching schemes together.[98] A *kamenier* was guardian of her mistress's privacy, and *vryerijboeken* accordingly advised young men to ingratiate themselves with their ladies' maids.[99] In the play *De klucht van Sr. Filibert* (The Farce of Sr. Filibert), it is Filibert's servant Weerhaen who pleads with Laurette's maid on behalf of his master:

> I know . . . that you have very private audience with your Lady . . .
> Listen, so I say, can you arrange it so that my Master can enjoy your Lady's affection [?][100]

Lady Writing a Letter with Her Maid (Plate 30) represents the epilogue to the arrival of a letter. A moment before, the maid had probably delivered the letter that now lies crumpled on the floor in the foreground, its detached red seal and a stick of sealing wax next to it. As her mistress pens her own missive, the maid looks out the window, perhaps at the messenger who waits outside the door for the reply; or perhaps she considers that the errand she is about to run will offer amorous opportunities for herself.[101] In any case, her gaze underscores the charged relationship between the interior, in which she enjoys "very private audience" with her lady, and the outside world, from which the letter has come and to which another will be sent. The discarded letter on the floor reminds us of a recurring motif in the prose romances. In one story from the collection *De wonderlijke vryagien, en rampzaalige, doch bly-eyndige, trouw-gevallen van deze tijdt . . . voorgevalle in het roem-ruchtigh Hollandt* (The Wondrous Courtships and Betrothals of This Time . . . Both Disastrous and Happy, Occurring in the Famous Holland), Leliana receives a letter that she at first assumes to be from her favorite Coredan:

> . . . but having opened [the letter], and seeing at the bottom the name of Kandoris, [she] became as angry as she had once appeared happy, and without looking at it further, threw it on the floor without casting the slightest glance at it.[102]

Vermeer, typically, leaves it to us to reconstruct the story. The lady, having received and discarded one letter (in anger, or merely urgency?), sits down to write (to the author of the letter, or to another?). The picture-within-the-picture

of *The Finding of Moses* places Pharaoh's daughter holding the infant Moses directly over Vermeer's letter writer. One senses an analogy along the lines of the sending and receiving of something (a baby, a letter) of great value, but Vermeer's precise intent remains customarily obscure.[103]

To see Vermeer's paintings as involving love letters allows for further speculation about what kind of love, or *vrijen*, they depict. Many texts of the period have housewives plotting adulterous affairs in consultation with their maids.[104] In *De hoofse Clitie*, letters allow Clitie and Cleander to communicate secretly. Issues of privacy generate drama in the story. When Clitie, for example, receives a letter from Cleander, ". . . seeing that her husband's absence gave her the chance to reply, [Clitie] took the pen and wrote as follows. . . ."[105] Reading such narratives into Vermeer's paintings leads us to imagine other, unseen characters – the lover, the husband – offstage, as it were, but potentially threatening the privacy of the scene before us.

If Vermeer's ladies are unmarried *vrijsters* corresponding with their suitors, however, we must take their parents or guardians into account. In his *Avond-school*, Westerbaen advises young women:

> Even if you are closely watched, you will find the chance
> To communicate to your *vrijer* through your maid.
> You will have the chance to write back and forth.
> Your little letters will go forth, and all remain hidden.[106]

Again the maid plays a key role. In the farce *Sijtje Fobers,* the parents, suspecting that their daughter Sijtje is carrying on an affair, consult their maid about what she is up to.[107] *Kameniers* often had divided loyalties. The tale of Coredan and Leliana from *De wonderlijke vryagien,* for example, describes a web of conflicts among Arkel, his daughter Leliana, and her maid Grindela. At one point, Grindela, more loyal to Arkel than to Leliana, intercepts a letter from the *vrijer* Coredan and gives it to Arkel, who holds Coredan in disfavor. Later, however, when Leliana is speaking with Coredan through her window at night, Grindela warns her mistress that her father is about.[108]

The air of privacy hangs heaviest in Vermeer's two paintings of solitary women reading letters (Plates 7, 19). Let us look at three passages from prose romances that describe the reading of a letter. In *De hoofse Clitie,* Cleander gives a letter to Clitie's lady-in-waiting, who delivers it to Clitie and then retires:

> Clitie, finding herself alone, took it [the letter], and – having stuck it in her bosom – went to a private room. O lucky Paper, though without feeling, can you not feel, and though without eyes can you not see, and though without lips can you not kiss this beautiful bosom? Cleander, fear not that your letter was lost. . . . Before she opened it, she kissed it, and sighed at every word as she read it. And her sighs called forth tears. . . .[109]

In another story from *De wonderlijke vryagien,* Fierandus, a young nobleman from The Hague, sends a letter to his beloved Leonora:

Leonora was given this letter as she was about to go to the banquet; but her curiosity to read it was so great that she could not wait until she returned again, so she went to her room. Having broken open [the letter], she found it as I have told. . . . And now Leonora is beset by thousands of unsettling emotions: however much her soul is disturbed, however, she so controls herself that one could see nothing amiss in her expression.[110]

Finally, in one tale from the collection *Hollantse trouw-gevallen* (Dutch Betrothals), Rudolf, a courtier in The Hague, delivers his letter personally to Aurelia but bashfully tells her it is from someone else. She suspects him to be the author, but her sense of humor about this only delights him.[111] Then comes the reading of the letter: "Aurelia was full of longing to see the contents of the letter, and as soon as she got home, went immediately alone to her room, opened the letter and found therein the following. . . ."[112] In each case, the young lady, on receiving the letter, hurriedly retreats to a private chamber, for the reading of the letter is an intimate communion of a kind with her beloved.

Model love letters from the epistolary manuals often invoke the theme of separation: the man fears that his beloved will grow fickle while he is away, or he compares himself to a boat carried far from port.[113] Distance fetishizes. Clitie speaks to the letter, kisses it, and imagines it kissing her in return. Similarly, another letter has the man writing to his lady: "Happy your slipper which receives every morning the kiss of your precious foot!"[114] (Compare *The Love Letter,* Plate 29.) Letters involved certain dangers.[115] In prose romances, they are misdelivered, lost and stolen in bewildering plot twists that seem emblematic of love's vulnerability to the whims of fortune. The letter's safe delivery therefore gives rise to ecstatic delight ("Cleander, fear not that your letter was lost").[116] Even as the letter bridges the separation of the lovers, however, it remains a token of unfulfilled desire. In Vermeer's scenes, the empty chairs facing the woman (for example, Plate 19) evoke the absent *vrijer:* ". . . the dear hall where we so often sat," as Karel says in *Den volstandigen minnaer*. At the same time, a letter can imply a certain preference for distance on the part of its author. In *Hollantse trouw-gevallen,* even when Rudolf delivers the letter to Aurelia himself, he thereby avoids the anxieties of a direct, verbal declaration of his love.

The curtains in Vermeer's letter paintings (Plates 7, 29, 30) seem to carry a particular meaning in this context. In the *Girl Reading a Letter at an Open Window* (Plate 7), the curtain rod refers to the real curtains with which paintings were sometimes hung in the seventeenth century. We find this trompe l'oeil pun in other Dutch paintings. Their fictive curtains, however, reveal such things as church interiors, still-life arrangements, or figures looking out at us.[117] Rather differently, Vermeer gives the motif a voyeuristic charge. The Dresden painting may also have evoked for contemporary viewers the curtains that were hung on interior windows in Dutch homes (that is, windows separating one room from another; see Pieter de Hooch's (1629–84) painting *The Bedroom,* Fig. 6). Such

curtains were markers of privacy. As viewers of Vermeer's paintings, our gaze merges with that of anyone we might imagine to have an interest in these women: husbands, parents, or *vrijers* (licit or illicit).

There is a tension, however, in the degree to which we have access to these figures. The strict profile of Vermeer's letter readers (Plates 7, 19), like that of his *Diana and Her Companions* (Plate 3) – another inaccessible object of desire often named in love songs – distances us from them.[118] They betray no emotion as they read, which recalls Leonora from *De wonderlijke vryagien,* who "however much her soul is disturbed . . . so controls herself that one could see nothing amiss in her expression."[119] The clear geometry of these spaces connects us to the figures; it places us as viewers.[120] Vermeer's slightly blurred brushwork, as though he were looking through lenses not quite in focus, seems to record emphatically direct visual perceptions, in which forms are intensely observed but not conceptually grasped – seen, but not "touched."[121] Here, in the very mode of his vision, is a peculiar joining of closeness and distance.[122] The presence of the figures before us is compelling, yet we are reminded that that closeness is of a purely optical order; its sober power is precisely what makes the figures' emotional inaccessibility so poignant.

Vermeer's women seem almost to be called into being by the light. Herein lies the power and fragility of the vision of the love object. At the limit of optical reality, Vermeer points to what lies beyond his desire, or power, to record: the secrets of the heart. Female viewers may have identified with these women and the quiet drama of their epistolary meditations. Within this distance, this hushed reserve, we may also locate the shyness and anxiety of the male lover, whose vision of the beloved excites his desire only to remind him of his present separation from her. Even as she reads, or rereads, his letter, she perhaps considers her response. And he waits, with the usual mixture of hope and fear. We do not know the end of the story, and neither do they. Such indeed is the indeterminacy of courtship.

Conclusion: *The Girl with a Pearl Earring*

She appears confident and self-possessed (Plate 24), hardly deigning to glance at us. We look again, and she is vulnerable, her parted lips and raised eyebrows apprehensive, uncertain, even fearful. Her gaze is inquisitive yet knowing. She wants to learn more of us but seems to know, despite herself, why we are here, standing before her, waiting for her response. She turns slightly to look at us: it is we who have intruded into her space. She emerges from a darkness that was her own and to which she might yet withdraw, were it not for the painter's art, which fixes this luminous moment forever.

To contextualize an image of such immediacy might seem an act of evasion.[123] On one level her vaguely exotic dress lifts her out of a local setting.[124] It also fits, however, the mythopoetic tone of many Dutch writers who, even when

they invoked local settings, could not resist giving their characters fanciful Italian or French names taken from pastoral poetry. Her most arresting features – that glistening triad of earring, lips and eyes – are the clichés of love poetry. "O Pearl of all women!" proclaims one song from *Delfs Cupidoos schighje*, a line repeated endlessly in other verses of the time.[125] Similarly ubiquitous were references to the beloved's moist lips and brilliant eyes.[126]

In Simon de Vries's 1646 verse romance *De uytnemende vryagie, tusschen den stantvastigen Floradin, en de ialoursche Lusinde* (The Excellent Courtship, Between the Steadfast Floradin, and the Jealous Lusinde), the male lover speaks of his beloved's gaze:

> O cruel beauty, O dangerous eyes,
> . . . Friend: turn, ah turn,
> And cast a favorable eye down to your servant.[127]

The linkage of the woman's gaze with her withdrawal, together with the lover's plea to her to turn toward him, should be considered in relation to Vermeer's figure, who seems to enact a similar narrative with the viewer. The phrase "turn, ah turn," ("keer, ey keer"), in fact, recurs in amatory texts of the period. In *Den volstandigen minnaer,* Karel confronts the reluctant Brandyne:

> What is it that hurts you? What plays with your thoughts?
> Or do you fear, sweet Maid, to be married too early?
> Or do you deem me not worthy of your love, and of your splendor? . . .
> What of your beauty? Trust it not, for it is vain,
> The longer it exists, the sooner it will pass,
> It is a tender rose, which full of charms,
> Shines today, and tomorrow lies trampled.
> Ah little Nymph turn, ah turn, and plunge into my life, . . .[128]

The concluding line ("Ay Nymphjen keer, ay keer, en stort mij leven in, . . .") evokes the tale of Apollo and Daphne and other mythic lovers in pursuit of fleeing nymphs. *Delfs Cupidoos schighje* includes a duet between Thetis and a nymph, "Dialogue between *Thetis,* and one who *turns away* from him [en een die *afkeerig* van hem is]," in which the nymph is repeatedly named as the *"afkeerige"* (the one who turns away).[129] The drama of male pursuit and female flight, as we have noted previously, can be fit into several quite different contexts, from the Petrarchan ideal of the remote lady to the teaching of moralists like Cats that a young woman should take a passive role in courtship.[130] It may even have been understood as characteristically Dutch. The Dutch translator of Boccaccio's *De arte amandi* or Art of Love (*De konst der vryery*) notes that Dutch women are more "afkeerig" to their suitors than are their Italian counterparts.[131]

Whatever inflection one gives the theme, it is implicit in the gaze of the *Girl with a Pearl Earring,* a gaze that acknowledges the viewer's presence but promises no recompense. Indeed, many features of Vermeer's paintings that I have discussed – the delicate emotional tone, the role of the viewer, the themat-

ics of privacy, order, purity, and of certain details like the pearl – have been noted by earlier critics (as Gowing wrote: ". . . the only simile is that which Vermeer offers us: [she] is like a pearl").[132] Such meanings, I think, take on a special richness, and precision, when placed in a seventeenth-century context. In some measure, however, they have always been there, in the image itself, for the sensitive viewer. It is perhaps by having reduced his pictorial language to such simple and lucid terms that Vermeer continues to speak to us so directly. But it is the ambiguities of that language, its quietly interrogatory tone, that still make it equal to such a subject as love.

7 Religion in the Art and Life of Vermeer

Valerie Hedquist

When The Netherlands revolted in 1572 to gain political and religious independence from Spain, one of the goals of the Dutch leader William the Silent (1533–84) and his followers was a society where people of different faiths could worship openly in an environment of religious tolerance.[1] This peaceful coexistence was evident in Delft, where for several months in 1572–3, Roman Catholics were able to worship in the *Oude Kerk* (Old Church; see no. 4 on the foldout map) while the Protestants were given the *Nieuwe Kerk* (New Church; see no. 10 on the foldout map) as a sanctuary for their services.[2]

Regrettably, this high-minded aim of religious toleration was short-lived. By early 1573, violence and intolerance led the community of Delft to demand the *Oude Kerk,* as well, for Calvinist worship.[3] After all, the Dutch people viewed the fight for independence as a battle against a southern enemy of Roman Catholics whose leaders were encouraged and supported by the pope.[4] The general animosity of the Dutch against the distant Spanish and Flemish Roman Catholics led to specific acts of distrust and hostility against the visible, local presence of the Roman Catholic faith. By the year 1584, when William the Silent was assassinated by a Catholic zealot in Delft, Roman Catholic churches in Dutch cities had been seized, the interiors sacked, and the liturgical objects, such as paintings, sculpture, and silver, destroyed. Celebrations of the mass were forbidden and Roman Catholic priests were forced out of their parishes and communities.[5] In 1615, when the parents of Johannes Vermeer were married, the suppression of the Roman Catholic faith was complete and Protestantism had triumphed.

In the first decades of the new century, however, rival Protestant sects faced a series of new difficulties in the Dutch Republic. The conservative Calvinist faith of the Dutch Reformed Church along with Lutherans, Mennonites, and other nondogmatic Protestant groups all competed for new members in a society that had rejected the old faith of Roman Catholicism. In Delft, as elsewhere in the Northern Netherlands, most of these Protestant groups could publicly

worship; however, only the Dutch Reformed Church enjoyed the official endorsement and promotion by the authorities at every level of city and state government.[6] Indeed, the Calvinists were especially wary of permitting worship by the competing, alternative Protestant faiths and they successfully suppressed both the Lutheran and Mennonite minorities during the early years of the seventeenth century.[7]

The Calvinist Reformers themselves were soon divided into two warring factions when the more tolerant Remonstrants, who followed Jacobus Arminius (1560–1609), and the more orthodox Counter-Remonstrants, who followed Franciscus Gomarus (1563–1641), clashed over issues of faith, specifically the role of predestination and church-state relations. By 1619, one year after the Synod of Dordrecht, the Remonstrants were condemned as heretics, disseminators of false doctrine, and agitators of state and church unrest.[8] In Delft, as elsewhere, the followers of Arminius joined Roman Catholics as outsiders who were officially banned from municipal positions and public worship.

Although national decrees denied Dutch Roman Catholics the right to serve in political office, to own or transfer property, or to congregate, they often continued to enjoy a great deal of religious freedom. In some areas, such as Utrecht, a majority of the local population and governing body remained Roman Catholic, which guaranteed widespread tolerance of their religion.[9] In other instances, Roman Catholics bribed sheriffs and judicial authorities to permit secret services in barns, warehouses, and private houses.[10] Against formidable odds, Dutch Roman Catholics continued to worship, educate, and proselytize throughout the seventeenth century with hopes that their circumstances would eventually improve.[11]

During these years of hardship, the papal administration in Rome was compelled to restructure the organization of the Roman Catholic Church in the Northern Netherlands, and the area was designated a mission region under the administration of the *Propaganda Fide* (Propagation of the Faith) in Rome.[12] In 1592 Sasbout Vosmeer, a secular priest in Delft, became the first apostolic vicar in The Netherlands, acting as the spiritual and administrative leader of all missionary activities.[13] His successor, Phillip Rovenius, directed the expansion of Catholic education, service, and mission activities. Both secular clergy and missionaries from various religious orders, such as the Jesuits, Franciscans, and Dominicans, served the growing Catholic communities in the Northern Netherlands.[14] According to Rovenius, the number of secular priests, trained in Dutch-supported seminaries in Cologne and Louvain, rose from approximately two hundred in 1616 to four hundred in 1650.[15] The number of priests who were members of a particular religious order (regular clergy) also increased dramatically during the years of Rovenius's administration. In 1616, there were only fifteen Jesuits in the mission area; by 1645 the sixty-two Jesuits were joined by twenty-five Franciscans, twenty-six Dominicans, eight Capuchins, twelve Augustinians, four Carmelites, and five Benedictines.[16]

Although the number of priests working in the mission area continued to

increase during the seventeenth century, most church leaders preferred to serve urban areas, which were, in general, more tolerant than the rural areas.[17] In the countryside, which was notoriously unsympathetic to Roman Catholicism, itinerant priests traveled from parish to parish, carrying whatever they needed to provide the sacraments to Roman Catholic believers. Both the rural and urban priests were often assisted by unmarried women, called *klopjes*, who prepared the altar for the mass, conducted choirs, taught the Roman Catholic catechism to children and young adults, and visited the sick and elderly.[18] Eventually, the shortage of priests in the countryside became a problem in urban centers as well, as the number of Roman Catholic parishioners in the major Dutch cities increased.[19] According to a report sent to Rovenius from a local Delft Jesuit missionary, Lodewijk Makeblijde, of the 23,000 people who lived in Delft in 1622, approximately 2,000 were Roman Catholics. This number grew to about 5,500 by 1656.[20] In his report sent to the *Propaganda Fide* in 1668, Rovenius's successor, the apostolic vicar Johan van Neercassel, noted the autonomy enjoyed by the growing number of Roman Catholics in the United Provinces.

The freedoms enjoyed by Catholics in the North depended primarily on local officials and how stringently they enforced the laws intended to limit papist excesses. In large cities such as Amsterdam, Haarlem, and Utrecht, where commercial concerns mollified the severity of any anti-Catholic legislation, deference and tolerance prevailed.[21] In smaller communities, such as Delft, the Roman Catholic community enjoyed religious freedom as long as they were discreet and continued to pay annual bribes to local officials. This tolerable situation for the Dutch Catholics was further improved after the Peace of Münster in 1648 when the long war with Spain ended and Dutch Catholics were no longer considered potential traitors.

In this complex religious climate, Vermeer's parents, Reynier Jansz. Vermeer (alias Vos; ca. 1591–1652) and Digna Baltens (ca. 1595–1670), were married in 1615 in Amsterdam before Jacobus Triglandius, a famous Calvinist and strictly Orthodox Reformed Church minister. A moderate Remonstrant preacher and the pastor of the *Nieuwe Kerk* in Delft, Johannes Taurinus, provided an attestation to the bridegroom to marry outside of Delft.[22] Although their marriage arrangements imply a commitment to the Dutch Reformed Church, neither parent was registered as a member of this faith. In order to become a documented, confessing member of the official Reformed faith with the right to participate in the sacrament of communion, individuals needed to educate themselves in the doctrinal issues of the faith and make a public confession of faith. On Vermeer's paternal side, his grandmother, an aunt, and a great uncle were all documented members of the Reformed faith.[23] As for the family of Vermeer's mother, they emigrated from Antwerp and were not acknowledged members of the local Calvinist church. Therefore, it is likely that neither Jansz. nor Baltens was fervently attached to Calvinism. Instead, they, like many others at the time, including members of the Roman Catholic and Remonstrant faiths, celebrated important familial events, such as marriage, birth, baptism, and death, with

ceremonies conducted in the officially sanctioned public Reformed churches of
the community.

In the *Markt,* the main square in Delft, the *Nieuwe Kerk* served as the indis-
putable center of religious and public life. In 1620, Vermeer's only sibling,
Gertruy, was baptized in this church, and twelve years later, on October 31, 1632,
Vermeer was also baptized in the same location by a Dutch Reformed minister.[24]
The baptisms of the Vermeer children prove only that the parents wished to
record their births in the religious location sanctioned by the government, not
that they would become Calvinist believers.[25] For the citizens of Delft, the
Nieuwe Kerk served as the communal setting for these important familial events.

A painting of the *Nieuwe Kerk* by Gerard Houckgeest (ca. 1600–61) shows
the striking renovated interior of an old Roman Catholic church, formerly dedi-
cated to St. Ursula (Fig. 10).[26] In October 1566, during the first wave of icono-
clasm, the reformers forever altered the richly ornamented interior of the earlier
Roman Catholic building by destroying paintings of Christ's Passion, statues of
saints, and elaborate reliquaries.[27] As Houckgeest's image from 1651 shows, clear
panes of glass replaced the colorful stained-glass windows of the earlier church,
and the stark white walls created a clean, sparse interior space for the pulpit
that replaced the altar as the primary focus of the church service. In earlier cen-
turies, when Roman Catholics worshiped in the *Nieuwe Kerk,* the priest cele-
brated the rite of the eucharistic mass at the altar in front of the congregation.
In the seventeenth century, when the Reformed congregation gathered in this
church, the preacher delivered sermons based on biblical text from a pulpit in
the middle of the congregation. By the early seventeenth century, the 250-year-
old church had also become the setting for the tomb of the national hero,
William the Silent, created by Hendrick de Keyser (see Fig. 10). Therefore, at
the time of Vermeer's baptism, the religious and political lives of the people of
The Netherlands and, more specifically, of Delft, were joined in the central nave
of the *Nieuwe Kerk.*

The *Nieuwe Kerk* certainly figured in the environment in which Vermeer
grew up. In 1641, when Vermeer was nine years old, his father, Reynier Jansz.,
purchased a large house called the *Mechelen* located on the market square
opposite the *Nieuwe Kerk* (see no. V2 on the foldout map).[28] Here, Jansz. estab-
lished an inn where he also sold paintings. It is very likely that Vermeer received
some informal introduction to art from the artists and art dealers who gathered
at his father's workplace. The lack of factual information regarding Vermeer's
artistic education has led to a number of conjectures regarding Vermeer's early
apprenticeship and training. Whether Vermeer received instruction in his home-
town of Delft, in Utrecht, in Amsterdam, or as far away as in Italy, remains
purely speculative. Strong circumstantial evidence points to Amsterdam, where
Vermeer's father had studied the technique of weaving caffa, a type of silk-satin
fabric, from 1611 to 1615, or to Utrecht, where Vermeer may have been appren-
ticed to a Roman Catholic painter through whom he could have met his future
wife. It is the puzzling union of Johannes Vermeer and Catharina Bolnes that

heightens the likelihood that a Roman Catholic artist was the master of the young Delft painter. Vermeer came from a middle-class family of craftsmen in Delft who were only marginally involved in contemporary Calvinist circles, while Bolnes was from a patrician family of landowners in and around Gouda who were devoutly Roman Catholic. Scholars have argued that either Leonard Bramer (1596–1674) in Delft or Abraham Bloemaert (1566–1651) in Utrecht served not only as Vermeer's teacher but also as the mutual friend who introduced the Delft painter to his future bride.[29]

An acknowledged Roman Catholic, Leonard Bramer was an acquaintance of the Vermeer family who had served as a witness to several notarized documents dealing with transactions involving both Vermeer's father and mother.[30] Importantly, he also witnessed a notarization at the time of Vermeer's marriage to Bolnes. According to some scholars, as one of Vermeer's early teachers, Bramer could have also encouraged Vermeer to travel to Italy where the older artist had spent many years and where he had been listed as a Catholic Church member in 1620.[31] Vermeer may have studied with Bramer, but his own paintings do not, in general, reveal the stylistic or thematic interests of the older Delft painter, celebrated for his small-scale nocturnal scenes.

Instead, similarities between Vermeer's early paintings, such as *Christ in the House of Mary and Martha* (Plate 2), *Diana and Her Companions* (Plate 3), and *The Procuress* (Plate 4), and works by the so-called Utrecht Caravaggists, Hendrick ter Brugghen (1588–1629), Dirck van Baburen (ca. 1595–1624), and Gerrit van Honthorst (1592–1656), suggest that the Delft painter went to Utrecht for his artistic education. If he did train with the acknowledged master of the Utrecht school, Abraham Bloemaert, Vermeer's relationship with this well-established Dutch artist could help to explain his presumed absence from Delft and his eventual marriage to Bolnes, whose mother, Maria Thins, was related to Bloemaert through marriage.[32]

Vermeer's marriage is recorded in two documents from April 5, 1653. The first notarized document states that Maria Thins, mother of Catharina Bolnes, had refused to give her consent for the public registration of the vows between her daughter and the painter, Johannes Vermeer.[33] The Roman Catholic painter, Leonard Bramer, and a Protestant sea captain, Bartholomeus Melling, witnessed this document.[34] In this act, Maria Thins followed the warnings of local Roman Catholic officials who advised parents to dissuade children from marriages to members of the Reformed faith.[35] Although she would not give her consent, Thins also stated that she would tolerate the registration of the marriage in the town hall in Delft.[36] The second document to name Vermeer from April 5, 1653, records the registration of marriage between the painter and Bolnes with a marginal notation citing the attestation of this union in the town of Schipluy (present-day Schipluiden) on April 20, 1653.[37]

Many scholars believe Vermeer probably converted to Roman Catholicism during the period between the civic registration of the marriage on April 5 and the religious ceremony that apparently took place on April 20.[38] The imminent

conversion of Vermeer to Roman Catholicism may account for the willingness
of Thins to tolerate the publishing of the banns prior to the nuptial ceremony
on Easter Sunday in Schipluy. This rural village was a center of Roman Catholi-
cism served by a Jesuit missionary who came from Gouda, the bride's home-
town.[39] It is likely, therefore, that Vermeer's in-laws had close ties to this parish
and encouraged the marriage ceremony in Schipluy. Since Roman Catholics
could not openly celebrate mass and practice their religious beliefs, Vermeer
and his bride probably celebrated their nuptial rites in a barn or domestic
church building. The union of Vermeer and Bolnes in a sacrament celebrated at
Easter in 1653 confirms the Roman Catholic context of their marriage and serves
as an initial documented event linking Vermeer to his Roman Catholic wife and
her family, to the local Jesuit community, and to the broader Roman Catholic
neighborhood where he would soon live. Without documentation confirming
Vermeer's individual acceptance of Roman Catholicism, it is difficult to state
definitively that he converted.[40] Nevertheless, his marriage and eventual living
situation firmly place him in the Roman Catholic center of Delft.

When he married Bolnes, Vermeer became part of a Roman Catholic family
and neighborhood. Vermeer's mother-in-law was a devout Roman Catholic who
had grown up in a stronghold of Dutch Catholicism, the town of Gouda, where
her family celebrated mass secretly in their home, *De Trapjes* (The Little
Steps).[41] In this house in 1619, local sheriffs interrupted an illegal gathering of
Roman Catholics.[42] Another indication of the devout ties of the Thins family to
the Roman Catholic Church is the decision of Maria's sister, Elisabeth, to
become a nun in Louvain.[43] Maria's other three siblings did not marry either,
and her own marriage in 1622 to Reynier Bolnes was troubled from the very
beginning.[44] After nearly twenty years of domestic abuse, Maria Thins finally
left her husband in Gouda and moved to Delft where she eventually lived in a
house that had been purchased in 1641 by her cousin and guardian, Jan Geensz.
Thins from Gouda.[45]

This house was located along the Oude Langendijk, the street where the
Jesuits, who had established their first Dutch mission in Delft in 1592, moved to a
permanent location in 1612 (see no. V3 on the foldout map).[46] This *schuilkerk* or
hidden church was well known to the local Roman Catholics and to the city offi-
cials. Bribes totaling 2,000 to 2,200 guilders per year were paid to the local sheriffs
to ensure undisturbed services in these private sanctuaries.[47] Although local
Protestants complained about the growth and tenacity of the Roman Catholic con-
gregations, the hidden churches continued to prosper, and by the 1650s and 1660s,
many Delft Catholics had established a neighborhood near the Jesuit mission
church in an area that came to be called the *paepenhoek,* or Papists' Corner.[48]
When he purchased property here in 1641, Maria Thins's cousin probably intended
to assist the Delft Jesuits by providing a place to celebrate mass, to establish a
school, or perhaps even to generate rent income.[49] In an early-eighteenth-century
drawing by Abraham Rademaker, the women are entering the Jesuit church and at
the far right is the likely location of the Thins residence (Fig. 44).[50]

Fig. 44. Abraham Rademaker, *The Jesuit Church on the Oude Langendijck* (pen and ink drawing). Delft, Gemeentearchief. Photo: Gemeentearchief.

By 1660, Vermeer was living in this house at the corner of the Oude Langendijk and the Molenpoort in the Papists' Corner with his wife, three or four children, and his mother-in-law.[51] Economic necessity may have motivated Vermeer to accept this domestic arrangement. Vermeer earned very little from his paintings during the early and late years of his marriage, and he enjoyed only a brief period of financial security during the 1660s. Income from his father's inn supported Vermeer's mother and sister until 1670 when the artist finally inherited the *Mechelen* and eventually rented it out for crucial income.[52] During the financial vicissitudes of his family life, Vermeer and his wife depended on his mother-in-law and her family for support. Money from the estates of his wife's uncle, Jan, and aunt, Cornelia, as well as financial gifts from his mother-in-law are documented. Furthermore, it is likely that Vermeer and his wife lived rent-free in the house in the Papists' Corner.[53]

The fifteen children Vermeer and his wife had during the twenty-two years of their marriage exacerbated the Dutch painter's economic hardship.[54] A family of this size was rare in the Dutch Republic when many Dutch families were having far fewer children.[55] In light of Vermeer's large family, it isn't surprising that he relied on wealth generated from his wife's family. Perhaps in recognition of this dependence, many of the Vermeer children were given names of close Roman Catholic relatives or were named after Roman Catholic saints.[56] Their first child, born in 1654, was named Maria, probably in acknowledgment of the important familial contributions of his mother-in-law and in honor of the Virgin Mary.

Another daughter was named Elisabeth, perhaps after Catharina's aunt who had become a nun in Flanders. Other children, such as Beatrix, were named after Thins family members who were especially close to the Roman Catholic Church. In all probability, Vermeer named two of his sons after important Jesuit saints. A boy born around 1664 was named Franciscus, perhaps in recognition of the Jesuit martyr St. Francis Xavier, to whom the Dutch Jesuits had been dedicated since 1658.[57] Another child born in 1672 was also given an important Jesuit name, Ignatius, after St. Ignatius Loyola, the founder of the Jesuit order. Of the fifteen children born to Vermeer and his wife, infants died in 1660, 1667, 1669, and 1673. These children were buried in both the *Oude Kerk* and in the *Nieuwe Kerk,* where interment for many different religious sects occurred.[58]

Not much is known about Vermeer's surviving eleven children. However, in the Roman Catholic household where the Vermeer family lived, the children would have presumably received a thorough education in the faith as recommended by the local missionaries.[59] After infant baptism in the local *schuilkerk,* a child growing up in the Papists' Corner would be taught about Christ's life, the important role of the Virgin Mary, the significance of the Roman Catholic saints, and the seven sacraments, especially confession and the Eucharist. Devotional literature, religious songbooks, and catechisms provided the educational tools for parents, priests, and *klopjes* as they instructed the youth of their Roman Catholic community. Two influential and widely disseminated devotional works by celebrated Delft clerics, a catechism by the Jesuit Lodewijk Makeblijde and a songbook by the priest Stalpaert van der Wiele, inculcated in the young the significance of the beliefs and rituals of the Roman Catholic Church.[60] For most children, the first memorable rite in which they participated was first communion at the age of twelve. After that ceremony, they were expected to attend monthly or weekly celebrations of the mass. As they became young adults, Roman Catholic parents hoped that their offspring would marry in the faith or perhaps accept a vocation in the church.[61]

Among Vermeer's children, his first son and namesake, Johannes, apparently intended to become a priest. The younger Johannes was named a beneficiary of an altar in the Roman Catholic church of Schoonhoven after the death in 1676 of his uncle, his mother's brother, Willem Bolnes.[62] The designation of a vicariate for Johannes was meant to finance his seminary training in the Southern Netherlands.[63] Although in the end, Vermeer's son did not become a priest, he apparently remained faithful to Roman Catholicism as is indicated by the baptism of his son that occurred in a Roman Catholic church in 1688.[64] Furthermore, Vermeer's eldest daughter, Maria, married a Roman Catholic man and raised children who were baptized and educated in the Jesuit mission in Delft.[65] Her son, Aegidius, who was born in 1690, became a Catholic priest.[66] Three of Vermeer's daughters never married. Without spouses to support them, these girls relied on inheritances and revenues from properties owned by the Roman Catholic Thins and Bolnes families long after the deaths of the artist, his wife, and his mother-in-law.[67]

Vermeer's large family must have created a crowded, noisy domestic environ-

ment in which the Delft master painted a small number of mostly easel paintings during his twenty-year artistic career. As an artist famed for his images of every-day life, Vermeer's large-scale religious paintings are unusual. Two obvious religious themes appear in his corpus of universally accepted paintings: the early painting of *Christ in the House of Mary and Martha* (Plate 2) and the late painting of the *Allegory of Faith* (Plate 32). In the intervening years, Vermeer painted several works that allude to religious themes by including a painting of a religious subject on the back wall of a domestic interior. In two paintings, *The Astronomer* (Plate 27) and the *Lady Writing a Letter with Her Maid* (Plate 30), variations of a work depicting the finding of Moses hang in the background.[68] A depiction of the Last Judgment is included in Vermeer's famous painting of a *Woman Holding a Balance* (Plate 15). In addition to these pictures, a lost painting called the *Visit to the Tomb* is noted in the famous Amsterdam collection of Johannes de Renialme as early as 1657. Moreover, a painting of *Saint Praxedis* (Plate 1) has also been attributed to Vermeer, a work that if indeed genuine would certainly strengthen early ties to the Roman Catholic Church for the Dutch painter.[69]

The canvas depicts the unusual subject of an early Christian saint named Praxedis collecting the blood of a beheaded martyr (Plate 1).[70] It is signed in the lower left "Meer 1655" and in the lower right "Meer N R[. .]o[.]o. . ," which may mean "Meer naar Riposo," or "Vermeer after Riposo."[71] Compositionally and stylistically, the painting closely follows a version of the same subject painted circa 1640–5 by the Italian Baroque painter Felice Ficherelli (1605–1669?), whose nickname was Riposo.[72] Initially, the similarities between the two paintings supported the position that both works were painted by Ficherelli; however, the unusual signatures in the later work, certain painting techniques associated with Dutch rather than Italian artists, and stylistic similarities to Vermeer's other early paintings led some scholars to attribute *Saint Praxedis* (Plate 1) to Vermeer as a copy after Ficherelli.[73]

In spite of these arguments, doubts have been raised regarding the attribution to the Dutch master. First, neither of the two signatures resembles Vermeer's autograph.[74] Furthermore, in order to copy this work so faithfully, Vermeer either went to see the original Ficherelli canvas in Italy, where it has been since the seventeenth century, or saw a copy, no longer extant, in The Netherlands. It is possible that Vermeer copied a work after Ficherelli that the Dutch painter saw somewhere in his hometown of Delft or in the cities where he likely received his training, either Utrecht or Amsterdam. Copies after Italian paintings were popular and desirable and appeared in the inventories of well-known collectors, such as De Renialme, who owned ten Italian pictures.[75] Since the original painting of *Saint Praxedis* by Ficherelli has never left Italy, some scholars have suggested that Vermeer traveled to Italy and saw the work there.[76] After all, Vermeer's life is undocumented from the time of his baptism to the time of his marriage, and as mentioned earlier he may have traveled south to study on the recommendation of Leonard Bramer.[77]

Certainly, the subject matter of this painting would be an appropriate topic for a recent convert to Roman Catholicism. After all, St. Praxedis and her sister,

St. Pudentiana, arranged baptisms for converts in the early Roman church and preserved the blood and relics of early Christian martyrs. In the seventeenth century, the Jesuits encouraged meditation on the lives of early martyrs, such as Praxedis and Pudentiana, because these saints had worked for the preservation of the Christian faith during a period of persecution.[78] Perhaps in response to a patron's wishes, the artist altered the Italian prototype by adding a crucifix to the hands of the saint to underscore the relationship between the blood of the martyrs and the sacrifice of Christ.[79] Whether by Johannes Vermeer of Delft or by another hand, the subject matter is highly unusual in seventeenth-century Dutch painting and suggests a strong Roman Catholic conviction on the part of the painter and patron.[80]

The painting of *Saint Praxedis* as a theme for Vermeer's early career is not implausible. Vermeer began as a painter of history by concentrating on mythological and religious art themes. In addition to a painting of *Diana and Her Companions* (Plate 3), Vermeer also executed the well-documented early painting of a religious scene *Christ in the House of Mary and Martha* (Plate 2). In this signed canvas dating from the period shortly after he married his Catholic bride, Vermeer acknowledged one of the central issues of debate between Protestants and Roman Catholics: the role of faith and good works in the attainment of salvation. Scholars have consistently commented on the compositional balance of the sisters around Christ in Vermeer's early painting.[81] Both Martha, who carries a basket of bread to the table, and Mary, who rests on a stool at Christ's feet, gaze at Christ. Christ reciprocates the attention of both women by gesturing to Mary and looking at Martha. Vermeer's unifying composition differs from sixteenth-century interpretations of the theme by artists such as Pieter Aertsen (ca. 1507/8–75) and Joachim Beuckelaer (ca. 1534–74). In their works, the active role of Martha and the contemplative role of Mary are sharply contrasted in compositions that separate and distinguish the realms of each sister. Vermeer's unusual pictorial solution emphasizes the shared roles of the active and contemplative lives and subsequently recognizes the significance of both good works and faith.[82]

In this story from the New Testament, Mary and her sister, Martha, entertain Christ in their home. While Martha prepares and serves food, Mary rests at Christ's feet and attentively listens to his teachings. In Luke 10:41–42, Martha complains that she has been left to work alone, "But the Lord answered and said to her, 'Martha, Martha, thou art anxious and troubled about many things; and yet only one thing is needful. Mary has chosen the best part, and it will not be taken away from her.'" In this account, biblical commentators have recognized a contrast between the active life of Martha and the contemplative life of Mary. Furthermore, the sisters have been identified as representing opposing paths to salvation. As she busily labors in the kitchen, Martha stands for the necessity of performing good works. Mary, on the other hand, turns away from the earthly concerns of the hearth and puts her faith in the message of eternal life promised by Christ.

In the sixteenth and seventeenth centuries, Protestants and Roman Catholics disputed the precise roles of faith and good works in the forgiveness of sins and

the promise of eternal salvation as presented in this biblical narrative. For Protestant Reformers, such as Martin Luther and John Calvin, the story of Martha and Mary supported the doctrine of justification by faith alone. According to Protestant doctrinal writings, salvation rests solely on belief in the forgiveness of sin by a merciful God earned by Christ's Crucifixion. In their writings on the gospel of St. Luke, both Luther and Calvin contrasted the domestic activities of Martha to the spiritual concentration of Mary to support their position on faith as the essential requirement for salvation.[83]

Roman Catholics, however, interpret this biblical story as emphasizing the necessity of both faith and good works. In contrast to Protestant doctrine, Roman Catholic teaching claims that man cannot earn salvation by believing solely in the grace of God and the sacrifice of Christ. Instead, faith must lead to acts of humility and good works that concretely secure the redemption of each individual. While visiting the sisters Martha and Mary, Christ recognizes Mary's contemplative role, associated with faith, as the better half. Yet, according to Roman Catholic interpretations of the biblical text, Mary's position is incomplete without the equally important second half, which is the active life of performing good works, represented by Mary's sister, Martha. Together, the faith of Mary and the good works of Martha lead to eternal salvation.[84]

In this first documented religious painting by Vermeer, the Dutch painter acknowledged two divergent paths to salvation. Yet he united the two paths in one compositional and theological presentation. The women and Christ are unified in a circle of interaction that speaks to the coordinated necessity of both good works and faith. It seems that Vermeer understood the conflicts of the Roman Catholic and Protestant approaches to eternal salvation, but he reconciled the divergent views in one convincing compositional solution. It is likely that his marriage to Catharina Bolnes and the close familial ties he established with her Roman Catholic family provided Vermeer with a broad theological reference for understanding and reconciling sectarian differences.

This early painting is informative regarding Vermeer's religious ideas, but it is also important as a confirmation of outside stylistic influences upon the young Delft painter. In this large-scale painting, Vermeer has created a work unlike the pictures produced by most of his Delft contemporaries, including his purported early teacher, Leonard Bramer. Instead, the picture resembles the history paintings of the Utrecht Caravaggists, such as Hendrick ter Brugghen, who studied with Abraham Bloemaert. A stylistic comparison of Ter Brugghen's *St. Sebastian* of 1625 (Fig. 12) and Vermeer's *Christ in the House of Mary and Martha* (Plate 2) shows that both artists present a closely integrated grouping of large-scale figures in the foreground of the composition. Furthermore, the figures, the attributes, and the cursory backgrounds are broadly painted in both works.[85] The similarities between the two paintings seem to confirm an artistic training period in the community of Utrecht in the early 1650s.

Several years later, Vermeer began to paint the representative works with which we associate the painter and his life: that is, small canvases of solitary women in quiet interiors, often engaged in simple acts of domesticity. In general,

uniform midday light illuminates these interior scenes. By contrast, in the *Woman Holding a Balance* (Plate 15), a dark, somber ambience is created in which a solitary, pregnant woman, dressed in a dark blue jacket and white headdress, stands balancing scales before a table covered with pearls, ribbons, and coins. The only suggestion of the outside world is a diagonal beam of white light that slips in through the golden curtain at the upper window to illuminate the warm, orange color of the woman's protruding abdomen. In the background, a painting of the *Last Judgment* is positioned so the figure of Christ, judging the damned and the saved, is placed directly above the head of the standing woman. In contrast to the worldly maps found in other genre paintings, the large, prominent placement of the *Last Judgment* imparts a religious orientation to this depiction.

The inclusion of the *Last Judgment* in the *Woman Holding a Balance* has led some scholars to propose that the spiritual action of Christ in the painting in the background contrasts with the secular business of the woman in the foreground. According to this interpretation of Vermeer's painting, the woman is worldly and vain, weighing precious materials on temporal scales, while in the background, Christ directs the spiritual weighing of souls and determines each individual's fate.[86] Scholars accepted this *vanitas* explanation until the discovery that Vermeer's woman does not weigh anything at all, but instead balances empty scales.[87] Since this revelation, most allegorical interpretations of the painting have focused on moderation, divine truth, and justice.[88]

In these later studies and others, the painting of the *Last Judgment* in the background does not oppose, but rather confirms the woman's activities in the foreground. Since the woman appears to stand squarely between the damned and the saved in the painting on the back wall, she seems to present an optimistic view of the fate of the child she carries in her womb. According to this interpretation, her unborn child is not predestined for heaven or hell at the time of conception, as Calvinists would have argued, but rather, the child is unblemished and will be able to participate actively in the path to eternal life, a position held by Roman Catholics.[89] In Vermeer's pictorial presentation, the final decision regarding salvation or damnation rests with Christ; however, all men and women have the opportunity to work toward salvation through the grace of God and good works.[90] Here, then, Vermeer continued his interest, as he had in his painting of *Christ in the House of Mary and Martha* (Plate 2), in the contentious religious debates of his time regarding free will, predestination, and the efficacy of good works in determining one's salvation.

The depiction of the woman balancing scales also resembles several traditional representations of the Virgin Mary and the iconographic messages they communicate.[91] According to one scholar, the light strikes the woman's stomach "like an annunciate Mary" and other writers have noted that the blue cloak is the traditional color of the Virgin's mantle.[92] Furthermore, the modest attire of the female figure, her placement and illumination within the picture plane, her compositional and iconographic relationship to the painting of the *Last Judgment,* and, finally, the pearls on the table and mirror on the left wall, all support the identification of this woman as a secularized depiction of the Virgin Mary.

If he intended to paint a scene of the Virgin Mary in a secular setting, Vermeer was participating in a tradition established earlier by fifteenth-century Netherlandish painters such as Jan van Eyck, Robert Campin, Rogier van der Weyden, and Petrus Christus. Vermeer's painting of a *Woman Holding a Balance* shares compositional and symbolic characteristics with works such as Christus's panel of the *Virgin and Child in a Chamber,* painted around 1460 (Fig. 45). In both Christus's and Vermeer's images, the Virgin Mary appears as a contemporary mother in a carefully delineated Northern interior with a soft light entering from a window on the viewer's left to illuminate the domestic setting.[93] Vermeer's representation of light streaming into the room from an opened, upper window also resembles the light of conception found in early-fifteenth-century images such as Jan van Eyck's *Annunciation* (Washington, National Gallery of Art) or Robert Campin's *Annunciation* in the center panel of the renowned *Mérode Altarpiece* (New York, The Metropolitan Museum of Art).[94] Furthermore, the Virgin Mary is an important figure in conventional scenes of the *Last*

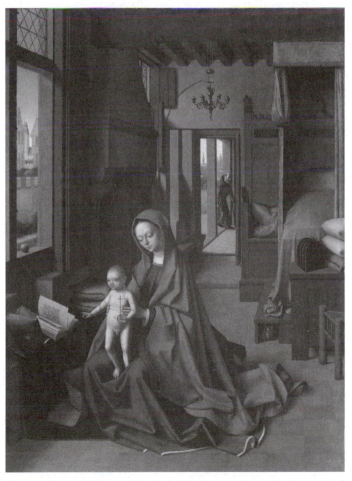

Fig. 45. Petrus Christus, *The Holy Family in a Domestic Interior* (oil on panel, 71.4 × 52.1 cm). Kansas City, The Nelson-Atkins Museum of Art, Purchase, Nelson Trust. Photo: museum.

Judgment from this same early period, such as Rogier van der Weyden's *Beaune Altarpiece* (Beaune, Hôtel-Dieu), where, attired in her traditional blue cloak and a white headdress, she intercedes for the sinner with her son, Jesus Christ. In the *Beaune Altarpiece,* the Archangel Michael weighs the deeds of the dead on scales immediately below the figure of Christ.[95] In Vermeer's painting, the woman balancing the scales takes the place of St. Michael in a contemporary domestic interior.

Like his early Netherlandish predecessors, Vermeer may have depicted a convincing secular setting in order to emphasize the temporal, carnal presence of Christ's first appearance as man on earth in contrast to the second coming of Christ as depicted in the painting on the back wall. If the pregnant woman in Vermeer's painting represents the Virgin Mary, she may be bathed in the light of the annunciation, at the moment of the incarnation, when the savior of the world, Jesus Christ, first comes to earth.[96] For Roman Catholics, such as the members of the Vermeer household, the Virgin Mary is also the intercessor and mediator for sinners on earth; she is the link between heaven and earth, the balance between the secular and the spiritual.[97] The Virgin's placement in Vermeer's composition confirms her role as the fulcrum that balances the celestial and the temporal. She stands vertically with the painting of Christ enthroned in heaven directly above her head while her arm reaches out horizontally to embrace the world.

A consideration of traditional Marian symbolism reveals that Vermeer presented ideas as familiar to seventeenth-century Dutch Roman Catholics as they were to earlier adherents to the faith. Devotional literature, religious celebrations, and paintings produced for Roman Catholic congregations in the North continued to familiarize believers with the traditional attributes of the Virgin Mary, such as the mirror and pearls found in Vermeer's painting.[98] For example, the Virgin is the spotless mirror of God's majesty, a well-known association found in the office for the assumption of the Virgin.[99] In addition, the pearls strewn across the tabletop in Vermeer's painting could also correspond to the role of the Virgin Mary in the incarnation of Christ on earth. According to an account in the thirteenth-century *Golden Legend* of Jacobus de Voragine, which continued to be popular among Dutch Roman Catholics of Vermeer's day, the Virgin Mary is like the shellfish who opened up her soul to the Holy Spirit, which brought forth in her womb the pearl, that is, Christ.[100]

Recently, yet another compelling religious interpretation of Vermeer's depiction of a woman holding a balance has been suggested; the painting may present the concept of conscience and its relationship to death and the Last Judgment.[101] During the sixteenth and seventeenth centuries, Jesuit writers, including the founder, Ignatius Loyola; the famous author of emblems, Adriaen Poirters; and the Amsterdammer, Augustinus van Teylingen, wrote about the role of conscience. Van Teylingen admonished Roman Catholic believers, "And examine your conscience as if you were to die this night and appear before God's judgment."[102] Personifications of conscience appeared as engraved labels

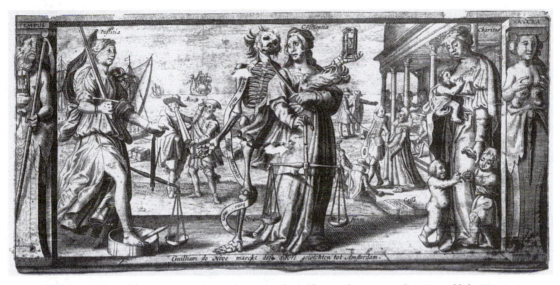

Fig. 46. Guilliam de Neve, *Conscience* (engraving). Leiden, Rijksmuseum het Koninklijk Penning-kabinet. Photo: museum.

on coin-weight boxes, such as the box on the table in Vermeer's painting. In an example from the seventeenth century, the figure of conscience is a woman holding scales and a flaming heart (Fig. 46). According to this interpretation of Vermeer's painting, the scales balanced by the woman signify the internal workings of one's conscience and the moral decisions made by men and women on earth that will be weighed in heaven.[103]

Most of the multiple interpretations of Vermeer's *Woman Holding a Balance* (Plate 15) acknowledge the pivotal interpretive role of the depiction of the *Last Judgment* and the contemplative mood of the image. Whether he intended to present a specific Roman Catholic subject, such as the Virgin Mary, or a more general theological theme, such as the role of conscience or free will, it seems certain that Vermeer included the *Last Judgment* to support and direct the understanding of his painting. In the early 1670s, Vermeer painted another interior scene with a religious painting in the background, but in the *Allegory of Faith* (Plate 32), the religious connotations are much more clearly set forth.

In this late painting, an unusual scene is depicted in a domestic interior that is otherwise typical for Vermeer. A tapestry curtain is pulled back to reveal an elegantly dressed woman gazing heavenward toward a hanging glass ball above her head. With her right hand on her breast, Vermeer's female figure places her right foot on a terrestrial globe and leans with her left arm on a table. A book, chalice, crucifix, crown of thorns, and a slender strip of green material are arranged on an elevated table. A section of gold-embossed leather is placed directly behind the altar, and in the background hangs a large painting of Christ's Crucifixion. In the foreground of Vermeer's interior, a chair with a blue cushion, a snake crushed by a fallen cornerstone, and a partially eaten apple complete the curious composition.

The strange profusion of objects, the theatrical pose of the woman, and the staged presentation of the scene may explain the very early attempts to render intelligible a painting by Vermeer that many scholars in later centuries considered a failure.[104] Although recent scholarship continues to broaden the understanding of the *Allegory of Faith*, it is clear from research conducted as long ago as 1914 that the female figure personifies faith based on entries for faith and specifically Catholic faith in the 1644 Dutch publication of Cesare Ripa's *Iconologia* (Iconology).[105] According to the *Iconologia,* the chalice and book on the table are attributes of faith; the cornerstone symbolizes Christ who destroys Original Sin, symbolized by the snake and apple. Expounding on this identification, later scholars have looked to the pearls around the neck and in the hair of the figure of faith and on the glass ball hanging above this female figure's head. The pearls may serve as a symbol of virtue and refer directly to Catholic faith as expressed in a poem by the celebrated seventeenth-century Dutch author Joost van den Vondel.[106] The strange glass ball hanging from the ceiling has been related to an emblem in a Jesuit publication where a winged youth, representing the soul, looks at the heavenly glass sphere that reflects a crucifix and the sun. The accompanying emblematic message states that even the restricted human mind can comprehend God just as the glass globe can reflect the universe.[107]

An attentive visual examination of the hanging glass globe in the *Allegory of Faith* reveals that Vermeer painted the partially shuttered windows of his own studio on the lustrous surface (Fig. 47). This reflection underscores Vermeer's artistic participation and presence in controlling the illumination of his allegorical scene where a sharp, intense light falls on the tapestry in the foreground and a subtle, more somber light surrounds the personification of faith. According to a recent study of Vermeer's allegorical imagery, the Dutch painter may have likened his deliberate control of pictorial illumination and the application of paint to the canvas of the *Allegory of Faith* to the creative acts of the Christian God in making the invisible or absent present in the visible world.[108] If this interpretation is true, then Vermeer's conversion to Roman Catholicism may be central to the artist's development of a Catholic aesthetic in which the mystical union of the visible and the invisible occurs in his painting.[109] Vermeer's desire to make the absent present in paint corresponds to an interpretation of this painting that acknowledges the Dutch painter's intimate understanding of the rites and doctrines of the Roman Catholic Church.

The pivotal role of contemporary Roman Catholicism for an understanding of Vermeer's painting might explain the Dutch painter's decision to deviate symbolically and compositionally from the descriptions and illustrations found in Ripa's *Iconologia*. Vermeer substituted a scene of the *Crucifixion* for the prescribed image of *Abraham's Sacrifice,* and the artist added a crucifix and a long, fringed piece of green satin cloth, which may be a priest's stole, to the chalice, book, and crown of thorns mentioned by Ripa in his entries on faith, in order to underscore the specifically Roman Catholic nature of his faith. Vermeer's *Allegory of Faith* depends on a thorough knowledge of the central doctrine of Roman

Fig. 47. Detail of Plate 32.

Catholic faith, the mass as a celebration and commemoration of Christ's Passion. Specifically, Vermeer's idiosyncratic image refers to the central issue of disagreement between Roman Catholics and Protestants in the Northern Netherlands in the seventeenth century: the doctrine of transubstantiation, the real presence of Christ's crucified body and blood in the bread and wine of the Eucharist.[110] Furthermore, Vermeer may have depicted a genre interior that served as a contemporary domestic church setting where clandestine celebrations of the mass were held.

According to Roman Catholic teachings, the eucharistic meal of Christ's sacrificial body and blood, initiated during the Last Supper and consummated at the Crucifixion, unfolds at the Roman Catholic altar during every mass. In fact, the entire Roman Catholic liturgy is viewed as a reenactment of Christ's Passion from the moment the priest enters the sanctuary until the final prayers are offered at the close of the service.

Dutch illustrated mass books from the seventeenth century clearly parallel the actions of the priest during the rite to the events of Christ's Passion.[111] In mass books published in Amsterdam and Haarlem, illustrations depicting episodes from Christ's Passion narrative and the corresponding actions of the priest in the church sanctuary are paired with prayers and meditations on the historical events of Christ's final days and their parallels to the daily eucharistic mass (Fig. 48). In the Haarlem mass book, the interpretation of the rite as a reenactment of Christ's Passion is explicitly established, "The Mass shows you Christ's death that he suffered for our great sins. O soul, learn here at God's altar everything that God's son suffered on Calvary."[112]

In the *Allegory of Faith* (Plate 32), the table becomes an altar that conforms in many respects to contemporary Roman Catholic accounts regarding the altar and its liturgical articles. In his devotional writings, the Jesuit priest Johannes David described the Catholic Church altar as decorated "in beautiful tapestries, statues, paintings, lights, and above all the various relics and bones of the Saints."[113] According to liturgical standards, the altar should be placed on an elevated platform and should be carpeted as the altar is in Vermeer's painting, in the illustrations of the Amsterdam and Haarlem mass books, and in prints depicting Roman Catholic sanctuaries.[114] Curtains also hang near the altars in mass-book illustrations and other print sources, which suggests they may have also been adopted in covert Roman Catholic churches in the United Provinces. In Vermeer's painting, the tapestry functions as an altar curtain that is drawn back in the left foreground to reveal the religious setting and invite the viewer to participate in the celebration of the mass as a member of the congregation.[115]

The choice and arrangement of liturgical objects on the altar supports the view that Vermeer intended to present contemporary Roman Catholic Church practices. The most obvious liturgical item is the crucifix, which is a sign "that there [on the altar] living, the same sacrifice is offered/ which once on the cross had been offered/ and therefore during the service of the mass/ we must have the Passion of Christ before our eyes."[116] The chalice also refers to contemporary worship in this domestic sanctuary. According to Roman Catholics, the chalice contains the wine that is miraculously transformed into Christ's blood during consecration on the altar during mass. In Vermeer's painting the large open book with gold clasps on the altar resembles contemporary missals that provided the officiating priest with the complete rite of the mass.[117]

In the *Allegory of Faith*, Vermeer referred not only to the contemporary mass that celebrates the reenactment of the Passion on the altar but also to Christ's actual, historical Crucifixion. Vermeer included a direct reference to Christ's Passion by placing a true crown of thorns on the opened missal on the altar and in the background a large depiction of the *Crucifixion*. For the Roman Catholic community, the representation of the crucified Christ affirms the significance of the mass as a reenactment of Christ's sacrifice at Golgotha. Depictions of the *Crucifixion* were commonly found at the altars or in the sanctuaries of Roman Catholic churches, including the hidden churches in the Northern Netherlands.

The large size and central position of the scene of the *Crucifixion* further supports its integral role in the meaning of the *Allegory of Faith*.[118] The sacrifice of Christ by God the Father is the New Testament covenant that supersedes the Old Testament covenant of Abraham's sacrifice of Isaac.[119] The relationship of Christ's death on the cross, the chalice, and the Eucharist as a New Testament is proclaimed in the Canon of the Mass during the consecration of the wine in the chalice, which Vermeer has placed between the depiction of Christ's body on the cross in the painting on the back wall and on the crucifix on the altar: "Take, and drink ye all of it. For this is the chalice of My blood, of the new and

SACERDOS SIGNAT OBLATA

Fig. 48. Illustration from Andreas van der Kruyssen, *Misse, haer korte uytlegginge*, Amsterdam, 1651. Amsterdam, Universiteits-Bibliotheek Amsterdam. Photo: courtesy Universiteits-Bibliotheek Amsterdam.

eternal testament: the mystery of faith: which shall be shed for you, and for many, unto the remission of sins."[120]

The celebration of the mass and participation in the Eucharist were encouraged by Vermeer's neighbors, the Delft Jesuits. Although the missionaries advocated monthly or even weekly communion, parishioners usually celebrated this important sacrament only during major religious holidays, such as Easter and Christmas.[121] Perhaps as a contemplative and didactic invitation to the Eucharist, Vermeer's *Allegory of Faith* spoke to contemporary Dutch Catholics of the connection between the supreme sacrifice of Christ in the New Testament, as shown in the large painting on the back wall, and the importance of the reenactment of that sacrifice and the real presence of Christ at the altar in the domestic interior.

Nearly every scholar concurs that the sophisticated symbolism in the *Allegory of Faith* was the result of a private, Roman Catholic commission with iconographic advice coming from the local Jesuits. It is unlikely that a specific patron for Vermeer's picture will ever be identified; however, the unusual iconography points to a personal interest in this work that may be traced directly to the painter or to his immediate circle of family and friends.

Within the context of this Roman Catholic community in Delft, the intimate, domestic setting of Vermeer's *Allegory of Faith* is not at all unusual as an actual location of contemporary Dutch Catholic mass.[122] Many of the objects depicted in Vermeer's painting of faith correspond to items in the artist's own death inventory of February 1676, which strengthens ties to Vermeer's personal involvement in domestic church activities. For example, the *Crucifixion* painting in the background of the *Allegory of Faith* is a variation of Jacob Jordaens's original compositions and may refer to the painting of *Christ on the Cross* in Vermeer's death inventory.[123] Moreover, the ebony crucifix and the piece of gilt leather, as well as chairs, tapestries, curtains, and cushions, are all recorded in the 1676 document.[124]

The detailed inventory of Vermeer's possessions was recorded several months after his death on December 13 or 14, 1675.[125] He was buried in the *Oude Kerk* in Delft in a grave purchased by his mother-in-law, Maria Thins.[126] Vermeer was survived by his wife and eleven children, ten of whom were still minors.[127] His family continued to live in the city's Catholic quarter with Maria Thins, and they survived on the kindness and generosity of family and friends of like faith.

Acknowledging the Roman Catholic religious ambience of his home and neighborhood enriches our understanding of Vermeer's artistic themes, stylistic characteristics, and iconographic decisions. A wide range of documents, from the initial marriage announcement in the Delft city archives to the notarized activities of his wife, mother-in-law, and children, attest to the significant role played by the local Roman Catholic Church in Vermeer's life. Although the Northern Netherlands was ostensibly a Protestant country, the Delft Papists' Corner provided a close-knit community of believers who persevered in their support of Roman Catholicism. Vermeer lived in this neighborhood, and although he maintained contacts with religious "outsiders," such as his patron, the reputed Remonstrant, Pieter Claesz. van Ruijven, his art, namely, his handling of religious subjects, is closely related to Roman Catholic teachings and to the interests of the local adherents of this time-honored faith.

8 Vermeer and the Representation of Science

Klaas van Berkel

A painting by Vermeer, presented for auction in Amsterdam on November 25, 1778, was described thus in the auction catalogue:

> Dit Stukje verbeeld een Kamer, waar in een Philosooph zittende in zyn japon voor een Tafel met een Tapytje overdekt, waar op een Hemel Globe, Boeken, en Astronomische Instrumenten, hy schynt met aandagt de Globe te beschouwen, het bevallige Ligt, het geen door een Vengster ter linkerzyde nederdaalt, doed een fraaije en natuurlyke Werking. Verder is het voorzien met eenige Meubelen, alles meesterlyk en fiks Gepenceelt. [This piece depicts a room where a philosopher in his robe is seated at a table covered with a small carpet, and on this a celestial globe, books, and astronomical instruments. His attention seems to be focused on the globe. The light, falling attractively through a window to the left, gives a beautiful and natural effect. The room also contains some furniture, painted with skillful and vigorous brush strokes.]

The painting now hangs in the Louvre in Paris and is called *The Astronomer* (Plate 27), a fairly obvious title in view of the attributes depicted. We see a magnificent celestial globe covered with colorfully decorated constellations. An astrolabe, an instrument for measuring the altitude of the stars, is resting against the foot of the globe. There is also a pair of compasses and in front of the man is a book opened at a page showing a geometrical figure and thus suggesting some connection with mathematics or astronomy.

Such a description will be sufficient for most museum visitors, and indeed, perhaps this is all one needs to be able to appreciate the painting. Yet it is worthwhile dwelling a little longer on the attributes on the table and in the rest of the room. The celestial globe is not just any arbitrary globe. Like the maps that appear in Vermeer's paintings it can be identified quite precisely. The globe in the painting appears to match exactly a celestial globe offered for sale in 1618 by the Amsterdam globe and mapmaker Jodocus Hondius (Fig. 49). Nor is the book on the table just any old book; it is the second edition of Adriaan Metius's *Insti-*

tutiones astronomicae geographicae; fondamentale ende grondelijkcke onderwys-
inghe van de sterrekonst ende beschryvinghe der aerden door het gebruyck van de
hemelsche ende aerdtsche globen (Institutes of Astronomical Geography; Foun-
dational and Thorough Instruction in Astronomy and a Description of the Earth
through the Use of Celestial and Terrestial Globes), published in Amsterdam in
1621 (Fig. 50). Metius was a professor of mathematics in Franeker and had a
series of mathematical textbooks to his name. Although he died in 1635, a few
years after Vermeer was born, his books were not yet considered really obsolete
at the time *The Astronomer* was painted.

But it would be wrong to rush to the conclusion that this painting is a fine
portrayal of "modern" science in Vermeer's day, a painterly expression of what is
often referred to as the Copernican revolution in astronomy, or more broadly
speaking, the scientific revolution of the seventeenth century. To begin with, it
is worth pointing out that representations such as that of the astronomer could
also have an allegorical or emblematic function in the seventeenth century. In
his *Spiegel van het menselijk bedrijf* (The Mirror of Human Trades) of 1694, the

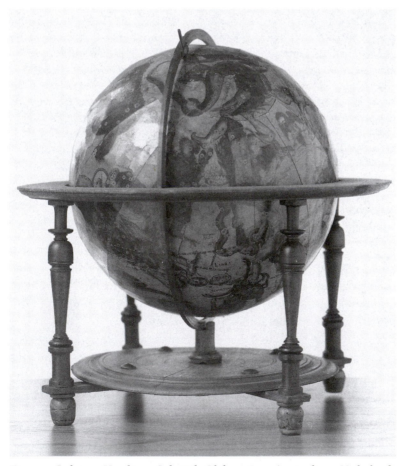

Fig. 49. Joducus Hondius, *Celestial Globe,* 1600. Amsterdam, Nederlands
Scheepvaartmuseum. Photo: museum.

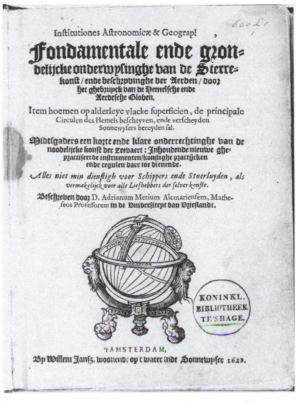

Fig. 50. Title page from Adriaan Metius, *Institutiones astronomicae geographicae . . .* , Amsterdam, 1621. The Hague, Koninklijke Bibliotheek. Photo: Koninklijke Bibliotheek.

Fig. 51. Illustration from Jan Luiken, *Spiegel van het menselijk bedrijf*, Amsterdam, 1695. The Hague, Museum Meermanno-Westreenianum. Photo: museum.

well-known poet and etcher Jan Luiken included an engraving of *The Astrologist* (Fig. 51) and underneath it a moralistic interpretation:

> Soo laag in 't stof te zijn geseeten,/ En 's hoogen heemels loop te meeten,/ Schynt veel: Maar 't is van veel meer nut,/ Den loop des leevens na te speuren,/ En wat' er Eind'ling staat te beuren,/ Op dat men 't Eeuwich Onheil schut [Seated in the dust, so low,/ from where to measure high heaven's course up there/ Seems much: but a far better way to go/ Is on the course of life to ponder,/ On our final lot to wonder,/ So as to avert eternal woe] . . .

Of course we cannot be certain that Vermeer had such moralistic motives in mind when he painted his astronomer, but it is worth remembering that seventeenth-century art and science were still permeated with this moralizing tendency.

An even clearer indication that we should not give too modern an interpretation to Vermeer's painting is the painting-within-the-painting, a shadowy picture of Moses in the ark of bulrushes in the background on the right. The choice of this particular scene for a painting of an astronomer might seem merely fortuitous until one realizes that Moses was associated with science in the seventeenth century, sometimes being referred to as "the oldest geographer." In the Acts of the Apostles 7:22, Moses, having been rescued and brought up by the Pharaoh's daughter, is described as "learned in all the wisdom of the Egyptians. . . ." And indeed, people in Vermeer's day still spoke of "Mosaic science," which was older, wiser, and more respectable than Greek science. In other words, Moses was the patron saint of a type of science that sought knowledge not through new observations, experiments, and calculations but through a return to older sources of wisdom in ancient Egypt or other ancient civilizations.

So this painting presents us with two very different types of seventeenth-century science: the new beside the old, the strictly calculated beside the contemplative, knowledge beside wisdom. Juxtaposed, but not opposed. For even if Vermeer was fully aware of the different types of science represented in his painting, he would not have experienced this as antithetical, any more than would those for whom the painting was intended. Calculation and contemplation were both still elements of one and the same learned world, a world that only began to diverge during the course of the seventeenth century. Vermeer was an outsider; as a painter and art dealer in Delft, a town without a university, he stood outside the intellectual world of scholars and mathematicians. There is no evidence to suggest that he was acquainted with other natural scientists living in Delft (for example, the anatomist Reinier de Graaf and the microscopist Anthony van Leeuwenhoek), and the still frequently voiced assumption that the astronomer in the painting is Van Leeuwenhoek (Fig. 52) is totally unfounded.

But the very fact that Vermeer was an outsider can make it interesting to look at the way he depicted seventeenth-century natural science and in so doing to discover that his work reflects the idea that the study of nature comprehended more than we would nowadays understand by "natural science." *The*

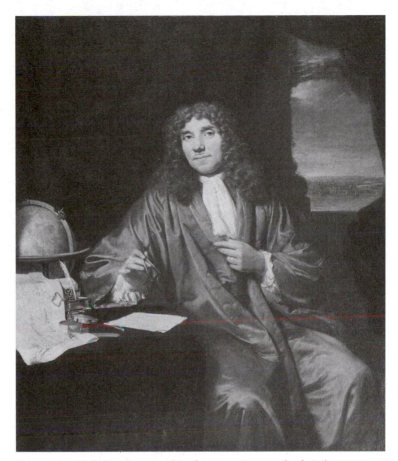

Fig. 52. Jan Verkolje, *Portrait of Anthony van Leeuwenhoek* (oil on canvas, 56 × 47.5 cm). Amsterdam, Rijksmuseum. Photo: Rijksmuseum-Stichting.

Astronomer may in fact serve to put our own view of seventeenth-century natural science into perspective by encouraging us to view seventeenth-century attitudes to nature through the eyes of an outsider with an obvious interest in the subject.

The history of natural sciences in the Dutch Republic is usually linked to a small number of famous names: Stevin, Huygens, Swammerdam, and Van Leeuwenhoek. Those with a wider knowledge of the subject would want to add the names of Snellius, Beeckman, Van Schooten, and De Witt, but this exhausts the list of important names. Subjects such as the acceptance and development of the Copernican system, the introduction of Cartesian philosophy, and the mathematization of natural science culminating in the work of Christiaan Huygens give a brief idea of the way the natural sciences were developing, with Swammerdam and Van Leeuwenhoek's anatomical and microscopic research as their counterpart in the life sciences. If one wanted to encapsulate the various developments in a single phrase, one could talk of "the mechanization of the world picture." Provided this concept is interpreted broadly enough and taken to

include the introduction of mathematics in general and mechanics in particular, as well as a predilection for illustrative mechanical models, it can indeed cover almost anything: Stevin and the development of mathematics; the introduction of the Copernican system, which subjected both heaven and earth to the same mathematical laws; the philosophy of Descartes, who saw in nature nothing but matter in motion; and the anatomy of Swammerdam and Van Leeuwenhoek, who tried to capture the life processes, too, in illustrative models.

But all this is only one side of the picture of seventeenth-century natural science, and one might even wonder whether the coherence suggested by the umbrella concept of the "mechanization of the world picture" does not rope together developments that only superficial observation suggests are related. Because we are used to considering natural science as an entity, based on a particular world view and a common research philosophy, it is difficult for us to recognize that matters were different and more complicated in the seventeenth century. The idea of science as a coherent enterprise was just emerging at this time and still had to compete with other ideal types, for instance, scholarship, and with other ideas about nature. Eventually modern natural science, as we know it, with its specific notions of the researcher and nature, won the day and determined our view of seventeenth-century attitudes to natural science, but in order to reach a well-balanced opinion of what went on in those days, we need to bring the underexposed aspects into the light.

For there was so much more than the mechanistic view of nature. Simon Stevin, who was active in Delft at the beginning of the seventeenth century, did not confine himself to a systematic treatment of all branches of mathematics (especially mechanics) that continued where Archimedes had left off. He was also the man who assumed that there had been a time before classical antiquity when all there was to know about nature was already known. This mythical time he dubbed the *Wijsentijt,* or "Time of Wisdom," and it is clear that wisdom here implied more than mere knowledge and learning. The use of this term indicates that even a man as level-headed as Stevin was affected by the deep fascination with antiquity that was even more apparent in other learned men in the early seventeenth century, and so characteristic of what is usually called the Renaissance. At the time when Stevin was speculating about the *Wijsentijt,* interest in hermetical ideas was taking Europe by storm. These ideas, set down in the *Corpus Hermeticum* (a group of supposedly ancient writings on the occult sciences that were rediscovered during the Renaissance), were older than Plato's dialogues, having originated in ancient Egypt around the time of Moses. Not everyone was charmed by the magic described in the *Corpus Hermeticum,* but even those who distanced themselves from it considered Egypt – in the words of the Leiden anatomist Otho Heurnius – "de opvoedster oudtijds in alle takken van wetenschap en ook heden nog bij alle ontwikkelden stralend in de glans der oudheid" (the educator in ancient times in all branches of learning, and also still today in the eyes of all educated people radiant in the glow of antiquity).

The combination of learning and wisdom expressed in the veneration of

ancient Egypt implied a view of nature itself that seems strange to our modern eyes and at odds with the practice of natural science. But this view, the concept of "the book of nature," was characteristic of the seventeenth-century mentality. According to this concept, everything that occurs in nature has a meaning and refers to a higher moral order on which people should focus. To our eyes this appears to confuse completely the world of facts with the world of values; according to modern opinion natural phenomena have no moral significance and moral judgments can never be based on facts alone. But those who believed in the concept of the book of nature saw things differently: the individual elements, but also the overall structure of the world, implied a Creator who had created nothing without a reason and who had included a lesson or admonition in everything He created. Actually, the world was one great emblem of a higher reality.

In its explicit form, the idea of the world being a text that could be read in a specific way goes back to St. Augustine, but its seed had already been sown in certain passages in the Bible that speak of the "language of things." St. Augustine introduced the metaphor of the two books: in addition to the Bible, where one could read God's revelation, there was the book of nature, where even the illiterate could read about God's intentions with man. Since then the notion of a "legible" world has been a standard feature of Christian culture, and was especially intense during the Renaissance and the Reformation. It was a notion that was particularly popular with the Calvinists, but even for those outside the Calvinist tradition – like Vermeer, who was probably a Roman Catholic – it was a premise that informed their way of thinking and did not necessarily have to be explicitly formulated in order to be actually and decisively present. And unlike the veneration of ancient Egypt, this concept did not wear out in the course of the seventeenth century. A man like the microscopist Swammerdam, although five years younger than Vermeer, still lived entirely in this world; he saw the finger of God in the anatomy of a louse and left behind a work that was later, and quite in accordance with the author's intentions, published as *Bijbel der natuur* (Bible of Nature).

But not everyone gave such clear expression to this idea. In his detailed descriptions of what he saw through his self-built microscopes, Swammerdam's fellow Delft microscopist, Anthony van Leeuwenhoek, betrayed hardly any real emotion about the wisdom and omnipotence of God that was visible in even the *allerkleinste dierkens,* the tiniest of creatures. He behaved or posed as the open-minded self-taught man who merely recorded what he saw, and he did not allow himself to be influenced by the learned and lofty ideas about nature that were to be found in books. But he was the exception that proved the rule, and this rule was more aptly illustrated by the many cabinets of natural curiosities that became increasingly popular in the middle of the seventeenth century. The cabinets were an expression of the notion that nature in all her multifaceted variety was the counterpart of the book of grace that was read aloud at home and in churches.

The average cabinet of curiosities also contained some mathematical instruments, a pair of compasses, a Jacob's staff (a device for navigators to measure latitude), and an astrolabe or a set square (to be joined later on by physical instruments such as the microscope, the thermometer, and the vacuum pump). The presence of such instruments reflected an important aspect of seventeenth-century science: the flourishing of the mathematical, often very practice-oriented, sciences. The study of mathematics was pursued not only as a science per se but also, and in particular, for any practical applications it might have. In a country under construction – an epithet that certainly applied to the Dutch Republic at the beginning of the seventeenth century – there was great need of mathematical expertise in a wide variety of fields: for architects designing buildings, for cartographers mapping shipping routes and land reclamation schemes, for instructors in navigation teaching seamen how to chart a course at sea, for engineers building fortifications and providing assistance for sieges, and for teachers of arithmetic educating students in modern accounting methods. Painters, by virtue of their knowledge of perspective, were part of this world of mathematics and practical application and they, too, used old or new instruments. Yet it would be a mistake to overemphasize the practical value of the instruments. The production of mathematical equipment went beyond what was necessary for the scientific and practical market: the instruments were also status symbols intended to show that their owners were keeping pace with their time and shared the contemporary passion for meticulously measuring, mapping, classifying, and describing the "book of nature."

And so we have come full circle to Vermeer's *Astronomer*. It does not portray a "real-life" astronomer – someone like Christiaan Huygens, who in 1656 had discovered the ring of Saturn with the aid of a telescope. By 1668, when Vermeer painted his picture, this instrument was part of the standard equipment of every astronomer, but it is not to be found in Vermeer's painting. Vermeer's attention to detail in painting the globe and the book is utterly misleading, or rather, given their age, utterly revealing. It is true that Metius's book was not exactly obsolete, but it was certainly not the latest and most up-to-date, and the same applied to Hondius's celestial globe. Vermeer shows us an idealized picture of the astronomer/philosopher reflecting on the cosmos with the help of a book and some instruments; someone who not only calculates and describes but also reflects and contemplates.

He did something similar in another painting, nowadays known as *The Geographer* (Plate 28). For a long time these two paintings were bought and sold together – *The Geographer* contains a terrestrial globe that is a pendant of the celestial globe in *The Astronomer* – and in auction catalogues they were often described in a similar way. In addition to architect and scholar, the pictured geographer was also called philosopher. The symbolic import of the portrayal is even more evident in *The Geographer* than in *The Astronomer*. Eddy de Jongh has previously pointed to a strong affinity with a geographer (Fig. 53) depicted in Abraham Spinneker's *Leerzame zinnebeelden* (Instructive Emblems of Virtue) of

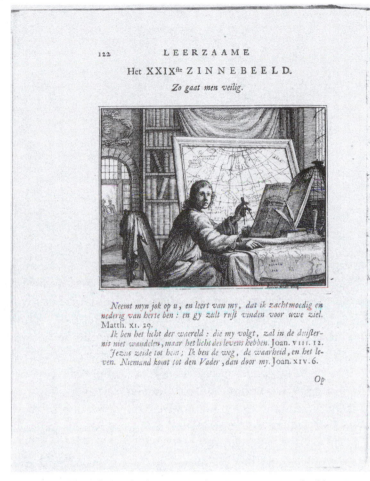

Fig. 53. Emblem from Abraham Spinneker, *Leerzame zinnebeelden*, Haarlem, 1714. The Hague, Koninklijke Bibliotheek. Photo: Koninklijke Bibliotheek.

1714, in which the observer/reader is informed in an accompanying verse that he needs only two "maps" to guide him safely through life: the Gospel and the life of Jesus. The moral dimension is not so explicitly visible in Vermeer's painting, but it must have served as a background to interpretation for both painter and spectator. Since this moral dimension had not yet disappeared from the science of his day, Vermeer turns out to have been closer to the reality of seventeenth-century science than we had originally supposed.

9 Seven Vermeers

Collection, Reception, Response

Christiane Hertel

"Everybody likes Vermeer, except me. He doesn't mean anything, he has no significance."[1] The truth of these recent statements by the British painter Francis Bacon (1909–92) might be self-evident to the viewer of his paintings as much as it is to the reader of the many enthusiastic reviews of the 1995–6 Vermeer exhibition in Washington, D.C., and The Hague, the only comprehensive Vermeer exhibition to date.[2] Bacon's vehemence, however, would seem to suggest that Vermeer is a famous contemporary artist whose shadow or presumed influence Bacon means to shed or confute. Indeed, one way of thinking about Vermeer is to think about the phenomenon that his relevance in the present continues to issue the kind of direct emotional and intellectual challenge usually connected only with contemporary art.

Arguably, the history of collecting Vermeers and the history of his critical reception are closely related, since before their color reproduction, let alone digital ubiquity, any attempt to understand them would be most productive where several of his works could be seen together, for example, in Amsterdam or The Hague. In Jon Jost's film *All the Vermeers in New York* (1992) the notion of such a group as a set of established or powerfully suggestive relations still seems to be at work. The art historian, however, may be said to be free to combine, arrange, and compare the thirty-five or so Vermeers in any way she or he chooses to. To take responsibility for one's free choices means to be aware of one's guiding interests, such as, for example, understanding the functions and the power of Vermeer's paintings. It is here that it can be helpful to know to what extent one's interests stand in art-historical and critical traditions and can be supported by them, or, on the contrary, to what extent they seem thus far to have been excluded by those traditions.

Here the focus will *not* be on the ideological conditions of art-historical inquiry or on methodology as such.[3] In three separate sections I will focus on specific aspects of Vermeer reception: collection, critical reception, and poetic and artistic response. To do so I have chosen seven paintings, a group suggested to me by George Deem's *Seven Vermeer Corners* of 1999 (Fig. 54), a painting that I will discuss at the end of this chapter. The seven Vermeers are *The Milkmaid*

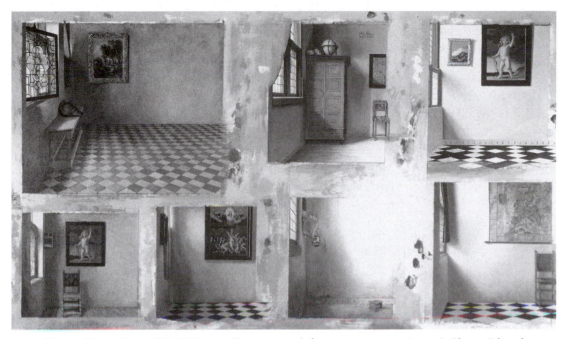

Fig. 54. George Deem, *Seven Vermeer Corners*, 1999 (oil on canvas, 127 × 218.4 cm). Photo: Edward Petersen Jr.

(Plate 8); *The Glass of Wine* (Plate 9); *Girl Interrupted at Her Music* (Plate 12); *Woman Holding a Balance* (Plate 15); *Woman with a Lute* (Plate 16); *The Geographer* (Plate 28); and *Lady Standing at the Virginal* (Plate 33).

I will begin by defining "reception" for our purposes. In *Truth and Method* (1965), the German philosopher Hans-Georg Gadamer relates reception to experience and understanding rather than to notions of aesthetic quality and taste, and then raises the question of how experience relates to history:

> Admittedly, there appears to be an obvious distinction between the original world structure established by a work of art and its survival in the changed circumstances of the world thereafter. But where exactly is the dividing line between the present and the world that comes to be? How is the original life significance transformed into the reflective experience that is cultural significance?[4]

I draw attention to this passage not in order to advocate that we no longer distinguish between the "original life" and "survival" or afterlife of works of art but rather to make us mindful of what such a distinction can accomplish. Where the documented history of collecting Vermeer and Vermeer historiography are concerned, this distinction between original life and afterlife is obviously useful. But where questions of understanding and of cultural significance are raised, this distinction is insufficient to the extent that it does not correspond to the individual reflective and self-reflective experience on which, in Gadamer's account, cultural significance relies. He further specifies this experience as understanding:

Understanding is never a subjective relation to a given "object" but to the history of its effect; in other words, understanding belongs to the being of that which is understood.[5]

On this account the notion of an Archimedian point outside of the hermeneutic circle or outside of the history of Vermeer's reception becomes untenable. What there is, instead, is the art historian's situation of being always already immersed in this history, even as one is standing in front of a painting and endeavoring to take a fresh look. The endeavor is not foreclosed by this immersion, but it is informed by it. To understand cultural significance then means to understand both painting and reception from within both. In the three following sections on collection, reception, and response, my account will therefore shift from the presentation of facts to that of interpretations.

Collection

> SHE: *It's the Queen's picture.*
>
> – Silence –
>
> HE: *I hope she appreciates it.*
>
> (A couple attending the Vermeer exhibition at the
> Mauritshuis in The Hague in April 1996)

Among Vermeer's first documented collectors were the wealthy burgher Pieter Claesz. van Ruijven and the baker Hendrick van Buyten.[6] Both were citizens of Delft and art collectors. After Vermeer's death Van Buyten accepted two of Vermeer's paintings as security against a staggering debt "for bread delivered" amounting to over 600 guilders, a historical detail crystallizing like no other the painter's inability to earn his bread.[7] And yet the above-mentioned value would suggest that Vermeer's was by no means a breadless art. In 1657 Van Ruijven lent money to Vermeer, and though he may have started his collection of perhaps as many as twenty Vermeers out of financial interest, it was only to find himself eventually changed into a spellbound admirer and owner of nearly "all the Vermeers in Delft," or so we may speculate.[8]

When the Van Ruijven collection, turned by inheritances into the Jacob Dissius collection, was auctioned in Amsterdam on May 16, 1696, not a single one of the listed twenty-one Vermeer paintings fetched the high price Van Buyten had found appropriate many years earlier.[9] Presumably he appreciated them, for evidently these two as well as another large Vermeer can be found on the posthumous inventory of Van Buyten's collection of paintings drawn up in July 1701.[10] But in any case one can only gauge the esteem in which Vermeer was held on the basis of his works' sales value. Today, as the interest in landscape and cityscape is rising, it is noteworthy that in 1696 lot thirty-one, *The View of*

Delft (Plate 11), "was valued higher than any other picture in the sale." For a subsequent collector of a Vermeer, however, it was much more important to see the work listed at all in the Dissius sale catalogue as the best possible pedigree one could hope for.[11] In fact, most of the paintings listed in it have been identified, with some open questions left about similar paintings, "similar" to the extent that the spare descriptive language of the catalogue might in some cases apply to several paintings depicting musicians.

Of our seven Vermeers three are found on the Dissius list, *Woman Holding a Balance* (Plate 15) and *The Milkmaid* (Plate 8) as lots one and two, and, probably, *A Lady Standing at the Virginal* (Plate 33) as lot 37; they sold for 155, 175, and 42 florins, respectively. The first two were bought by the Mennonite merchant Isaac Rooleeuw, whose initial eagerness in bidding high might have set a promising tone for this auction. Here I want to consider the fortune of *The Milkmaid*. The 1696 catalogue entry was brief: "A maid who pours milk, outstandingly good."[12] When for reasons of bankruptcy Rooleeuw had to part with his Vermeers already in April 1701, this work was titled *A Little Milk Pourer* and described as *"krachtig,"* or "vigorously" painted.[13] When it changed hands and collections seven more times, the description as "vigorously" painted became attached to it. It was taken up in nineteenth- and twentieth-century scholarship, beginning with Roeland van Eijnden and Adriaan van der Willigen in their *History of Painting in the Fatherland* (1816). After likening Vermeer to Titian because of his vibrant colorism, they write of the "famous" *Kitchen Maid* that they know of "no other painting of this subject that surpasses it in vigor and natural expression."[14]

The customary, if inaccurate, title *The Milkmaid* suggests a rustic scene of actual milking, and this georgic association may have contributed to the popularity of the painting, as if this kitchen maid had come to stand in for the quintessential and heraldic "Dutch Maid" in "Holland's Garden," and, up to the age of television advertisement, for the wholesomeness of Dutch dairy products.[15] In this sense Vermeer's *The Milkmaid* would eventually come to belong to the entire Dutch people, yet her entry into the national collection of Dutch paintings, the Rijksmuseum in Amsterdam, was rather complicated. It had been part of the Van Winter Six Collection since 1822, until in 1907 the Six van Vromade family decided to offer thirty-nine paintings total, including *The Milkmaid*, for sale, with the stipulation that all be bought together.[16] After some negotiation the Rembrandt Society agreed to this and appealed to the Dutch government to contribute three-quarters of the needed funds, a decision to be made in parliament. Arguing against this acquisition was the art historian Frits Lugt, and his article written to this effect stirred a response that turned Vermeer's *Milkmaid* overnight into an invaluable national treasure whose imminent loss to rich American collectors buying up all Vermeers on the art market at whichever price would be considered a national embarrassment.

Abraham Bredius, scholar of Vermeer and the director of the Mauritshuis, went so far as to suggest trading Paulus Potter's (1625–54) best-known painting,

The Young Bull (1647; The Hague, Mauritshuis), for the *The Milkmaid*.[17] In retrospect this almost chivalrous gesture of sacrificing a bull in order to rescue a maid may have its comical side, but at the time it meant to fight and win "the battle to preserve the Dutch art possessions for the fatherland."[18] From Van Eijnden and Van der Willigen's early patriotic viewpoint this sacrifice would probably have been senseless, for in 1816 they considered Potter's *Young Bull* a "widely famous piece." They point out that as part of the Napoleonic art booty of 1795 *The Young Bull* had been "one of the most admired pieces" in Paris and been returned home as "our triumphant weapon."[19] It did not fall prey to Bredius's suggested sacrifice, for in 1908 the Dutch parliament decided overwhelmingly to acquire all thirty-nine paintings.[20]

This drama made *The Milkmaid* worth at least thirty-eight other, by now highly valued, Dutch paintings and attached as much patrimonial as material value to the painting. Accidental or not, Vermeer's creative transformation in it of the daily staple of bread and rolls into what appear like the most precious sparkling, bejeweled objects almost foreshadowed the transformation of Vermeer's paintings into a precious commodity (and, in four instances, victim of theft).[21] Apparently Dutch museums could not compete for Vermeer's *Woman Holding a Balance* (Plate 15), which was acquired by Peter Widener in 1911 and once, between 1696 and 1701, had been the companion to *The Milkmaid* in Rooleeuw's collection. It is now "one of the greatest masterpieces in America," and in 1986 Beatrix, Queen of the Netherlands, prefaced Peter Sutton's guidebook, *Dutch Art in America*, with the insight that "art reveals the creativity of a people and perhaps even its identity. . . I therefore hope this *guide* will pave the way for the enjoyment of Dutch art in the United States."[22]

But what happened in the centuries between the sales of Vermeer's paintings to wealthy burghers in the early eighteenth century and their sale in the years around 1900 again to wealthy collectors from the world of business and commerce?[23] First, some Vermeers, though only five, or perhaps six, of the extant thirty-five, appeared at court. Referring to that sovereign's 1754 purchase of Raphael's *Sistine Madonna* (Dresden, Gemäldegalerie Alte Meister), Prussia's enlightened absolute ruler King Frederick the Great famously quipped:

> The King of Poland is free to spend 30,000 *Ducaten* on a painting and to impose a tax of 100,000 *Reichsthaler* on Saxony, but this is not my method. What I can afford, for a reasonable price, I buy, but what is too expensive, that I leave to the King of Poland; for I cannot make money, and to impose taxes is not my way.[24]

Judging by his *Observations on Painting* of 1762, Christian Friedrich Hagedorn, soon to become director of Dresden's newly founded Royal Academy of Art (1764), approved of Frederick the Great's reasonable taste for contemporary French art and seventeenth-century Dutch painting. With obvious innuendo to Frederick's modern ideas on art and on the state he remarked: "At a certain German Court, in the case that a poll were conducted, Raphael would lose against

Watteau."[25] He pointedly added: "We love change."[26] And while it is true that Frederick acquired the finest version of Gerard ter Borch's *Paternal Admonition* (Berlin, Gemäldegalerie), he did not buy the Vermeers now in the same museum (*The Glass of Wine* [Plate 9] and *Woman with a Pearl Necklace* [Plate 14]), whereas Augustus III, Elector of Saxony and King of Poland, did acquire those Vermeer paintings now in Dresden. In fact, he amassed a large collection of excellent paintings from all "schools," including the Dutch, among them Vermeer's *Procuress* (Plate 4) in 1741 from the Wallenstein collection in Dux and *Girl Reading a Letter at an Open Window* (Plate 7) in 1742 in Paris.[27] Of course, this latter picture was thought to be by Govert Flinck, and when Johann Wolfgang von Goethe visited the Dresden Paintings Gallery in 1794, he annotated entry 346 in his French collection catalogue of 1771 with the words "cute and pretty."[28]

To develop a taste for Dutch painting was not uncommon among the royalty and upper aristocracy of eighteenth-century Europe, and paintings by Vermeer entered their collections, if not always under his name. In 1762 George III, King of England, acquired Vermeer's *The Music Lesson* (Plate 17) as a Frans van Mieris the Elder (1635–81).[29] And at some point between 1777, its last documented sale, and 1826, when it was sold again by Maximilian I Joseph, King of Bavaria by Napoleon's grace, Vermeer's *Woman Holding a Balance* (Plate 15) entered the Bavarian court collection as a "Gabriël Metsu, and according to others van der Meer."[30] Duke Anton Ulrich of Brunswick, who bought Vermeer's *The Girl with the Wine Glass* (Plate 13) as a Vermeer by 1711, was an outstanding connoisseur of Dutch and Flemish painting who may have traveled to Holland when some of the authors of the works he collected for his gallery at Saltzdahlum (Saltzthal) – Rembrandt van Rijn (1609–69), Jacob van Ruisdael (ca. 1628/9–82), Vermeer, Jan Steen (1626–79), and others – were still alive.[31] And *Lady Seated at the Virginal* (Plate 35) entered the Schönborn collection at Pommersfelden in 1764.

In 1785 the art dealer Alexandre Joseph Paillet imported Vermeer's pendants, *The Astronomer* and *The Geographer* (Plates 27, 28), to Paris, and offered them, along with other paintings, to Count Angevillier, Louis XVI's General Director of Works, for the as yet to be completed Luxembourg galleries.[32] Of the eleven Dutch paintings the two Vermeers and a painting by Pieter de Hooch (1629–84) were rejected. All three, as well as Vermeer's *Lady Standing at the Virginal* (Plate 33), were for sale from the collection of Jan Danser Nymans in September 1797 in Amsterdam. At this point *The Astronomer* and *The Geographer* were separated and henceforth have remained so.[33] "It's a miracle!" one critic exclaimed when the two were temporarily reunited, not in Washington, D.C., or The Hague, but in Frankfurt in 1997, "by courtesy of Angevillier's current successor, the French minister of Culture."[34]

While the notion of the collector as connoisseur of art and, in this sense, as art critic, dates back at least to the Renaissance, such a notion received a far sharper profile in the eighteenth century, the age of critique. By the century's end this notion or ideal received Goethe's fictional treatment, undoubtedly inspired by Denis Diderot, whom he translated, in his *The Collector and His*

Circle of 1799.[35] With regard to Vermeer, it is in Etienne Joseph Théophile Thoré alias William Bürger that we find this notion realized, not idealized, to an as yet unprecedented degree. His work as collector of Vermeers and as author of the first catalogue raisonné on the artist was foundational.[36] After promoting the showing of eleven Vermeers, only four of which are now accepted, at the Retrospective Exhibition of old and modern masters at the Palais des Champs-Elysées, Thoré published his Vermeer monograph and catalogue raisonné in three parts in the *Gazette des Beaux-Arts* in the fall of 1866.[37]

In his Vermeer monograph Thoré refers to this exhibition without mentioning his role in it, and when he refers to *The Geographer* (Plate 28) at the "Galérie Péreire," we might never guess what we now know, namely, that he had negotiated Isaac Péreire's advantageous purchase of it a few years earlier.[38] Furthermore, in Thoré's mind, there may well have existed connections between his efforts in Vermeer matters that year and his critique of the 1866 *Salon,* in which he interprets Gustave Courbet's *Stonebreakers* (1851; formerly Dresden, Gemäldegalerie Neue Meister) as an allegory of "hard, unproductive and mind-deadening work" and, by contrast, Jozef Israëls's *Interior of an Orphanage at Katwijk* (1866) as a "naïve" allegory of "simplicity, chastity and work" in the tradition of Gerard ter Borch (1617–81) and De Hooch.[39]

Of the seven Vermeers, Thoré owned one, *A Lady Standing at the Virginal* (Plate 33), since 1864, and discussed six in his 1866 monograph, that is, all except for the *Woman with a Lute* (Plate 16), whose whereabouts between 1817 and 1897 remain unknown.[40] He owned three more, *Woman with a Pearl Necklace* (Plate 14), *The Concert* (Plate 20), and *A Lady Seated at the Virginal* (Plate 35), in addition to others he wrongly attributed to Vermeer. For example, he owned an *Interior of a Béguinage,* which he playfully used as a headpiece illustration for his monograph's first part (Fig. 55).[41] Thoré also advised both private and public collectors, among the former the Parisian Léopold Double on his purchase of *The Astronomer* (Plate 27), and among the latter Sir Charles Eastlake, director of the National Gallery in London, who sought Thoré's advice in 1864, only to let three opportunities pass.[42] In the case of *A Lady Standing at the Virginal* (Plate 33), which Eastlake rejected as "not quite eligible," the painting finally entered the National Gallery after all from Thoré's own collection auctioned in Paris in 1892.[43]

Finally, toward the end of the nineteenth century, we see the collecting of Vermeer to be no longer exclusively a private activity but one pursued on behalf of the general educated public as well. Between 1885 and 1911 our seven Vermeers entered the collections in which they still reside. Four of them entered museums: *The Geographer* (Plate 28) in 1885, *The Glass of Wine* (Plate 9) in 1901, *A Lady Standing at the Virginal* (Plate 33) in 1892, and *The Milkmaid* (Plate 8) in 1908. The other three entered private collections that were subsequently bequeathed to the public or given to museums: *Woman with a Lute* (Huntington Collection, 1897; Plate 16) in 1925, *Girl Interrupted at Her Music* (Frick Collec-

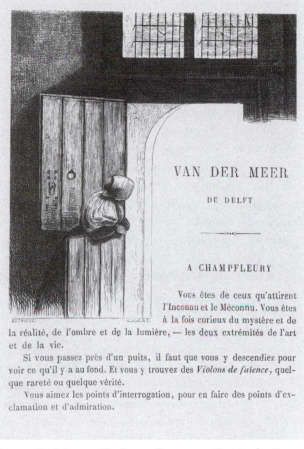

Fig. 55. Noël Sotain, Headpiece illustration, *Gazette des Beaux-Arts* 21 (1866): 297. Photo: David Sullivan.

tion, 1901; Plate 12) in 1935, and *Woman Holding a Balance* (Widener Collection, 1911; Plate 15) in 1942.

Reception

We are going from Oriental to French!

(A Philadelphia suburban homeowner explaining her
"part-contents of house sale" in September 1999)

Thoré's work revealed "the shifting boundaries between his roles as art historian, critic, expert, *amateur,* and dealer."[44] It also prompted criticism, from Henry Havard in 1888 to Ben Broos in 1998, of negligent or even deliberate historical inaccuracy on his part and unfounded judgment.[45] In a (too) practical sense these shifting boundaries between Thoré's roles would seem to correlate

to Gadamer's question, "But where exactly is the dividing line between the present world and the world that comes to be?" It appears that with regard to Thoré this has recently become the question of his integrity rather than the question of what kind of world disposed him to engage with Vermeer in the ways that he did. One medium of engagement, and my main interest in this section, was his art critical language, which was not simply his own.

In a small part at least this language began to be formulated in the sales catalogues of auctions, and thus again with the aforementioned Dissius sale in 1696. "Artful," "vigorous," and "beautiful" are the most common adjectives used there for Vermeer's paintings. Presumably he shared them with some of the other 111 paintings auctioned that day, this sharing being the very condition of the catalogue's legibility. In 1696 *Woman Holding a Balance* (Plate 15) is described as "painted in an extraordinarily skillful and vigorous way," and in 1767 again as "painted in a vigorous, elaborate and radiant way," whereas in 1826 "vigor" makes room for "exquisite softness" and "natural effect."[46] Such exquisite softness combined with natural effect is in keeping with the early-nineteenth-century taste for the Dutch *fijnschilders* (fine painters), their almost imperceptibly refined application of paint and its overall appearance of high finish.[47] While no one today would place Vermeer's art in the context of the *fijnschilders,* in 1826 this placement was a way to relate it to a current taste, within which Vermeer's *Woman Holding a Balance* received high marks, as it was offered for sale from the Bavarian Royal Collections. There are reconcilable aspects in both accounts, that of Vermeer's vigor and that of Vermeer's exquisite softness, and both have found their way into the recent critical descriptive language for his painterly accomplishments in *Woman Holding a Balance.*[48] In this case the early, brief characterizations of Vermeer's manner and technique of painting and contemporary accounts, based in part on scientific analysis, mutually elucidate each other and may testify to permanent qualities in Vermeer's art of painting.

As this example demonstrates, the descriptive language chosen for Vermeer can be historically bound and at the same time valid or helpful in a different period. Probing this possibility further, we might ask how it makes sense that the terms *krachtig* (powerful) or *vigoureux* (vigorous) were applied to both Vermeer's *Milkmaid* and *Woman Holding a Balance* (Plates 8, 15) in the eighteenth century, when to us the first now looks colorful and vibrant, whereas the second derives its power from a tonal chiaroscuro. To understand better how the term "vigorous" was then used, we might first seek out its equivalents in Karel van Mander's earlier *Book on Painting* (1604) and in later Dutch texts. We may then trace the different eighteenth-century French usage, which was so influential in the development of modern critical terms, in Diderot's *Notes on Painting* (1765) or in Antoine-Joseph Pernéty's *Portable Dictionary of Painting, Sculpture and Engraving* (1757).[49]

Is it possible that a particular art dealer may not only have reacted to the early accounts of the value and of what is particular to Vermeer's art but also

shaped those accounts? Five of our seven paintings were sold at one time or another by the dealer Philips van der Schley, Amsterdam, some even several times. "From 1760 on Philips van der Schley and his associates were the chief auctioneers" in Amsterdam and their sales were "the most important in Holland."[50] Their catalogues were published in French. Did they coin a set of adjectives for the appraisal of Vermeer's paintings by others as well as for the critical writings of later generations? In the Van der Schley descriptions nothing counts but the outstanding quality of Vermeer's technique and its effects. Here is what is said about them: *Woman Holding a Balance* (Plate 15) is "painted very softly and thickly being from the best period" (1777); *Woman with a Lute* (Plate 16) is "striking of light and beautifully painted" (1817); *Lady Standing at the Virginal* (Plate 33) is "very beautiful of brushwork" (1797).[51] *The Astronomer* (Plate 27) is "masterfully and vigorously" painted and *The Geographer* (Plate 28) "no less artfully" than "the preceding piece, being a pendant of the same" (1778). This characterization is repeated in 1797 ("artful and masterly") and again in 1803 ("masterly").[52] The only surprise comes in the one case where the Van der Schley catalogue entry speaks of the subject in *Girl Interrupted at Her Music* (Plate 12), which is said to be "of pleasant touch, bright coloring and very expressive action" (1811).[53] Here we may take the interruption, the woman's acknowledgment of a viewer's presence, to be that "very expressive action." While much of this now appears self-evident or even commonplace, it is only because these very phrases that once served the purpose of advertising have gradually become one with a general and popular notion of Vermeer as a great master.

It is to *The Geographer* (Plate 28) that I now wish to turn for the exploration of other modes of reception than that based on inherited descriptive terms, namely, the modes of art-historical inquiry practiced in the twentieth century with links back to older critical traditions. Of the seven Vermeers, *The Geographer* is the only painting with a single male figure. At the same time, it is one of seven with a window, of three with a rug, of two with a map, of four with a curtain, of three with objects lying on the floor, of three with a border of tiles. It is also one of three with what I will call a blank, that is, an unidentifiable though prominently placed object. It is one of two interiors with a single man in Vermeer's extant oeuvre, the other, of course, being its pendant, *The Astronomer* (Plate 27). This is to say that we tend to perceive Vermeer's domestic interiors as women's spaces. The men who visit them there, as in the *Girl Interrupted at Her Music* (Plate 12) or *The Glass of Wine* (Plate 9), stand. Their presence may also be taken as external to what is shown, as in *Lady Standing at the Virginal* (Plate 33), where both the Lady and her Cupid look out at what is often presumed to be a male beholder-lover, or as, perhaps, in *Woman with a Lute* (Plate 16), where the musician may just be daydreaming and tuning her instrument, but who also has been said to look out of the window awaiting her musical companion.

Given the many other motifs shared with women's spaces, such as the rug, how does *The Geographer*'s interior become a man's space? At least in part, this seems to be the task of the cabinet or cupboard standing in the corner. The

objects on its top, books and Jodocus Hondius's terrestrial globe of 1618, fore-
stall any association of this piece of furniture with linen closets. Whatever it fig-
uratively contains instead must have to do with the geographer's occupation and
knowledge, and the same may be said about *The Astronomer,* the only other
work showing this cupboard. This is to say that like all of the seven Vermeers,
but with special emphasis, *The Geographer* is organized along and in relation to
the powerful vertical of its corner. This formal observation becomes more inter-
esting when one considers what exactly Vermeer has placed in front of the cup-
board's lower half and why.

To pursue these issues further within the framework of *The Geographer*'s
modern art-historical reception, we may turn to the following statement about
Vermeer that the art critic and historian Wilhelm Hausenstein made in a letter
of October 16, 1923, while traveling in the Netherlands: "Vermeer is the classical
sublimation of that Dutch situation of flatness at 0 meter above sea level."[54] We
can take this as a "high versus low" statement that elevates Vermeer above and,
in fact, sees him overcome, the age-old account of the Dutch situation as flat
and low. Seventeenth-century English anti-Dutch propaganda takes "flat" to
mean "base" ("this indigested vomit of the sea," 1651), and eighteenth-century
French art criticism associates it with a phlegmatic, if perseverant mind-set
incapable of an elevated style ("ce flegme laborieux, & persévérant dans le tra-
vail," "le genre ignoble," 1757).[55] But if this were so, whence Vermeer's ability in
sublimation and elevation?

Here is the great scholar of Netherlandish painting Max J. Friedländer, from
his 1923 handbook on seventeenth-century Dutch painting (in the *Propyläen
Kunstgeschichte* series):

> Vermeer was strangely unproductive . . . [and worked with the] clean subtlety
> of a goldsmith, who aims at bringing forth something rare, precious, and
> keeps himself free from that tradesman-like routine with which almost all
> Dutch painters of the time economically exploited the dexterity of their hand.
> He works slowly and thoughtfully, as if for another public than his peers do,
> as if for ambitious art lovers who appreciated and remunerated the extraordi-
> nary. What he saw, people and buildings, is familiar, Dutch, however, in his
> way of seeing, there is something foreign.[56]

And this "something," Friedländer adds, makes Vermeer "a hummingbird among
sparrows" and an artist whose genius lies in his "perceptive sensibility" (*Sinnener-
leben*).[57] And so Dutch phlegm acquires color and wings. It was Thoré who in 1866
first speculated on this "foreignness" in relation to *The Geographer* (Plate 28):

> Perhaps Vermeer often wished to go to Japan, to Java, in order to see there
> the atmosphere and color? Perhaps he thought of those countries of the sun,
> when he painted his *Geographer* . . . measuring the distance![58]

In these characterizations Vermeer is a gentleman painter, too refined and digni-
fied to pursue painting for the sake of earning his bread and, in this sense, as a
form of self-exploitation. This Vermeer can detach himself from his time and

place enough so as to wish for another far-away world, and to see his own as if from far away. In Thoré's accounts of Vermeer, such a characterization occurs more than once, suggesting ties to French Orientalism, to Maxime du Camp, or to Eugène Fromentin and Henry Havard. Each of them wrote on his voyage to the Orient as well as to The Netherlands and interwove his ideas of Venice, the Far East, and the Near East with his studies of Dutch culture.[59]

Thoré would seem to make his fanciful references to Vermeer and Asia almost in spite of himself, for otherwise his Vermeer is not a flying Dutchman but a realist. In his essay "New Ambitions in Art" of 1857, he checks others as much as himself for knowing too little and imagining too much:

> Our winged angels are for the Orientals what their winged chimeras are for us: more or less attractive figures of fantasy. The Chinese cannot guess what a lamb lying on a cross is supposed to mean, just as we cannot guess the meaning of the dragons and other monsters fluttering on their buildings, vessels and clothes. And yet this is the language of their belief, their knowledge, their thought, their life and the result of their particular civilization. We call their visual language "*Chinoiséries*" among us. But over there, what do they call the products of occidental imagination?[60]

For Thoré to imagine a Vermeer longing for the Far East, for Friedländer to think of his painting as something exotic, refined, and elevated above the world of Dutch commerce, for Hausenstein to see Vermeer sublimate Dutch flatness, is, on the simplest level, to engage in embarrassing clichés and to indulge prejudices. Yet, if we think of Gadamer, a prejudice is nothing more or less than a beginning, the beginning of the process of understanding, in which the pre-judged can become judged truthfully.[61] Whether or not one agrees with this value-free notion of prejudice, here it may be useful to the extent that it makes us realize that Thoré, Hausenstein, and Friedländer are trying to articulate something that we can then look for and eventually find in a more sophisticated yet also less directly expressed form in late-twentieth-century critical accounts of Vermeer's *The Geographer* (Plate 28). Taken together their accounts offer the following observation: in Vermeer's *The Geographer* – as in other Vermeers, such as *The Milkmaid* (Plate 8) – nothing is done that can be identified as practical, let alone as work. And yet, whatever it may be that is being done, it looks entirely purposeful. If the three authors imagine Vermeer to be or to aspire to being like the figure he depicts, namely, someone apart from the rest, "a hummingbird among sparrows," this has much to do with their concept of the artist, whether it be Vermeer or any other artist.

That *The Geographer* may be more about cognition than about a clearly identifiable profession is registered in the early catalogues. There the painting is said to represent "a mathematical artist" (1713), one of "two astrologers" (1729), "a philosopher in his study" (1778), "a person . . . holding in his right hand a pair of dividers" (1797), "a scholar" (1803), "a scholar with a pair of dividers in his hands" (1833).[62] Even the 1924 catalogue of the Städelsche Kunstinstitut in Frankfurt lists the work as "An Astronomer in His Study."[63] If Thoré's, Hausen-

stein's, and Friedländer's passages are taken into consideration, it would seem that three motifs combine to make Vermeer's man much, if by no means all, of the preceding characters, rather than clearly and unambiguously a cartographer or surveyor, a seventeenth-century modern man of the scientific age. The three motifs are, first, his reflective gaze and right-hand gesture of suspense, even as he steadies his pose by firmly grasping a book with his left hand; then, his silk robe; and, last, the Turkish rug.

The silk robe is also worn by Anthony van Leeuwenhoek (1632–1723), the cloth merchant, inventor, and builder of microscopes, discoverer of spermatozoa, and executor of Vermeer's estate (or, rather, posthumous bankruptcy), in an undated portrait by Jan Verkolje (1650–93; Fig. 52).[64] But while Verkolje's Van Leeuwenhoek also holds dividers and has Hondius's globe next to him on the table, he looks directly and firmly out at the beholder and wants to be acknowledged as an identified sitter. His accoutrements, including the silk robe, are subordinated to his portrayal. Vermeer's geographer looks we don't quite know where, and Vermeer's beholder is foremost faced with cropped barriers, the pushed-up rug on the table and a low wooden stool on the right with a square on it. As the geographer doesn't hold our gaze with his own, his accoutrements take on importance in characterizing him for us.

Both the silk robe and rug are clear referents to the Orient, that is, to Japan and to the Levant. The so-called *Japonsche rok* was a highly desired garment, a kimono tailored into a kind of house robe.[65] In Vermeer's and Van Leeuwenhoek's days such *keizersrokken,* or Imperial kimonos, were gifts given in batches of thirty and sometimes even more to Dutch merchants who passed the test of their annual visit to the Imperial court in Edo (Tokyo). This visit was their only permitted sojourn on the Japanese mainland; at all other times they were confined to Deshima, the island assigned to them for the duration of their stay in Japan. Thus these robes were neither merchandise in Japan nor clearly for sale back home in Holland. There they were worn indoors by scholars, amateurs, gentlemen, even mayors.[66] By the mid–eighteenth century they were made from imported Indian and Chinese silk and became a more common imitation ware.[67] In Vermeer's day, then, for his geographer to wear a *Japon* is to wear an as yet not commodified garment, in a way quite in keeping with Friedländer's idea of Vermeer.

The motif of the pushed-back rug reappears in *The Astronomer* (Plate 27) and, somewhat mysteriously, as if pushed back from "our" end of the table, in *A Woman Asleep at a Table* (Plate 5), and as a suggestively precarious support for the Chinese bowl of fruit in *Girl Reading a Letter at an Open Window* (Plate 7). The motif's connotation of leisure is evident in Ter Borch's depictions of ladies receiving or writing "love letters."[68] In Ter Borch's *A Lady Writing a Letter* (The Hague, Mauritshuis) and *Lady Reading a Letter* (London, Wallace Collection), the women prefer the table's plain wooden surface to the rug. The bed in the one and the folding screen in the other painting characterize these interiors as women's private spaces. By contrast, Metsu (1629–67) depicts a *Man Writing a*

Letter (Dublin, National Gallery of Ireland) who seems to be acting on impulse when he writes on a sheet of paper bulging over a table rug's folds and does not take the time to push the rug back. In *Easy Come Easy Go* (1661; Rotterdam, Museum Boijmans-van Beuningen), Steen represents a happy squanderer who is seated at a table with a partly pushed-back, partly napkin-covered rug on it that contributes a sense of disorder. Finally, in Metsu's *The Duet* (London, The National Gallery), we see a rug pushed back so as to make room on the table for the violin and to reveal the wine jug underneath. By contrast, in Vermeer's *Music Lesson* (Plate 17) and *Young Woman with a Water Jug* (Plate 18), we see orderly, straightened rugs. With its connotations, at least in the examples cited here, of love letters, squandering, drinking, and courting, the motif of the pushed-back rug adds an element to the geographer's situation that seems not quite in keeping with his presumably serious, rational, scientific occupation.

Thoré, as we saw, makes sense of all that is here by linking the landscape of the sumptuous Turkish rug and the Japanese silk robe with the man's moment of suspense or reflection by filling the latter with the former, thus attributing to him a longing for the East Indian "atmosphere and color." What this suggests is the existence of a structure in Vermeer's *Geographer* (Plate 28) that may seem to allow for these precise links of motifs to meaning. How do contemporary art historians incorporate the three elements in their interpretations?

Andreas Hauser and Per-Olov Elovsson are two scholars inclined toward analyzing structure and toward interpreting it as a rational element in *The Geographer,* rather than as literally eccentric and oriented toward something outside of it and far away as Thoré did.[69] In his study of 1981 Hauser opts for the earliest description of the work as representing a "mathematical artist" (1713) and titles it *Messkünstler,* or *Artist of/in Measuring.*[70] The structure he seeks out is that of *Ikono-logik,* or "icono-logy." Taking the latter to refer to the logic of an image, he aligns "image" with "artist" and "logic" with "measuring," and ultimately "image"/"artist" with Vermeer, and "logic"/"measuring" with the geographer. Hauser sets out to understand how exactly the two clusters of terms and names relate to each other, starting out from the observation and premise that visually they appear to be in harmony. He relates the first cluster, image/artist/Vermeer to the sensual rug, and the rug to Pliny's story on painterly illusionism and trompe l'oeil, the story of Zeuxis and Parrhasios. In their contest as to who is the better illusionist, Zeuxis succeeds in deceiving sparrows into picking at his painted grapes, whereas Parrhasios succeeds in deceiving Zeuxis into pulling at his painted curtain to reveal the painting presumed by Zeuxis to be underneath. Vermeer is a "second Parrhasios," writes Hauser; he is the painter of illusionistic billowing curtains and bulging rugs.[71] This claim is not so unlike Friedländer's that Vermeer is "a hummingbird among sparrows." For Zeuxis is only a sparrow picking at a painting. And yet, for Hauser that makes Vermeer/Parrhasios the less progressive artist.

Hauser asks: "But how does such regressive indulgence in inarticulate mate-

rial agree with the commitment to the 'art of measuring' of optics, perspective and projection in a picture like Vermeer's *Geographer*?"[72] His answer is that the "restless, rolling landscape," "the rotting dark zone of the rug . . . conceals an uncanny aliveness which threatens" the order of the work.[73] He sees a contrast between this threatening "painterly chaos" and the rational grid of the "window-picture," the "grid of coordinates," the "perspectival-optical principle of representation," toward which the geographer's head seems turned. The cluster logic/measuring/geographer is prefigured in Albrecht Dürer's woodcut from his *Instruction on Measuring* (1525), depicting a draftsman who fixates a naked woman through a framed grid in order to transfer the foreshortened view of her body to his squared drawing sheet.[74] She is to Dürer's draftsman what the rug is to Vermeer's geographer. In the end Hauser sees the two opposites of painterly chaos and "grid of coordinates" harmoniously integrated in the geographer's art of cartography, in his intensive reflections. Above all he sees this synthesis in the very map spread out on the table where the rug has been pushed back, because "in fact it is empty," a complete *blank*.[75] That it has always been trusted with being a map, and probably a good, carefully produced one, supports Hauser's notion of Vermeer as a "second Parrhasios" and of the latter as of an "artist of measuring" and calculating. The "blank sheet of paper" is the "dialectical figure" in which the two clusters image/artist/Vermeer and logic/measuring/geographer become one: "It is as if the attempt at heightening reality is only undertaken in order to make it transparent toward the two moments it contains – the dream of Eden and origination and the [abstract] purity of a utopia beyond reality."[76]

For Elovsson, writing ten years after Hauser, "the geographer's heart" is the origin of all structure in this painting.[77] Taking his concept of structure, the system of coordinates, from René Descartes's geometry as used by Michel Serres to interpret Vermeer's *Woman Holding a Balance* (Plate 15), he observes that the two principal, central coordinates in *The Geographer* (Plate 28) intersect at the center of Vermeer's painting and in the geographer's heart.[78] He further suggests that Van Leeuwenhoek may well have been Vermeer's model, when both painter and scientist were thirty-five years old.[79] According to Elovsson Vermeer organizes his picture's iconography within the system of coordinates formed along the two central vertical and horizontal axes and the diagonals. Entirely planar, this system resembles the quasi-cartographic geometrical pattern by which a cartographer structures the world, even as it is ultimately Vermeer's skill in perspectival illusionism that realizes the geographer's world, his maps and globe as well as his study, for the beholder. Elovsson emphasizes that the "geographer's heart" and Vermeer's vanishing point are not identical.[80] It has since been shown that Vermeer's vanishing points are visible tiny holes, pierced so as to attach one or more strings to aid him in measuring his perspectival constructs throughout the painting process.[81] In other words, Vermeer's figures are never his focal point. By separating the vanishing point and the coordinate system's intersection, he avoids piercing the man's body in *The Geographer* and also precludes his beholder's experience of confronting a Jasper Johns–like target.

(Interestingly, the latter himself has recently turned to the string, a string suspended between two points, and thus become "a master of silence."[82])

"An answer is still needed to the most essential question of why Vermeer constructed the *Geographer* . . . in this way," Elovsson asserts.[83] After repeating his observation that "Vermeer has allowed the geographer's line of sight to form part of the composition of the painting" – it is identical with the principal horizontal coordinate – he concludes: "To describe the geographer's heart as full of melancholy feeling and the center of futile daydreams is therefore misleading. The geographer's heart is instead the center of a new coherent and rational vision of the world."[84] He does not speculate about Vermeer's heart, which is perhaps in neither of the two possibilities, for judging by Elovsson's logic, Vermeer's heart is somewhere near the vanishing point, on the blank wall between cupboard and tapestry-upholstered chair. Hauser, too, gives thought to the heart; his is the metaphorical heart of it all: "Chaos resurfaces in the heart of that art of measuring, which intended to elevate itself above the blind and undifferentiated."[85]

And this returns us to Hausenstein's letter written from Wassenaar in 1923, according to which Vermeer sublimated "that Dutch situation of flatness at o meter above sea level." But unlike Hausenstein, who sees in Vermeer's work a "classical" moment of equilibrium, Hauser's "artists of/in measuring," Vermeer and *The Geographer,* are pre-Romantic melancholics who cannot help "going from Oriental to French," from sensual to rational, and for whom there is slightly more loss than gain, slightly more futility than progress in this. As they measure, order, and represent their world, it loses "the aura of the indisplaceable given."[86]

In some ways, Hauser's insight is as much a Hegelian insight into the end of art's "classical" moment in which form and content are one, as is Elovsson's trust in Vermeer's progressive age of science and philosophy as art's new vantage point.[87] Of course, what Elovsson does not discuss is the painter's material, paint, and its sensual threat of a "rotting darkness," "an uncanny aliveness."[88]

This threat, then, is one aspect of the artist's power that remains three hundred years after the scientific revolution pondered in these accounts of *The Geographer.* In 1952 Lawrence Gowing suggested what even Hauser does not explicitly acknowledge, namely, that this dialectic of chaos and order, of the rug and the grid, is gendered. Thus he writes of the carpet-covered table: "It is felt as the embodiment, perhaps, of whatever of the fertility of women has not been incorporated in this world."[89] Contrasting with these subtle analyses of Vermeer's pictorial world is the spiteful title "Girls: Or Winning the World by Looking at It" chosen by Mark Kremer for an art review. He discusses three exhibitions, two of contemporary Dutch art and, sandwiched between them, the showcasing of Vermeer's *Art of Painting* (Plate 26) on an actual easel at the end of a corridor-like gallery at the Kunsthistorische Museum, Vienna, during the fall and winter of 1993. It must be Vermeer's back-turned painter looking at his model that prompted the title of this review, if not the "fundamental question" at its end: "What actually is looking? . . ."[90]

Response

> *Standing before it I felt like those looming clouds were rolling off the*
> *canvas, or perhaps that the picture was about to envelop me.*
>
> (Bryn Mawr '01 student's Junior Year Abroad experience
> before Vermeer's *View of Delft* [Plate 11])

Looking can stir the looker to a strong response and to the feeling that the painting actively engages her or him. In his review of the 1995–6 Vermeer exhibition David Littlejohn writes that "serious scholars" probably do not allow themselves such a response as his:

> So I found myself fascinated each time I came back to what felt like the same corner of the same room – with the same window, the same little mirror, the same little drape. Standing in front of the famous sunwashed corner, I felt I was standing precisely where Vermeer must often have stood, in a room of his own house . . . in the Catholic quarter of Delft.[91]

In her essay "Vermeer's Annunciation," also written on the occasion of the exhibition, the writer Siri Hustvedt similarly suggests that there is a principal difference between her and the Vermeer scholar. She spent two hours in front of Vermeer's *Woman with a Pearl Necklace* (Plate 14) and at some point found herself "reprimanded by the guard. Perhaps my nose came too close to the paint or perhaps my obsessive focus on one painting struck him as slightly deranged. He waved me off, and I made an attempt to look less awed and more professional."[92] One poet and essayist who relishes this presumed difference between him and *the* scholar is the late Zbigniew Herbert. In his "apocryphal" essay, "Letter," he fulfills the scholar's desire to find a documented link between Vermeer and Van Leeuwenhoek, though in a rather unexpected manner.[93] In this document, Vermeer's letter to Van Leeuwenhoek, the painter breaks off their friendship: "Our paths part," he writes, for he has been struck by a profound and unshakable insight, namely, that on the path of science "we are more and more lonely in the mysterious void of the universe." And on the path of painting his own "task is not to solve enigmas, but to be aware of them, to bow our heads before them and also to prepare the eyes for never-ending delight and wonder."[94] In short, his goal is "to continue our archaic procedure" and to guard the world against the universe, "to tell the world . . . of the eternal desire for reciprocated love."[95]

While perhaps Littlejohn and Hustvedt are mistaken in their assumptions about the "professional" viewer's rigorous self-deprivation of all feeling, it is not at all clear for such a viewer what Herbert's Vermeer means when he wishes to speak through his paintings to the beholder's "eternal desire for reciprocated love." Two scholars who have explored Vermeer's paintings for their emotional and erotic engagement of the beholder are Martin Pops and Edward Snow, indebted in their respective endeavors, one phenomenological, the other psy-

choanalytical, to Lawrence Gowing's 1952 monograph on the artist.[96] Snow explicitly positions himself as a male spectator who stands in Vermeer's shoes and who takes Vermeer to be his own first spectator, and thus the first to seek, and perhaps find, in his own paintings "reciprocated love." This view suggests the exclusion of the female spectator, not de facto but conceptually, from the very beginning. From this angle Kremer's title, "Girls: Or Winning the World by Looking at It," would seem to refer to a selfish patriarchal Vermeer.

It is therefore interesting to find that women, Debra Allbery, Winifred Hughes, and JoEllen Kwiatek, write poetry in response to Vermeer's paintings. In their poems Hughes and Kwiatek assume a beholding subject, "you," and a beheld object, the Vermeer painting. Hughes modifies this juxtaposition in the course of her poem. By contrast, as we shall see, Allbery entirely suspends the subject-object opposition.

In "Fabric Collage After Vermeer" (1996), Hughes reconciles a female spectator to Vermeer's *The Milkmaid* (Plate 8) or, more precisely, to what she takes to be Vermeer's exclusion of the maid or any other of his depicted women as spectators of her or their representation by him.[97] The poem is a reflective, searching monologue addressed to a "you":

> They didn't satisfy you,
> the Old Masters. You brooded over them,
> meditating adjustments.
> You wanted to translate them
> into your own vernacular,
> the scraps and patches of your woman's life.
> (Lines 1–6)

The first stanza's introduction of the task of translation by way of "fabric collage" is followed by two stanzas reflecting on how this could be and finally was achieved. One answer is by coexistence, which I take to be an alternative to Herbert's "reciprocated love." By coexistence the two women, Vermeer's *Milkmaid* and "you," become familiar, begin to live in each other's memory, seem to have worn the same dress. And in the course of this coexistence *The Milkmaid* separates from the artist: "She has aged / since she labored for Vermeer, . . ." (lines 16, 17), and so the nourishing milk and crusty bread show themselves to "you" only now:

> Her jug of water has thickened to milk,
> the loaf of bread crusted over.
> For decades you have lived with her,
> salvaging remnants from your life
> to mend hers.
> (Lines 21–25)

In short, "You have tidied up/ after Vermeer, . . ." (lines 28, 29). This is a surprising twist of the phrase "after Vermeer," which in the poem's title may lead the unsuspecting reader to understand it in the sense of imitation or translation.

Instead, Vermeer is "thrust . . . back out of the kitchen" (line 30). Vermeer has to be made absent from his painting so that "paying homage" (line 31) to his maid eventually becomes a possibility for "you."

Without analyzing this further, for example, as being caused by an "empty" intersection in a system of coordinates or an "empty" vanishing point (on Elovsson's model), Hustvedt, too, speaks of absence or emptiness as full of interest and possibility when she writes of *Woman with a Pearl Necklace* (Plate 14): "I realized that I had picked it because of its empty center."[98] In "A Painting by Vermeer" (1985) Kwiatek also responds to *The Milkmaid* (Plate 8) and also engages a notion of absence, or rather, absentation.[99] The maid is "passive as a madonna / or good nurse" (lines 5,6), and evokes a similar response in her beholder:

> You are moved
> and consoled by your absence, the canny
> refusal: not desire – not
> desire, but patience.
> (Lines 12–15)

Who refuses what to whom? Who is patient with whom? Accepting the origin of consolation (rather than frustration), "you," the beholder, end up playing by "yourself":

> The pleasure
> of stalling pleasure, of outwitting
> your own response.
> (Lines 17–19)

This is not quite enough for the speaker of Debra Allbery's "Woman Holding a Balance," one of three poems "After Vermeer" (1994).[100] The poem is so much *in* the painting that the painting is never mentioned other than as the world in and of which the "poetic I" speaks. If there is a "you" at all, it is the poem's reader. This is by far the most complex of the three poems and it may require a description. The place is "our bedroom," the time is "dawn," and in the course of the poem's four stanzas something "dawns" on "I" as she reveals it to the reader. There are more persons present, her sleeping husband, and also both her waking husband and his father in her dream, which I take to be the equivalent of Vermeer's picture-within-a-picture, the *Last Judgment* on the back wall (see Plate 15). There is also the unborn child, the

> . . . tightened mass
> of another life inside me, a phantom fullness
> I can never name, a quickening.
> (Lines 28–30)

In the dream the husband is cleaning out gutters, an apt simile for the Last Judgment, and lifts

> . . . a small doll by one heel
> from the eaves, brackish water draining
> from its joints, its open eyes.
> (Lines 13–15)

The eeriness of the event is heightened by the presence, in addition to "my husband" alias Saint Michael, of his father alias the Lord gesturing judgment, muttering "advice toward the ground, / hand raised in an irritated benediction" (lines 11, 12). Perhaps the gutter-cleaning/Last Judgment scene rescues the doll/soul and clears it from the pollution of brackish water/sin. But perhaps the inversion of positions – husband/St. Michael up there, his father/the Lord on the ground – means that this is not the end of time but rather a beginning, with the husband acting as midwife to the birth of his child and his father partly turning away and partly blessing the child. All of this happened in a dream, or nightmare, "last night" (line 8), and now "I," pregnant wife and daughter-in-law, lies weary in bed, observing "the threadbare browns / of early winter" (lines 20, 21). "Without looking back I can see / (. . .) darkness / folding itself away like a heavy drape," as the "worn light finds" her husband (30–34). He is freed from an oppressive dream of which he knows nothing; instead

> in his dream, perhaps, is my own hand
> resting on the clean edge of a table.
> (Lines 35, 36)

In his dream she is a reassuring presence, or so it seems, as long as these words evoke the woman's gesture of slightly steadying herself in Vermeer's *Woman Holding a Balance* (Plate 15). But she might also be dead, laid out on a table, in which case her ominous dream is completed in his dream. The juxtaposition of images of early winter and early morning, of dying and becoming, is ambiguously resolved by this ending. What is mildly reassuring to the reader is that everything that happened happened in dreams, and that the woman, the "poetic I," is alive to speak of them.

Those of us who, lacking artistic talent, use a scholarly mode of response must be grateful for these poetic responses. They remind us that metaphorically speaking the "serious scholar" will also do one or more of these three things: tidy up after Vermeer, feel by him benignly left to her- or himself, and inhabit his work with all the existential consequences of having done so.

Artistic response can be analytical or interpretative without the use of words. I am referring here to George Deem's *Seven Vermeer Corners* of 1999 (Fig. 54), the painting that helped me to frame my discussion of the collection of, reception of, and response to (upper register, from left to right) *The Glass of Wine* (Plate 9), *The Geographer* (Plate 28), *Lady Standing at the Virginal* (Plate 33), (lower register, from left to right) *Girl Interrupted at Her Music* (Plate 12), *Woman Holding a Balance* (Plate 15), *The Milkmaid* (Plate 8), and *Woman with a Lute* (Plate 16). It is a to scale representation in oil of these seven Vermeer

interiors on one canvas. From each of these he has taken away all human fig-
ures and most of the furnishings, thereby allowing Vermeer's seven spaces,
along with a few of their contents, to show themselves as spaces somehow exist-
ing prior to the Vermeers we believe we know. In each case the corner of a or
the room appears as the axis of departure, the place from where the painted
world originates and unfolds, both the spare one we see here and the familiar
original. The space unfolds from the corner, even as the light falling through a
window on the left seems to reveal it. It does this in relation to both its actual
geometrical – though never its perspectival – construct, and to its coloristic
mood or disposition. In this as in other Vermeers painted since the 1970s,
George Deem's project is deeply hermeneutical and often witty, the project of
one painter attempting to understand another.

In Deem's *Seven Vermeer Corners* we see *The Geographer* (Plate 28) and *A
Lady Standing at the Virginal* (Plate 33) next to each other, as they perhaps were
for some time between 1785 and 1797. And he has also brought *The Milkmaid*
(Plate 8) and *Woman Holding a Balance* (Plate 15) back together, placing them
side by side as they might have been in Rooleeuw's collection of 1696–1701.
More than that, he has initiated a dialogue between them. Hung in its corner,
which on the floor level extends its spatial openness beyond Vermeer's limits,
the mirror in Vermeer's *Woman Holding a Balance* reflects nothing in particular.
Here, however, this means that the mirror faces traces of Deem's deliberately
visible squaring of his canvas and his seemingly unformed patches and smudges
of paint in luminous hues between the two Vermeers. These patches echo the
orange curtain next to the mirror as well as the light-saturated wall of *The Milk-
maid,* as if they were the source of light filtered through the window of her inte-
rior. Yet in this subtle dialogue the two paintings remain very different. Bereft of
their women and jewels, the one still challenges the beholder with its striking
orange curtain and the late Mannerist *Last Judgment,* whereas the other appears
self-contained in its diagonal balancing of the wicker basket, copper pail, and
foot warmer. Meanwhile the figures on *The Milkmaid*'s border of tiles busy
themselves beyond Vermeer's limit on the right and in the direction of *Woman
with a Lute* (Plate 16), who is looking their way.

It is owing partly to its completion in Deem's representation of *The Geogra-
pher* (Plate 28) in *Seven Vermeer Corners* that the cupboard's powerful physical
presence demonstrates its commanding position in the room's corner. Here the
rug, the geographer, and the blank between them are not yet or no longer seen,
taken away. Large and bursting from its rational seams, the cupboard conceals
as much as reveals what cannot be found in any of the women's interiors, some-
thing having to do with natural scientific knowledge and scholarly cognition. Or
so it seems; because there is also the curtain, or, rather, in its place, a blank,
which is the painter's carefully prepared canvas: Parrhasios all over again.

10 The Appreciation of Vermeer in Twentieth-Century America

Arthur K. Wheelock Jr. and Marguerite Glass

Should anyone have ever questioned that Johannes Vermeer is an artist of international repute, as beloved in the United States as he is in The Netherlands or France, one only needed to have been in Washington, D.C., during the winter of 1995–6 to have witnessed the extraordinary response to the Vermeer exhibition when it was shown at the National Gallery of Art. It was an unforgettable experience to have felt the excitement of anticipation at the time of its opening; to have been in the crowded galleries as Vermeer-lovers, both new and old, stood quietly and reverentially before his luminous works, sometimes spending three to four hours viewing the twenty-one masterpieces assembled from around the world; to have seen day after day those who had traveled enormous distances from around the country, from Maine to California, lining up for hours in hopes of procuring an entrance ticket (Fig. 56).

Fig. 56. Crowds outside the Vermeer exhibition at the National Gallery of Art.

People came of all ages – from mothers with baby strollers to grandparents in wheelchairs – and all economic backgrounds, enduring below-freezing weather, snowstorms, and rain. By the last week of the exhibition, lines started forming in the middle of the night. Those standing in line, which often wrapped entirely around the National Gallery, brought tents, mattresses, chairs, chess games, and lots of hot coffee as they waited patiently, sometimes up to twelve hours, before the exhibition would open in the morning.

In part because it became a victim to two government shutdowns and a blizzard that virtually closed the city of Washington, D.C., for a few days in January, the exhibition evoked an emotional chord in the American people unique in the history of American museums. Its status became front-page news across the country. Nearly every major magazine ran a story and some even multiple stories on Vermeer, all including beautifully reproduced images from the exhibit.[1] Television and radio also accorded the exhibition headline status. A number of influential editorial writers decried its closing, arguing that during the federal government shutdown the Vermeer exhibition, rather than agencies like the C.I.A., should be kept open, for this once-in-a-lifetime experience of seeing so many of Vermeer's paintings together provided something really essential to human life. Indeed, offers of private funds allowed the exhibition to reopen when the rest of the National Gallery, and the federal government, remained closed.

When the exhibition finally ended in Washington, D.C., on February 11, before moving to the Mauritshuis in The Hague, it had been seen by more than 330,000 people. Viewers had bought more than 55,000 catalogues, so many that the gallery had ordered three reprintings and still ran out of catalogues more than a week before the end of the show. Weeks thereafter, articles continued to appear in print, reflecting upon the enormous emotional impact this exhibition had exerted on people's lives.

The outpouring of public enthusiasm during the Vermeer exhibition, both in Washington, D.C., and The Hague, is all the more unbelievable when one considers that it was not until the writings of the French critic Etienne Joseph Théophile Thoré, alias William Bürger, in the late 1860s that Vermeer's name became known beyond a small group of collectors and amateurs.[2] What happened during the course of the twentieth century to place Vermeer at the center of such a cultural phenomenon? His life's story would hardly seem to have encouraged this response. Unlike a Rembrandt van Rijn (1606–69) or a Paul Gauguin (1848–1903), this Dutch seventeenth-century painter from a small, provincial city did not call attention to himself through outrageous behavior. On the contrary, he led a responsible life, caring for his family while working as a painter and art dealer. The fact that he died penniless in 1675 seems to have been less his own fault than the collapse of the art market that ensued after the invasion of The Netherlands by the troops of Louis XIV in 1672. Finally, his quiet, intimate scenes of domestic life are unremarkable in subject matter, hardly the type of image that would seem to excite a late-twentieth-century society that all too often seems to crave the new, the exotic, and the unusual.

So, why did people stand in line in the snow and ice for hours outside the National Gallery to have an opportunity to see this small group of masterpieces? They were there for a lot of reasons, to be sure. However, to judge from the sentiments expressed in hundreds of letters, poems, photographs, and art objects made from Vermeer images that were sent to the National Gallery,[3] most viewers came to the exhibition because of the special human quality that pervades these works. One letter, written in advance of the exhibit, expressed a common thread among those who felt compelled to travel far distances to see the paintings:

> I, too, was first attracted to Vermeer's work because of his perfect composition and the harmony of his colors. But as I grew older and matured, I began to sense that his work could help me understand my life experience.[4]

Vermeer's images are so distinctive that once seen, they are never forgotten, and that is true of works as varied as the *View of Delft* (Plate 11) and *The Girl with the Red Hat* (Plate 22). With knowing one, there is this powerful urge to see another, and yet another, for one can never tire of the beauty of his light and color, or the sense of peace that his works bring. As only about thirty-five paintings are known to exist, it is easy to build a repertoire of these images in one's mind and even to imagine that it might be possible to see them all and undertake the sort of pilgrimage first traveled by Thoré in the 1860s. It was partly to fulfill that pilgrimage that many braved the ice and snow in Washington, D.C., to see the exhibition.[5]

Still, the question exists, how is it that Vermeer's genius, once seemingly appreciated by only a small group of collectors and connoisseurs, has entered into the mainstream of cultural life? Certainly, color reproductions of his paintings have brought them to a wide public and have helped make Vermeer's art known to many who have never actually stood in front of one of his works.[6] Vermeer's paintings reproduce remarkably well. While printed reproductions rarely capture the impact of scale and texture, they effectively convey the clarity of his compositions, the purity of his light, and his distinctive yellows and blues. Indeed, the *Smithsonian Magazine*'s best-selling issue occurred in November 1995 when it featured the Vermeer exhibition and illustrated the *Girl with a Pearl Earring* (Plate 24) on its cover (Fig. 57).[7] The availability of reproductions, however, is only part of the answer for this broad appreciation of Vermeer in America at the end of the twentieth century. A full explanation for this phenomenon may never be possible, but a glimpse back at the varied responses to Vermeer's paintings as they were collected, copied, and forged in the earlier years of this century does offer some insights into the reactions of art lovers to his works today.

The discovery of Vermeer's unique qualities as an artist coincided in America with what Annette Stott has defined as a "Holland Mania."[8] Around the turn of the century, a number of writers, editors, and ministers credited the Dutch, as opposed to the English, with introducing many of the political ideals, cultural institutions, and moral values that lay at the foundation of American society.

The framework for these opinions was established by John Lothrop Motley in his extremely popular histories, *The Rise of the Dutch Republic* (1855) and the *History of the United Netherlands* (1867).[9] Motley noted not only the parallels between the Dutch Revolt against Spain and the American Revolution but also the spectacular rise to wealth and power that each country subsequently enjoyed. Others extended the associations to language, customs, and, not insignificantly, to parallels in religious freedom and artistic expression.

Much of the appeal of The Netherlands was that it was a beautiful, picturesque land, unspoiled by the Industrial Revolution that was transforming the American landscape. The demand for images of The Netherlands, and its wholesome people, was so great that no fewer than six colonies of American artists lived and worked there in the 1890s, settling in small villages such as Volendam, Laren, and Egmond aan Zee. These artists, among them George Hitchcock (1850–1913) and Gari Melchers (1860–1932), sent back numerous picturesque images of contemporary Dutch life, but they also studied, and copied, paintings from the great museums in The Hague, Haarlem, and Amsterdam.

Travel books proliferated, stimulating the imagination of the American public with captivating anecdotes of Dutch life. Art played a large role in these accounts, not only because of the beauty of the paintings but also because of their realism. Travelers discovered with wonder that the paintings of the old masters constantly reinforced their own experiences: "If I found the birds and game of Hondecoeter and Weenix predominating at the poultry show, I discovered later in my Utrecht poulterer's shop the interiors of Metsu and the Van Mierises."[10] Evocative descriptions of Dutch seventeenth-century paintings helped authors characterize for their readers the distinctive features of the land, the food, and the people. Since illustrations in these little books were few, the writers had to make the paintings come alive for their readers, which they did with great success.

Rembrandt, of course, played a major role in these accounts, as did Frans Hals (ca. 1582/3–1666), Jan Steen (1626–79), and Nicolaes Maes (1634–93). But surprisingly, for an artist whose works were hardly known in America, so did Vermeer. One Bostonian, traveling to The Netherlands with her architect husband in 1907, placed Vermeer "shoulder to shoulder" with Rembrandt as the greatest of Dutch painters. This traveler, Mary Waller, boldly defended her opinion by asserting: "I dare affirm this, and I believe that future judgment will confirm it." Vermeer, she continued

> has given to the world one great landscape, or rather a town with a river frontage. This, however, is immortal: the wonderful *View of Delft* in the Mauritshuis . . . our Mecca on the occasion of every visit, and they were many, to that gallery. On dark days the sweet brilliancy of its coloring lighted all the gloom within the walls, and on the rare sunny ones, the clarity of its blue matched the patch of sky, as seen from the window beside it. . . . This blue is entrancing: a blue the color of the Virgin's mantle in the great Raphael of the Dresden Gallery; the color of the Rhone at Geneva as it sweeps swift, deep,

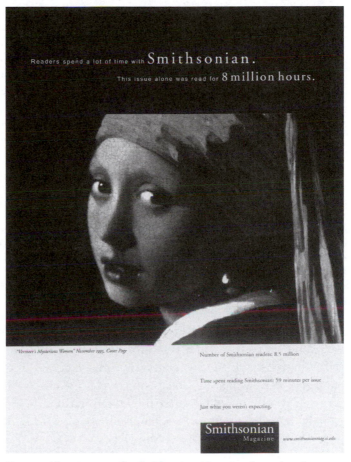

Fig. 57. Advertisement for *Smithsonian Magazine* featuring the cover of the November 1995 issue.

and strong; the blue of Alpine gentians as seen beside a drift of snow on the heights of the Simplon.

O Jan Vermeer of Delft! Whence did you get this idealizing blue note that shows in all your precious works? From a mother's eyes? From the blue waters of the Schie? From the sky above the pointed towers of St. Catherine's Gate in your native town? Whencesoever you obtained it, it is, and must remain, the expression of an ideal elemental color of the universe.[11]

The joy of this text is the author's metaphorical search to discover the mysterious source of Vermeer's genius, an artist about whom so little was known. What were the sources of his art that seem at once so personal and so universal? Waller was not alone in her efforts to convey the remarkable character of Vermeer's work, which so resembled yet so differed from paintings by other Dutch artists. For example, one English turn-of-the-century traveler, E. V. Lucas, also found the universal qualities in Vermeer's paintings that Waller sought to define in the *View of Delft*.[12] For Lucas, whose book *A Wanderer in Holland* was published in New York in 1905, the *Girl with a Pearl Earring* (Plate 24)

. . . is one of the most beautiful things in Holland. It is, however, in no sense
Dutch: the girl is not Dutch, the painting is Dutch only because it is the
work of a Dutchman. No other Dutch painter could compass such liquid
clarity, such cool surfaces. Indeed, none of the others seem to have tried: a
different ideal was theirs. Apart, however, from the question of technique,
upon which I am not entitled to speak, the picture has to me human interest
beyond description. There is a winning charm in this simple Eastern face
that no words of mine can express. All that is hard in the Dutch nature dis-
solves beneath her reluctant smile. She symbolizes the fairest and sweetest
things in the eleven Provinces. She makes Holland sacred ground.[13]

Such accounts are particularly interesting because they were made by travel
writers rather than art critics or collectors. They suggest not only how directly
Vermeer's paintings spoke to this generation of art lovers but also how his works
fascinated viewers because they could not be precisely defined and described.
Most important, these writers recognized that Vermeer's genius lay in his ability
to fuse the specifics of Dutch realism with the universal and the spiritual.

At the turn of the century most Americans knew of Vermeer and other Dutch
artists through the evocative language of such travelers. The seminal publica-
tions of French authors, Thoré in the late 1860s and Henry Havard in the 1880s,
would not have reached a very broad American audience.[14] Other than for the
reproductive work of the engraver Timothy Cole, few images of old master
paintings were available. Cole, who traveled to The Netherlands in 1892, made a
series of wood engravings after the Dutch masters, which he not only sold indi-
vidually but also included in a handsome book, *Old Dutch and Flemish Masters,*
with commentaries by John C. van Dyke.[15]

The situation, however, was rapidly changing, at least on the East Coast
where a number of Vermeer's rare paintings began to enter American collections.
Indeed, the period of the Holland Mania coincided with the rise of an extraordi-
nary breed of American collectors intent upon enriching their lives with master-
pieces of European art. Their impact in this country was almost immediate. For
example, *The Concert* (Plate 20) at Fenway Court, Isabella Stewart Gardner's
museum, influenced a number of Boston painters, among them Edmund C. Tar-
bell (1862–1938; Fig. 58), William McGregor Paxton (1869–1941), Philip Leslie
Hale (1865–1931; Fig. 59), and, perhaps, travelers such as Mary Waller.[16] Hale
wrote of the Boston School of painters, "To paint like nature is to paint like Ver-
meer and in this sense many Bostonians were and are his followers."[17]

America in the late nineteenth century was in the midst of enormous eco-
nomic growth, spurred by the development of natural resources, the expansion
of building industries and railroads, and the rise of banking and financial specu-
lation. Several of these "captains of industry" – among them Henry Clay Frick,
J. Pierpont Morgan, Peter A. B. Widener, and Benjamin Altman – worked
closely with dealers such as Knoedler, Colnaghi, and Duveen to find exceptional
paintings and furniture and objets d'art for their homes. Their desire to import
culture, however, was also civic-minded, for these same individuals also sup-
ported the founding of many of the country's great symphonies, libraries, and

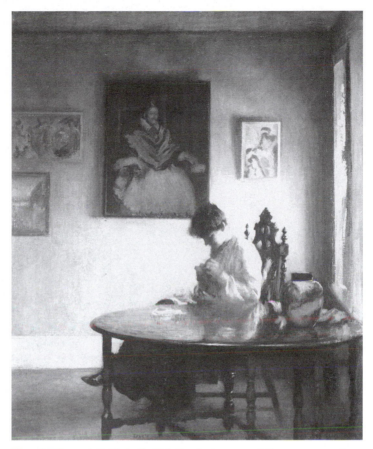

Fig. 58 Edmund C. Tarbell, *Girl Crocheting*, 1905 (oil on canvas, 76.2 × 63.5 cm). Canajoharie, N.Y., Canajoharie Library & Art Gallery. Photo: Canajoharie Library & Art Gallery.

museums – among them The Metropolitan Museum of Art, the Art Institute of Chicago, the Philadelphia Museum of Art, and the Museum of Fine Arts in Boston. Indeed, in 1889, one year after the New York banker Henry G. Marquand had acquired *Young Woman with a Water Jug* (Plate 18), he donated it to The Metropolitan Museum of Art. It was the first Vermeer to enter an American collection.

The public debut of these collecting activities occurred at the memorable Hudson-Fulton Celebration, an exhibition of 150 Dutch paintings held at The Metropolitan Museum of Art in 1909. Wilhelm Valentiner, who organized the exhibition, wrote in the introduction to the catalogue that the range and quality of the paintings would "astonish" European art circles, particularly the thirty-seven paintings by Rembrandt, twenty paintings by Hals, and, remarkably, six paintings by Vermeer.[18]

Valentiner was right – the exhibition did astonish everyone who saw it, and, in particular, it brought Vermeer to the awareness of a broader public for the first time.[19] As one reporter recounted: "The rare and incomparable artist Vermeer . . . might be called the revelation and the bright, particular star of this

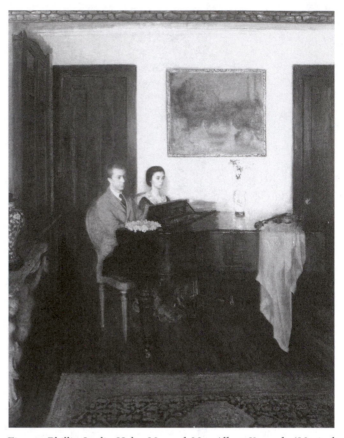

Fig. 59. Phillip Leslie Hale, *Mr. and Mrs. Albert Kennedy (Musical Moment),* ca. 1923 (oil on canvas, 102.2 × 86.4 cm). Saint Joseph, Mo., The Albrecht-Kemper Museum of Art. Photo: museum.

grand collection." This same reporter described one of the Vermeers in the exhibition, *Young Woman with a Water Jug,* as "one of the immortal productions of the art of Holland, a gem of purest ray serene."

The other Vermeer paintings in the exhibition had all been acquired within the previous twelve years: *Woman with a Lute* (Plate 16), acquired by Mrs. C. P. Huntington of New York in 1897, *Girl Interrupted at Her Music* (Plate 12), acquired by Frick in 1901; *A Lady Writing* (Plate 21), acquired by Morgan in 1907, *A Woman Asleep at a Table* (Plate 5), acquired by Altman in 1909, and *The Guitar Player,* later determined to be a copy of the painting in Kenwood (Plate 34), from the Johnson Collection in Philadelphia.[20]

The precise reasons for this passion for Vermeer among these collectors are not really known. However, the catalogue of the Thoré sale in Paris in 1892, where Isabella Stewart Gardner acquired *The Concert* (Plate 20), indicates that by that time Vermeer's extremely rare works were already "considered as classics, and worthy of ornamenting the finest cabinets of paintings." Thus, for a collector aspiring to form such a cabinet, the acquisition of a Vermeer painting would have been a high priority. Nevertheless, it is not entirely certain that all of

these American collectors were interested in these paintings because they were by Vermeer. For example, when Marquand acquired *Young Woman with a Water Jug* (Plate 18) in 1887 from a Paris dealer for $800, it was attributed to Pieter de Hooch (1629–84).[21] Even more remarkable is the story of J. Pierpont Morgan, who had never heard of the artist's name prior to the day in 1907 when he bought *A Lady Writing* (Plate 21) for $100,000.

Clearly something about Vermeer's paintings struck a chord with these collectors, just as had happened with Mary Waller and other travelers abroad. Some, who did not have adequate funds to acquire a Vermeer painting, commissioned copies of his works. Bartlett Arkell, for example, who bought a copy of *The Milkmaid* (Plate 8) from the Dutch artist M. V. Leeuven when he traveled to The Netherlands in 1914, subsequently commissioned three more copies of Vermeer's paintings, including *The Little Street* (Plate 10 and Fig. 60) from another Dutch copyist, Milton Kopershoeck.[22] For those with more limited resources, in 1916 and 1917 the *Ladies Home Journal* published large color reproductions of the

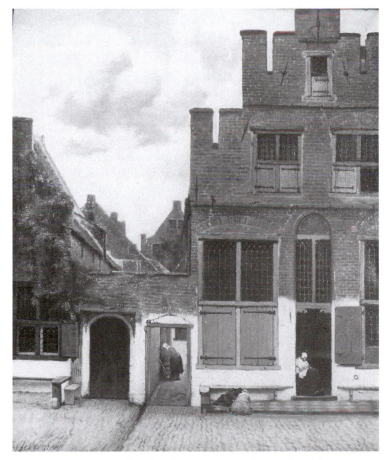

Fig. 60. Milton Kopershoeck, *The Little Street* (copy after Johannes Vermeer), ca. 1920 (oil on canvas, 44.4 × 50.8 cm). Canajoharie, N.Y., Canajoharie Library & Art Gallery. Photo: Canajoharie Library & Art Gallery.

Woman Holding a Balance (Plate 15) and *A Lady Writing* (Plate 21) suitable for framing. In fact, each print was accompanied with framing instructions.[23]

Unlike those who wrote about their emotional reactions to the artist's paintings they saw on museum walls, American collectors never wrote about their feelings toward the Vermeer paintings in their own collections.[24] Valentiner, however, may well speak for that generation, for he knew these collectors intimately, and advised many of them, particularly P. A. B. Widener, who acquired his first Vermeer, the *Woman Holding a Balance,* in 1911. In the introduction to the Hudson-Fulton catalogue, Valentiner attempted to explain why Vermeer was so superior to other Dutch genre painters, how it is that his works alone have this "penetrating effectiveness." He concluded that Vermeer's "power is concentrated in obtaining a perfection of surface," as well as in the "wonderful play of light," the "perfect arrangement of the few colors he employs," and the manner in which he blended these "to a perfect harmony." Valentiner also noted that Vermeer was unique in "his rejection of all the detail in which contemporary genre painters delighted. Compared with their work, his canvases with their few large surfaces seem empty, but the little there depicted presents in its exquisite proportions an absolutely harmonious whole." All of these qualities, Valentiner concluded, gave Vermeer's paintings a "modern spirit," quite unlike those of his contemporaries.[25]

Part of that modern spirit, according to Valentiner, was Vermeer's focus on the "purely aesthetic." For Valentiner, however, the aesthetic aspect of Vermeer's art was intimately bound together with an emotional detachment. He noted that

> Vermeer's figures seem to lead a detached existence, apart from joy or sorrow. They are in themselves almost expressionless, and only clothed in a lovely outward sheen which touches their simple life with mystery. There is no deep spirituality in this art as in Rembrandt's. Its perfection is purely aesthetic and, like all artificial and slightly decadent art, only conceivable within certain spiritual limitations.[26]

In 1913, only four years after the Hudson-Fulton exhibition, the Boston painter and art teacher Philip Hale, who had so carefully studied Vermeer's *The Concert* (Plate 20) at Fenway Court, published the first American monograph on Vermeer, a 389-page tome examining the life and art of the man he considered "the greatest painter who has ever lived."[27] Hale also was struck by Vermeer's modernity. No other old master, he explained, had ever attempted to arrive "at tone by an exquisitely just relation of colour values," an idea, he continued, that "lies at the root of all really good modern painting." Hale found other qualities in Vermeer's paintings that he considered singularly modern: "his point of view, his design, his colour values, his edges, his way of using the square touch, his occasionally *pointillé* touch." At the same time, Vermeer managed to retain "something of the serenity, poise and finish that we regard as peculiarly the property of the old masters."[28] In his chapter on "Vermeer and Modern Painting" Hale wrote: "If ever a man believed in art for art's sake it was he. He anticipated the modern

idea of impersonality in art . . . he makes no comment on the picture. One does not see by his composition what he thought of it all."[29]

* * *

It is clear from such assessments of Vermeer's paintings from this period that much of their appeal lay in their modernity, particularly in relation to the works' aesthetic qualities. They were pictures to be admired as treasured jewels, radiant and harmonious in all their parts, yet emotionally cool and removed. This approach came to dominate Vermeer studies for the next fifty years, not only because his paintings had very little anecdotal detail or obvious narrative content, but also because the artist, whose life story was shrouded in mystery, remained such an indefinable entity. Hale, noting that "Rembrandt, the painter of mystery, is no mystery to us," found it ironic that "Vermeer – the painter of daylight – is engulfed in darkness."[30] Thus, unlike assessments of Rembrandt's works, analyses of Vermeer's paintings were separated from biographical considerations. It was frequently noted that when Vermeer came to paint "his self-portrait" in the *Art of Painting* (Plate 26), he turned away from the viewer.

The Dutch art historian P. T. A. Swillens, who first began his studies on Vermeer in 1914 but who only published his results after World War II, was fully convinced of the impersonality of Vermeer's images. The English edition of his book had enormous impact on the appreciation of Vermeer after midcentury in the United States, possibly because his ideas expanded upon already existing perceptions of Vermeer's method of working in a carefully calculated manner. Swillens, much as with Valentiner and Hale, also believed that Vermeer had no interest in the "inner life" of his models and was intrigued only by the "play of light and colour" upon them.[31] Convinced that none of Vermeer's creations proclaim "an idea, a thought or an action," he wrote:

> If the artist, like Vermeer, does not wish to announce an idea, the purely pictorial element remains, that is to say, the artist only reveals what is of value to him as a painter, not what intrigues him as a human being and a thinker. The purely pictorial observation comprises space as a light and colour picture, the abstraction in isolation of light and colour from everything else that happens in this space.[32]

Swillens's approach was integral to his underlying conviction that Vermeer's paintings were timeless creations. He hoped that by analyzing Vermeer's compositional structure and painting techniques he could come closer to understanding how the artist reached this universal level of art. For Swillens, the timelessness of Vermeer's paintings precluded the possibility that specific emotional interchanges could be occurring in these works. Today, however, Swillens's overriding emphasis on the aesthetic abstractions of Vermeer's images seems to miss one of the most compelling aspects of Vermeer's work: the emotional intensity of his figures. Lawrence Gowing already had anticipated such evolution in taste when he wrote in 1952: "The precious material of Vermeer's pictures does not

attract the old devotion. The symbol which we used to find in [Proust's] *petit pan de mur jaune* of aesthetic altruism, the apparently generous disinterest with which artists enrich us, is no longer quite convincing."[33] But then he added: "But when [Vermeer's] standpoint and the perfect style in which he enshrined it are understood, as they yield their strangely emotional content, it becomes clear that his position is if anything rarer, his achievement with its complexity more incomparable than the most devoted apologist has claimed."[34]

The 1995–6 Vermeer exhibition clearly demonstrates a shift in the appreciation of Vermeer from the early-twentieth-century attitudes of Valentiner, Hale, and Swillens. People who stood so long in line to view the Vermeer exhibition at the National Gallery of Art had not come solely to admire carefully conceived, aesthetically created works of art. They were there because these paintings, and the human situations depicted within them, spoke directly to fundamental human emotions, ones that reverberated throughout the exhibition as each work was seen in the context of others. The letters and poems these visitors wrote after viewing the exhibition indicated a yearning for the sense of human dignity, inner peace, and serenity that Vermeer's paintings convey. For these viewers, the subtle, understated dramas of his images, whether the nature of the text being read by the *Woman in Blue Reading a Letter* (Plate 19) or that being written by *A Lady Writing* (Plate 21), were captivating and compelling. One visitor wrote of *The Girl with the Red Hat* (Plate 22): "the unexpected contact of her gaze startles. Time dissolves. We are part of her world."

It was widely acknowledged during the early twentieth century that Thoré had been overly optimistic in his attributions to Vermeer in his articles in the *Gazette des Beaux-Arts*. Consequently, art historians paid careful attention to Vermeer's signatures, painting technique, and handling of light when they determined attribution.[35] Not only were earlier attributions to Vermeer assessed, but newly discovered ones as well. In his diaries René Gimpel noted a number of paintings on the market during the 1920s whose attributions to Vermeer he questioned.[36] These issues were formally addressed in A. B. de Vries's 1939 monograph on the artist, which was the first study about Vermeer to discuss the attributions of questionable paintings.[37]

Not surprisingly, attribution issues arise in an early celebration of Vermeer's artistic genius in popular American literature. One extended discussion of Vermeer's work appears in of all places, a children's book: *Maida's Little Houseboat*, written by Inez Haynes Irwin in 1943.[38] In this story, Maida's father, Jerome Westabrook, is a wealthy investor who had amassed an important collection of old master paintings, the Vermeer being his prized possession. Westabrook is visited by a famous French painter, M. Fanton-Perrière, who tells Maida and her friends that "Seeing a new Vermeer is a great event in a painter's life." The two men talk for an hour about the novel's fictional painting, *Women Talking*, whose description brings together physical characteristics recognizable from Vermeer's real works. During their discussion the question of attribution arises. M. Fanton-Perrière agrees with his host that the attribution is correct, saying:

"I have had no doubt from the instant I entered this room. That yellow in the jacket of the woman at the right is the true Vermeer yellow. The blue in the walls is the true Vermeer blue. And there is, for example, one of the Vermeer chairs with the lions' heads." "Anybody could copy them," Mr. Westabrook pointed out. "True," his painter-guest acknowledged. "But nobody save Vermeer could have done that further corner with that effect of light."[39]

Maida and her friends were fascinated with this discussion, and amazed that the two connoisseurs found "in so small a picture enough to talk about for an hour." They eagerly listened to words like "composition," "highlights," "volume," "atmosphere," and "middle distance." Finally one of the young girls bravely entered into the attribution discussion: "I don't think it makes any difference *who* painted it – it's so beautiful that it almost makes you cry."[40]

Irwin perceptively indicated the various responses to Vermeer in the early 1940s as art lovers encountered newly discovered works by the master and debated questions of attribution by juxtaposing the aesthetic assessments of authorities with the emotional response of the amateur. Irwin placed her scene within the home of a wealthy Boston collector, but by the mid-1940s, the opportunity to have an informed discussion before one of Vermeer's rare paintings was a reality for more and more Americans. By that decade, his masterpieces graced the walls of a number of America's finest museums: The Frick Collection, The Metropolitan Museum of Art, the Isabella Stewart Gardner Museum, and the newly founded National Gallery of Art. Monographs with colored plates had also begun to appear, which made images of Vermeer's paintings more widely available to the public.[41]

Attribution issues, however, were rather benign until the 1940s when the astonishing discovery was made that twentieth-century forgeries of Vermeer's paintings, particularly those of Han van Meegeren (1889–1947), had deceived important connoisseurs and collectors. To the mysteries surrounding the artist and his paintings was now added intrigue and sensationalism. As one author wrote: "If the story of Van Meegeren disturbed the connoisseur, it fascinated the layman; for it was the story of an ordinary little man . . . who had accumulated a fortune and notoriety at the expense of those who had refused him recognition."[42] The Van Meegeren trial in Rotterdam in 1947, which focused on Van Meegeren's collaboration with the Nazis, was the most spectacular event surrounding the question of authenticity of Vermeer paintings, but by no means the first.

In retrospect, the scenario could have been predicted. By the 1920s Vermeer's paintings had become scarcer. In 1925, the most important of the next generation of American collector after Widener, Andrew Mellon, acquired from the art dealer Knoedler a luminous but quite small masterpiece by Vermeer, *The Girl with a Red Hat* (Plate 22), that had just been discovered in a Paris collection. The excitement surrounding this discovery, widely reported in the press, was repeated only two years later with yet two more discoveries of "Vermeer" paintings, *The Lacemaker* (Fig. 61) and *The Smiling Girl* (Fig. 62). To gather some

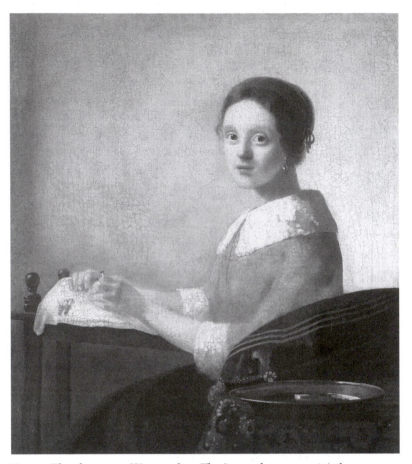

Fig. 61. Theodorus van Wijngaarden, *The Lacemaker,* ca. 1926 (oil on canvas, 44.5 × 40 cm). Washington, D.C., National Gallery of Art. Photo: museum.

sense of the success of these two forgeries, which also entered the Andrew Mellon collection by way of Duveen, one need only read the passionate description by one Vermeer expert about *The Lacemaker:*

> It was not without emotion that I held, unframed, in my hands, this precious canvas. At leisure, I made it reflect the setting sun, and little by little the beauties of detail shown up beneath my eyes. The analysis of a work so complete in its simplicity demands some patience from the collector. The eye is seized firstly by the impression of the ensemble, by the grace of the subject, by the general harmony of the tones. Then the spectator stops at the more lively tones, at the "highlights" of the English critics, and only arrives at the details by steps more or less long. . . . Only works of certain great masters stand up under this severe test; the slightest defect of a painter appears under such profound examination. The artist, in this case, shows himself singularly the master of his tools: even a monochrome reproduction . . . will permit us to unify the pleasure based on our admiration and the perfect technique of this infinitely charming work.[43]

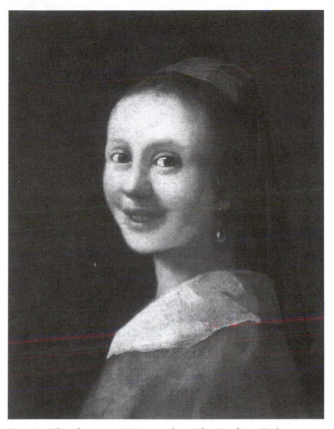

Fig. 62. Theodorus van Wijngaarden, *The Smiling Girl,* ca. 1925 (oil on canvas, 41 × 31.8 cm). Washington, D.C., National Gallery of Art. Photo: museum.

The forger of these "Vermeers," a Dutchman by the name of Theo van Wijngaarden, gained significantly from a unique historical situation.[44] In the 1920s Vermeer was a newly discovered master, and recognized as a forgotten genius. In their eagerness to learn more about the artist, and to expand his oeuvre beyond a few securely attributed paintings, many scholars accepted uncritically works that suddenly appeared in the art market. Contemporary art historians recognized the possibilities for deception posed by this historical moment. Ironically, Wilhelm Valentiner introduced his 1928 article on *The Smiling Girl* and *The Lacemaker* with the following warning:

> To hear almost every year of a newly discovered Vermeer may cause suspicion. And indeed we can be sure that in the endeavor to discover unknown works by this rare master in recent times, paintings have often been associated with this name which cannot stand serious criticism. . . . [Nevertheless, we know that] . . . Vermeer used a very small number of models, and repeated certain details like costumes, curtains, pillows, windows, mantelpieces, and even the paintings hanging on the wall so often that newly discovered works by him

frequently seem like puzzle pictures composed of pieces taken from different groupings in known paintings by him.[45]

Valentiner's appraisal of the historical situation and of Vermeer's limited repertory was astute. However, it also underscores the difficulty that he and other art historians had when faced with paintings that depicted typical Vermeer themes, often pastiches drawn from his original compositions. Indeed, the forger who made *The Lacemaker* and *The Smiling Girl* anticipated art historians' modus operandi by deriving his compositions from several securely attributed Vermeer paintings. For example, he excerpted the smiling expression of *The Smiling Girl* from the seated woman in the *The Girl with the Wine Glass* (Plate 13), but derived the pose from the *Girl with a Pearl Earring* (Plate 24).[46] Similarly, the forger adapted the pose of the girl for *The Lacemaker* from *The Girl with the Wine Glass*, but derived his subject from Vermeer's *Lacemaker* (Plate 31). He borrowed the basin in the foreground from the *Young Woman with a Water Jug* (Plate 18). Van Wijngaarden succeeded in his efforts, at least for a generation, which is the normal lifespan for a forgery. After Mellon acquired them, he donated them to the National Gallery of Art. Although disputes over the paintings' attributions were widespread, they remained on view and attributed to Vermeer until the early 1970s.

Issues of attribution and discoveries of forgeries greatly broadened the interest in Vermeer in this country. So, too, did the spate of thefts of Vermeer's paintings that occurred in the 1970s, 1980s, and, most recently and most poignantly for American art lovers, in 1990 at the Isabella Stewart Gardner Museum. The stories of these thefts and the large ransoms demanded for the return of the paintings, sometimes for political causes, brought home the realization that these fragile little paintings had enormous economic value and symbolic importance. The disappearance of any one of Vermeer's rare masterpieces was a cause for great distress worldwide.

As Vermeer's work became widely known to a broader public – through museum visitation, travel abroad, art history courses taken in colleges and universities, and the publication of monographic studies about Vermeer's life and art – the visual power of the artist's paintings began to appeal to book cover designers. Vermeer's images graced not just museum catalogues and books on Dutch art but also novels and books of poetry. By the late 1980s, advertisers were appropriating Vermeer's images, as, for example, in a cover of *Forbes Magazine* (Fig. 63) or in a promotion from *House & Garden* (Fig. 64). AT&T used a subtle allusion to the *Girl with a Pearl Earring* (Plate 24) to enhance the effectiveness of a widely run telephone advertisement from 1988 (Fig. 65).

Similarly, by the 1940s, filmmakers began alluding to Vermeer's compositions through the mise-en-scène, framing views through doorways similar to that in *The Love Letter* (Plate 29) or posing solitary women near a window. As Anne Hollander has emphasized, allusions to Vermeer's images in the lighting and framing of various scenes in films from the 1940s, such as *The Great Lie* from

Fig. 63. Cover of *Forbes*, April 18, 1988.

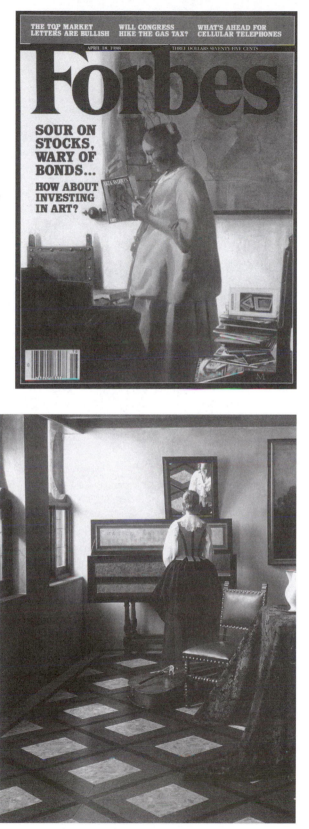

Fig. 64. Promotion by Helena Laidaw in *House & Garden*, 1988.

Fig. 65. Advertisement for AT&T, 1988.

1941, were indirect rather than direct.[47] Nevertheless, by the 1980s, more specific visual references to Vermeer's paintings began to appear. In Ridley Scott's *Blade Runner* of 1982, for example, a photograph that serves as a central clue in the evolving science-fiction drama bears a striking resemblance to Vermeer's *Music Lesson* (Plate 17). The connections to Vermeer's painting are enhanced by the fact that this photograph is seen in conjunction with a piano, sheet music, and a narrative theme that focuses around "learning."[48] The most explicit use of Vermeer's paintings within a film has been Jon Jost's *All the Vermeers in New York* (1992). Not only do many of the scenes depict the central characters viewing Vermeer's paintings in The Metropolitan Museum of Art, or posed in a manner resembling that of a Vermeer composition, but they also explore a sense of unrequited searching and desire that is only fulfilled through the experience of viewing these works.

Vermeer's paintings have also provided a source of inspiration for a number of late-twentieth-century painters, both in this country and abroad.[49] George Deem, for example, has based much of his work on Vermeer's paintings, studying their color, cropping, pictorial structure, and attention to natural light.[50] However, unlike Tarbell and Hale, Deem has not subsumed Vermeer's images

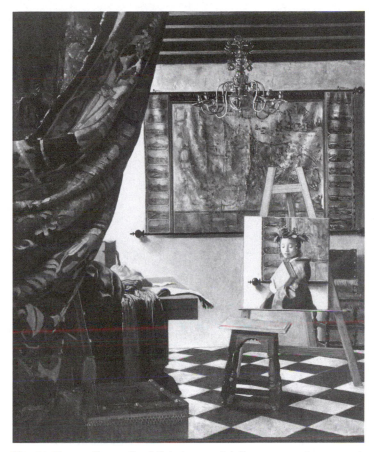

Fig. 66. George Deem, *Easel Painting,* 1976 (oil on canvas, 60 × 50 cm). St. Louis, Collection of Robert H. Orchard.

under his own creations but has celebrated his connections with the Delft master through his imaginative reinterpretations of Vermeer's paintings. In his *Easel Painting* (1976), Deem moved the narrative moment of Vermeer's *Art of Painting* (Plate 26) ahead in time (Fig. 66). Here, the artist and model have left the studio with the completed painting displayed prominently on its easel. In *Vermeer Interior,* also dated 1976, Deem fused the *Art of Painting* with *The Music Lesson* (Plate 17), transforming the image by widening the space of the room, adjusting the lighting, and moving the artist closer to the viewer. Deem's reassessments of Vermeer's images pay homage to the master, but they also are strangely disquieting in the way they hint at life beyond the carefully constructed confines that Vermeer reveals in his images.

Interestingly, it is in the realm of the novel that Vermeer and his work seem to be providing the broadest impact in late-twentieth-century popular culture. For an artist who shunned narrative scenes, whose images earlier critics described as being impersonal, and whose life story lacked great drama, Vermeer would seem to offer few possibilities for narrative fiction. Nevertheless, the mysteries surrounding his life and the dramatic changes in the apprecia-

tion of his paintings have proven to be fertile ground for the imagination of writers. J. P. Smith's *The Discovery of Light* (1992) uses Vermeer's *Woman Holding a Balance* (Plate 15) and other Vermeer paintings as points of departure for a story about the ambiguities of life and the difficulty of truly understanding the thoughts of a beloved.[51] The story travels back and forth between an imaginative account of Vermeer's life in Delft, particularly his relationship with his wife Catharina Bolnes, and the narrator's own conflicts with his loved ones. In the *Girl with a Pearl Earring* (1999), Tracy Chevalier constructs a moving story about the genesis of the most mysterious of all of Vermeer's paintings, the *Girl with a Pearl Earring* (Plate 24).[52] Chevalier also creates a scenario where Vermeer's relations to his family and models come alive, and where the enigmatic character of his images can be seen as an outgrowth of human needs and concerns.

The emotional power of Vermeer's paintings is a theme that contemporary writers have explored in different ways. Susan Vreeland creates an imaginative account of the impact of a painting by Vermeer on its successive owners in her novel, *Girl in Hyacinth Blue* (1999).[53] Tracing the fictional history of the work from the present to the moment Vermeer first conceived his idea for the painting, she reveals the various ways the work affected the lives of its different owners. Some novels actually focus around events associated with the aforementioned Vermeer exhibition. The premise of John Bayley's *The Red Hat* (1997) is the resemblance between the protagonist, Nancy Deverell, and Vermeer's *Girl in the Red Hat* (Plate 22), a painting she sees at the exhibition in The Hague.[54] In *The Music Lesson* (1998; Fig. 67), Katharine Weber creates a complex mystery surrounding the efforts to steal from the exhibition one of Vermeer's paintings (a fictional painting that takes characteristics from several Vermeer images).[55] This story evokes not only the powerful emotional spell of one of Vermeer's paintings, but, as well, the political intrigues associated with some of the actual thefts of Vermeer's works during the 1970s and 1980s.

Each of these filmmakers, artists, and novelists has created a narrative scenario that draws upon his or her personal observations and reactions to Vermeer's paintings.[56] They have also steeped themselves in recent literature on the artist, found not only in exhibition catalogues and monographs but also in technical examinations of Vermeer's work and in the archival studies of John Michael Montias.[57] Indeed, as the films, novels, and paintings, and even Louis Andriessen and Peter Greenaway's newly composed opera (1999), *Writing to Vermeer,* remind us, Vermeer is a far different figure today than he would have been for art lovers in the early twentieth century – more accessible, yet more complex. Stories such as his conversion to Catholicism because of his love for a young woman are now known and belie the idea that he was unemotional and detached. The early-twentieth-century art lover, moreover, had yet to witness the dramatic stories of theft and forgery that have followed the artist's rise in popularity, stories that highlight the emotional, monetary, and political value with

Fig. 67. Cover of Katharine Weber, *The Music Lesson*, New York, 1998.

which his works have been invested. All of these components enter into our joyous appreciation of his paintings today. His quiet scenes of daily life are at once mysterious and accessible. They engage the viewer with their beauty and serenity, and open worlds of imagination that continually enrich and ennoble the human spirit.

Notes

INTRODUCTION

1. For an excellent history of The Netherlands during this period, see Israel 1995.
2. For an excellent overview of the economic aspects of seventeenth-century Dutch art, which synthesizes recent scholarship on this subject, see North 1997.

CHAPTER I. JOHANNES VERMEER. AN OVERVIEW OF HIS LIFE AND STYLISTIC DEVELOPMENT

1. Yet Vermeer's name never sank entirely into oblivion: see the recent essays by Broos 1995–6, pp. 55–61; Idem 1998; and Jowell 1998. See also the chapter by Christiane Hertel in this volume.
2. For example, the exhaustive study by Montias 1989. Montias's book concludes with an appendix containing a substantial list of documents concerning Vermeer and his relatives; with each document, Montias provides a reference to the scholar who discovered it and first published it. In the present volume, reference will simply be made to Montias's document numbers, from which the reader can find further information about when and by whom the document in question was originally discovered. Among the most important reviews of Montias's book are Van der Waals 1992 and Van der Veen 1992. Montias himself has also written two "postscripts" to his original study, in the form of articles; see Montias 1991; Idem 1998.
3. See Montias 1989, pp. 76–8; Idem 1991, p. 46.
4. See Montias 1991, pp. 44–5.
5. Montias 1982, p. 88; Van der Veen 1996, p. 126. See also note 11, here.
6. Van Bleyswijck 1667, p. 854. It was Blankert 1978, pp. 147–8, who discovered that surviving copies of Van Bleyswijck's book contain two different versions of the last stanza of the poem.
7. For Fabritius, see Brown 1981.
8. For Bramer's paintings, see Exhib. cat. Milwaukee 1992; Exhib. cat. Delft 1994. Wheelock 1992, p. 21, makes the fascinating suggestion that there might have been a stylistic connection between Bramer's now lost murals (known today only through related drawings) and Vermeer's early paintings; see also Idem 1995–6, pp. 17–18.
9. Montias 1989, pp. 99, 308, doc. no. 249. See also Wheelock 1992 and the discussion following.
10. For the details of this story, which concerns repairs to the fortified wall that then encircled the town, see Montias 1989, pp. 93–6, 309, doc. no. 254.
11. Montias 1989, pp. 105–7, 110. Vermeer was required to pay an entrance fee of six

guilders when he was admitted into the Guild of Saint Luke in 1653. Normally, new admittees into the guild whose fathers had been members – as was the case with Vermeer – were required to pay three guilders, provided that they had trained for two years with a master of the guild. According to Van der Veen 1996, p. 126, the only plausible explanation for the higher admission fee is that Vermeer's training had occurred outside of Delft.

12. See the following discussion.

13. Montias 1989, pp. 106–7, 110, 123–4, 296, doc. no. 188. See also idem 1991, p. 43.

14. As Abels 1996, p. 73, points out, Vermeer was not an official member of the Reformed Church. Wheelock 1992, pp. 19–21, argues that earlier interpretations of Thins's objections to the match have been overstated; see also idem 1995–6, p. 16.

15. Vermeer is identified as living at that address in the burial books of Delft's Old Church, where the burial of one of his children was recorded on December 27, 1660; see Montias 1989, p. 314, doc. no. 279.

16. See Montias 1989, pp. 174, 213; Idem 1998, pp. 103–4.

17. There is considerable disagreement among scholars concerning Vermeer's zeal for his adopted faith; Abels 1996, for example, believes that the artist's conversion to Catholicism was somewhat superficial. On the other hand, Wheelock writing in Exhib. cat. Washington, D.C. 1995–6, pp. 86–8, 190, and Montias 1998, pp. 103–4, argue that Vermeer was indeed a zealous Catholic. See also Montias 1997, p. 197; and the chapter by Valerie Hedquist in this volume.

18. For the Guild of Saint Luke in Delft, see Montias 1982, pp. 74–100; Van der Veen 1996, pp. 124–6. For Vermeer's activities as an art dealer, about which little is known, see Montias 1989, pp. 185, 219.

19. For the importance of history painting in seventeenth-century Dutch art, see Blankert 1980.

20. Wheelock 1995–6, p. 20, rightly points out that history painting was quite important in Delft and The Hague around 1650 because of the presence of the court nearby in The Hague with its predilection for pictures in this genre.

21. The most recent discussion of the painting and its pictorial sources can be found in Exhib. cat. Washington, D.C. 1995–6, cat. no. 2.

22. See Goldscheider 1967, p. 125.

23. For the relationship of Vermeer's paintings to those by the Utrecht Caravaggisti, see Slatkes 1998.

24. See Slatkes 1981, p. 16.

25. As noted by Wheelock writing in Exhib. cat. Washington, D.C. 1995–6, p. 98, where he observes that Vermeer could well have learned about Rembrandt's approach to painting from his erstwhile pupil, Carel Fabritius. As we have seen, Fabritius resided in Delft up until his tragic death in 1654.

26. See the observations of Albert Blankert, writing in Exhib. cat. Washington, D.C. 1980, pp. 211–12.

27. At its auction in Paris in 1876, the painting was hailed as a masterpiece by Nicolaes Maes, a former Rembrandt pupil. At that time it bore the false monogram "N. M." See Exhib. cat. Washington, D.C. 1995–6, p. 100.

28. Wheelock, writing in Exhib. cat. Washington, D.C. 1995–6, p. 88, notes the improbability that Vermeer was in Delft during the early 1650s since no documents locate him there before April 1653. Therefore a possible trip to Italy taken at that time, perhaps upon the recommendation of Leonard Bramer, cannot be excluded.

29. For De Renialme, see Montias 1982, pp. 214–15; Idem 1989, pp. 139–40, 312, doc. no. 269. Idem 1988 has also written about art dealers in general in The Netherlands during the seventeenth century.

30. See Montias 1989, pp. 33–4, 333–4, doc. no. 341.

31. This painting was first attributed to Vermeer by Kitson 1969, p. 410. It has consequently been studied in great detail by Wheelock, who accepts it; see Wheelock

1986; Exhib. cat. Cracow 1991; Exhib. cat. Washington, D.C. 1995–6, cat. no. 1. Over the years, various scholars have expressed their doubts about its authenticity; see, for example, Blankert 1978, p. 75 n. 13; Brown 1996, p. 281; Broos 1998, p. 30; Wadum 1998, pp. 214–19. One of them, Weber 1993, pp. 300–1, argued that the picture in question must have been made by Johannes van der Meer – as opposed to Johannes Vermeer – a contemporary artist from Utrecht who presumably copied Ficherelli's painting during his stay in Italy in the mid-1650s. Weber's ingenious argument was recently challenged by Bok 1998, pp. 67–8.

32. As was stated in n. 27, Vermeer's *Diana and Her Companions* (Plate 3) was once attributed to Maes. For paintings by this artist, see Sumowski 1983, vol. 3, pp. 1951–2174.

33. This observation was made by De Winkel 1998, p. 334.

34. Representations of the Prodigal Son in contemporary guise are, however, far outweighed by those representing debauched youths, which display no connections whatsoever with the New Testament parable; see Franits 1997a, pp. 117–18.

35. The reasons why Vermeer stopped painting history subjects are not entirely clear.

36. Blankert 1978, pp. 24–6, provides an insightful survey of these formal and thematic changes.

37. Complex social and cultural causes likely underlie these changes; see Franits 1996.

38. See Montias 1989, pp. 101–3, 308, doc. no. 251.

39. For De Hooch's paintings, see Sutton 1980a and Exhib. cat. Hartford 1998–9.

40. For the long-noted relationship of Vermeer's work to that by De Hooch, see, most recently, Exhib. cat. Hartford 1998–9, pp. 24, 53–4, 178, passim.

41. A full record of the provenance of this striking painting can be found in Blankert 1978, cat. no. 7; see also Exhib. cat. Washington, D.C. 1995–6, cat. no. 5.

42. See Wheelock 1995a, p. 65.

43. Among the most notable studies of Vermeer and the camera obscura are Seymour 1964; Schwartz 1966; Fink 1971; Wheelock 1977a; Wheelock 1977b, pp. 283–301; Delsaute 1998. The following discussion is to a large extent based on the work of these scholars.

44. See, for example, Constantijn Huygens's enthusiastic comments about the image projected by the camera obscura, as recorded by Wheelock 1977a, p. 93.

45. Bramer, for example, had contacts with the renowned perspective specialist Agostino Tassi in Italy; his knowledge of the work of Tassi and other Italian artists undoubtedly informed the boldly illusionistic decorative paintings and frescoes that the artist made after his return to Delft in 1628. For Bramer's activities in this regard, see Plomp and Ten Brink Goldsmith 1994, pp. 63–7.

46. For example, Boström 1951, pp. 119–21; Seymour 1964, p. 329. Swillens 1950, p. 92, identified the actual building from which he claimed that Vermeer painted the *View of Delft*.

47. See, for example, Wheelock 1977b, pp. 285–95, who persuasively critiques the article by Fink 1971, which had offered the most extensive discussion of Vermeer's use of the camera obscura. See also Exhib. cat. Washington, D.C. 1995–6, pp. 122–3.

48. Delsaute 1998, p. 120.

49. This was noted by Wheelock 1981, p. 88.

50. Wheelock has pointed this out in several publications: see, for example, Wheelock 1977b, pp. 292–3; Idem 1981, p. 96; Wheelock and Kaldenbach 1982, 20–3.

51. For this auction, see Montias 1989, pp. 255–7, 364, doc. no. 439. See further the following discussion.

52. See Montias 1989, pp. 159, 171, 317, doc. no. 291.

53. The following paragraphs are based on Montias's important archival findings concerning Van Ruijven and his wife; see Montias 1987, pp. 68–71; Idem 1989, pp. 246–51; Idem 1998, pp. 93–9. Wheelock 1995–6, pp. 22–3, has advocated caution in assessing Van Ruijven's relationship with Vermeer since all of the evidence that Montias has

mustered in support of his hypothesis that he was the artist's patron is circumstantial. See Montias's rebuttal in Montias 1998, pp. 93–9. See also Brown 1996, p. 283.

54. For the following discussion, see Montias 1987, pp. 71–3; Idem 1989, pp. 251–7.

55. As Montias 1989, p. 252, points out, Dissius had no means of his own when he married Magdelena van Ruijven in 1680. Moreover, he had so little money that he was forced to borrow money from his father to pay the costs of his wife's funeral in 1682. See also Broos 1995–6, p. 53.

56. Initially, and for reasons that are not clear, Van Ruijven's estate was divided between Dissius and his father Abraham. Among Abraham's share were fourteen paintings, including six by Vermeer. His son Jacob inherited these along with the rest of his father's estate when Abraham died in 1694; see Montias 1989, pp. 254–5.

57. It was Wijsenbeek-Olthuis 1987, p. 269, who first noted the presence of a now lost mythological painting by Vermeer among the Van Berckel family possessions. For Van Assendelft's patronage, see Broos 1998, p. 48; see also Wijsenbeek-Olthuis 1987, pp. 266, 392 n. 16.

58. Montias 1991, pp. 48–51. See also idem 1998, pp. 99–100; Broos 1998, pp. 49–50.

59. Nieuwenhuys-Van Berkum 1987 provides an overview of Huygens's activities in the art world of his day.

60. See Broos 1995–6, p. 50. The potential connections between Huygens and Vermeer are fascinating, but perhaps Broos overstates them in his otherwise carefully documented essay; see Montias's response to Broos's hypotheses in Montias 1998, p. 97.

61. Wadum 1995–6, pp. 71–2, rightly interprets this statement as a reference to Vermeer's carefully constructed interior scenes such as *The Love Letter* (Plate 29); see Exhib. cat. Washington, D.C. 1995–6, cat. no. 18, where it is stated that Van Berckhout might have had this painting in mind.

62. For Van Buyten, see Montias 1987, pp. 74–6; Idem 1989, pp. 258–61.

63. For this inventory, see Montias 1989, pp. 364–5, doc. no. 442.

64. See Montias 1989, pp. 216–18, 338, doc. 361; Idem 1998, pp. 101–3. That two paintings could cover a debt of over 600 guilders – a substantial sum of money at that time – provides evidence of the generally high prices at which Vermeer's art was appraised at that time. Most scholars agree that the painting to which the document refers as "representing two persons one of whom is sitting and writing a letter," must be the *Lady Writing a Letter with Her Maid* (Plate 30). (However, Montias 1989, pp. 217, 260–1, identifies it as the *Mistress and Maid* [Plate 25]). Likewise there is general agreement that the second picture, "a person playing a cittern," is likely *The Guitar Player* (Plate 34).

65. See Montias 1989, pp. 180–1, and Broos 1995–6, pp. 48–9, who argues that Huygens likely persuaded De Monconys to return to Delft – he had toured the city briefly several days earlier – in order to visit Vermeer. See also Montias 1998, p. 99.

66. See Blankert, Montias, and Aillaud 1988, pp. 156, 205. Curiously, Sysmus associates Vermeer with the themes of "little dandies and castles"; see further Blankert 1995–6, pp. 32–3, 43 n. 8.

67. See Montias 1989, pp. 182–3, 318–19, doc. no. 298.

68. See ibid., pp. 257–8, 364, doc. no. 440.

69. See ibid., pp. 257, 358, doc. no. 415.

70. Indeed, one of the principal criticisms of Montias's book is his tendency to consider Vermeer a somewhat insulated artist. As Van der Waals 1992, pp. 183–4, has pointed out, Vermeer must have been well known among elite connoisseurs of the day who traveled to major cities in The Netherlands in order to visit artists and/or important collections. See also Van der Veen 1992, pp. 100–1; Haks 1996, pp. 95–104.

71. This discovery was made by Van der Waals and published in Idem 1992, pp. 181–2. See also Haks 1996, pp. 103–4; Montias 1998, pp. 100–1. However, there is some evidence that during the second half of the seventeenth century, citizens of less substantial means gained membership into militia companies. For militia companies in

general, see Singeling 1981; Haverkamp-Begemann 1982, pp. 37–50; Exhib. cat. Haarlem 1988; Levy-Van Halm and Abraham 1989; and especially Knevel 1994.

72. The preceding observations were taken from Wheelock 1981, p. 116; Idem 1995a, pp. 108–11; see also Exhib. cat. Washington, D.C. 1995–6, p. 148. Wheelock's studies of Vermeer's technique rank among the most perceptive and sensitive to date. See as well the recent studies by Gifford 1998; Costaras 1998; and Wadum 1998.

73. In particular, *The Girl with the Wine Glass* (Plate 13) has often been associated with Van Mieris's work; see Slatkes 1981, p. 49; Blankert 1978, p. 41; Wheelock 1981, p. 92; Blankert 1995–6, p. 37; Exhib. cat. Washington, D.C. 1995–6, cat. no. 6. For Van Mieris, see Naumann 1981.

74. See Wheelock 1981, p. 118; Exhib. cat. Washington, D.C. 1995–6, cat. no. 15.

75. Slatkes 1981, p. 69, posited that the figure, with its great immediacy and slightly parted lips, might represent a sibyl or some biblical personage.

76. For Vermeer's startling use of perspective, see Wadum 1995; Idem 1995–6.

77. The preceding observations borrow heavily from Wheelock 1981, pp. 100–2; Idem 1995a, pp. 90–5; Exhib. cat. Washington, D.C. 1995–6, cat. no. 8. Laboratory analysis has revealed that the artist continually reworked his paintings to clarify compositional, spatial, and iconographic relationships, as he did, for example, in the *Woman Asleep at a Table* (Plate 5). At various stages in its genesis, it included a dog in the doorway, a man entering the room, an additional chair or table at the middle right edge, and grapes and grape leaves in a bowl on the table in the foreground; see Ainsworth et al. 1982, pp. 18–26. See also Wheelock 1987.

78. See especially Swillens 1950, pp. 69–77, 113–21. See also Montias 1989, pp. 194–5.

79. See Swillens 1950, pp. 77–90; Welu 1975; Idem 1986; Montias 1989, pp. 194–5.

80. For this inventory, see Montias 1989, pp. 220–2, 339–44, doc. no. 364; Haks 1996, pp. 97–8.

81. As Montias 1989, pp. 219–20, 229, 338–9, doc. no. 363, relates, shortly after Vermeer's death, his wife desperately tried to keep this painting out of the hands of his creditors by ceding it to her mother, Maria Thins.

82. Sluijter 1998, who discusses the earlier scholarly literature on the painting.

83. See Franits 1995.

84. Slatkes 1981, pp. 73–4. Wheelock, writing in Exhib. cat. Washington, D.C. 1995–6, p. 180, links *The Love Letter* (Plate 29) to a painting by Pieter de Hooch of a couple with a parrot (his fig. 1), which is said to be dated 1668, a date supposedly consistent with its stylistic features. According to Sutton, writing in Exhib. cat. Hartford 1998–9, p. 178, there is no visible date on De Hooch's canvas. Moreover, Sutton argues that it most closely resembles the artist's works of the later 1670s and consequently was probably inspired by Vermeer's painting.

85. Wheelock 1995a, pp. 149, 200 n. 1, dates this picture to circa 1670, citing its supposed stylistic affinities with paintings of the late 1660s. However, to my mind, such details as the flat strokes of yellow paint that delineate the highlights on the frame of the painting behind the woman and the flat color patterns that compose her dress are quite similar to those seen in *A Lady Seated at the Virginal* of circa 1675 (Plate 35).

86. For this tumultuous period in Dutch history, see Israel 1995, pp. 796–814; Van der Sman 1996. For Dutch culture at this time, see Munt 1997. Van der Waals 1992, p. 182, argues that the art market recovered fairly quickly from the impact of the disastrous events of 1672. He wonders whether there were other, still unknown reasons for Vermeer's financial problems. However, Van der Waals's view of the recovery of the art market is not supported by recent studies; see Bok 1994, pp. 121–7. In any event, further evidence of his difficulties is furnished by the absence of Vermeer's name from the Delft tax-levy register of 1674, composed of all citizens in the city whose property amounted to more than 1,000 guilders. This fascinating register, which includes the name of Vermeer's wealthy mother-in-law, Maria Thins, was discovered by Van der Wiel 1996, pp. 59–61.

87. This translation is taken from Montias 1989, p. 212, who speculates that "Vermeer, frantic over his inability to earn money to support his large family and to repay his debts, had a stroke or a heart attack from which he had died in a day or two." A partial transcription of the original document can be found in ibid., pp. 351–2, doc. no. 383. Delft's municipal authorities appointed the renowned scientist and inventor of the microscope, Anthony van Leeuwenhoek (see Fig. 52), trustee of Vermeer's estate. In light of Vermeer's interest in optics it is tempting to posit that Van Leeuwenhoek accepted this appointment on the basis of his acquaintance with the artist. See Wheelock 1981, pp. 13–15; Idem 1995–6, p. 16; Idem 1997, pp. 19–20; Idem writing in Exhib. cat. Washington, D.C. 1995–6, cat. no. 16, who also made the intriguing suggestion that Van Leeuwenhoek was the model for the scientists in Vermeer's pendants of *The Astronomer* and *The Geographer* (Plates 27, 28) or perhaps even commissioned them. Wheelock's identification of Van Leeuwenhoek as the model for these pendants has been challenged by Blankert, Montias, and Aillaud 1988, pp. 87–8; Montias 1989, p. 225; Van Berkel 1997; and Van Berkel's chapter in this volume. As for Van Leeuwenhoek's trusteeship over Vermeer's estate, city officials entrusted such tasks to him on several different occasions during the 1670s. And in the case of the artist's estate, Van Leeuwenhoek vigorously defended the interests of the artist's numerous creditors, showing no partiality toward his widow. It is therefore unlikely that the artist and scientist were well acquainted; see further Montias 1989, pp. 225–30, 232–3; Van der Waals 1992, pp. 178–9; Montias 1998, pp. 101–2.

88. Montias 1989, Appendix A (pp. 265–7), estimates Vermeer's total lifetime output at between approximately forty-four and sixty paintings. While it has traditionally been maintained that Vermeer's working method was slow and laborious, recent studies have suggested that this was not always the case. Certain passages of Vermeer's pictures were rendered "wet on wet," which would indicate a more rapid manner of execution; see Wadum 1995–6, p. 77, and Costaras 1998, p. 156. However, both authors note that periods of time may have elapsed between painting sessions.

CHAPTER 2. VERMEER TEACHING HIMSELF

Editor's note: This chapter is reprinted, with some minor revisions, as well as the addition of some illustrations, from Exhib. cat. Stockholm, *Rembrandt och hans tid, Rembrandt and His Age,* pp. 89–105, Nationalmuseum, 1992–3.

1. Hubert von Sonnenburg, Chief Conservator, The Metropolitan Museum of Art, New York, in conversation, 1991. See also Von Sonnenburg 1973, which follows, Walsh 1973, the unpaginated article by my predecessor.

2. Huygens's account is published in English translation in Schwartz 1985, pp. 73–6 (see p. 74, col. 1). For some viewers a comparison of Rembrandt's *Capture of Samson* (Berlin, Gemäldegalerie) with the painting of the same subject by Lievens (Amsterdam, Rijksmuseum; Ibid., figs. 68, 69) would support Huygens's criticism.

3. Wheelock 1981, p. 64; Swillens 1950, p. 64, no. B. Swillens also rejected the *Diana* (Plate 3).

4. See the *Capture of Samson* by Christiaen van Couwenbergh of circa 1632 (Dordrecht, Dordrechts Museum; Schwartz 1985, fig. 70). For Bramer, see Wichmann 1923; Exhib. cat. Hempstead 1991.

5. On a case in point, see Liedtke 1989a, p. 29.

6. For the hypothesis that Bramer may have been Vermeer's teacher: Blankert 1978, p. 11; Wheelock 1981, p. 16; Gowing 1990, p. 159; Montias 1989, pp. 100, 103–4, on the evidence, and for Montias's doubts. If Vermeer was Bramer's pupil he was so in the same way that Rembrandt was indebted to Jacob van Swanenburg (Schwartz 1985, pp. 21–2).

7. Judson 1959, cat. no. 199, fig. 37. Van Honthorst is not mentioned in Blankert 1978 or Wheelock 1981, and only with respect to later paintings in Gowing 1970, pp. 126, 157. Slatkes 1981, p. 28, mentions "Vermeer's continuing interest in the Utrecht followers of Caravaggio" and then goes right on to cite "the open-handed gesture of the laughing girl," but he does not cite Van Honthorst, whose *Procuress* (Fig. 13) shows the same gesture.

8. On the origins of the quote, see Reff 1960.

9. That is, Van Honthorst's silhouetted figure in the immediate foreground: compare Rembrandt's *Presentation in the Temple* (Hamburg, Kunsthalle) and *Christ at Emmaus* (Paris, Musée Jacquemart-André), both dating from circa 1628 (Schwartz 1985, figs. 29, 32).

10. See n. 12, following. Wheelock 1981, p. 82, flatly states that "this work is exuberant and stresses momentary action," while Blankert 1978, p. 33, sees the figures here as "frozen" by Vermeer's "meticulous technique," which "prevented him from creating an effective suggestion of movement." Is the action in Van Honthorst's *Procuress* (see n. 7) "momentary" or "frozen"? The question reveals our postphotographic approach to Vermeer. The modern reading of action in his paintings must be very different from that of his contemporaries or even from that of Thoré-Bürger (on whom see Blankert 1978, pp. 67–9); Vermeer's pictures do not recall photography now but rather nineteenth-century photographs.

11. See Liedtke 1988, which rejects the extremely simplified view of Blankert 1978, pp. 29–31, to the effect that it was all De Hooch's idea. Nonetheless, Gowing 1970, pp. 107–8, rightly follows Valentiner in comparing de Hooch's approximately contemporary *Card Players* (Private Collection; see also Sutton 1980a, p. 81, cat. no. 25, pl. 22). The comments by Gowing 1970, pp. 105–8, on the setting of Vermeer's *Officer and a Laughing Girl* (Plate 6) have not been surpassed, as in the following: "One can trace in Vermeer's clear and rigid rectangle of space another sign of his acute eye for the essence of the varied elements in his tradition" (p. 107). Liedtke 1988 gives this tradition a name but Gowing gave me the idea twenty years ago.

12. Wheelock 1981, p. 82, who finds the same effect in Gerrit Dou and Carel Fabritius. The man's larger scale, which would be close to normal if he took off his hat and coat, may be an arbitrary exaggeration introduced both to enhance the sense of depth and to express something about the couple's impromptu relationship. Vermeer's male figures often seem intrusive, if not intimidating. The cocked arm might be seen as a response to the woman's gesture or words (compare the pose of the listening man in Van Brekelenkam's *Sentimental Conversation* [New York, The Metropolitan Museum of Art; Cat. New York 1980, vol. 3, p. 434, ill.]).

13. See now Cat. London 1991, pp. 137–8, pl. 116, for a review of the literature. At the risk of seeming ungrateful (Brown endorses Liedtke 1976 on the composition's design) I want to stress that my remarks on the swan were poetic license not iconology.

14. Liedtke 1982, chaps. 1, 3.

15. Compare Adam Pick's lost *Man at a Table* (see Blankert 1978, p. 34, fig. 25) and *The Terrace* (Chicago, Art Institute of Chicago), attributed to Hendrick van der Burch (Sutton 1980b, p. 325, figs. 57, 58).

16. Both chairs, both figures, and the window set up diagonal recessions to the left that balance the stronger recession to the right. This approach to very near forms in an architectural space is more reminiscent of Emanuel de Witte's church interiors (for example, Liedtke 1982, figs. 75–77, of ca. 1650–2) than of those by Houckgeest or Hendrick van Vliet.

17. Brown 1981, cat. no. 7, color pl. III.

18. On both, see Kahr 1982, a perceptive review of Snow 1979.

19. I refer, of course, to classicizing design principles that became common in the 1650s (Rembrandt's *Flora* [New York, The Metropolitan Museum of Art] is another example).

Vermeer's figures are often posed in ways apparently suggested by the works of other genre painters, especially Gerard ter Borch (see Fig. 1, text, and n. 56, following).

20. Wheelock, despite his keen interest in the device, has rightly emphasized Vermeer's many adjustments in compositional design: Idem 1981, in several commentaries to the plates; Idem 1987.

21. Gombrich 1972; for most of the relevant literature see now Parker 1990. A refreshing referral to Gombrich informs Van de Wetering 1991, esp. pp. 24, 26.

22. All this is established in detail by Montias 1989, chap. 13, passim.

23. This approach effectively began with Gowing 1970, pt. 2, pp. 75–157, and is now standard in Vermeer monographs. See also Slatkes 1981, and Liedtke 1988 for a broader view.

24. Gowing 1970, pt. 1, pp. 17–72. Kahr 1982, p. 339, considers Gowing 1970 as still the best monograph on Vermeer. Gowing's obituary appeared in the *New York Times,* Jan. 7, 1991, D25.

25. Wheelock 1977c, p. 440.

26. I hasten to add that Wheelock's subsequent monograph (Idem 1981) is filled with sensitive observations more reminiscent of Gowing than of lab reports.

27. Blankert 1978, pp. 15–17, pls. 1, 2; Wheelock 1981, pp. 64–9, as circa 1654–5 (*Christ in the House of Mary and Martha*) and circa 1655–6 (*Diana and Her Companions*); Slatkes 1981, pp. 15–19 (same dates as in Wheelock 1981). For the connection with Jacob van Loo (see Fig. 3), see Gowing 1970, p. 96 (two versions; the idea of a "direct quotation" is exaggerated); Blankert 1978, p. 15, fig. 6; Wheelock 1981, p. 68, fig. 61.

28. Slatkes 1981, p. 18 (right on both counts).

29. Blankert 1978, p. 13, describes *Diana and Her Companions* as "more complex" than *Christ in the House of Mary and Martha,* but one hopes he means "unresolved."

30. A Theodore Rousseau travel grant from the Metropolitan Museum enabled me to study the two paintings within a period of a few days (Nov. 1991). I am grateful to Drs. F. Duparc, Director of the Mauritshuis, and Julia Lloyd-Williams, curator at the National Gallery of Scotland, for their helpful comments.

31. The foreshortened rectangle on the wall never was clearly defined, to judge from X rays, various kinds of photographs, and the painting itself. It looks less like a window than a print hanging on the wall (as in Pieter de Bloot's painting of the same subject: see Exhib. cat. New York 1985–6, cat. no. 170). In any case, the point of this motif appears to have been to clarify the recession, which does not read in photographs. Before the painting itself it is clear that Christ's chair, which is at some slight angle to the wall, could not be pushed further back.

32. Here I differ completely with Wheelock 1981, pp. 66, 72. It is of some interest for the chronology that *Christ in the House of Mary and Martha,* not only the *Diana and Her Companions* (Plate 3), seems to look back to Jacob van Loo's *Diana and Her Companions* of 1648 (Fig. 3), where the modeling, the triangular groupings, and the three nearest figures present interesting analogies to the figures of Christ, Mary, and Martha.

33. The sash has a red, a white, and a mustard-colored stripe at the point where it circles Mary's back. Wheelock 1981, color pl. 1, is fairly faithful but a bit too red and blue: Mary's skirt is bluish green, her shirt a deeper, bluer red, and all the colors are richer, less opaque, and more in harmony with each other than in any published photograph.

34. Radiographs are in the curatorial file in Edinburgh.

35. There is also a resemblance to Ter Brugghen in facial types. A much more reliable observation, however, is that the silhouetted figure of Mary (compare Ter Brugghen's *Flute Player* [Kassel, Gemäldegalerie Alte Meister] and Christ in *The Calling of Matthew* [Utrecht, Centraalmuseum]) is conceived and painted as if in response to Ter Brugghen. The way Vermeer contrasts the volume of Mary's right arm with the flat plane of the other is Ter Brugghen–like, as are the broad white highlights

(for example, on her hand), the subtly blended colors (both headscarves), and the flow of drapery, especially in Mary's skirt.

36. Wheelock 1981, p. 64, fig. 59; De Bruyn 1988, p. 143, cat. no. 66, as circa 1640–5; reproduced in color in Exhib. cat. Caen 1990, pp. 144–5, cat. no. F27, accepting De Bruyn's date but doubting Adriaen van Utrecht's collaboration.

37. The picture is strongly defended as an autograph work in Wheelock 1986; Idem 1988, pp. 8, 13, 50–1; Idem in Exhib. cat. Warsaw 1990, pp. 272–7; Idem in Exhib. cat. Cracow 1991. On Felice Ficherelli (1605–69), known as Il Riposo, see Cantelli 1983.

38. This was done in both venues of the Vermeer exhibition in 1995–6 (see Exhib. cat. Washington, D.C. 1995–6). The present writer agrees with the opinion formed by some scholars at that time, which is that the painting is not by Vermeer and, possibly, not Dutch. [Editor's note: This note replaces Liedtke's original n. 38.]

39. The Ficherelli was exhibited next to the Vermeer in Exhib. cat. Warsaw 1990. Some idea of the Italian's technique can be gained from the colorplate of his *Salome* (Sale London, Sotheby's, December 11, 1991, lot no. 64).

40. Montias 1989, pp. 105–7, on Vermeer in Utrecht or Amsterdam.

41. De Bruyn 1988, pp. 32–3, 61, and cat. no. 180. For some reason Montias 1989, p. 105, has Quellinus in Amsterdam during the early 1650s.

42. According to Montias 1989, pp. 139–40. Like the *Christ in the House of Mary and Martha,* the *Visit to the Tomb* ("Three Marys") makes one wonder whether the subject was partly a tribute to Vermeer's mother-in-law, Maria Thins.

43. Wheelock 1981, p. 72; Montias 1989, pp. 254, 364. Of course many painters in The Netherlands went to Amsterdam during the city's most prosperous period, the 1650s and 1660s.

44. Montias 1989, pp. 185, 219, 351.

45. Indeed, he ignored much of what was produced in Delft, the great variety of which is evident not from the literature of Vermeer but from Eisler 1923; Exhib. cat. Delft 1981, chap. 6, pp. 172–202; and Montias 1982.

46. Slatkes 1969, nos. A12, A20, figs. 17, 22. Nearly the same composition is found in Van Honthorst's *Merry Company* (Helsingör, Schloss Kronborg), which also dates from 1623 (see Exhib. cat. Utrecht 1986–7, p. 59, fig. 55). The arrangement of the three figures on the right in Vermeer's *Procuress* is anticipated by dozens of prints and paintings dating back to the turn of the century (for example, Nichols 1991, fig. 35).

47. See Blankert in Exhib. cat. Utrecht 1986–7, pp. 35, 39–40, fig. 30 (Van Couwenbergh).

48. See Wheelock 1981, fig. 58; Exhib. cat. Utrecht 1986–7, pp. 240–1, cat. no. 50; and Döring 1988, pp. 162–3, fig. 211.

49. Wheelock 1981, p. 72. Wheelock does not see the *Christ in the House of Mary and Martha* (Plate 2) as a response to Flemish technique and therefore considers *The Procuress* (Plate 4) to be closer in handling to the *Diana and Her Companions* (Plate 3). Even if this were convincing, the *Diana and Her Companions* would not have to be brought forward in date: Vermeer's early development is rich in technical digressions, even within single paintings. In its action (the couple on the right bear a curious resemblance to Christ and Martha), setting, color, and quality, *The Procuress* is much closer to the *Christ in the House of Mary and Martha* than to the *Diana and Her Companions.*

50. The interest of Maes for *A Woman Asleep at a Table* is noted in all Vermeer monographs from Gowing 1970 onward; see Wheelock 1981, p. 74. Not only the composition and motifs but also aspects of Maes's manner of execution and coloring are recalled in this picture, and essentially in this picture alone.

51. Montias 1989, pp. 134–5, 364, doc. no. 8.

52. See Wheelock 1981, p. 74, and sources cited. Less reliable are Wheelock's reference to "the girl's melancholic state" (her smile is unmistakable) and the application here (p. 37) of his familiar theory about lenses, convex mirrors, and "optical distortions." The space in this painting is entirely comprehensible as an evolution from the *Christ*

in the House of Mary and Martha and *The Procuress* (Plates 3, 4), from Nicolaes Maes, and from Vermeer's highly visual imagination.

53. Wheelock 1987, fig. 21. The *roemer* recalls both the pitcher and the abraded glass in *A Woman Asleep at a Table,* but as a *repoussoir* (a motif positioned in the right or left foreground of a picture to lead the viewer's eye into it) it corresponds to the back of the chair. There appears to be an abraded *roemer* on its side in *The Procuress.*

54. Compare Liedtke 1982, figs. 41, 44, 62, color pl. VI; Van Vliet's curtains are usually green, as in the Vermeer.

55. The similarity of the illusionistic curtain (Plate 7) to the wall on the right (Plate 5) even extends to the double lines of daylight that flash down from the top frame (in Plate 7, from the leftmost curtain ring). Also similar is the progress from shadow to bright light as the viewer's gaze descends from the empty space above.

56. See Gudlaugsson 1959–60, vol. 1, pls. 77, 80, 112–14, 125, 126, etc. Of course the similarity extends to the letter-reading theme. Vermeer and Ter Borch served together as witnesses on April 22, 1653 (Montias 1989, pp. 101–3). Ter Borch was probably in the area of The Hague and Delft more often than documents indicate (see Liedtke in Cat. New York 1984, pp. 86–7).

57. Wheelock 1987, pp. 410–11.

58. For example, in *The Girl with the Wine Glass* (Plate 13). Compare Ter Borch's *A Glass of Lemonade* (St. Petersburg, Hermitage), reproduced in Exhib. cat. New York 1988b, cat. no. 4; see Liedtke 1989b, p. 155.

59. A footnote to my discussion of shared compositions in Liedtke 1988 is that the window in the *Officer and a Laughing Girl* (Plate 6) corresponds in its recession, type of frame, and mullions to the windows found in Quiringh van Brekelenkam's paintings of tailor shops (which date from 1653 onward), where the sequence on the left of a chair, a figure with a hat facing away from us, a distinctly smaller figure facing forward, and then a wall with a broad rectangular image on it is similarly arranged (see Fleischer 1988, figs. 4–9, etc.). The point is not that Vermeer needed the help of an artist in Leiden to discover this design but that he could find it in countless variations, one of which may have been models posed in an actual interior.

60. The illusionism and modeling in *The Milkmaid* suggest that it follows fairly closely after the *Girl Reading a Letter at an Open Window* (Plate 7), or about 1657–8. See Wheelock 1987, pp. 389, figs. 4, 5, and 391, for the clothes basket that Vermeer first painted in the right background.

CHAPTER 3. VERMEER'S CRAFT AND ARTISTRY

1. This text is largely drawn from Wheelock 1995a, pp. 6–17.

2. Much valuable work in this area has been done by John Michael Montias. See, in particular, Montias 1989 and idem 1991.

3. The impetus for much of the recent examination and conservation of Vermeer's paintings was the 1995–6 Vermeer exhibition in Washington, D.C., and The Hague. For an excellent assessment of Vermeer's materials and techniques that resulted from this research, see Costaras 1998.

4. See, for example, Gifford 1998; Wadum 1998.

5. Ainsworth et al. 1982.

6. The most extensive analysis of Vermeer's pigments was undertaken by Kühn 1968.

7. For further discussions of the camera obscura, see Wheelock 1995a, pp. 17–19.

8. For a fuller discussion of these issues, see Wheelock 1991.

9. Van Hoogstraten 1678, p. 274, "Maer ik zegge dat een Schilder, diens werk het is, het gezigt to bedriegen, ook zoo veel kennis van de natuur der dingen moet hebben, dat hy grondig verstaet, waer door het oog bedroogen wort."

10. Orlers 1641, p. 377.

11. Angel 1642, pp. 53–4.

12. Ibid., pp. 54–5. For an excellent discussion of Dutch art theory as it relates to the Leiden *fijnschilders* ("fine painters") see Sluijter 1988.

13. De Bie 1661, p. 215. For an excellent assessment of De Bie's treatise, see De Villiers 1987.

14. Van Hoogstraten 1678, p. 25.

15. Evelyn n.d., p. 246.

16. De Piles 1715, p. 423.

17. Van Hoogstraten 1678, p. 79, ". . . den hoogsten en voornaemsten trap in de Schilderkonst, die alles onder zich heeft, geport en gedreven, welk is het uitbeelden der gedenkwaerdichste Historien."

18. See Blankert 1980, p. 16.

CHAPTER 4. PERSPECTIVES ON WOMEN IN THE ART OF VERMEER

My warm thanks to Ülkü Bates, Anne Lowenthal, and Lucy Oakley for helpfully commenting on a draft of this chapter, and to Alison McNeil Kettering for her dependable willingness to share ideas on matters large and small.

1. For an analysis of feminine attire in Vermeer's works by a costume historian, see De Winkel 1998. It should be noted that Vermeer freely manipulated (passing) fashion to fit his durable vision of subject and form, and his expressive purposes as well.

2. "Burgher" denotes a citizen of a town. It also had an economic dimension, referring to those whose assets were great enough to tax, thus skilled professionals of many kinds, well-off widows, but also the rich upper crust who supplied the members of each town's elite *vroedschap* (governing council). For the more prosperous segments of the broad economic spectrum connoted by the term, I will add such adjectives as "high-class." On specifically Delft burgher values in relation to Vermeer's *The Music Lesson* (Plate 17), see Bièvre 1995.

3. Charting the various scholarly interpretations of Vermeer's female figures would require a separate study of considerable length. Most publications perforce include discussion of his feminine imagery. Snow 1994 can be recommended for its thematic coherence, its close attention to Vermeer's figures as vivid evocations of human beings, and its sensitive analyses of pictorial devices that shape our understanding of them. Recent articles that directly address aspects of "women in Vermeer" include Elise Goodman's essay reprinted in this volume; Salomon 1998; Vergara 1998. On women in Gerard ter Borch's paintings, which had considerable impact on Vermeer, and for analytical categories applicable to much feminine imagery of the period, see Kettering 1993 (reprinted in Franits 1997b, pp. 98–115). Goffen 1997, a study of Titian's depictions of women, establishes ways of dealing with gender issues in the work of an individual artist. For gender issues in Dutch scenes of domesticity, see Franits 1993; Hollander 1994; Honig 1997. Also relevant here are women as subjects in high-class burgher marriage portraits, for which see Woodall 1997. For exploring gender issues in Dutch seventeenth-century culture generally, good starting points include the collection of essays in Kloek, Teeuwen, and Huisman 1994; Kloek 1993; Parente 1994; Moore 1994; Van Deursen 1991, esp. chap. 6; Schama 1988, esp. chap. 6. Readers of Dutch will find much interesting material in Keesing 1987.

4. Marrow 1997, p. 57. Marrow's discussion has considerable relevance for even so late a contributor to the Netherlandish tradition as Vermeer. For recent, informative accounts of various professional aspects of Vermeer's *Art of Painting*, see Asemissen 1993, Wheelock 1995a, chap. 13; Sluijter 1998.

5. Sluijter 1998, p. 272. In positing a lofty precedent for the *Art of Painting's* focus on a female model, Sluijter assigns more significance to the subject of *Apelles Painting Campaste* than to *St. Luke Portraying the Virgin*. The relevance of the latter seems

greater to me, for reasons of tone (Vermeer's model seems too young and chaste to recall the inherent eroticism and stress on "female pulchritude and grace" of the former subject) and specific reference (for example, in The Netherlands the religious subject had an important historical role in the development of artistic self-consciousness, and the map in the *Art of Painting* refers to Netherlandish achievements).

6. For documents concerning Vermeer's possession of the *Art of Painting* at the time of his death, see Montias 1989, pp. 228–30, 338–9, doc. no. 363, p. 350, doc. no. 379; and on the room in the house that Vermeer evidently used as a studio, given the presence there of artist's materials, see ibid., p. 341, doc. no. 364 ("in the front room"). The impressive new headquarters of the Guild of St. Luke in Delft had been decorated recently by an older painter, Leonard Bramer, with personifications of Painting and of the Seven Liberal Arts. That decorative scheme no longer exists.

7. Gowing 1970, p. 52.

8. Acres 1997 demonstrates Rogier's complex construction of meaning through axial relationships.

9. Snow 1994, p. 119, observes Vermeer's use of the map's lines and his signature to connect Painter and model in the *Art of Painting*.

10. Wadum 1995–6, pp. 67, 70 (diagram), analyzes the perspective.

11. Ripa 1644, p. 338.

12. Sluijter 1998, p. 267, describes the painting's gist along these lines. Sluijter downplays the notion of history (and thus Clio) in Vermeer's concept, yet many of the passages that he cites from the art literature of the time are deeply engaged with history, as is the very concept of Fame; Ibid., pp. 266–7, cites material linking Clio to honor, ambition, and fame. Sluijter implies that he views history as exclusively retrospective in nature, whereas his sources express a more common view of history as engaged with past, present, and future (as in "everlasting fame"). For Vermeer's local reputation as a "famous" painter, see Montias 1991, pp. 48–9. Vermeer's interest in history seems to be connected with the preparation, at the same time that he was conceiving the *Art of Painting*, of Van Bleyswijck 1667. This publication, with its strong sense of Delft history, mentions Vermeer twice, once in a poem that identifies him as having taken over the artistic torch of the late, great Carel Fabritius; see, most recently, Sluijter 1998, p. 269.

13. For a careful analysis of the costume, see Gordenker 1999, pp. 227–35 (the connection she makes between the costume and "history painting," however, does not apply in the case of Vermeer). Both Sluijter 1998, pp. 269, 281, ns. 46, 47; and De Winkel 1998, pp. 332–4, draw comparisons with other works of art in an attempt to characterize the costume as wholly contemporary, but none of the comparisons involves a doublet of the same type as Vermeer's. Further, the contexts in which the closest analogies occur actually support an interpretation of the doublet's peculiar slashings as retrospective. Sluijter 1998, p. 281, n. 48 (acknowledging Irene Groeneweg), provides a most interesting pamphlet of 1662 that acknowledges the difficulty of classifying the dress of painters; in that respect alone, the hybrid costume in the *Art of Painting* fits the social identity "painter" (see also, regarding the same pamphlet, De Winkel 1999, pp. 67–72). Indeed, depictions of painters in seventeenth-century Dutch art often bear this out, Rembrandt's many self-portraits providing the most familiar examples. On Rembrandt's likeness in the antique style, see ibid. The conclusion of ibid., p. 72, that some of Rembrandt's costumes in his self-portraits were "deliberate attempts to carve out a place for himself in a long tradition," in my opinion applies equally well to the costume of the Painter in the *Art of Painting*.

14. In a sale list of 1696 (see Blankert, Montias, and Aillaud 1988, p. 212, doc. 16 May 1696, nos. 38–40) there occur three *tronies* (bust-length figures) by Vermeer, one of which is specifically described as wearing *Antique Klederen* (antique dress). The references are to works such as Vermeer's *Head of a Girl* (Plate 23), where a piece of

blue drapery similar to that worn by the model in the *Art of Painting* would have been sufficient to warrant the term "antique." For an analysis of fluid variations on the term in relation to costume in seventeenth-century Dutch painting, see Gordenker 1995.

15. Snow 1994, p. 152.

16. Blankert, Montias, and Aillaud 1988, p. 212, doc. of 16 May 1696, no. 1.

17. On *Juffrouw* as a class marker, see Haks 1996, p. 101.

18. Wheelock 1981, p. 106, was the first scholar to absorb the precise gesture at the center of the *Woman Holding a Balance* into an interpretation of the work. Evidently, nearly all viewers intuitively – and to my mind correctly – regard the gesture of the figure in the *Woman Holding a Balance* as symbolic in nature. As a result, questions concerning the practical nature of the activity and what it conveys about the woman have not seemed urgent. It seems plausible that Vermeer's woman would have been construed as a merchant's wife. De Jongh 1998, pp. 361–2, with further references, explains that gold coins were balanced against special copper weights to make sure that they had not "been lightened by coin clippers, who trimmed off some of the metal around the edge. . . ." Ibid., p. 359, illustrates a weight box of a type relatively common in seventeenth-century household inventories and suggests that the smaller box on the table in Vermeer's painting is just such a container for holding a set of scales and weights. De Jongh's interest is not, however, in the woman's social role. He illustrates prints with personifications of the virtues necessary for a merchant's moral conduct, including, for comparison with Vermeer's woman, a represention of Conscience as a female figure with a flaming heart holding scales, and a skeleton with an hourglass standing behind her. These prints, De Jongh explains, were sometimes pasted under the lid of such boxes (ibid., figs. 11–14). The imagery he adduces is addressed to merchants, yet Vermeer's imagery somehow forestalls us from identifying the woman as a merchant's helpmate. Such motifs as the jewel box create the feeling that she dwells in her own feminine world. This example may give the reader a sense of the difficulty of confronting gender issues in Vermeer's art.

19. Gowing 1970, p. 53; Snow 1994, p. 158. Other writers, too, have discerned the exemplarity of the woman's gesture and of her depicted way of life; see, for example, Swillens 1950, p. 105; Wheelock 1981, pp. 106–8 (a brief but convincing interpretation); Idem 1995a, chap. 9, with many further references.

20. Salomon 1983, p. 220, citing a popular book by Jacob Cats, published in 1632, and a drawing by Jacob Jordaens. Art historians have frequently disagreed about whether Vermeer intended to depict the woman as pregnant, some citing contemporary fashion as the reason for her shape. However, De Winkel 1998, pp. 331–2, bringing expert knowledge of costume to bear on the subject, concludes that "dress alone provides no substantial evidence either for or against the hypothesis" that *Woman Holding a Balance* and *Woman in Blue Reading a Letter* (Plate 19) were meant to depict pregnant women. Since so many viewers perceive those figures as pregnant, however, to deny that the impression was intended implies that Vermeer was insensitive and inept as a figure painter. At the same time, it is understandable that he would not want his depiction of that state to overwhelm the other elements in the painting, as in some rare English portraits of women in a very advanced stage of pregnancy that De Winkel illustrates.

21. In a portrait of a woman holding a balance by Hendrik de Keyser, the scales must be complementary given the requirements of portraiture; Ann Jensen Adams illustrates the portrait in Exhib. cat. New York 1988a, cat. no. 28. That is, within Vermeer's visual culture, the imagery of the *Woman Holding a Balance* seems to be entirely positive. In his *Woman in Blue Reading a Letter* (Plate 19) the figure of a pregnant householder conveys some values in common with the *Woman Holding a Balance*; as Hedinger 1987, p. 154, points out, an inscription on the actual map that Vermeer depicted behind the letter reader states: "Dutch women are by nature pure, honor-

able, clever at running a home, very fertile, and bear an exceptional love for their children."

22. Ibid., p. 155, illustrates an unusual image that is much closer in time to Vermeer's, namely, an engraving of ca. 1650 from the circle of Cornelis Galle II depicting Mary pregnant, standing and reading a book; Hedinger compares the image to Vermeer's *Woman in Blue Reading a Letter* (Plate 19). The comparison is visually compelling, even though the engraving is artistically crude. And it is exactly the kind of devotional illustration that would have been available in the Catholic quarter of Delft where Vermeer lived.

23. Snow 1994, p. 158, vividly characterizes the "apocalyptic" background painting in relation to the figure of the woman, but he sees them as solely oppositional. His evocation of the woman and her qualities (Ibid., pp. 156–62) is nonetheless stimulating, including his meditation on a shadow in the shape of a large open hand on the woman's white headcovering. De Jongh 1998, pp. 360–2, argues that a reference to "conscience" is "at least one aspect of the overall meaning" of *Woman Holding a Balance*; see earlier, note 18.

24. Van Hoogstraten, 1678, p. 87; translation from Taylor 1998, p. 144.

25. Snow 1994, pp. 159–60. On self-reflective elements in Vermeer's art, see also Arasse 1998.

26. Blankert, Montias, and Aillaud 1988, p. 212, doc. of 16 May 1696, no. 11.

27. Kettering 2000 discusses Gerard ter Borch's paintings of soldiers in courtship scenes.

28. A diagram showing the horizon line and vanishing point in the *Officer and a Laughing Girl* is reproduced in Wadum 1995–6, p. 70. Wheelock 1981, p. 82, observed that the location of the vanishing point reinforced the bonds between the two figures. Wheelock 1995a, p. 57, extends his earlier discussion of the relationship between the figures by including the psychological associations of the colors they wear.

29. Blankert, Montias, and Aillaud 1988, p. 212, doc. of 16 May 1696, no. 6.

30. Wheelock 1995a, p. 87, connects Hooft's emblem to *The Music Lesson*. A more extended explanation of the emblem in light of the three accompanying mottoes and distichs is given in Hooft 1611/1983, pp. 160–1.

31. For example, an emblem with the motto "The heart, burning in the heat of love, trembles, in hope and fear," from Rollenhagen 1611, no. 39; reproduced in Henkel and Schöne 1967, pp. 1028–9.

32. Gowing 1970, pp. 52, 124.

33. Ibid., pp. 52, 125, correlates the captive Cimon with the gentleman, whom he regards as captive to the lady, and indeed as abjectly dependent on her. Montias 1989, p. 195, finds the mood of the painting "pensive, melancholy, oppressive," while Wheelock 1995a, p. 86, perceives that the suitor, "moved by the woman's beauty and that of her music, feels in perfect harmony with his beloved." It seems to me that here, as so often in Vermeer's work, the artist creates a dramatic tension so subtle that viewers are likely to focus on only one of the possibilities in its interplay of contrasts.

34. Gowing 1970, p. 121.

35. For an illustration of a virginal made in 1640 that has the same pattern on it, see Exhib. cat. Washington, D.C. 1995–6, p. 51. Students have often pointed out to me that the shape of the monogram is inscribed onto the forms of the figure herself; it is made by her arms and the bold stripes on the back of her bodice.

36. For the contents of the room that held Vermeer's painting materials, as listed in his death inventory, see Montias 1989, p. 341, doc. no. 364 ("In the front room"). For the painting described as "one who sucks at breast" that Vermeer's mother-in-law Maria Thins had inherited, see Montias 1989, p. 122; it is not listed in the death inventory. Since the latter does not include all of Maria Thins's possessions, and since some of the family's goods might have been previously sold or hidden away, we cannot be sure about what the household contained at any one time.

37. On Dutch depictions of artists' studios containing themes around music, see Raupp 1978. On the links between art and love, see Sluijter 1998, pp. 272–7.
38. Van Hoogstraten 1678, p. 87; translated and interpreted by Taylor 1992, pp. 213–14.
39. On Vermeer's relationship with Van Ruijven, and De Knuijt, see Montias 1989, chap. 13, which contains the fullest treatment of his discoveries. See also idem 1998.
40. On the art collection of Van Ruijven and De Knuijt, see Montias 1989, pp. 249–57, and pp. 359–61, 363–4, doc. nos. 417, 420, and 439, which can be used to reconstruct the collection on the basis of what evidently were bequests to their daughter.
41. On Pieter Spiering Silvercroon, see ibid., p. 247.
42. Angel 1642/1996, p. 238.
43. On Maria de Knuijt's bequest to Vermeer of 500 guilders, see Montias 1989, p. 250.
44. Honig 1997, pp. 193–4, sensibly argues that since the most important sphere for the consumption of Dutch painting was domestic, and since housewives were charged with creating the domestic environment, then an appeal to women must have played an important role in the production of Dutch art. That is, Dutch painting "was made to be viewed within a sphere increasingly identified as 'feminine.'" Kettering 1993, pp. 110–13, addresses the psychological condition of "viewing as a woman" with specific reference to the original audience for Gerard ter Borch's paintings.
45. Honig 1997, pp. 195–9, observes the overfeminization of the home in Dutch paintings of domestic subjects and deduces some of its ideological underpinnings.
46. Haks 1996, p. 101; and Montias 1989, passim, stress Vermeer's social mobility. Honig 1997, pp. 198–9, rightly points out that the kind of woman who figures in scenes of burgher domesticity is a signifier of affluence. Vermeer's paintings contributed to this phenomenon, and while I would not want to reduce his depictions of women and their spaces, as has ibid., p. 199, to "ciphers, possessed and possessing," that perspective does account for certain features of these works. Ibid. concludes that images of high-class burgher domesticity express a culture's "complacent pride"; depending on the painter, however, they seem to me to express a complex range of aspirations and ideals.
47. For Vermeer as a painter of "modern" burgher subjects, and some theoretical implications of his choice, see Vergara 1998, pp. 245–9.
48. Salomon 1983, p. 221, connects the kinship between the *Woman Holding a Balance* (Plate 15) and Marian paintings (for example, *The Annunciation*) to Vermeer's Catholicism. She also cautiously links the pregnancy motif to his wife, but from a slightly different premise (p. 217). Montias 1989, p. 162, speculates on the possible connection between Vermeer's solemn images of pregnant women and a violent threat against his pregnant wife. On correspondences between items in Vermeer's death inventory and in his paintings, see ibid., pp. 187–91; and De Winkel 1998 for costume in particular.
49. Fock 1998 has determined that such furnishings as the chandelier and the tiled marble floor were exceedingly rare in Dutch homes, even the wealthiest, and thus paintings such as *The Music Lesson* (Plate 17) and the *Art of Painting* (Plate 26) are misleading from the point of view of material culture. The tapestry, too, denotes wealth. But the setting in St. Luke guild pictures, too, was often unusually deluxe, and for the same reason: to convey the dignity of the art of painting. Further, a desire for wealth was explicitly acknowledged as one impetus for painting; for example, Vermeer's contemporary Samuel van Hoogstraten painted an emblem expressing this desire on the exterior of his famous perspective box (London, The National Gallery).
50. Haks 1996, pp. 93–4.
51. Montias 1989, p. 210, quoting a notarial deposition. Haks 1996, pp. 100–1, stresses the patrician status of Vermeer's in-laws.
52. Haks 1996, p. 101.
53. Ibid.
54. Montias 1989, p. 212.

55. Kloek, Teeuwen, and Huisman 1994, passim; Honig 1997, especially pp. 195–9. A small number of Vermeer's female figures might be interpreted as creating fault lines in the terrain of established perfections, but one could argue that these exceptions prove the rule: that his representational projects explored, albeit in highly original ways, culturally defined notions of feminine exemplarity.

56. Gowing 1970, p. 50.

CHAPTER 5. THE LANDSCAPE ON THE WALL IN VERMEER

The research for this chapter was completed during my tenure as a Visiting Senior Fellow at the Center for Advanced Study in the Visual Arts, National Gallery of Art, in 1983. I am grateful to the Center, especially to Henry Millon and Marianna S. Simpson, for creating such a congenial and stimulating environment in which to work. Subsequently, an abbreviated version of the chapter was presented at the 1985 College Art Association Annual Meeting in Los Angeles. I thank Laurinda Dixon and Wayne Franits for their interest and support; Walter Liedtke for reading and commenting on the essay; John Gouws for sharing his knowledge of seventeenth-century lyric poetry with me; and Suzanne Ferguson for advising me on musical instruments and practices reflected in Vermeer's paintings. I have retained the orthography and the punctuation of my seventeenth-century sources. I dedicate this essay to the memory of Judit Ebner (1940–91), Jim Ferguson (1928–89), and David Rahm Smith III (1946–98). [Editor's note: Elise Goodman's chapter was originally published in *Konsthistorisk Tidskrift* 58 (1989), pp. 76–88.]

1. Blankert 1978, p. 169, cat. no. 28.

2. Wheelock 1981, pp. 9, 41. I have followed Wheelock's chronology of the paintings discussed in this chapter.

3. The principal studies are De Jongh 1967, pp. 49–55; Gowing 1970, pp. 50–5; Kahr 1972; Welu 1975; Blankert 1978, pp. 44, 48–9, 156, cat. no. 4; Wheelock 1981, pp. 42–3, 74, 92, 98, 100, 106, 120, 128, 138, 142, 146, 152, with further references; Exhib. cat. Philadelphia 1984, pp. 340–5, with bibliography; Welu 1986, pp. 266–7.

4. For the relation of Vermeer's enframed landscapes, as well as those of other seventeenth-century Dutch artists, to painted landscapes by their contemporaries, see Stechow 1960.

5. For other studies that discuss love as the primary theme of Vermeer's paintings, see Seth 1980 and Reutersvärd 1988.

6. Murris 1925, pp. 89–90, 167–8; Grierson 1970, pp. 155–6; and Becker-Cantarino 1978, p. 61.

7. For Vermeer and emblems, see De Jongh, 1967, pp. 48–54, 67; Exhib. cat. Amsterdam 1976, cat. no. 71; Wheelock 1981, pp. 42–5, 52, 53, 59, 74, 92, 98, 128, 148, 152, with further references; and Seth 1980, pp. 17–40.

8. Vergara 1982, pp. 19–20.

9. Scherpbier 1933, pp. 102–3; Grierson 1970, pp. 155–7; Price 1974, pp. 84, 86, 88, 89, 114; and Sutton 1984, p. lxxiv.

10. Noske 1976, p. 181.

11. For Gesina ter Borch's songbook, see Curtis 1969, p. 159; and for a document cosigned by Vermeer and Ter Borch, see Montias 1977, pp. 280–1, doc. no. 46a.

12. Weevers 1960, p. 88.

13. See the basic study by Ypes 1934, pp. 97–218. Further, Forster 1969 discusses Petrarch's influence on European poets in general; and Goodman 1983 sees Titian's group of paintings (ca. 1550–70) as reflections of Petrarchan love lyrics set to musical accompaniment.

14. For the influence of French love and nature lyrics on Dutch poets and these poets' sojourns in France, see Grierson 1970, pp. 155–7, 159; Idem 1976, pp. 15, 35; Ypes

1934, pp. 18–19, 99; Hooft 1956, pp. 5–6; Weevers 1960, pp. 65–7, 74–5, 79, 93; Price 1974, pp. 86, 89, 94–6, 103; Becker-Cantarino 1978, pp. 26–7; Meijer 1978, pp. 112–13, 116, 121, 122, 142.

15. Curtis 1969, p. 158.

16. For Hooft's *Emblemata Amatoria,* see Meijer 1978, p. 115; and Praz 1964, pp. 371–2; and for the emblem book's connection with Dutch genre painting, Exhib. cat. Amsterdam 1976, pp. 186–9, cat. no. 46.

17. "Maer vraechtmen wat het singen bedujt / Op dese wijs beswaert: / 't Is om met sonderlingen gelujt / Te troonen t mijnewaert / De geene die mijn 't murruw hartjen heet / Wanneer se comt, met wassen handen kneedt," Weevers 1960, pp. 232–3.

18. "Door liefde groeien / De boom en struiken," Ibid., pp. 244–5.

19. Anon. 1961, pp. xxviii, 4–5, no. 2.

20. "'T 'jeughelijck jaer met sijn vroolijcke tijen, / Is rechtevoirt op sijn quixte (te) vrijen," in King 1971, p. 59.

21. For the emblematic figure of Temperance, which also appears in the stained glass window in Vermeer's *The Girl with the Wine Glass* (Plate 13), see Exhib. cat. Brunswick 1978, cat. no. 39. See also Neurdenberg 1942, pp. 65–9; Blankert 1978, p. 158, cat. no. 8; Exhib. cat. Philadelphia 1984, pp. 338–9, for the coat of arms, which has been identified with that of Janetje J. Vogel.

22. Grosse 1968. See also Schenkeveld-van der Dussen 1986, p. 75, for a brief treatment of the expression of poets' feelings about nature.

23. "Graves tesmoins de mes delices, / Chesnes touffus, beaux precipices, / Que j'ay veu tant d'estez, / Jaloux et glorieux de mes felicitez / . . . N'attendez plus que me rende / Où autre que l'Amour m'entende . . . ," in Huygens 1957, pp. 68–9.

24. "Vraecht yemandt wie datme soo stijve stem geeft, / 'T is, sonder wiens genae / Geen lust in mijnen lijve clem heeft, / Om wien ick singen gae / Dat vlacke stranden en stroomen blanck / En heuvels galmen van de wederclanck," Weevers 1960, pp. 232–3.

25. Krul 1640, p. 2, "Al zyt ghy vert, noyt uyt het Hart." Cited by De Jongh 1967, p. 50.

26. For a discussion of this picture, see Exhib. cat. London 1983, cat. no. 75.

27. De Vries 1948, pp. 23, 28. See also Blankert 1978, pp. 17, 148, for Vermeer and Italian paintings.

28. Bibliothèque Nationale, Collection Hennin, XXVII (1630), 10, no. 02334 G153058.

29. Weigert 1939–, vol. 7, p. 345.

30. Gowing 1970, p. 53.

31. "Ah dieux! quel-le diuine voix Anime ces cháps & ces bois, C'est un Ange, ou mon Uranie?" in Anon. 1629, fols. 7ᵛ–8ʳ.

32. De Azpiazu 1960, p. 21; Noad 1974, p. 4; Montagu 1979, pp. 19–21.

33. For two thorough discussions of the topos of the lady and the landscape, see the classic study by Leishman 1968, pp. 80–2, 137–8, 153, 190, 224–47, and Haase-Dubosc 1969, pp. 191–2, 200, 207, 216–18, 222, 292–3, 297.

34. See Bowring 1824, pp. 60–136; Huygens 1892–9, vol. 1, p. 77.

35. Quoted by Leishman 1968, p. 242.

36. Du Chesne 1605, fols. 18ʳ, 29ʳ–29ᵛ, 71ʳ–71ᵛ, "Comme en l'Arbre de Vie ont esté ramassées toutes les vertues & perfections des autres plantes, . . . aussi ce chef-d'oeuvre de la feme contenoit seul & particulierement, ainsi que quelque tableau racourcy, toutes les beautés & elegances des autres creatures. . . . qu'elle est exterieurement cogneuë, comme les arbres, esquels la beauté des fleurs fait témoignage de la bonté des fruicts. . . . Les plus mignars & blandicieux atraits de l'amour mondain gisent comme à l'abry sous cet ombrageux fueillage du chef feminin."

37. Corbin 1605, p. 78, "Qu'elle estoit . . . plus haute qu'un aulne esleué, . . . plus noble que les pommiers, plus regardable que le plus haut plantain."

38. Darcie 1622, p. 44. In addition to the many tributes to women as metaphorical trees in courtesy literature, female arboreal iconography was imaginatively expressed in

popular Dutch, German, and French prints of the seventeenth century that depict
lovely women who actually sprout like fruits from a tree, worshiped by gallants
below. Some of these are entitled *The New à la Mode Tree of All the Young Damoi-
selles and Maidens* (Nuremberg, 1629), *Here Stand the Trees Laden with Fruits for
Which Lovers Long* (Amsterdam, n.d.), *If You Want to Reach for Some, Reach for the
Ripe Ones* (Amsterdam, n.d.), and *L'arbre au beau fruict* (Paris, ca. 1660). The expos-
itory verses of *L'arbre au beau fruict* explain that the women allure their suitors and
vanquish their hearts; when their cavaliers taste this "fruit," it excites their amorous
desire and gives them new life. All of these engravings descend from a prototype in
De Bry 1611, no. xliv. The Latin *inscriptio* of De Bry's emblem suggests the particular
appeal of female arborification to the male imagination and male possessiveness:
"Happy Are the Young Men who have such a Tree in Their Garden." For these
unusual prints, which in the seventeenth century were allegories of the ardors and
risks of courtship, see Coupe 1966–7, vol. 1, pp. 178–9, vol. 2, pp. 246–7, nos. 102,
102a, 103, and fig. 103; and Beaumont-Maillet 1984, pp. 100–6.

39. L'Escale 1618, fol. 16ʳ; Saint-Gabriel 1660, pp. 2, 3, 253; Huygens 1892–9, vol. 8, p. 98. See also Cahn 1979, p. 86, for a brief history of the terms "chef-d'oeuvre" and "masterpiece."
40. De Passe 1640, p. 8.
41. See Pennington 1982, p. 99, nos. 610, 614.
42. Block 1890, p. 74, no. 73.
43. Weigert 1939–, vol. 5, p. 249, no. 30.
44. Block 1890, p. 74, no. 72.
45. See Leishman 1968, p. 80; Goodman 1994. See also Goodman 1992, pp. 57–63, for the theme of the "lady and the landscape."
46. De Jongh 1967, pp. 49–50.
47. The innocent woman in nature was hymned by Ronsard in "Bonjour mon coeur," which was set to music in Thysius 1889, p. 98, no. 87; by Huygens 1892–9, vol. 1, p. 77, in "Epithalamie au mariage de MonsR. Guilleaume de Liere avec Madᵉˡᵉ. Marie de Leefdael. Soubs les noms de Coridon et Philis"; by Vondel in *Lucifer,* in Mody 1976, p. 220; and by Jan van der Noot in "Sonnet," quoted in Weevers 1960, pp. 220–1.
48. Gowing 1970, p. 55.
49. See Wheelock 1981, pp. 154–5.
50. See Gowing 1970, pp. 52, 123–4; De Mirimonde 1961, 42–3; Kahr 1978, p. 284.
51. See Wheelock 1981, p. 120, and Moreno 1982.
52. Moreno 1982. Ibid. p. 56, compares the gesture of the standing woman in Vermeer's picture to that of a woman keeping time for musicians in Jan Miense Molenaer's *Musical Party* of 1633 (Richmond, Virginia Museum of Fine Arts), a painting that has been interpreted as a mirror of virtue.
53. I am grateful to Suzanne Ferguson for this information.
54. Finlay 1953, pp. 60–1.
55. See Anon. 1961, p. xiii.
56. King 1971, p. 59; Anon. 1661, fols. 16ᵛ–17ʳ, "Aminte approche-toy de ce plaisant boccage, / Entends de ces oyseaux l'agreable ramage: / . . . Aminte, tout cela ne parle que d'amour"; Anon. 1662, fols. 1ʳ–3ʳ, "Bois, ruisseaux, / aymable verdure, / Lieu charmāt & delicieux, / Qui vient gouster icy les plaisirs les plus doux, / . . . Ne sçauroient parler que d'amour."
57. For this painting, see Cat. Amsterdam 1976, p. 391, cat. no. c 140.
58. Ten Harmsel 1981, pp. 79–81; and Anon. 1961, pp. lviii, 126–27, "Ce soleil que j'ayme si fort, / A tant de beautes et de grace, / Qu' absent de sa divine face."
59. Waller 1905, vol. 1, p. 46, "At Penshurst."
60. Part and parcel of the "sympathy of nature" topos and present in Petrarch 1976, pp. 398–401 poem 239.

61. For discussions of nature in seventeenth-century literature, see McCann 1972, pp. 125, 138, 189; Crump 1928, pp. 13–14, 214; Delley 1969, p. 98; and Schenkeveld-van der Dussen 1986, p. 75.

CHAPTER 6. VERMEER ON THE QUESTION OF LOVE

I am extremely grateful to the University of Houston for the award of a PEER grant, which allowed me to conduct research for this chapter during the summer of 1999. All the translations from Dutch into English are my own, unless otherwise noted.

1. On genre painting in Delft in the first half of the seventeenth century, see Sluijter 1981, pp. 177–8.
2. Important studies of Dutch songbooks include Keersmaekers 1985; Grootes 1987; and Grijp 1992. For an introduction to the subject in English, see Grijp 1993. On music in Delft, see Van Boheemen and Van der Heijden 1981, pp. 251–2.
3. Blankert 1995–6, p. 31. Blankert cites Gerard de Lairesse (1707), though it should be noted that the concept of the "modern" picture is older: see Van Mander 1604, sigs. 284 and 299v.
4. Blankert 1995–6, pp. 32–5.
5. For example, Anon. 1602, p. 45. On this motif in earlier sixteenth-century songs see Renger 1985, pp. 40–1.
6. For the first interpretation, see Exhib. cat. Brunswick 1978, p. 167; for the second, Bedaux 1975, p. 35. Wheelock 1981, p. 92, considered both as plausible readings.
7. See, for example, the emblem of the smoking man with Cupid bringing him more pipes: Cats 1618, p. 12.
8. On the motif in paintings, see the interpretation of a painting by Gerbrand van den Eeckhout in Franits 1993, p. 44. The solitary pipe-smoking man observing the merry-making of others at a party is also found in Delft genre painting in the silhouetted figure standing to the left in Jacob Jansz. van Velsen's *Merry Company,* 1631 (London, The National Gallery): Exhib. cat. Delft 1981, p. 178, fig. 190. For the literary tradition, see the song *Den droevigen vryer* (The Sad *Vrijer*) in Bredero 1622/1975, vol. 1, pp. 341–2.
9. Van Dans 1668, p. 116; see also Anon. 1659, pp. 9–10.
10. Ionctys 1639, sig. E1v, ". . . een soette tong, een lieven lach/ Noch meer dan schoonheyds glantz vermag." Etiquette books cautioned women against laughing too loudly (to the point of showing their teeth), as Salomon 1998, pp. 319, 325 n. 39, notes, but the frequent praise of female laughter in poetry of the time seems to me at least as relevant a context for such images.
11. De Lairesse 1707, pt. 1, pp. 182–4. Similar remarks by De Lairesse are cited in Kettering 1993, pp. 108–9, who calls attention to the greater effect of narrative in the more focused compositions of later Dutch genre paintings compared to the earlier scenes. See also Riegl's discussion of what he calls the *"novellistisch"* phase of Dutch genre painting: Riegl 1931, pp. 274ff.
12. Pol 1987, vol. *"onderzoek,"* p. 42, compiles the following numbers for "novel-like writings" printed in The Netherlands (both original Dutch texts and translations, including reprints): 1600s – eight; 1610s – thirteen; 1620s – five; 1630s – twenty-nine; 1640s – eighty-seven; 1650s – sixty-one; 1660s – seventy-four.
13. Anon. 1668, p. 179.
14. Pol 1987, vol. *"onderzoek,"* pp. 51–6, 84–5.
15. Gerard ter Borch, *A Gentleman Letting a Lady Drink* (London, The Royal Collection); Blankert 1995–6, p. 36, compares this painting to Vermeer's *Glass of Wine* (Plate 9).
16. As noted by Wheelock 1988, pp. 68, 70. Such ambiguities have long been part of the literature on Vermeer: see, for example, Würtenberger 1937, pp. 49, 70–71.

17. See, for example, the two paintings by Jan Steen discussed in Wheelock 1995a, p. 86.
18. Ibid., p. 95.
19. See Gowing 1970, pp. 124, 126; Arasse 1994, pp. 37–9, 111 n. 41–3.
20. Arasse 1994, esp. chap. 3 "The Picture-within-the-Picture," pp. 22–39. For a discussion of the subject in the context of the rhetorical theory of *exempla*, see Weber 1998, pp. 295–307.
21. On the pastoral meaning of the landscape in *The Guitar Player* (Plate 34), see the article by Elise Goodman reprinted in this volume.
22. Mirimonde 1961, p. 42. Some images of prostitution were set in grand interiors, for example, Johannes Sadeler's engraving after Joos van Winghe, *Nocturnal Banquet with a Masquerade,* 1588, but the openly lascivious figures here set a different tone from Vermeer's *Concert.*
23. Moreno 1982, pp. 51–7. It is not necessary to follow Moreno in reading the musical group as an allegory of Temperance to see the contrast in tone between Van Baburen's scene and that of Vermeer.
24. La Serre 1641–2, vol. 1, pp. 306–7.
25. Westerbaen 1668, p. 59, "De stem heeft sommige gedient voor koppelaer."
26. Van Boheemen 1989, p. 53.
27. Montias 1989, pp. 122, 292, doc. no. 167.
28. On the meanings of *vrijen* see De Vries et al. 1882–1995, vol. 23, pp. 699–702.
29. Cats 1625, chap. 1, preface, sig. I (***)ij^v, "schoon bedroch . . . Schijn, en losse Droomen."
30. Ibid., chap. 1, preface, sigs. I (***)^v–I (***)ij^v.
31. See Kettering 1993, pp. 104–5, who cites Grootes 1987, p. 84.
32. See, for example, the songs in Anon. 1615/1985, p. 32; and Bredero 1622/1975, vol. 1, p. 160.
33. Cats 1625, chap. 2, p. 55: "Het schijnt dat ghy den vrijen tijt/ Van onse soete jeught benijt. . . ."
34. Westerbaen 1668, p. 70, ". . . in Saletten/ Van uwe vrienden."
35. Keersmaekers 1985, p. 119, has referred to a *vroomheidscultuur* (culture of piety) among Dutch youth, to which amatory songbooks appealed by emphasizing the honor of the songs.
36. Visscher 1614, pt. 2, p. 71, emblem X.
37. Van Heemskerck 1626, pp. 101–3, "Indien in d'ander Eeuw de Meysjes niet so seer/ Geciert en zijn geweest, de Jongmans waren weer/ As sy heel slecht en recht: indiens' haer doen niet kleden/In 't zyde noch fluweel, wat wonder was 't? Soo 'n deden Haer soet Vryers oock. . . . Het oude prijs wie wil, voor my ick bender een/ Die 't met onse houw; en blijf seer wel te vreen/ Dat ick geboren ben op dese tijd van heden . . . daerom dat men nu een goe bevalligheyd/ In alle dinghen speurt, en dat de bottigheyd/ Des onbedreven Eeuws geheel in onse daghen,/ Is door wel-levens-kunst ten lande uyt-geslagen."
38. See, for example, his discussion of Prince Maurits's military victories: Ibid., pp. 12–13.
39. Van Hoogstraten 1650, sig. *7, "Batav'sche Minnery in suyv're Moeder-taal,/ Door 't yslijk schateren der Bussen en Trompetten,/ Tot noch toe ongehoort: hoe-wel dat and're volkken,/ Soo Greik, Romeyn als Frank met oversoet gedicht/ Ons Schrijvers tarteden; maar naulijks had de Vrede/ Haar hayl'ge voet gestelt in Hollands snege Zalen;/ Of puyk van Poesi vertoont ons al 't geheym. . . ." This poem is signed K. V. Nispen.
40. The 1696 Dissius sale identifies the painting as "A soldier with a laughing girl, very beautiful"; see Montias 1989, p. 362, doc. no. 439. Hedinger 1986, pp. 79–84, notes the patriotic tone of the inscription on the map, which praises Holland's military

strength and the virtue of its women; Wheelock 1995a, p. 61, expands upon this reading.

41. Hooft 1611, p. 4, ". . . den strengen Mars, . . . / Alsoo te'ontlaten weet, dat toom, en gladde speyr/ . . . hem uyt zijn handen druypen,/ Als zy hem gheeft een wenck om tot haer in te sluypen." The contrast between the swaggering pose of the soldier's right arm in Vermeer's painting and the woman's arm lying on the table, which Snow 1994, p. 84, discusses – which seems to me to be a juxtaposition of masculine strength and feminine delicacy – reminds me of the lines from an English poem quoted (and simultaneously translated into Dutch) in Ionctys 1639, "Great Warriers erst their rigour to suppresse/ And mighty handes forget their manlinesse/ Driven with the power of an heart-burning eye/ That can with melting pleasure mollifie/ Their hardened hearts/ inur'd to cruelty."

42. La Serre 1641–2, vol. 1, sig. *3, ". . . maer gezelschap willende maken met zoodanige, die met haer in staet, kledingh, optoyzel, en gewoont van leven best over een qua-men, heeft u . . . ghekozen voor heur bezonderste Gezellinnen. . . ." The second volume is similarly dedicated to the "Amsterdamse Minnaers" (male lovers of Amsterdam) and vol. 3 to the "voornaemste Haerlemmer Jufferen, en Monsieurs" (the most eminent Haarlem ladies and gentlemen).

43. Anon. 1668, p. 422.

44. Rüdiger Klessmann's reading of the female figure holding the coat of arms in the Berlin and Brunswick paintings (Plates 9 and 13) as an allegory of Temperance (Exhib. cat. Brunswick 1978, pp. 167–8), which has been widely accepted in the literature on Vermeer, has recently been called into question (convincingly, I think) by Weber 1998, p. 303. Wadum 1998, pp. 211, 222 n. 48, notes that marble floors were rare even in upper-class households, and that they must have given such scenes an ambience of great wealth. On the keyboard instruments in Vermeer's paintings, see Buijsen 1996, pp. 118–20.

45. On apparent correlations between articles of clothing and other objects represented in Vermeer's paintings and the contents of his estate inventory, see Montias 1989, pp. 190–2. Haks 1996, p. 98, concludes that Vermeer and his wife did not have the possessions of the very richest Dutch families but were still among the upper level of the burgher class.

46. On Maria Thins's family, see Montias 1989, pp. 108–28.

47. Haks 1996, pp. 98, 101.

48. On this and other possible examples of Vermeer's social ambition, see ibid. On the coat of arms in the two paintings by Vermeer, see Montias 1989, p. 190.

49. For example, Jacob de Gheyn II's engraving *Vanitas*, as discussed in Exhib. cat. Boston 1981, cat. no. 11.

50. On the disorderly space of Steen's paintings, see Westermann 1997, pp. 117–22.

51. Vergara 1998, pp. 246, 254 n. 39, cites these passages from De Lairesse in reference to Vermeer.

52. See the section "Cleanliness and Godliness" in Schama 1988, pp. 375–97. On domestic culture in general, see Franits 1993.

53. On Vermeer's walls, see Stoichita 1997, p. 165.

54. [Van Heemskerck] 1637/1982, p. 86, ". . . was ick verwondert van daer te sien een nettigheydt (soo in ghewitte muren, als andere Hollantsche puntigheydt) daer myne ooghen door een langhe uytlandigheydt nu by-naest van af-ghewendt waren."

55. [Bon] 1652, p. 196.

56. La Serre 1641–2, vol. 3, p. 284.

57. De V. 1682, pp. 58–9, 69.

58. The connection with Van Veen's emblem was first proposed in De Jongh 1967, pp. 49–50. Yet another Cupid in a painting is found in Vermeer's *A Woman Asleep at a Table* (Plate 5), which has been related to another emblem from Otto van Veen's

Amorum Emblemata; for a discussion of this painting with reference to previous literature, see Wheelock 1995a, pp. 39–47.

59. For the theory that Vermeer's Cupid is holding a letter, see Weber 1998, p. 299; and Blankert 1995–6, p. 38. Gaskell 1998, p. 231, sees the object held by Cupid as deliberately unidentifiable. A painting of Cupid was listed in the inventory of Vermeer's estate; see Exhib. cat. Washington, D.C. 1995–6, p. 199 n. 2. There is also the painting of Cupid with a mask lying on the ground in Vermeer's *A Woman Asleep at a Table* (Plate 5); see n. 58, preceding. The relationships among all these Cupids – those in Vermeer's paintings, the painting listed in his estate, and the prints from Van Veen's emblem book – will likely never be sorted out.

60. Nevitt 1997, pp. 167–70, with further references.

61. On Dutch tiles, see Pluis 1997. See also the print by Willem Basse, *Pair of Lovers.* As De Jongh 1998, p. 353 (ill. on p. 354), points out, the painting of the satyr and nymph on the wall in Basse's scene relates to the pair of lovers in the same way that the Cupid painting reinforces the amatory theme in Vermeer's *A Lady Standing at the Virginal* (Plate 33). De Jongh does not mention the tiles in Basse's print, several of which clearly contain amorous pairs.

62. Van Dans 1668, p. 131: "Leert . . . herten stelen/ Met het Clavi-cymmel spelen."

63. For example, Ionctys 1639, sig. O2ᵛ, "Een Schaduw volgt het lichaem dicht,/ Waer op de Sonn syn strael koomt spreyden./ Ick, als een Schaduw van mijn Licht,/ Ben nimmer van haer afgescheyden." Wheelock 1995a, p. 87, compares Vermeer's *The Music Lesson* (Plate 17) to a print in Hooft 1611, p. 33, in which a man listens to a woman playing a keyboard, with the motto "Zy blinct en doet al blincken" (She shines and makes all shine).

64. [Bon] 1656, p. 87, "En hoe u Goddelijcke oogen/ Wel herten pogen/ te trecken by/ U heldre glans/ diet alles overwint:/ Waer door Apollos stralen staan verblint."

65. Ionctys 1639, sig. L3ᵛ, "En gy, Cupido . . . Gy moogt niet ongewapent leven:/ Want d'OOCHIES van mijn ROSELIIN/ Die sullen u weer schichjes geven."

66. Van Santen 1625, sig. A4ᵛ, "Geen luck was boven 't mijn, o schoon-geschapen-Vrouwe,/ Na t'beeld van Venus selfs, wiens aert dat ghy uyt beeld." These lines are from the Delft-born Gerrit van Santen's cycle of love poems in the form of letters, *Stomme-boden ofte brieven* (Silent Messengers or Letters). On the relations between Vermeer's family and Van Santen's, see Montias 1989, pp. 76–7.

67. [Bon] 1652, p. 71, "Ay siet wat vliegt daer gins om hoog/ Wel Trijngtje watte dinge/ 't Is een kleyn mantje met een boog."

68. Ibid., p. 73, "Ay/ ay/ ay/ lieve Cupido/ Je moetme niet vernielen/ Je selje pijltje smertme soo/ Hout op k sel voorje knielen . . ."

69. Visscher 1614, pt. 3, p. 178, emblem LVI; cited by Wheelock 1995a, pp. 71, 193 n. 9.

70. See the discussion of a painting by Jacob van Loo by Franits 1993, pp. 48–51.

71. Van Dans 1668, pp. 21, 23, "Maeghden-brandt die leydt verholen,/ In het hert bestaen de Kolen . . ."

72. Anon. 1659, p. 10, ". . . 't Vryers paetje/ om te sien/ en gesien te worden." On maid-servants, see Schama 1988, pp. 455–60, 467; Carlson 1994; and Hollander 1994.

73. Carlson 1994, pp. 92–3.

74. [Bon] 1652, p. 4, "Laet dit Boeckje niet verslingeren,/ Als wanneerje met je vingeren,/ Aerdigh dichte kantjes weeft."

75. See Blankert and Grijp 1995.

76. Franits 1993, p. 48.

77. Krul 1640, pp. 2–3: "Wel te recht mach Liefde by de Zee vergeleecken werden/ aenghesien haer veranderinge/ die d'eene uyr hoop/ d'ander uyr vreese doet veroorsaecken . . . ," cited in Exhib. cat. Amsterdam 1976, p. 52, in connection with Vermeer's *The Love Letter* and Dirck Hals's *Seated Woman with a Letter,* 1633 (Philadelphia, Philadelphia Museum of Art), and *Woman Tearing Up a Letter,* 1631 (Mainz, Mittelrheinisches Landesmuseum).

78. Wheelock 1995a, pp. 70–1.

79. If a male viewer found erotic interest in this figure, he would be comparable to the putative reader of *Venus minne giftjens* (1622) whom the text invites to leer at a modestly dressed maidservant scrubbing a tub; see Becker 1991, p. 148. A later episode in the life of *The Milkmaid* (Plate 8) may serve as an epilogue here. In 1908, when rumors surfaced that the American J. Pierpont Morgan was planning to buy the painting from the Six Collection, the Dutch parliament purchased it for the state. A Dutch cartoon showed the government minister Rink walking away arm-in-arm with the milkmaid, while her rejected suitor, Uncle Sam, stands forlornly in the background; see Exhib. cat. Washington, D.C. 1995–6, p. 112.

80. The *keuken-meid* is described in Anon. 1697, pp. 122, 123 (a defense of maids written in response to De V. 1682).

81. Kettering 1993, pp. 109–13. For a recent consideration of the female gaze in Dutch genre painting, see Honig 1997, pp. 193–5.

82. Heemskerck 1626, sig. A3, ". . . ghy die onder het dack van een statige bedaeghtheydt noch een jeughdigh hert huysvest." Finally, we should consider Vermeer himself as a viewer; on the relationship between Vermeer's female subjects and his own artistic identity, see Sluijter 1998.

83. Bredero 1622/1975, vol. 1, p. 109.

84. Van Steyn 1662, p. 18, "Hier sta ick voor het lief gebouw;/ In wiens gewelf, en dichte wanden/ Mijn afgeroofde ziel, in banden/ Gestadigh sucht: om weder-trouw./ Gesloten ingang, houdt mij buyten/ Indien mijn Engel mijn noch haet,/ En met dat vinnigh op-set gaet;/ Van hare ziel voor mij te sluyten." For the Delft-born playwright Van Steyn, see Exhib. cat. Delft 1981, pp. 250–1, though this particular play is not mentioned.

85. Van Steyn 1662, p. 26, "Mijn hart leydt op dees' stee, en gae soo troost'loos heen?/ Dit is die lieve zael daer wij soo dickmael saten,/ Daer ghy Hart rooverij (myn Engel) dorst beslaen."

86. For related discussions of "feminine" domestic space in Dutch genre painting, see Honig 1997, pp. 195–7; and Salomon 1998, pp. 316–19.

87. Two such manuals in The Netherlands were Mostart 1643 and the Dutch translation of La Serre 1651. On epistolary manuals, see Bray 1967. On their relation to Dutch paintings, see Adams 1993, pp. 69–92, and De Jongh 1997, pp. 50–1.

88. Vergara 1998, p. 248, notes that by his marriage Vermeer moved from a family in which the women were probably illiterate to a family in which female literacy was common; she cites Montias who related this to the artist's interest in women as the subjects of epistolary images, and who compiled evidence on the literacy of Vermeer's relatives and in-laws; Montias 1989, pp. 78, 87, 210, 237, 261. On the epistolary novel, see Kany 1937.

89. Gerard ter Borch, *Officer Writing a Letter with a Trumpeter* (Philadelphia, Philadelphia Museum of Art); see Exhib. cat. Frankfurt 1993, cat. no. 11.

90. Dirck Hals, *Seated Woman with a Letter,* 1633 (Philadelphia, Philadelphia Museum of Art), and *Woman Tearing Up a Letter,* 1631 (Mainz, Mittelrheinisches Landesmuseum); Gabriel Metsu, *Young Woman Reading a Letter* (Dublin, National Gallery of Ireland).

91. Mostart 1643, p. 4, "De Zendbrieven . . . en hebben geen bepaelt onderwerp; want men schrijft van allerhande stoffe ende voorvallen." See also the similar remarks in La Serre 1651, p. 4.

92. The exceptions are the tight-waisted dresses worn in *The Girl with the Wine Glass* (Plate 13) and *The Glass of Wine* (Plate 9). It seems to me, however, that a survey of a *Woman Holding a Balance* (Plate 15), a *Woman with a Pearl Necklace* (Plate 14), the woman on the right in *The Concert* (Plate 20), *A Lady Writing* (Plate 21), and *Mistress and Maid* (Plate 25; the latter figures, admittedly, are seated), as well as the maid in *Lady Writing a Letter with Her Maid* (Plate 30), and even the female figure

standing on the left in the foreground of the *View of Delft* (Plate 11), suggests that either all of these women are pregnant or, as seems more likely, they are wearing a style of dress that gives that impression to modern eyes. (Finally, compare Vermeer's painting of the virgin goddess Diana, in *Diana and Her Companions* [Plate 3].) In Blankert, Montias, and Aillaud 1988, p. 181, Blankert argues that the woman in *Woman in Blue Reading a Letter* (Plate 19) is not pregnant. The most recent study of costume in Vermeer's paintings, De Winkel 1998, pp. 331–2, concludes that nothing about the dress of Vermeer's women indicates that they are pregnant (see also her comments on the gowns, called *tabbaards*, worn in *The Girl with the Wine Glass* [Plate 13] and *The Glass of Wine* [Plate 9], p. 330). For reference to scholars who take the opposing viewpoint, see De Winkel 1998, p. 337 n. 33.

93. Wheelock 1981, p. 32, fig. 29; the alterations also included painting out a glass on the table on the left and a large glass in the lower right corner.

94. Vermeer's exclusive focus on women in the letter paintings may in itself suggest an amatory theme: in La Serre's epistolary manual, the bulk of the correspondence to and from women consists of love letters: see the section "Verscheyden Minne-Brieven, Op allerley begevingen en gevallen" (Diverse Love-Letters, for all kinds of needs and cases) in La Serre 1651, pp. 195ff. Most of La Serre's letters to women that are not about love are messages of condolence on the death of a husband (Ibid., pp. 182–8, 258–75; 309–22); I count only one nonamatory letter from a woman (pp. 188–9). On the other hand, Mostart 1643 adds marginal notes to most of his model letters that allow one to switch the gender of author and recipient.

95. Cats 1625, chap. 2, pp. 4–6, forbade young ladies to write letters, though he allowed that they might receive them from male suitors. More people likely took the approach of the *vryerijboeken*, which followed Ovid in recommending the writing of love letters for both sexes: for example, Westerbaen 1668, pp. 17–18, 64–5, 69. The epistolary manuals include women as both writers and receivers of love letters: Mostart 1643, pp. 233–43; and La Serre 1651, pp. 195ff. Finally, the prose romances devote about equal attention to men and women in the writing and receiving of letters.

96. For example, the incident in which Leliana receives a letter from Kandoris, thinking it is from Coredan: [Boekholt] 1668, p. 5.

97. On *kameniers*, see Anon. 1682, pp. 89–90.

98. Ibid., pp. 58–9.

99. Westerbaen 1668, p. 15. Similar advice is found in Van Dans 1668, p. 77. (Both texts cited here follow Ovid.)

100. "'k Weet . . . datje by je Juffer hebt seer secreete audientie . . . Hoor eens, sey 'k soo, ken je maecken dat mijn Meester jou Juffers affexie kan genieten." Cited by Van Moerkerken 1899, vol. 2, p. 359.

101. This is suggested by Vergara 1998, p. 242.

102. [Boekholt] 1668, p. 121, ". . . maer de zelve geopent hebbende, en onder aen Kandoris naem ziende, werdt zoo moeyelijk als ze haer even blijdelijk had vertoont, en zonder daer vorder in te zien, smeetze op de vloer, zonder de zelve de minste glimp van een oogenstrael te geven." For letters ripped up and thrown on the floor, see De Sille 1645, p. 54; Anon. 1657, cited by Van Moerkerken 1899, vol. 2, p. 355; and Voskuyl 1636, sigs. B4 and C2ᵛ. See also the painting by Dirck Hals, *Woman Tearing Up a Letter,* 1631 (Mainz, Mittelrheinisches Landesmuseum).

103. *The Finding of Moses* also appears in the background of Vermeer's *The Astronomer* (Plate 27). In a sustained reading of Vermeer's *Lady Writing a Letter with Her Maid* (Plate 30), Vergara 1998 stresses the analogy between the letter writer and Pharaoh's daughter as an ideal female type. See also Wheelock 1995a, pp. 161–2.

104. In Samuel Coster's *Boere-klucht* (1627), the wife remarks bitterly to her maid that she is rich but trapped in an unhappy marriage, while her maid is poor but free; for her help in arranging a liaison with a peasant, she rewards the maid with new clothes; see Coster 1883, pp. 1–70.

105. La Serre 1641–2, vol. 1, p. 299, "Ziende . . . dat het af-wezen van haer Man haer gelegenheyd gaf om te antwoorden nam de pen en schreef aldus."

106. Westerbaen 1668, p. 69, "Al werd ghy naeu bewaeckt: ghy vind gelegentheyd/ Om aen u vryer yet t'onbieden door uw meyd:/ Ghy vindt gelegentheyd om heen en weer te schrijven:/ Uw briefjes kunne gaen en 't kan verhoolen blijven."

107. Cited by Van Moerkerken 1899, vol. 1, pp. 189–92.

108. [Boekholt] 1668, pp. 104, 109–10.

109. La Serre 1641–2, vol. 1, p. 299, ". . . Clitie zich . . . alleen vindende, namze, en ging'er mee in'er vertreck kamer, die eerst gesteken hebbende in 'er boezem; O glikkigh Papier, zijtge niet gevoelijk, in uw ongevoelijkheydt, ziende zonder oogen deze schone boezem, en die kussende zonder lippen? Cleander vreestge niet dat uw brief verlooren is, . . . Eer dat zyze opende kuste zyze, en zuchte op elke woord toen zyze las. En haer zuchte riepen haer tranen. . . ."

110. [Boekholt] 1668, pp. 153–4, "Leonora komt deze Brief ter handt, zoo als ze staet om na 't Bankket te gaen; haer nieuwsgierigheit was zo groot om die te leze, dat ze niet kon wachte zoo lang tot datze daer weer van daen quam, en derhalven teedze in haer kamer, en vindtze, open gebroken hebbende, zoodanig als ik heb verhaelt. . . . en nu is 't dat Leonora met duyzenderley verweeringe is omheynt: en hoe de ontroeringe haer ziel heeft doorkroope, zo toomtze haer zodanig in, dat men niets aen haer gelaet daer van kon bemerken."

111. Anon. 1678, pp. 17–18.

112. Ibid., p. 19, "Aurelia was vol verlangen om den inhoudt van den brief te sien, en was soo gaeuw niet t'huys gekomen, of begaf haer alleen in haer kamer, opende den brief, en vondt dit volgende daer in geschreven. . . ."

113. Stoichita 1997, pp. 170–1, cites these clichés from French epistolary manuals in reference to Gabriel Metsu's *Young Man Writing a Letter* and *Young Woman Reading a Letter* (both paintings Dublin, National Gallery of Ireland).

114. Ibid., p. 171.

115. La Serre 1651, pp. 4–5, warns that it is dangerous to entrust secrets to letters, which can fall into the wrong hands.

116. See n. 109, earlier.

117. For example, Gerard Houckgeest, *Interior of the Oude Kerk in Delft* (Amsterdam, Rijksmuseum); Emanuel de Witte, *Interior of the Oude Kerk in Delft* (Ottowa, National Gallery of Canada); Gerrit Dou, *Still-Life with Watch and Candle* (Dresden, Staatliche Kunstsammlungen); Gerrit Dou, *Self-Portrait* (Amsterdam, Rijksmuseum).

118. Kettering 1993, p. 98, describes the Petrarchan woman in Ter Borch's paintings as posed in profile, with an erect posture. The young lady viewed in profile is indeed a recurring type in Dutch paintings of amatory themes. It is reminiscent of fifteenth-century Italian profile portraits of women (on which see Simons 1988). Could such figures in Dutch paintings have been related to a visual type that was associated with Petrarchan poetry? One possible source – there may have been many – is a compilation of writings about Petrarch by Iac. Phil. Tomasinus, *Petrarcha redivivus,* first published in Padua in 1630, which focuses on praise of Petrarch's Laura and includes an engraved portrait of her in profile (see Ypes 1934, p. 192). Ibid., pp. 193–4, establishes that both editions of this book were well known in The Netherlands.

119. See n. 110, earlier.

120. The effect of perspective impressed one viewer of the time, Pieter Teding van Berckhout, whose diary records a visit to Vermeer in 1669: "a celebrated painter named Vermeer . . . showed me several examples of his art, the most extraordinary and curious feature of which is the perspective." Cited by Montias 1991, p. 48.

121. Gowing 1970, p. 19, most famously articulated this aspect of Vermeer' style, "Vermeer seems almost not to care, or not even to know, what it is that he is painting. What do men call this wedge of light? A nose? A finger? What do we know of its

shape? To Vermeer none of this matters, the conceptual world of names and knowledge is forgotten, nothing concerns him but what is visible, the tone, the wedge of light." Such qualities, of course, are also tied up in the speculation about Vermeer's use of the camera obscura.

122. On the "reciprocal play of nearness and distance" in Vermeer, see Gowing 1970, p. 22. See also ibid., p. 25 ("There is in his thought, the paradoxical accompaniment of its clarity, a deep character of evasiveness, a perpetual withdrawal"). More recently, Arasse 1994, pp. 60–1, 79, approached Vermeer in a similar spirit.

123. See Snow 1994, p. 3; Snow's interpretation of the *Girl with a Pearl Earring* (pp. 3–22) is evocative and instructive; a number of ideas he develops recur in my own reading of the painting, though I have preferred to anchor them in a seventeenth-century context.

124. Is she one of the "2 heads [*Tronijen*] painted in Turkish fashion" or even the "head in Antique dress, exceptionally artful" listed in Vermeer's inventory? See Exhib. cat. Washington, D.C. 1995–6, pp. 168, 169 n. 9.

125. [Bon] 1652, p. 50, ". . . o Parel aller Vrouwen!"

126. On the lips, see ibid., p. 93, "Door een Kusje van u Mont,/ Wert eerst mijn Ziel gewont/ En den Nectar Dou,/ Wiens soete vocht Ick noyt verlaten wou . . ." The most copious treatment of eyes in Dutch literature is probably Ionctys 1639, a miscellany of poems and learned excursuses on sight and its relation to amorous desire.

127. De Vries 1646, sig. A4ᵛ–B1, "O wreede schoonheyt, ô gevarelycke oogen . . . Vriendinne, keer, ey, keer,/ En slaet een gunstich oogh op uwen dienaer neer."

128. Van Steyn 1662, p. 27, "Wat isser dat u deert? wat speelt u in de sinnen?/ Of vreest ghy, soete Maeght, te vroeg te zijn gepaert?/ Of acht ghy mij u min, en uwe glans niet waert? . . . / Wat wil u schoonheyt doch? vertrouwtse niet: s'is waen,/ Hoe langer dat zij staet, hoe eer zij sal vergaen,/ Het is een teere Roos, die vol bevalligheden,/ Op heden glinstert, en op morgen leydt vertreden./ Ay Nymphjen keer, ay keer, en stort mij leven in . . ."

129. [Bon] 1652, p. 174, "Questy: Tusschen *Thetis*, en een die *afkeerig* van hem is."

130. See earlier, n. 31.

131. Boccaccio 1675, sig. A4ᵛ.

132. Gowing 1970, p. 43.

CHAPTER 7. RELIGION IN THE ART AND LIFE OF VERMEER

1. Parker 1977, p. 151.
2. Israel 1995, p. 361.
3. Ibid.
4. Elliott 1990, p. 294.
5. Israel 1995, p. 361.
6. Van Thiel 1990–1, p. 50.
7. Israel 1995, pp. 366, 375–6.
8. Ibid., p. 462.
9. According to Schilling 1992, pp. 367–8, The Netherlands during the seventeenth century was a multiconfessional society in which Roman Catholics, Calvinists, and other dissident Protestant groups worshiped. See also De Kok 1964, pp. 203, 248.
10. Evenhuis 1965–78, vol. 2, p. 195, and Knuttel 1892–4, vol. 1, pp. 168–9.
11. For a review of the Roman Catholic situation in The Netherlands during the seventeenth and eighteenth centuries, see chap. 16 "Protestantization, Catholicization, Confessionalization," and chap. 27, "Confessionalization, 1647–1702," in Israel 1995, pp. 361–98 and 637–76.
12. Spiertz 1979, p. 345.
13. Rogier 1945–7, vol. 3, pp. 501–12, vol. 4, p. 767. See also Spiertz 1979, p. 344. A secular priest is one not affiliated with any religious order.

14. Rogier 1945–7, vol. 3, pp. 534–42.
15. Regular priests were educated by the individual orders outside of the United Provinces in cities in Flanders, Germany, and Italy. Secular priests, on the other hand, were educated in Louvain and Cologne at schools supported by funds raised in The Netherlands. See Knuttel 1892–4, vol. 1, p. 61.
16. Rogier 1945–7, vol. 3, p. 572.
17. Catholics were treated much more severely in rural areas, such as Friesland, which remained openly hostile to them, than in urban areas, such as Amsterdam, where the interest in trade kept measures against Roman Catholics to a minimum; see Knuttel 1892–4, vol. 1, p. 136. According to statistical studies by De Kok 1964, the percentage of Roman Catholics in the rural districts of Groningen, Zeeland, Friesland, and Drenthe was particularly low; see De Kok's tables as reproduced in Schilling 1992, pp. 367–8.
18. Van Deursen 1978–81, vol. 4, p. 71, and Hoppenbrouwers 1996, pp. 74–5.
19. The number of priests in the Northern Netherlands climbed to 482 in 1638 and remained at or around that number for the remainder of the seventeenth century. Spiertz 1989, pp. 287–301, specifically pp. 291–3 as cited in Israel 1995, p. 378.
20. Israel 1995, p. 380.
21. See ibid., pp. 640–1, and De Kok 1964, p. 203, table 34.
22. Montias 1989, p. 14.
23. Ibid., p. 65.
24. Ibid.
25. The only requirement made by the Reformed Church was that the children be Christians; see Abels 1996, pp. 70, 77.
26. Houckgeest painted several views of the *Nieuwe Kerk* in Delft between 1650 and 1651; see Liedtke 1982, pp. 41–9.
27. Montias 1989, p. 4.
28. Ibid., p. 72.
29. Blankert, Montias, and Aillaud 1988, pp. 34–6.
30. Montias 1989, pp. 96, 99.
31. Ibid., p. 100.
32. Ibid., p. 110.
33. Ibid., p. 99.
34. Ibid.
35. The apostolic vicar to The Netherlands, Phillip Rovenius, writing in 1648, equated the marriage of a Catholic to a nonbeliever to a pact with the devil: ". . . het aangaan van een huwelijk met de ongelovigen is niets anders dan de prostitutie van een lidmaat van Christus met de duivel." This passage is quoted by Hoppenbrouwers 1996, p. 70.
36. Maria Thins probably objected to the marriage not only because of religious differences but also on grounds that Vermeer was from a lower social class than the Thins/Bolnes family; see Montias 1989, p. 99.
37. Ibid., p. 101.
38. Ibid.
39. Abels 1996, p. 73.
40. Of course, Vermeer would not have needed to convert in order to marry into the Roman Catholic family of Catharina Bolnes. Recently, Abels 1996, p. 74, has raised doubts about Vermeer's conversion. The last testament of Maria de Knuijt, the wife of Vermeer's likely patron, Pieter van Ruijven, stipulated that Vermeer would receive 500 guilders from her estate, unless the painter died before she did. Abels interpreted this bequest as an attempt to prevent the money from falling into the hands of Vermeer's wife and, ultimately, the hated Jesuits. Abels speculates that De Knuijt, who was strongly inclined toward the Reformed faith, did not consider this a danger if Vermeer himself received the inheritance perhaps because the artist was less com-

mitted to Catholicism than was his wife. Montias 1998, p. 108 n. 77, challenges this hypothesis.

41. Gouda was served by three secular priests, a Franciscan, and a Jesuit. One of the clandestine churches was beautifully furnished with paintings, a crucifix, candelabras, and an organ. By 1656, one-third of Gouda's population was Roman Catholic. See Van Eck 1995, pp. 220, 222.

42. Montias 1989, p. 111.

43. Ibid.

44. Ibid., pp. 112, 114–15.

45. Where Maria Thins lived when she first arrived in Delft is uncertain, but she did settle in the Catholic neighborhood, called the *paepenhoek* (Papists' Corner), by the time of her daughter's marriage to Vermeer. See Montias 1989, p. 131.

46. Rogier 1945–7, vol. 4, p. 769.

47. Van Berkel 1900, p. 256, as cited in Montias 1989, p. 130.

48. Montias 1989, pp. 130–1.

49. Ibid., pp. 176–7.

50. Blankert, Montias, and Aillaud 1988, p. 43.

51. Montias 1989, p. 154. This type of living situation was fairly unusual in the Northern Netherlands in the seventeenth century when only about 5 percent of domestic households included relatives, such as mothers-in-law. See further Haks 1996, p. 93.

52. Ibid., p. 205.

53. Ibid., p. 185.

54. This large number of children must partly account for the artist's financial ruin. North 1997, pp. 15–16.

55. In Maasland, a town close to Delft, the average number of baptized children per marriage was 4.7. See Haks 1996, pp. 92–3.

56. Montias 1989, p. 214.

57. Hoppenbrouwers 1996, p. 89.

58. Montias 1989, pp. 314, 326, 330, 334–5.

59. Hoppenbrouwers 1996, p. 70.

60. Ibid., pp. 46, 49.

61. Ibid., p. 81.

62. Marten Jan Bok discovered the document as cited by Montias 1998, p. 103.

63. Montias 1998, p. 103.

64. Ibid., p. 239.

65. Maria Vermeer married Johannes Gillisz. Cramer in 1674 in Schipluy, perhaps in the same church where her parents married in 1653. See Montias 1989, pp. 211, 243–4. Another daughter, Beatrix, probably also married in the Roman Catholic Church since after her death, her surviving child was raised by Aleydis van Rosendael, a distant cousin who was also a *klopje*. See ibid., p. 241.

66. Ibid., p. 244.

67. Ibid., p. 244.

68. This painting of the *Finding of Moses* may be the work of Peter Lely (1618–80), who was active in The Netherlands until 1640. See Wheelock 1995a, pp. 161–2, 201 n. 3.

69. Montias 1989, pp. 139, 312.

70. Kitson 1969 first attributed this painting to Vermeer. Since that time, Arthur Wheelock has been the most active scholar to promote this work as an authentic painting by Vermeer; see Wheelock 1986, pp. 71–89; Idem 1991, pp. 8, 20 n. 3.

71. Wheelock 1991, pp. 10–12.

72. Ibid.

73. Ibid.

74. Broos 1998, p. 30, doubts the authenticity of the signature and he believes the painting is wrongly attributed to Vermeer. Furthermore, Wadum 1998, pp. 217–19, based on his comparison of the *Saint Praxedis* painting to other early history paintings by

Vermeer, concludes that it is by another hand, probably another version of the original, painted by Ficherelli himself.

75. Montias 1989, p. 141.
76. Exhib. cat. Washington, D.C. 1995–6, p. 88.
77. Ibid.
78. Montias 1989, pp. 141–2.
79. Montias 1989, p. 142, suggests that local Jesuits may have instructed Vermeer to add the crucifix to the hand of the young female saint as a testimony to the owner's adherence to the Catholic faith.
80. Recently, Weber 1993, p. 301, has suggested that *Saint Praxedis* may have been painted by Johannes van der Meer of Utrecht. This artist, who was documented in Italy around 1650, was interested in Italian religious art at this time. Bok 1998, p. 75, in his study of Van der Meer rejects this attribution to the Utrecht artist.
81. Exhib. cat. Washington, D.C. 1995–6, pp. 94–5.
82. Ibid.
83. Craig 1983, p. 39 n. 46.
84. This position is promulgated in sixteenth- and seventeenth-century Roman Catholic biblical commentaries on the Lucan passage about Christ in the house of Martha and Mary. Salvation is the culmination of good works that can only result after conversion and faith. See Verhelst 1996, pp. 150–1.
85. Exhib. cat. Washington, D.C. 1995–6, pp. 90, 92.
86. Rudolph 1938, p. 409.
87. Wheelock was the first scholar to recognize that the scales are empty. See Exhib. cat. Philadelphia 1984, pp. 342–3.
88. Snow 1994, pp. 158, 213 n. 22, lists several interpretations that depend on the *Last Judgment* as "the key that unlocks the allegory." He includes the transitory nature of life and the importance of temperance and moderation as unlikely meanings. Wheelock 1995a, p. 196 n. 12, also mentions several suggested interpretations of the painting, including justice and the divine truth of revealed religion. See also Exhib. cat. Philadelphia 1984, p. 344 n. 8.
89. Salomon 1983, p. 218.
90. Ibid.
91. See Cunnar 1990, pp. 509–19.
92. Salomon 1983, p. 217; Montias 1989, p. 191.
93. In his discussion of Petrus Christus, Snyder 1985, p. 154, saw the work of the Northern Renaissance artist as anticipating the carefully measured interiors of Vermeer.
94. Ibid., pp. 103–9, 120–2.
95. Ibid., p. 133.
96. Symbolic light is evident in Northern Renaissance examples and continues in seventeenth-century paintings of the *Annunciation* by such artists as Hendrick ter Brugghen, Pieter de Grebber, and Adriaen van de Velde (1636–1672). See Robb 1936; Exhib. cat. Washington, D.C. 1980–1, pp. 108–9, 194–5, 234–5.
97. Jesuits and other missionaries working in The Netherlands in the seventeenth century advocated the veneration of the Virgin Mary and promulgated her important role as intercessor and mediator at the Last Judgment. The apostolic vicar Rovenius joined Father Johannes David and the Delft priest Stalpaert van der Wiele in promoting the prayer "het Wees Gegroet," or the Ave Maria. See Graef 1965, pp. 17–25; Kronenburg 1911, pp. 193, 269.
98. For example, in 1679, four years after Vermeer's death, the Jesuits observed the feast day of the Immaculate Conception, December 8, with a weeklong celebration. Above the altar in their hidden church, parishioners looked upon a richly ornamented painting of the Virgin Mary dressed in pearls and gold; see Rogier 1960, p. 180.
99. From the biblical book of Wisdom 7:26. Meiss 1945, p. 180.
100. De Jongh 1975–6, p. 76.

101. De Jongh 1998, p. 361.
102. Ibid.
103. Ibid.
104. Blankert, Montias, and Aillaud 1988, p. 146, called certain elements of the *Allegory of Faith* "alien." Wheelock 1988, p. 118, considered the painting a "failure." Nash 1991, p. 108, claimed that Vermeer's painting is an unconvincing work that reveals an overall weakness in technique and meaning.
105. Barnouw 1914, pp. 50–4.
106. In citing a poem by Van den Vondel, De Jongh 1975–6, p. 76, looked to the work of a recent convert to Roman Catholicism.
107. Ibid., pp. 72–4.
108. Arasse 1994, p. 85.
109. Ibid., p. 81.
110. For a comprehensive look at the long-lived debate over the Eucharist in The Netherlands, see Polman 1948, pp. 239–54. See also Hedquist 2000.
111. See, for example, Van der Kruyssen 1651 and Anon. 1676. See also Clemens 1990, pp. 197–8.
112. Anon. 1676, p. 7, "De Mis verthoont u Christi doodt, Die hy lee om ons sonden groot: O ziel leert heir aen Godts autaer, Al wat Godts Soon lee op Calvaer!"
113. David 1622, p. 76, ". . . in schoone tapissten, beelden, schilderijen, lichten, ghekroonsel; ende boven all in verscheyden reliquien ende ghebeenten der heylighen." Johannes David published three books in 1607 regarding church ceremonies and doctrines. The texts were reissued during the seventeenth century, including one published in Gouda in 1658. See Hoppenbrouwers 1996, p. 46.
114. Eighteenth-century prints illustrating the interiors of Roman Catholic hidden church interiors in Amsterdam provide a good idea of what the church interiors may have looked like. See Tepe 1984, pp. 49, 83, 92, 129, 180.
115. In Northern Renaissance art, altar curtains are depicted in scenes of the celebration of the mass. The curtain is pulled back to reveal the elevation of the host in the *Mass of Saint Giles* by the Master of Saint Giles (London, The National Gallery); see Lane 1984, pp. 53–7.
116. David 1622, p. 27, "dat daer levendich het selve sacrifice geoffert wort/'t welck eens aen 't H. kruys is opgeoffert geweest; ende dat men daerom in de dienst der Misse de Passie Christi moet voor oogen hebben."
117. Missals contain the complete Roman Rite of the mass for every day of the year. See Anon. 1967, vol. 9, p. 897. Missals mentioned among the belongings of the Jesuit hidden churches in The Hague and Groningen resemble the missal on the altar in Vermeer's painting; see Exhib. cat. Utrecht 1991, p. 93, cat. nos. 91, 92.
118. Wheelock and Broos, writing in Exhib. cat. Washington, D.C. 1995–6, p. 192, suggest that the substitution of *Christ on the Cross* for the image of *Abraham's Sacrifice* is related to the importance of Christ's Crucifixion to the Jesuits. The authors quote St. Ignatius's renowned *Spiritual Exercises*, "Imagine Christ our Lord before you, hanging upon the cross. Speak with Him of how, being the creator he then became man, and how, possessing eternal life, He submitted to temporal death to die for our sins."
119. The typological pairing of these sacrifices is well established; see Réau 1955–9, vol. 1, p. 205.
120. Gassner 1949, pp. 276–7.
121. Hoppenbrouwers 1996, p. 81.
122. The intimate, domestic setting has caused confusion for most scholars. For example, Blankert, Montias, and Aillaud 1988, p. 146, stated, "Even if we understand the symbolism, it is unclear why the scene takes place in a fashionable Dutch living room." Montias 1998, pp. 98, 106 n. 38, has recently written that he believes Vermeer's home may have been used as a place of worship.

123. Montias 1989, pp. 155, 188–9.
124. Ibid., pp. 155, 191.
125. Ibid., p. 213.
126. Ibid.
127. Ibid., pp. 213–14.

CHAPTER 8. VERMEER AND THE REPRESENTATION OF SCIENCE

Editor's note: Klaas van Berkel's chapter originally appeared in *The Scholarly World of Vermeer,* ed. T. Brandenbarg, pp. 13–23, Zwolle, 1996. It was written with the assistance of the following secondary sources: Bergvelt and Kistemaker 1992; Van Berkel 1985; Idem 1995; Blankert, Montias, and Aillaud 1988; De Jongh 1967; Welu 1986.

CHAPTER 9. SEVEN VERMEERS: COLLECTION, RECEPTION, RESPONSE

This chapter is dedicated to George Deem. For their good editorial advice on an earlier version of this text I am grateful to David Cast and Jay Baker. I would also like to thank Debra Allbery for her gracious permission to quote her poem at length here. All translations are mine unless noted otherwise.

1. Archimbaud and Bacon 1993, p. 39.
2. Among the substantive reviews of its Washington venue, see Weschler 1995; Alpers 1996; Danto 1996.
3. For a study of such issues see Hertel 1996.
4. Gadamer 1996, p. xxx.
5. Ibid., p. xxxi.
6. Broos 1995–6, pp. 47–8, 53–4.
7. Van Peer 1957, pp. 94–5, 97; Montias 1989, pp. 180–4, 257–62; Wheelock 1995a, p. 28 n. 37; Hertel 1996, pp. 129, 246 n. 122.
8. Montias 1989, pp. 134–5, 246–7.; Blankert 1978, pp. 149–50.
9. Blankert 1978, pp. 153–4; Montias 1989, pp. 363–4.
10. Montias 1989, pp. 364–5.
11. Wright 1976, p. 75.
12. Blankert 1978, p. 157; Broos 1995–6, p. 54.
13. Blankert 1978, p. 157.
14. Van Eijnden and Van der Willigen 1816/1979, vol. 1, pt. 1, pp. 164–8.
15. On the heraldic image of the Dutch Maid, see Schama 1988, pp. 69ff.
16. Buijsen 1990–1, pp. 65–9.
17. Ibid., pp. 67–8.
18. Ibid., pp. 65, 69.
19. Van Eijnden and Van der Willigen 1816/1979, vol. 1, pt. 1, p. 413; vol. 2, pt. 4, p. 152.
20. Buijsen 1990, p. 69; Exhib. cat. Washington, D.C. 1995–6, p. 112; Cat. Amsterdam 1976, p. 35.
21. Montias 1989, p. 199; Wheelock 1995a, pp. 63–9.
22. Sutton 1986, pp. 311, v.
23. On the other hand, seventeenth- and eighteenth-century sources indicate that Vermeer's collectors knew what they were doing, whereas Courcy E. McIntosh suggests that Henry Frick showed an uninformed collector's "extremes of taste" when acquiring both Pascal-Adolphe-Jean Dagnan-Bouveret's *Consolatrix Afflictorum* of 1899 (Pittsburgh, The Frick Art & Historical Center) and Vermeer's *Girl Interrupted at Her Music* (Plate 12) in 1901. See Exhib. cat. Pittsburgh 1996, p. 158, cat. no. 108.
24. Fischel n.d., p. viii; see as well Börsch-Supan 1988.
25. Hagedorn 1762, vol. 1, p. 401.

26. Ibid., vol. 1, p. 403. On Hagedorn, see Manfred Altner et al. 1990, pp. 17–74, including a portrait of him by Anton Graff (1772), p. 31.
27. Cat. Dresden 1979, pp. 331ff. See also Meijers 1999, pp. 135–6.
28. Goethe 1954, vol. 13, p. 103.
29. Blankert 1978, p. 162.
30. Blankert 1978, p. 161. Swillens 1950, p. 57, has doubts about the picture's identity because of its different dimensions as listed.
31. Klessmann 1986.
32. Edwards 1986.
33. Thoré 1866, p. 459, speaks of the "two Geographers" in the Péreire collection, and Havard 1888, cat. 38, repeats the error. Swillens 1950, p. 66, mentions the Péreire *Astronomer* among the "works wrongly attributed to Vermeer."
34. *The Art Newspaper* 1997.
35. Goethe 1954, vol. 13, pp. 259–319; Idem 1994, pp. 121–59; Asman 1998, pp. 211–26.
36. On Thoré, see Thoré 1911, vol. 3; Jowell 1977.
37. Jowell 1995, p. 124; Jowell 1998, pp. 35–41.
38. Thoré 1866, p. 313; undated letter by Thoré to Péreire, Jowell 1995, p. 124, and Idem 1998, p. 41.
39. Thoré 1911, vol. 3, pp. 188, 291–2.
40. Jowell 1998, p. 49.
41. It is Thoré's cat. no. 51: see Thoré 1866, pp. 463, 569.
42. Jowell 1995, p. 125.
43. Blankert 1978, p. 167.
44. Jowell 1995, p. 124.
45. Havard 1888, pp. 14, 18, 19; Broos 1998, pp. 22–4; see also Armstrong 1891, p. 23. For the prolific art historian, historian, and travel writer Henry Havard (1838–1921), see Hertel 1996, pp. 85–92.
46. Blankert 1978, p. 161.
47. Demetz 1963; Hertel 1996, pp. 22–30.
48. Wheelock 1995a, pp. 97–103; Gifford 1998, p. 194.
49. For the French use of "vigorous," see Pernéty 1757/1972, pp. 554–5; Diderot 1995, vol. 1, pp. 189–240; 208, with reference to Rembrandt. For a study of Dutch usage of art terms as well as topoi of praise, see Melion 1991. It appears that vigorous covers what van Mander discusses under *reflexy-const, wel verwen,* and *affecten.*
50. Blankert 1978, pp. 62–3, 62.
51. Ibid., pp. 161, 171, 167.
52. Ibid., pp. 166–7.
53. Ibid., p. 172.
54. Exhib. cat. Marbach 1967, p. 66.
55. Schama 1988, p. 263; Pernéty 1757/1972, pp. 239–40.
56. Friedländer 1926, pp. 37–8.
57. Ibid., p. 38.
58. Thoré 1866, p. 461.
59. Hertel 1996, pp. 83–92.
60. Thoré 1911, vol. 1, pp. 10–11.
61. Gadamer 1996, pp. 277–307, esp. 277, 306.
62. Blankert 1978, pp. 166–7.
63. Cat. Frankfurt 1924, p. 240, no. 1149.
64. Palm 1982.
65. Lubberhuizen-van Gelder 1947; Kootte and Wolff 1989.
66. See the portraits listed by Lubberhuizen-van Gelder 1947, pp. 146ff.
67. Ibid., p. 150; Breukink-Peeze 1989.
68. Alpers 1983, pp. 192–207.

69. For yet other recent approaches to Vermeer's *The Geographer* and *The Astronomer,* see Exhib. cat. Washington, D.C. 1995–6.
70. Hauser 1981, passim.
71. Ibid., p. 194.
72. Ibid.
73. Ibid., p. 195.
74. Ibid., pp. 198, 196, 191.
75. Ibid., p. 191.
76. Ibid., p. 200.
77. Elovsson 1991.
78. His reference, more than his exact model, is Serres 1988.
79. Elovsson 1991, pp. 18–19; and first suggested in Wheelock 1981, p. 108; repeated in Exhib. cat. Washington, D.C. 1995–6, p. 172.
80. Elovsson 1991, p. 20.
81. Wadum 1995–6.
82. Wallach 1999, p. 29.
83. Elovsson 1991, p. 23.
84. Ibid., pp. 24–5. He also refers to William Harvey's discovery in 1628 of the heart as the center of blood circulation.
85. Hauser 1981, p. 198.
86. Ibid.
87. Alpers 1983 accounts historically for this shift.
88. Hauser 1981, p. 195.
89. Gowing 1970, p. 45.
90. Kremer 1993, p. 52.
91. Littlejohn 1996, p. 262.
92. Hustvedt 1998, pp. 46–61, 49.
93. Herbert 1991, pp. 146–50.
94. Ibid., p. 150.
95. Ibid.
96. Pops 1984; Snow 1994; Gowing 1970.
97. Hughes 1996.
98. Hustvedt 1996, p. 49.
99. Kwiatek 1985.
100. Allbery 1994, pp. 196–7.

CHAPTER 10. THE APPRECIATION OF VERMEER IN TWENTIETH-CENTURY AMERICA

1. *Time, Newsweek, U.S. News & World Report, Vogue, The New Yorker,* and even *Reader's Digest,* among others, all sang Vermeer's praises.
2. For the influence of Thoré's articles in the *Gazette des Beaux-Arts* in 1866, see Jowell 1998.
3. These items are preserved in a private archive. The photographs include images not only of artists' paintings influenced by Vermeer but also of friends and relatives posed in a Vermeer-like manner.
4. Letter from George Sorrels to Arthur K. Wheelock Jr., September 15, 1995.
5. Prior to their visit to the exhibition, Mayer and Bernice Alpert from Sheboygan, Wisconsin, sent a copy of an article written about their lifelong quest to see Vermeer's work, which shows them photographed surrounded by books reproducing his paintings. The article, by Dawn Jax Belleau, "Meer Memories," *The Sheboygan Press,* January 25, 1996, reads: "As art collectors, Mayer and Bernice Alpert stand alone. They collect Vermeers. More precisely, they collect the 'experience' of stand-

ing before those softly-lit, simple, yet elegant, scenes of daily life that define the work of 17th century Dutch painter Johannes Vermeer."

6. For the importance of reproductions in transmitting images of works of art, see Benjamin 1969.
7. The advertisement for the *Smithsonian Magazine* (Fig. 57) notes that the issue was read by 8.5 million people.
8. Stott 1998.
9. Ibid., pp. 79–81.
10. Waller 1907, p. 63.
11. Ibid., pp. 65–6.
12. Lucas 1905, p. 68, admitted that to "explain the charm of the 'View of Delft' is beyond my power." Nevertheless, he did note that "Before Rembrandt one stands awed, in the presence of an ancient giant; before Vermeer one rejoices, as in the presence of a friend and contemporary."
13. Ibid., p. 68.
14. As Boone 1991–2, p. 52, has noted, the first American publication on Vermeer appeared in 1904. Published as part of the series *Masters in Art: A Series of Illustrated Monographs* by the Bates and Guild Company, Boston, it contained a number of excerpts from French and German writers, including a passage from Thoré's 1866 article in *Gazette des Beaux-Arts*.
15. Cole and Van Dyke 1911. As Boone 1991–2, p. 50, has noted, Cole's wood engraving of Vermeer's *A Lady Standing at the Virginal* (Plate 33) graced the frontispiece of *Century Magazine* 50, no. 6, 1895. This issue also contained his article on the artist.
16. Shand-Tucci 1997, pp. 187–8. For an excellent assessment of the influence of Vermeer on the Boston School, see Leader 1981, pp. 172–6.
17. Hale 1932, p. 355, concluded, "But it's hard to paint with the probity and simplicity of Vermeer. Perhaps that's why there are so few who get even near him."
18. Valentiner 1909, p. ix.
19. Boone 1991–2, p. 56, notes that the exhibition was seen by more than 300,000 people.
20. Isabella Stewart Gardner's *The Concert* (Plate 20) was not lent to the exhibition.
21. Although the painting's previous owner had changed the attribution of *Young Woman with a Water Jug* from Gabriel Metsu to Vermeer, the Paris dealer who sold Marquand the painting had reattributed it to De Hooch. Whether or not Marquand knew the correct attribution, it seems probable that the painting's appeal was primarily its subject matter and exceptional quality rather than any burning desire to acquire a painting by Vermeer. For further discussion of the provenance of this painting, see Exhib. cat. Washington, D.C. 1995–6, pp. 148–50.
22. These copies of the *Woman in Blue Reading a Letter, The Lacemaker,* and *The Little Street* (Fig. 61), as well as *The Milkmaid,* are at the Canajoharie Library & Art Gallery, Canajoharie, New York. We would like to thank James Crawford, curator of the collection, for providing information about them.
23. Boone 1991–2, p. 57.
24. Biographical accounts of American art collectors, however, often speculate on the feelings and motivations behind the acquisition of specific works of art. In Sanger 1998, p. 157, the author, Henry Clay Frick's great-granddaughter, links Frick's collecting decisions, particularly his acquisition of three Vermeer paintings, to his lifelong mourning over the death of his daughter Martha at the age of five.
25. Valentiner 1909, pp. xxxix–xli.
26. Ibid., p. xl.
27. Hale 1913, p. 3.
28. Ibid., p. 6.
29. Ibid., pp. 220–1.
30. Ibid., p. 70.
31. Swillens 1950, p. 150.

32. Ibid., pp. 149–50.
33. Gowing 1970, pp. 65–6. Gowing's reference is to a famous passage in Proust 1982. For a good discussion of this and other literary works that have shaped our understanding of Vermeer, see Hertel 1996.
34. Gowing 1970, p. 66.
35. Gimpel 1987, pp. 215, 223–4, for example, spent much time assessing Vermeer's signatures.
36. Ibid., pp. 230, 238, 413.
37. De Vries 1939, p. xx.
38. Irwin 1943, pp. 166–71. This book is one of a series of about twenty "Maida books" that were published during the first half of this century. We would like to thank Pamela J. Burke for bringing this book to our attention and for sharing her personal copy of it with us.
39. Ibid., pp. 169–70.
40. Ibid., p. 171.
41. See, for example, Bodkin 1940.
42. Godley 1952, pp. 10–11.
43. De Ricci 1927, pp. 306–7. The translation is by Arthur K. Wheelock Jr.
44. For a discussion of these forgeries, see Wheelock 1995b.
45. Valentiner 1928, pp. 101–2.
46. Von Bode 1926, p. 251, considered *The Smiling Girl* to be a preparatory study for *The Girl with the Wine Glass*.
47. Hollander 1989, pp. 441–3.
48. As Marguerite Glass has noted, Ridley Scott also employs Vermeer's lighting effects and mise-en-scène composition in other films, including *The Duelists* (1977) and *1492: Conquest of Paradise* (1992).
49. See Exhib. cat. Delft 1996b.
50. We gratefully acknowledge the time and assistance George Deem and his assistant Ronald Vance have provided us within the context of our Vermeer research.
51. Smith 1992.
52. Chevalier 1999.
53. Vreeland 1999.
54. Bayley 1997.
55. Weber 1998.
56. For other examples of filmmakers, artists, and novelists appropriating Vermeer's images, see Hertel 1996, pp. 1–5.
57. Montias 1989.

Bibliography

PRIMARY REFERENCES (BY DATE OR ERA OF AUTHOR'S ACTIVITY)

Angel, Philips. *Lof der schilder-konst.* Leiden, 1642.
 "'*Praise of painting* (1642).' Trans. Michael Hoyle, with an Introduction and Commentary by Hessel Miedema." *Simiolus* 24 (1996): 227–58.
Anon. *Nieuwen Lust-Hof.* Amsterdam, 1602.
Anon. *Apollo, of ghesangh der musen* (1615). Ed. A. Keersmaekers. Deventer, 1985.
Anon. *Airs de cour avec la tablature de luth et de guitarre de Estienne Moulinié; Troisiesme livre.* Paris, 1629.
Anon. *Klucht van de koeck-vreyer.* Amsterdam, 1659.
Anon. *Livre d'airs de differents autheurs à deux parties.* Paris, 1661.
Anon. *Livre d'airs de differents autheurs a deux parties.* Paris, 1662.
Anon. *De schouburg der verliefde* . . . Amsterdam, 1668.
Anon. *Mysterie van den godts-dienst der H. Misse; Christi bloedige passie ver-beeldt in het onbloedigh sacrificie der H. Misse.* Haarlem, 1676.
Anon. *Hollantse trouw-gevallen* . . . Amsterdam, 1678.
Anon. *Zeven duivelen, regerende en vervoerende de hedendaagsche dienst-maagden.* Amsterdam, 1682.
Anon. *De seven engelen der dienst-maagden* . . . Leiden, 1697.
Anon. *Airs de cour pour voix et luth (1603–1643).* Transc. and intro. A. Verchaly. Paris, 1961.
Bie, Cornelis de. *Het gulden cabinet vande vry schilderconst.* Antwerp, 1661.
Bleyswijck, Dirck van. *Beschryvinge der stadt Delft.* Delft, 1667.
Boccaccio, Giovanni. *De konst der vryery* . . . Amsterdam, 1675.
[Boekholt, Baltes]. *De wonderlijke vryagien en rampzaalige, doch bly-eyndige, trouw-gevallen van deze tijdt* . . . Amsterdam, 1668.
[Bon, Aernold]. *Delfs Cupidoos schighje.* Delft, 1652.
 Tweede Delfs Cupidoos schighje. Delft, 1656.
Bredero, Gerbrandt Adriaensz. *Boertigh, amoreus, en aendachtigh groot lied-boeck* (Amsterdam, 1622). 3 vols. Ed. G. Stuiveling. Culemborg, 1975.
Bry, Theodor de. *Emblemata secularia* . . . Oppenheim, 1611.
Cats, Jacob. *Emblemata ofte minnelycke, zedelijk ende stichtelijke sinnebeelden.* Middelburg, 1618.
 Houwelyck. Dat is de ganschen gelegentheyt des echten staets. Middelburg, 1625.
 Alle de wercken. Amsterdam, 1655.
Chesne, André du. *Figures mystiques du riche et precieux cabinet des dames* . . . Paris, 1605.

Corbin, Jacques. *La royne Marguerite*. Paris, 1605.

Coster, Samuel. *Samuel Coster's werken*. Ed. R. A. Kollewijn. Haarlem, 1883.

Dans, Johan van. *Scoperos satyra ofte thyrsis minnewit*. 2d ed. (First published in 1636.) Amsterdam, 1668.

Darcie, Abraham. *The Honour of Ladies: Or, a True Description of Their Noble Perfections*. London, 1622.

David, J. *Den bloem-hof der kerckelicker ceremonien*. Antwerp, 1622.

Diderot, Denis. *Diderot on Art*. Trans. J. Goodman, intro. T. Crow. 2 vols. New Haven/London, 1995.

Evelyn, John. *Memoirs of John Evelyn, Esq., F.R.S.* Ed. W. Bray. London, n.d.

Heemskerck, Johan van. *Minne-kunst, minne-baet, minne-dichten, mengel-dichten*. Amsterdam, 1626.

 Inleydinghe tot het ontwerp van een Batavische arcadia. Amsterdam, 1637; reprint ed., Ed. P. E. L. Verkuyl. Deventer, 1982.

Hooft, Pieter Cornelisz. *Emblemata amatoria*. Amsterdam, 1611.

 Erotische gedichten. Intro. C. C. van Slooten. Zutphen, 1956.

 Emblemata amatoria (Amsterdam 1611). Intro. and ed. K. Porteman. Leiden, 1983.

Hoogstraten, Samuel van. *Schoone Roseliin of, de getrouwe liefde van Panthus*. Dordrecht, 1650.

 Inleyding tot de hooge schoole der schilderkonst . . . Rotterdam, 1678.

Huygens, Constantijn. *De gedichten van Constantijn Huygens*. 9 vols. Ed. J. A. Worp. Groningen, 1892–9.

 Pathodia Sacra et Profana. Ed. Frits Noske, Amsterdam, 1957.

Ionctys, Daniël. *Roseliins oochies . . .* Dordrecht, 1639.

Krul, Jan Harmensz. *Minnebeelden: toe-ghepast de lievende ionckheyt*. 2d ed. Amsterdam, 1640.

Kruyssen, Andreas van der. *Misse, haer korte uytlegginge en godvruchtige oeffeninge onder de zelve, neffens eenige besondere zegeninge en het gebruyck der H. H. Sacrament*. Amsterdam, 1651.

Lairesse, Gerard de. *Groot schilderboek*. 2 pts. Amsterdam, 1707.

La Serre, Jean Puget de. *De hoofse Clitie*. 3 vols. Trans. J. J. Schipper. Amsterdam, 1641–2.

 Fatsoenlicke zend-brief-schryver. Trans. I. D. Amsterdam, 1651.

L'Escale, Chevalier de. *Le champion des femmes*. Paris, 1618.

Mander, Karel van. *Het schilder-boeck*. Haarlem, 1604.

Mostart, Daniël. *Vermeerderde Nederduytsche secretaris oft zendtbrief schryver*. Amsterdam, 1643.

Orlers, J. J. *Beschrijvinge der stadt Leyden*. Leiden/Delft, 1641.

Passe, Crispijn de. *Les vrais pourtraits de quelques unes des plus grandes dames de la Chrestienté, desguisées en bergères*. Amsterdam, 1640.

Pernéty, Antoine-Joseph. *Dictionnaire portatif de peinture, sculpture et gravure* (Paris, 1757). Geneva, 1972.

Petrarch. *Petrarch's Lyric Poems*. Trans. and ed. R. M. Durling. Cambridge, Mass., 1976.

Piles, Roger de. *Abregé de la vie des peintres . . .* 2d ed. Paris, 1715.

Ripa, Cesare. *Iconologia of uytbeeldinghe des verstands*. Trans. D. P. Pers. Amsterdam, 1644.

Rollenhagen, Gabriel. *Nucleus emblematum selectissimorum . . .* Arnhem, 1611.

Saint-Gabriel, Sieur de. *Le mérite des dames*. 3d ed. Paris, 1660.

Santen, Gerrit van. *Stomme-boden ofte brieven*. The Hague, 1625.

Sille, G. de. *Dwalende liefde . . .* Amsterdam, 1645.

Steyn, Adriaan van. *Den volstandigen minnaer. Kort-spel*. Delft, 1662.

Thysius, Johan. *Het Luitboek van Thysius . . . Répertoire d'un luthiste hollandais vers les premières années du XVIIe siècle*. Ed. J. P. N. Land. Amsterdam, 1889.

V., S. de [Simon de Vries?]. *Seven duyvelen, regeerende en vervoerende de hedensdaegsche dienst-maegden.* Amsterdam, 1682.

Visscher, Roemer. *Sinne-poppen.* Amsterdam, 1614.

Voskuyl, M. P. *Kuyssche Roelandyne.* Amsterdam, 1636.

Vries, Simon de. *De uytnemende vryagie, tusschen den stantvastigen Floradin, en de ialoursche Lusinde.* Utrecht, 1646.

Westerbaen, Jacob. *Avond-school voor vvyers en vrysters . . .* The Hague, 1668.

GENERAL BIBLIOGRAPHY

Abels, Paul. "Church and Religion in the Life of Vermeer." In *Dutch Society in the Age of Vermeer,* ed. D. Haks and M. C. van der Sman, pp. 68–77. Zwolle, 1996.

Acres, Alfred. "Luke, Rolin, and Seeing Relationships." In *Rogier van der Weyden, "St. Luke Drawing the Virgin": Selected Essays in Context,* ed. C. Purtle, pp. 23–37. Turnhout, 1997.

Adams, Ann Jensen. "'Der Sprechende Brief'; Kunst des Lesens, Kunst des Schreibens; Schriftkunde und *schoonschrijft* in den Niederländen im 17. Jahrhundert." In Exhib. cat. Frankfurt, *Leselust; Niederländische Malerei von Rembrandt bis Vermeer,* pp. 69–92. Schirn Kunsthalle, 1993.

Ainsworth, Maryan Wynn, et al. *Art and Autoradiography: Insights into the Genesis of Paintings by Rembrandt, Van Dyck and Vermeer.* New York, 1982.

Allbery, Debra. "After Vermeer." *TriQuarterly* 91 (1994): 196–9.

Alpers, Svetlana. *The Art of Describing: Dutch Art in the Seventeenth Century.* Chicago, 1983.

 "The Strangeness of Vermeer." *Art in America* 84 (May 1996): 62–9.

Altner, Manfred, et al. *Dresden: von der Kunstakademie zur Hochschule für Bildende Künste (1764–1989).* Dresden, 1990.

Andersen, Rae. "The Artist's Studio as a Space of Creativity." *Canadian Review of Art Education. Revue Canadienne d'Éducation Artistique* 22 (1995): 56–80.

Anon. *New Catholic Encyclopedia.* 15 vols. New York, 1967.

Arasse, Daniel. *Vermeer; Faith in Painting.* Princeton, 1994.

 "Vermeer's Private Allegories." In *Vermeer Studies,* ed. I. Gaskell and M. Jonker, pp. 341–50. Washington, D.C., 1998.

Archimbaud, Michel, and Bacon, Francis. *Francis Bacon: In Conversation with Michel Archimbaud.* London, 1993.

Armstrong, Walter. "Johannes Vermeer of Delft." *The Portfolio* 22 (1891): 22–7.

Asemissen, Hans Ulrich. *Jan Vermeer: Die Malkunst, Aspekte eines Berufsbildes.* Frankfurt am Main, 1993.

Asman, Carrie, "Orte des Sammelns: Xanadu, Weimar." In *Sammler – Bibliophile – Exzentriker,* ed. A. Assmann, M. Gomille, and G. Rippl, pp. 211–26. Tübingen, 1998.

Azpiazu, José de. *The Guitar and Guitarists from the Beginning to the Present Day.* London, 1960.

Barnouw, A. J. "Vermeer's zoogenaamd Novum Testamentum." *Oud Holland* 34 (1914): 50–4.

Bayley, John. *The Red Hat.* New York, 1997.

Beaumont-Maillet, Laure. *La guerre des sexes: les albums du Cabinet des Estampes.* Paris, 1984.

Becker, Jochen. "Are These Girls Really So Neat?; On Kitchen Scenes and Method." In *Art in History; History in Art; Studies in Seventeenth-Century Dutch Culture,* ed. D. Freedberg and J. de Vries, pp. 139–73. Santa Monica, 1991.

Becker-Cantarino, Baerbel. *Daniel Heinsius.* Boston, 1978.

Bedaux, Jan Baptist. "Minnekoorts-, zwangerschaps- en doodsverschijnselen op zeventiende-eeuwse schilderijen." *Antiek* 10 (1975): 17–42.

Benjamin, Walter. "The Work of Art in the Age of Mechanical Reproduction (1936)." In *Walter Benjamin, Illuminations*, trans. H. Zohn, pp. 217–51. New York, 1969.

Bergvelt, Ellinoor, and Kistemaker, Renée, eds. *De wereld binnen handbereik. Nederlandse kunst- en rariteitenverzamelingen, 1585–1735.* Zwolle, 1992.

Berkel, H. E. van. "Priesters te Delft en Delfshaven 1646–1696." *Bijdragen voor de geschiedenis van het Bisdom van Haarlem* 25 (1900): 230–63.

Berkel, Klaas van. *In het voetspoor van Stevin. Geschiedenis van de natuurwetenschap in Nederland 1580–1940.* Amsterdam, 1985.

 "De geleerde." In *Gestalten in de Gouden Eeuw. Een Hollands groepportret*, ed. A. Th. van Deursen and G. J. van Setten, pp. 185–217. Amsterdam, 1995.

 "Johannes Vermeer und Antoni van Leeuwenhoek." In Exhib. cat. Frankfurt, *Johannes Vermeer; Der Geograph und Der Astronom nach 200 Jahren wieder vereint*, pp. 23–30. Städelsches Kunstinstitut, 1997.

Bièvre, Elisabeth de. "The Urban Subconscious: The Art of Delft and Leiden." *Art History* 18 (1995): 222–52.

Blankert, Albert. *Vermeer of Delft; Complete Edition of the Paintings.* Oxford, 1978.

 "General Introduction." In Exhib. cat. Washington, D.C., *Gods, Saints and Heroes; Dutch Painting in the Age of Rembrandt*, pp. 15–33. National Gallery of Art, 1980.

 "Vermeer's Modern Themes and Their Tradition." In Exhib. cat. Washington, D.C., *Johannes Vermeer*, pp. 31–45. National Gallery of Art, 1995–6.

Blankert, Albert, and Grijp, Louis. "An Adjustable Leg and a Book: Lacemakers by Vermeer and Others, and Bredero's *Groot Lied-Boeck* in One by Dou." In *Shop Talk: Studies in Honor of Seymour Slive Presented on His Seventy-Fifth Birthday*, ed. C. P. Schneider, W. W. Robinson, and A. I. Davies, pp. 289–92. Cambridge, Mass., 1995.

Blankert, Albert, Montias, John Michael, and Aillaud, Gilles. *Vermeer.* New York, 1988.

Block, J. C. *Jeremias Falck: sein Leben und seine Werke.* Danzig/Leipzig/Vienna, 1890.

Bode, Wilhelm von. "Kunsthistorische Ausbeute aus dem deutschen Kunsthandel von Heute." *Repertorium für Kunstwissenschaft* 47 (1926): 251–65.

Bodkin, Thomas. *The Paintings of Jan Vermeer.* London, 1940.

Boheemen, F. C. van, and Heijden, Th. C. J. van der. "Literatuur en toneel te Delft (1572–1667)." In Exhib. cat. Delft, *De stad Delft: cultuur en maatschappij van 1572 tot 1667*, pp. 242–52. Stedelijk Museum "Het Prinsenhof," 1981.

Boheemen, Petra van. "'Hoe men een lief vinden en krygen zal': Ovidius als leermeester." In Exhib. cat. Apeldoorn, *Kent, en versint, eer datje mint; vrijen en trouwen, 1500–1800*, pp. 53–63. Historisch Museum Marialust, 1989.

Bok, Marten Jan. *Vraag en aanbod op de Nederlandse kunstmarkt, 1580–1700* (proefschrift, Rijksuniversiteit te Utrecht). Utrecht, 1994.

 "Not to Be Confused with the Sphinx of Delft: The Utrecht Painter Johannes van der Meer (Schipluiden 1630–1695/97 Vreeswijk?)." In *Vermeer Studies*, ed. I. Gaskell and M. Jonker, pp. 67–79. Washington, D.C., 1998.

Boone, M. Elizabeth. "Gilded Age Values and a Golden Age Painter: American Perceptions of Jan Vermeer." *Rutgers Art Review* 12–13 (1991–2): 47–68.

Börsch-Supan, Helmut. "Friedrich des Großen Umgang mit Bildern." *Zeitschrift für Kunstwissenschaft* 42 (1988): 23–32.

Boström, Kjell. "Jan Vermeer van Delft en Cornelis van der Meulen." *Oud Holland* 66 (1951): 117–22.

Bowring, John. *Batavian Anthology; Or, Specimens of the Dutch Poets.* London, 1824.

Bray, Bernard E. *L'art de la lettre amoureuse; des manuels aux romans (1500–1700).* The Hague and Paris, 1967.

Breukink-Peeze, Margaretha. "Japanese Robes: A Craze." In *Imitation and Inspiration: Japanese Influence on Dutch Art*, ed. S. van Raay, pp. 53–60. Amsterdam, 1989.

Broos, Ben. "Un celebre Peijntre nommé Verme[e]r." In Exhib. cat. Washington, D.C., *Johannes Vermeer*, pp. 47–65. National Gallery of Art, 1995–6.

"Vermeer: Malice and Misconception." In *Vermeer Studies,* ed. I. Gaskell and M. Jonker, pp. 19–33. Washington, D.C., 1998.

Brown, Christopher. *Carel Fabritius.* Ithaca, 1981.

"Washington and The Hague, Vermeer." *Burlington Magazine* 138 (1996): 281–3.

Bruyn, Jean-Pierre de. *Erasmus II Quellinus (1607–1678).* Freren, 1988.

Buijsen, Edwin. "The Battle Against the Dollar: The Dutch Reaction to American Collecting in the Period from 1900 to 1914." In Exhib. cat. The Hague, *Great Dutch Paintings from America,* pp. 60–78. Mauritshuis, 1990–1.

"Music in the Age of Vermeer." In *Dutch Society in the Age of Vermeer,* ed. D. Haks and M. C. van der Sman, pp. 106–23. Zwolle, 1996.

Cahn, Walter. *Masterpieces: Chapters on the History of an Idea.* Princeton, 1979.

Cantelli, G. *Repertorio della pittura fiorentina del seicento.* Florence, 1983.

Carlson, Marybeth. "A Trojan Horse of Worldliness?; Maidservants in the Burgher Household in Rotterdam at the End of the Seventeenth Century." In *Women of the Golden Age: An International Debate on Women in Seventeenth-Century Holland, England, and Italy,* ed. E. Kloek, N. Teeuwen, and M. Huisman, pp. 87–101. Hilversum, 1994.

Cat. Amsterdam. *All the Paintings of the Rijksmuseum in Amsterdam,* 1976.

Cat. Dresden. *Gemäldegalerie Alte Meister, Katalog der Ausgestellten Werke,* 1979.

Cat. Frankfurt. *Verzeichnis der Gemälde aus dem Besitz des Städelschen Kunstinstituts und der Stadt Frankfurt,* 1924.

Cat. London. *National Gallery Catalogues: The Dutch School 1600–1900* (catalogue by N. Maclaren and C. Brown). Revised ed., 1991.

Cat. New York. *European Paintings in The Metropolitan Museum of Art by Artists Born in or before 1865; A Summary Catalogue* (catalogue by K. Baetjer). 3 vols., 1980.

Cat. New York. *The Jack and Belle Linsky Collection in The Metropolitan Museum of Art,* 1984.

Chevalier, Tracy. *Girl with a Pearl Earring.* New York, 1999.

Clemens, T. "Liturgy and Piety in The Netherlands during the Seventeenth and Eighteenth centuries." In *Omnes Circumadstantes; Contributions towards a History of the Role of the People in the Liturgy,* ed. C. Caspers and M. Schneiders, pp. 197–233. Kampen, 1990.

Cole, Timothy, and Dyke, John C. van. *Old Dutch and Flemish Masters* (first published in 1893). New York, 1911.

Costaras, Nicola. "A Study of the Materials and Techniques of Johannes Vermeer." In *Vermeer Studies,* ed. I. Gaskell and M. Jonker, pp. 145–67. Washington, D.C., 1998.

Coupe, William A. *The German Illustrated Broadsheet in the Seventeenth Century: Historical and Iconographical Studies.* 2 vols. Baden-Baden, 1966–7.

Craig, Kenneth M. "*Pars Ergo Marthae Transit*: Pieter Aertsen's 'Inverted' Paintings of Christ in the House of Martha and Mary." *Oud Holland* 97 (1983): 25–39.

Crump, Phyllis E. *Nature in the Age of Louis XIV.* London, 1928.

Cunnar, Eugene R. "The Viewer's Share: Three Sectarian Readings of Vermeer's *Woman with a Balance.*" *Exemplaria* 2 (1990): 501–36.

Curtis, Alan. *Sweelinck's Keyboard Music: A Study of English Elements in Seventeenth-Century Dutch Composition.* Leiden/London, 1969.

Danto, C. Arthur. "Vermeer." *The Nation,* February 19, 1996, 32–5.

Delley, Gilbert. *L'assomption de la nature dans la lyrique française de l'âge baroque.* Bern, 1969.

Delsaute, Jean-Luc. "The Camera Obscura and Painting in the Sixteenth and Seventeenth Centuries." In *Vermeer Studies,* ed. I. Gaskell and M. Jonker, pp. 111–23. Washington, D.C., 1998.

Demetz, Peter. "Defenses of Dutch Painting and the Theory of Realism." *Comparative Literature* 15 (1963): 97–115.

Deursen, A. Th. van. *Het kopergeld van de Gouden Eeuw.* 4 vols. Assen, 1978–81.
 Plain Lives in a Golden Age: Popular Culture, Religion and Society in Seventeenth-Century Holland. Trans. M. Ultee. Cambridge/New York, 1991.
Döring, Thomas. "Caravaggeske Aspekte im Werk Johannes van Bronchorsts." In *Hendrick ter Brugghen und die Nachfolger Caravaggios in Holland,* ed. R. Klessman, pp. 155–65. Braunschweig, 1988.
Eck, Xander van. "From Doubt to Conviction: Clandestine Catholic Churches as Patrons of Dutch Caravaggesque Painting." *Simiolus* 22 (1995): 217–34.
Edwards, Jolynn. "La curieuse histoire de l'Astronome de Vermeer et de son 'pendant' au XVIIIe siècle." *Revue du Louvre et des Musées de France* 36 (1986): 197–201.
Eijnden, Roeland van, and Willigen, Adriaan van der. *Geschiedenis der vaderlandsche schilderkunst.* 2 vols. 4 pts. (Haarlem, 1816.) Amsterdam, 1979.
Eisler, Max. *Alt-Delft, Kultur und Kunst.* Amsterdam/Vienna, 1923.
Elliott, John Paul. "Protestantization in the Northern Netherlands, a Case Study: The Classis of Dordrecht, 1572–1640." Ph.D. dissertation, Columbia University, New York, 1990.
Elovsson, Per-Olov. "The Geographer's Heart: A Study of Vermeer's Scientists." *Konsthistorisk Tidskrift* 60 (1991): 17–25.
Evenhuis, R. B. *Ook dat was Amsterdam.* 5 vols. Amsterdam, 1965–78.
Exhib. cat. Amsterdam. *Tot lering en vermaak; betekenissen van Hollandse genrevoorstellingen uit de zeventiende eeuw.* Rijksmuseum, 1976.
Exhib. cat. Apeldoorn. *Kent, en versint, eer datje mint; vrijen en trouwen, 1500–1800.* Historisch Museum Marialust, 1989.
Exhib. cat. Boston. *Printmaking in the Age of Rembrandt.* Museum of Fine Arts, 1981.
Exhib. cat. Brunswick. *Die Sprache der Bilder: Realität und Bedeutung in der niederländischen Malerei des 17. Jahrhunderts.* Herzog Anton Ulrich-Museum, 1978.
Exhib. cat. Caen. *Les vanités dans la peinture au XVII siècle.* Musée des Beaux-Arts, 1990.
Exhib. cat. Cracow. *Jan Vermeer van Delft: St. Praxedis.* International Cultural Centre, 1991.
Exhib. cat. Delft. *De stad Delft; cultuur en maatschappij van 1572 tot 1667.* Stedelijk Museum "Het Prinsenhof," 1981.
Exhib. cat. Delft. *Leonaert Bramer 1596–1674; Ingenious Painter and Draughtsman in Rome and Delft.* Stedelijk Museum "Het Prinsenhof," 1994.
Exhib. cat. Delft. *Delft Masters, Vermeer's Contemporaries.* Stedelijk Museum "Het Prinsenhof," 1996a.
Exhib. cat. Delft. *In gesprek met Vermeer: Hedendaagse kunst in dialoog.* Stedelijk Museum "Het Prinsenhof," 1996b.
Exhib. cat. Eugene. *The New Traditionalists.* University of Oregon Museum of Art, 1996.
Exhib. cat. Frankfurt. *Leselust; Niederländische Malerei von Rembrandt bis Vermeer.* Schirn Kunsthalle, 1993.
Exhib. cat. Haarlem. *Schutters in Holland; kracht en zenuwen van de stad.* Frans Halsmuseum, 1988.
Exhib. cat. Hartford. *Pieter de Hooch 1629–1684.* Wadsworth Atheneum, 1998–9.
Exhib. cat. Hempstead. *Street Scenes: Leonard Bramer's Drawings of Seventeenth-Century Dutch Daily Life.* Hofstra Museum, 1991.
Exhib. cat. London. *The Genius of Venice 1500–1600.* Royal Academy of Arts, 1983.
Exhib. cat. Marbach. *Wilhelm Hausenstein: Wege eines Europäers.* Deutsches Literaturarchiv im Schiller-Nationalmuseum, 1967.
Exhib. cat. Milwaukee. *Leonaert Bramer 1596–1674; A Painter of the Night.* The Patrick and Beatrice Haggerty Museum of Art, 1992.
Exhib. cat. New York. *Liechtenstein: The Princely Collections.* The Metropolitan Museum of Art, 1985–6.

Exhib. cat. New York. *Dutch and Flemish Paintings from New York Private Collections.* National Academy of Design, 1988a.

Exhib. cat. New York. *Dutch and Flemish Paintings from the Hermitage.* The Metropolitan Museum of Art, 1988b.

Exhib. cat. Philadelphia. *Masters of Seventeenth-Century Dutch Genre Painting.* Philadelphia Museum of Art, 1984.

Exhib. cat. Pittsburgh. *Collecting in the Gilded Age.* Frick Art and Historical Center, 1996.

Exhib. cat. The Hague. *Meesterwerken in het Mauritshuis.* Koninklijk Kabinet van Schilderijen *Mauritshuis,* 1987.

Exhib. cat. Utrecht. *Nieuw licht op de Gouden Eeuw; Hendrick ter Brugghen en tijdgenoten.* Centraal Museum, 1986–7.

Exhib. cat. Utrecht. *Jezuïeten in Nederland.* Rijksmuseum Het Catharijneconvent, 1991.

Exhib. cat. Warsaw. *Opus Sacrum; Catalogue of the Exhibition from the Collection of Barbara Piasecka Johnson.* Royal Castle, 1990.

Exhib. cat. Washington, D.C. *Gods, Saints and Heroes; Dutch Painting in the Age of Rembrandt.* National Gallery of Art, 1980–1.

Exhib. cat. Washington, D.C. *Johannes Vermeer.* National Gallery of Art, 1995–6.

Fink, Daniel A. "Vermeer's Use of the Camera Obscura – A Comparative Study." *Art Bulletin* 53 (1971): 493–505.

Finlay, Ian F. "Musical Instruments in Seventeenth-Century Dutch Paintings." *The Galpin Society Journal* 6 (1953): 52–69.

Fischel, Oskar. *Die Meisterwerke des Kaiser-Friedrich Museums zu Berlin.* Munich, n.d. (ca. 1900–5).

Fleischer, Roland E. "Quirijn van Brekelenkam and 'The Artist's Workshop' in the Hermitage Museum." In *The Age of Rembrandt; Studies in Seventeenth-Century Dutch Painting, Papers in Art History from The Pennslyvania State University,* vol. 3, ed. R. E. Fleischer and S. S. Munshower, pp. 70–93. University Park, 1988.

Fock, C. Willemijn. "Werkelijkheid of schijn. Het beeld van het Hollandse interieur in de zeventiende-eeuwse genreschilderkunst." *Oud Holland* 112 (1998): 187–246.

Forster, Leonard. *The Icy Fire: Five Studies in European Petrarchism.* Cambridge, 1969.

Franits, Wayne. *Paragons of Virtue; Women and Domesticity in Seventeenth-Century Dutch Art.* Cambridge/New York, 1993.

"'Young Women Preferred White to Brown': Some Remarks on Nicolaes Maes and the Cultural Context of Late Seventeenth-Century Dutch Portraiture." In *Beeld en zelfbeeld in de Nederlandse kunst, 1550–1750* (*Nederlands Kunsthistorisch Jaarboek* 46), ed. R. Falkenburg et al., pp. 394–415. Zwolle, 1995.

"Domesticity, Privacy, Civility, and the Transformation of Adriaen van Ostade's Art." In *Images of Women in Seventeenth-Century Dutch Art; Domesticity and the Representation of the Peasant,* ed. P. Phagan, pp. 3–25. Athens, Ga., 1996.

"Emerging from the Shadows: Genre Painting by the Utrecht Caravaggisti and Its Contemporary Reception." In Exhib. cat. San Francisco, *Masters of Light: Dutch Painters in Utrecht during the Golden Age,* pp. 114–20. Fine Arts Museums of San Francisco: California Palace of the Legion of Honor, 1997a.

ed. *Looking at Seventeenth-Century Dutch Art: Realism Reconsidered.* Cambridge/New York, 1997b.

Friedländer, Max J. *Die niederländischen Maler des 17. Jahrhunderts.* 2d ed. Berlin, 1926.

Gadamer, Hans Georg. *Truth and Method.* 2d rev. ed. New York, 1996.

Gassner, Jerome. *The Canon of the Mass: Its History, Theology and Art.* St. Louis, 1949.

Gifford, E. Melanie. "Painting Light: Recent Observations on Vermeer's Technique." In *Vermeer Studies,* ed. I. Gaskell and M. Jonker, pp. 185–99. Washington, D.C., 1998.

Gimpel, René. *Diary of an Art Dealer 1918–1939* First published in 1963. New York, 1987.

Godley, John. *The Master Forger: The Story of Han van Meegeren.* New York, 1952.

Goethe, Johann Wolfgang von. *Schriften zur Kunst. Gedenkausgabe.* 24 vols. Ed. C. Beutler. Zürich, 1954.

　Goethe; Essays on Art and Literature. Trans. E. von Nardroff and E. H. Von Nardroff. Ed. J. Gearey. Princeton, 1994.

Goffen, Rona. *Titian's Women.* New Haven/London, 1997.

Goldscheider, Ludwig. *Jan Vermeer. The Paintings: Complete Edition.* 2d ed. London, 1967.

Gombrich, Ernst. *Art and Illusion.* London, 1972.

Goodman, Elise. "Petrarchism in Titian's *The Lady and the Musician.*" *Storia dell'Arte* 49 (1983): 179–86.

　Rubens: The Garden of Love as Conversatie à la mode. Amsterdam/Philadelphia 1992.

　"Woman's Supremacy Over Nature: Van Dyck's Portrait of Elena Grimaldi." *Artibus et Historiae* 30 (1994): 129–43.

Gordenker, Emilie E. S. "'En rafelkraagen, die hy schilderachtig vond': Was Rembrandt een voddenraper?" In *Kostuumverzameling in beweging; twaalf studies over kostuumverzameling in Nederland,* ed. M. Breukink-Peeze, pp. 21–32. N.p. (Amersfoort), 1995.

　"Is the History of Dress Marginal? Some Thoughts on Costume in Seventeenth-Century Painting." *Fashion Theory* 3 (1999): 219–40.

Gowing, Lawrence. *Vermeer.* 2d ed. New York, 1970.

　"Counterfeiter of Grace (Review of J. M. Montias, *Vermeer and His Milieu*)." *Times Literary Supplement,* February 16–22, 1990, p. 159.

Graef, Hilda. *Mary: A History of Doctrine and Devotion.* 2 vols. New York, 1965.

Grierson, Herbert. "Two Dutch Poets." In *Essays and Addresses* (first published in 1940), pp. 153–85. Folcroft, Pa., 1970.

　The First Half of the Seventeenth Century (first published in 1906). Folcroft, Pa., 1976.

Grijp, L. P. *Het Nederlands lied in de Gouden Eeuw; Het mechanisme van de contrafactuur.* Amsterdam, 1991.

　"De Rotterdamsche Faem-Bazuyn; De lokale dimensie van liedboeken uit de Gouden Eeuw." *Volkskundig Bulletin* 18 (1992): 23–78.

　"Local Song Books in the Golden Age." *Canadian Journal of Netherlandic Studies (Special Issue: From Renaissance to Revolution; The Culture of the Low Countries 1400–1800)* 14 (1993): 76–88.

Grootes, E. K. "Het jeugdige publiek van de 'nieuwe liedboeken' in het eerste kwart van de zeventiende eeuw." In *Het woord aan de lezer; zeven literatuurhistorische verkenningen,* ed. W. van den Berg and J. Stouten, pp. 72–88. Groningen, 1987.

Grosse, Ernst Ulrich. *Sympathie der Natur: Geschichte eines Topos.* Munich, 1968.

Gudlaugsson, S. J. *Gerard ter Borch.* 2 vols. The Hague, 1959–60.

Haase-Dubosc, Danielle. "Lyric Nature Poetry in the First Half of the Seventeenth Century." Ph.D. dissertation, Columbia University, New York, 1969.

Hagedorn, Christian Friedrich. *Betrachtungen über die Mahlerey.* 2 vols. Leipzig, 1762.

Haks, Donald. "The Household of Johannes Vermeer." In *Dutch Society in the Age of Vermeer,* ed. D. Haks and M. C. van der Sman, pp. 92–105. Zwolle, 1996.

Hale, Philip. *Jan Vermeer of Delft.* Boston, 1913.

　"Painting and Etching." In *Fifty Years of Boston: A Memorial Volume Issued in Commemoration of the Tercentenary of 1930,* pp. 353–67. Boston, 1932.

Harmsel, Henrietta ten. "P. C. Hooft in Translation: Five Sonnets with Commentary." In *Hooft: Essays,* pp. 78–92. Amsterdam, 1981.

Hauser, Andreas. "Allegorischer Realismus: Zur Ikono-Logik von Vermeers *Messkünstler.*" *Städel-Jahrbuch* 8 (1981): 186–203.

Havard, Henry. *Van der Meer de Delft.* Paris, 1888.

Haverkamp-Begemann, Egbert. *Rembrandt: The Nightwatch.* Princeton, 1982.

Hedinger, Bärbel. *Karten in Bildern; zur Ikonographie der Wandkarte in holländischen Interieurgemälden des 17. Jahrhunderts.* Hildesheim, 1986.

"Karten in Bildern. Zur politischen Ikonographie der Wandkarte bei Willem Buytewech und Jan Vermeer." In *Holländische Genremalerei im 17. Jahrhundert: Symposium Berlin 1984*, ed. H. Bock and T. W. Gaehtgens, pp. 139–68. Berlin, 1987.

Hedquist, Valerie. "The Real Presence of Christ and the Penitent Mary Magdalen in the *Allegory of Faith* by Johannes Vermeer." *Art History* 23 (2000): 333–64.

Henkel, Arthur, and Schöne, Albrecht. *Emblemata: Handbuch zur Sinnbildkunst des XVI. und XVII. Jahrhunderts.* Stuttgart, 1967.

Herbert, Zbigniew. *Still Life with a Bridle: Essays and Apocryphas.* Trans. J. Carpenter and B. Carpenter. Hopewell, N.Y., 1991.

Hertel, Christiane. *Vermeer: Reception and Interpretation.* Cambridge/New York, 1996.

Hollander, Anne. *Moving Pictures.* New York, 1989.

Hollander, Martha. "The Divided Household of Nicolaes Maes." *Word and Image* 10 (1994): 138–55.

Honig, Elizabeth Alice. "The Space of Gender in Seventeenth-Century Dutch Painting." In *Looking at Seventeenth-Century Dutch Art; Realism Reconsidered*, ed. W. Franits, pp. 187–201. Cambridge/New York, 1997.

Hoppenbrouwers, F. J. M. *Oefening in volmaaktheid: de zeventiende-eeuwse rooms-katholieke spiritualiteit in de republiek.* The Hague, 1996.

Hughes, Winifred. "Fabric Collage After Vermeer." *Dalhousie Review* 75 (Winter 1996): 350.

Hustvedt, Siri. *Yonder.* New York, 1998.

Irwin, Inez Haynes. *Maida's Little Houseboat.* New York, 1943.

Israel, Jonathan I. *The Dutch Republic; Its Rise, Greatness, and Fall 1477–1806.* Oxford, 1995.

Jongh, Eddy de. *Zinne- en minnebeelden in de schilderkunst van de zeventiende eeuw.* N.p. (Amsterdam), 1967.

"Pearls of Virtue and Pearls of Vice." *Simiolus* 8 (1975–6): 69–97.

"Realism and Seeming Realism in Seventeenth-Century Dutch Painting." In *Looking at Seventeenth-Century Dutch Art; Realism Reconsidered*, ed. W. Franits, pp. 21–56. Cambridge/New York, 1997.

"On Balance." In *Vermeer Studies*, ed. I. Gaskell and M. Jonker, pp. 351–65. Washington, D.C., 1998.

Jowell, Frances Suzman. *Thoré-Bürger and the Art of the Past.* New York/London, 1977.

"Thoré-Bürger and Vermeer: Critical and Commercial Fortunes." In *Shop Talk: Studies in Honor of Seymour Slive Presented on His Seventy-Fifth Birthday*, ed. C. P. Schneider, W. W. Robinson, and A. I. Davies, pp. 124–7. Cambridge, Mass., 1995.

"Vermeer and Thoré-Bürger: Recoveries of Reputation." In *Vermeer Studies*, ed. I. Gaskell and M. Jonker, pp. 35–57. Washington, D.C., 1998.

Judson, J. Richard. *Gerrit van Honthorst: A Discussion of His Position in Dutch Art.* The Hague, 1959.

Kahr, Madlyn Millner. "Vermeer's Girl Asleep, A Moral Emblem." *Metropolitan Museum of Art Journal* 6 (1972): 115–32.

Dutch Painting in the Seventeenth Century. New York, 1978.

"Review of E. Snow, *A Study of Vermeer*." *Art Bulletin* 64 (1982): 338–40.

Kany, Charles E. *The Beginnings of the Epistolary Novel in France, Italy, and Spain.* Berkeley/Los Angeles, 1937.

Keersmaekers, A. A. *Wandelend in den nieuwen lust-hof; studie over een Amsterdams liedboek 1602–(1604)–1607–(1610).* Nijmegen, 1985.

Keesing, Elisabeth. *Het volk met lange rokken: vrouwen rondom Constantijn Huygens.* Amsterdam, 1987.

Kettering, Alison McNeil. "Ter Borch's Ladies in Satin." *Art History* 16 (1993): 95–124.

"Ter Borch's Military Men: Masculinity Transformed." In *The Public and Private in Dutch Culture of the Golden Age; Proceedings of the Symposium Sponsored by the Center for Renaissance and Baroque Studies, University of Maryland, April 1993*, ed. A. Wheelock and A. F. Seeff, pp. 100–19. Newark, Del., 2000.

King, P. K. *Dawn Poetry in the Netherlands*. Amsterdam, 1971.

Kitson, Michael. "Florentine Baroque Art in New York." *Burlington Magazine* 111 (1969): 409–10.

Klessmann, Rüdiger. "Duke Anton Ulrich: Connoisseur of Dutch and Flemish Painting." *Apollo* 123 (1986): 150–9.

Kloek, Els. "The Case of Judith Leyster: Exception or Paradigm?" In Exhib. cat. Haarlem, *Judith Leyster: A Dutch Master and Her World*, pp. 55–68. Frans Halsmuseum, 1993.

Kloek, Els, Teeuwen, Nicole, and Huisman, Marijke, eds. *Women of the Golden Age: An International Debate on Women in Seventeenth-Century Holland, England, and Italy*. Hilversum, 1994.

Knevel, Paul. *Burgers in het geweer; de schutterijen in Holland, 1550–1700*. Hilversum, 1994.

Knuttel, W. P. C. *De toestand der Nederlandsche katholieken ter tijde der Republiek*. 2 vols. The Hague, 1892–4.

Kok, J. A. de. *Nederland op de breuklijn Rome-Reformatie: numerieke aspekten van protestantisering en katholieke herleving in de Noordelijke Nederlanden 1580–1880*. Assen, 1964.

Kootte, Tanya G., and Wolff, Martine P. "The Dutch in Japan." In *Imitation and Inspiration: Japanese Influence on Dutch Art*, ed. S. van Raay, pp. 7–23. Amsterdam, 1989.

Kremer, Mark. "Girls: Or Winning the World by Looking at It." *Kunst & Museum Journaal* 4 (1993): 49–52.

Kronenburg, J. A. F. *Maria's heerlijkheid in Nederland geschiedkundige schets van de vereering der H. Maagd in ons Valderland, van de vroegste tijden tot op onze dagen*. Amsterdam, 1911.

Kühn, Hermann. "A Study of the Pigments and the Grounds Used by Jan Vermeer." *Reports and Studies in the History of Art* 2 (1968): 154–202.

Kwiatek, JoEllen. "A Painting by Vermeer." *The Antioch Review* 43 (1985): 465.

Lane, Barbara G. *The Altar and the Altarpiece: Sacramental Themes in Early Netherlandish Painting*. New York, 1984.

Leader, Bernice Kramer. "The Boston School and Vermeer." *Arts Magazine* 55 (1981): 172–6.

Leishman, J. B. *The Art of Marvell's Poetry*. 2d ed. New York, 1968.

Levy-van Halm, Koos, and Abraham, Liesbeth. "Frans Hals, Militiaman and Painter: The Civic Guard Portrait as an Historical Document." In Exhib. cat. Washington, D.C., *Frans Hals*, pp. 87–102. National Gallery of Art, 1989.

Liedtke, Walter. "The 'View in Delft' by Carel Fabritius." *Burlington Magazine* 118 (1976): 61–73.

 Architectural Painting in Delft. Doornspijk, 1982.

 "Toward a History of Dutch Genre Painting II: The South Holland Tradition." In *The Age of Rembrandt; Studies in Seventeenth-Century Dutch Painting, Papers in Art History from The Pennslyvania State University*, vol. 3, ed. R. E. Fleischer and S. S. Munshower, pp. 92–131. University Park, 1988.

 The Royal Horse and Rider: Painting, Sculpture and Horsemanship 1500–1800. New York, 1989a.

 "Dutch and Flemish Paintings from the Hermitage: Some Notes to an Exhibition Catalogue, with Special Attention to Rembrandt, Van Dyck and Jordaens." *Oud Holland* 103 (1989b): 154–68.

Littlejohn, David. "What's So Great about Vermeer? Reflections on the Washington Exhibition." *The Hudson Review* 49 (1996): 259–72.

Lubberhuizen-van Gelder, A. M. "Japonsche Rokken." *Oud Holland* 62 (1947): 137–52.

Lucas, E. V. *A Wanderer in Holland*. New York, 1905.

Marrow, James. "Artistic Identity in Early Netherlandish Painting: The Place of Rogier van

der Weyden's *St. Luke Drawing the Virgin.*" In *Rogier van der Weyden, "St. Luke Drawing the Virgin": Selected Essays in Context,* ed. C. Purtle, pp. 53–9. Turnhout, 1997.

McCann, G. L. *Le sentiment de la nature en France dans la première moitié du dix-septième siècle* (first published in 1926). New York, 1972.

Meijer, Reinder P. *Literature of the Low Countries: A Short History of Dutch Literature in The Netherlands and Belgium.* 2d ed. Cheltenham, 1978.

Meijers, Debra J. "Two Princely German Collections and the Image of Seventeenth-Century Dutch Art." In *The Golden Age of Dutch Painting in Historical Perspective,* ed. F. Grijzenhout and H. van Veen, pp. 130–41. Cambridge/New York, 1999.

Meiss, Millard. "Light as Form and Symbol in Some Fifteenth-Century Paintings." *Art Bulletin* 27 (1945): 175–81.

Melion, Walter S. *Shaping the Netherlandish Canon; Karel van Mander's Schilder-boeck.* Chicago, 1991.

Mirimonde, A. P. de. "Les sujets musicaux chez Vermeer de Delft." *Gazette des Beaux-Arts* 57 (1961): 29–52.

Mody, J. R. P. *Vondel and Milton* (first published in 1942). Folcroft, Pa., 1976.

Moerkerken, P. H. van. *Het Nederlandsch kluchtspel in de 17de eeuw.* 2 vols. Sneek, 1899.

Montagu, Jeremy. *The World of Baroque and Classical Musical Instruments.* Woodstock, N.Y., 1979.

Montias, John Michael. "New Documents on Vermeer and His Family." *Oud Holland* 91 (1977): 267–87.

 Artists and Artisans in Delft; A Socio-Economic Study of the Seventeenth Century. Princeton, 1982.

 "Vermeer's Clients and Patrons." *Art Bulletin* 69 (1987): 68–76.

 "Art Dealers in the Seventeenth-Century Netherlands." *Simiolus* 18 (1988): 244–56.

 Vermeer and His Milieu: A Web of Social History. Princeton, 1989.

 "A Postscript on Vermeer and His Milieu." *Mercury* 12 (1991): 42–52.

 "Review of *Dutch Society in the Age of Vermeer.*" *Oud Holland* 111 (1997): 196–200.

 "Recent Archival Research on Vermeer." In *Vermeer Studies,* ed. I. Gaskell and M. Jonker, pp. 93–109. Washington, D.C., 1998.

Moore, Cornelia Niekus. "'Not by Nature but by Custom': Johan van Beverwijck's *Van de wtnementheyt des vrouwelicken geslachts. Sixteenth Century Journal* 25 (1994): 633–51.

Moreno, Ignacio L. "Vermeer's *The Concert*: A Study in Harmony and Contrasts." *The Rutgers Art Review* 3 (1982): 51–7.

Munt, Annette. "The Impact of the *Rampjaar* on Dutch Golden Age Culture." *Dutch Crossing* 21 (1997): 3–51.

Murris, R. *La Hollande et les Hollandais au XVIIᵉ et au XVIIIᵉ siècles vus par les Français.* Paris, 1925.

Nash, John. *Vermeer.* New York, 1991.

Naumann, Otto. *Frans van Mieris the Elder (1635–1681).* 2 vols. Doornspijk, 1981.

Neurdenberg, E. "Joannes Vermeer, eenige opmerkingen naar aanleiding van de nieuwste studies over den Delftschen schilder." *Oud Holland* 59 (1942): 65–73.

Nevitt, H. Rodney, Jr. "Rembrandt's Hidden Lovers." In *Natuur en landschap in de Nederlandse kunst 1500–1800 (Nederlands Kunsthistorisch Jaarboek* 48), ed. R. Falkenburg et al., pp. 163–91. Zwolle, 1997.

Nichols, Lawrence W. "The 'Pen Works' of Hendrick Goltzius." *Bulletin of the Philadelphia Museum of Art* 38 (1991): 1–57.

Nieuwenhuis-Van Berkum, A. "Constantijn Huygens als kunstadviseur; schilders, aankopen en opdrachten, 1625–1652." In *Huygens in noorder licht; lezingen van het Groningse Huygens-symposium,* ed. N. Streekstra and P. Verkuyl, pp. 113–26. Groningen, 1987.

Noad, Frederick. *The Baroque Guitar.* New York, 1974.

North, Michael. *Art and Commerce in the Dutch Golden Age.* Trans. C. Hill. New Haven, 1997.

Noske, Frits. "Remarques sur les luthistes du Pays-Bays (1580–1620)." In *Le Luth et sa musique,* 2d ed., ed. J. Jacquot, pp. 179–92. Paris, 1976.

Ornee, W. A. *Van Bredero tot Langendyk; een bloemlezing uit de Nederlandse kluchten van het begin van de zeventiende eeuw tot 1730.* Zutphen, 1985.

Palm, L. C. "Antoni van Leeuwenhoek (1632–1723)." In Exhib. cat. Delft, *De stad Delft: cultuur en maatschappij van 1667 tot 1813,* pp. 96–102. Stedelijk Museum "Het Prinsenhof," 1982.

Parente, James A. "Anna Roemers Visscher and Maria Tesselschade Roemers Visscher." In *Women Writing in Dutch,* ed. K. Aercke, pp. 147–84. New York, 1994.

Parker, D. M. *Perception and Artistic Style.* Amsterdam, 1990.

Parker, Geoffrey. *The Dutch Revolt.* Ithaca, 1977.

Peer, J. J. M. van. "Drie collecties schilderijen van Johannes Vermeer." *Oud Holland* 72 (1957): 92–103.

Pennington, Richard. *A Descriptive Catalogue of the Etched Work of Wenceslaus Hollar 1607–1677.* Cambridge, 1982.

Plomp, Michael, and Goldsmith, Jane ten Brink. "Leonaert Bramer the Painter." In Exhib. cat. Delft, *Leonaert Bramer 1596–1674; Ingenious Painter and Draughtsman in Rome and Delft,* pp. 47–74. Stedelijk Museum "Het Prinsenhof," 1994.

Pluis, Jan. *De Nederlandse tegel: decors en benamingen, 1570–1930.* Leiden, 1997.

Pol, L. R. *Romanbeschouwing in voorredes; een onderzoek naar het denken over de roman in Nederland tussen 1600 en 1755.* 2 vols. Utrecht, 1987.

Polman, P. "De Heilige Eucharistie in de Nederlandse polemiek." *Studia Catholica* 23 (1948): 239–54.

Pops, Martin. *Vermeer and the Chamber of Being.* Ann Arbor, 1984.

Praz, Mario. *Studies in Seventeenth-Century Imagery.* 2d ed. Rome, 1964.

Price, J. L. *Culture and Society in the Dutch Republic during the Seventeenth Century.* New York, 1974.

Proust, Marcel. *Remembrance of Things Past.* 3 vols. Trans. C. K. Scott Moncrieff, T. Kilmartin, and A. Mayor. New York, 1982.

Raupp, Hans–Joachim. "Musik im Atelier. Darstellungen musizierender Künstler in der niederländischen Malerei des 17. Jahrhunderts." *Oud Holland* 92 (1978): 106–29.

Réau, L. *Iconographie de l'art chrétien.* 3 vols. Paris, 1955–9.

Reff, Theodore. "Cézanne and Poussin." *Journal of the Warburg and Courtauld Institutes* 23 (1960): 150–74.

Renger, Konrad. "Alte Liebe, gleich und ungleich: zu einem satirischen Bildthema bei Jan Massys." In *Netherlandish Mannerism: Papers Given at a Symposium in the Nationalmuseum, Stockholm, 21–22 September 1984,* ed. Görel Cavalli-Bjorkman, pp. 35–46. Stockholm, 1985.

Reuterswärd, Patrik. "Vermeer. Ett försvar för ögats vittnesbörd." *Konsthistorisk Tidskrift* 57 (1988): 55–9.

Ricci, Seymour de. "Le quarante-et-unième Vermeer." *Gazette des Beaux-Arts* 16 (1927): 305–10.

Riegl, Alois. *Das holländische Gruppenporträt.* Vienna, 1931.

Robb, David. "The Iconography of the Annunciation in the Fourteenth and Fifteenth Centuries." *Art Bulletin* 18 (1936): 480–526.

Rogier, Jan. "De betekenis van de terugkeer van de minderbroeders te Delft in 1709." *Archief voor de Geschiedenis van de Katholieke Kerk in Nederland* 2 (1960): 169–203.

Rogier, L. J. *Geschiedenis van het Katholicisme in Noord-Nederland in de 16de en de 17de eeuw.* 5 vols. Amsterdam, 1945–7.

Rudolph, Herbert. "Vanitas: Die Bedeutung mittelalterlicher und humanistischer Bildinhalte in der niederländischen Malerei des 17. Jahrhunderts." In *Festschrift für Wilhelm Pinder zum 60 Geburtstag,* pp. 405–33. Leipzig, 1938.

Salomon, Nanette. "Vermeer and the Balance of Destiny." In *Essays in Northern European Art Presented to Egbert Haverkamp-Begemann on His Sixtieth Birthday,* ed. A. M. Logan, et al., pp. 216–21. Doornspijk, 1983.

"From Sexuality to Civility: Vermeer's Women." In *Vermeer Studies,* ed. I. Gaskell and M. Jonker, pp. 309–25. Washington, D.C., 1998.

Sanger, Martha Frick Symington. *Henry Clay Frick: An Intimate Portrait.* New York, 1998.

Schama, Simon. *The Embarrassment of Riches: An Interpretation of Dutch Culture in the Golden Age.* Berkeley/London, 1988.

Schenkeveld-van der Dussen, M. A. "Nature and Landscape in Dutch Literature of the Golden Age." In Exhib. cat. London, *Dutch Landscape, the Early Years: Haarlem and Amsterdam 1590–1650,* pp. 72–8. The National Gallery, 1986.

Scherpbier, H. *Milton in Holland: A Study in the Literary Relations of England and Holland Before 1730.* Amsterdam, 1933.

Schilling, Heinz. *Religion, Political Culture, and the Emergence of Early Modern Society: Essays in German and Dutch History.* Leiden, 1992.

Schwartz, Gary. *Rembrandt, His Life, His Paintings.* Harmondsworth, 1985.

Schwartz, Heinrich. "Vermeer and the Camera Obscura." *Pantheon* 24 (1966): 170–80.

Serres, Michel. "Ambrosia and Gold." In *Calligram: Essays in New Art History from France,* ed. N. Bryson, pp. 116–30. Cambridge/New York, 1988.

Seth, Lennart. "Vermeer och van Veens *Amorum Emblemata.*" *Konsthistorisk Tidskrift* 49 (1980): 17–40.

Seymour, Charles. "Dark Chamber and Light-Filled Room: Vermeer and the Camera Obscura." *Art Bulletin* 46 (1964): 323–31.

Shand-Tucci, Douglass. *The Art of Scandal: The Life and Times of Isabella Stewart Gardner.* New York, 1997.

Simons, Patricia. "Women in Frames: The Gaze, the Eye, the Profile in Renaissance Portraiture." *History Workshop* 25 (1988): 4–30.

Singeling, B. P. Th. "De Delftse schutterij." In Exhib. cat. Delft, *De stad Delft. Cultuur en maatschappij van 1572 tot 1667,* pp. 140–5. Stedelijk Museum "Het Prinsenhof," 1981.

Slatkes, Leonard J. *Dirck van Baburen (c. 1595–1624); A Dutch Painter in Utrecht and Rome.* 2d ed. Utrecht, 1969.

Vermeer and His Contemporaries. New York, 1981.

"Utrecht and Delft: Vermeer and Caravaggism." In *Vermeer Studies,* ed. I. Gaskell and M. Jonker, pp. 81–91. Washington, D.C., 1998.

Sluijter, Eric Jan. "De schilderkunst van ca. 1570 tot ca. 1650." In Exhib. cat. Delft, *De stad Delft: cultuur en maatschappij van 1572 tot 1667,* pp. 172–81. Stedelijk Museum "Het Prinsenhof," 1981.

"Schilders van 'cleyne, subtile ende curieuse dingen': Leidse 'fijnschilders' in contemporaine bronnen." In Exhib. cat. Leiden, *Leidse fijnschilders; van Gerrit Dou tot Frans van Mieris de Jonge, 1630–1760,* pp. 15–55. Stedelijk Museum de Lakenhal, 1988.

"Vermeer, Fame, and Female Beauty: *The Art of Painting.*" In *Vermeer Studies,* ed. I. Gaskell and M. Jonker, pp. 265–83. Washington, D.C., 1998.

Sman, Marie Christine van der. "The Year of Disaster: 1672." In *Dutch Society in the Age of Vermeer,* ed. D. Haks and M. C. van der Sman, pp. 136–40. Zwolle, 1996.

Smith, J. P. *The Discovery of Light.* New York, 1992.

Snow, Edward. *A Study of Vermeer.* 2d rev. ed. Berkeley/London, 1994.

Snyder, James. *Northern Renaissance Art: Painting, Sculpture, the Graphic Arts from 1350 to 1575.* New York, 1985.

Sonnenburg, Hubert von. "Technical Comments." *The Metropolitan Museum of Art Bulletin* 31 (Summer 1973): unpaginated.

Spiertz, M. P. G. "Godsdienstig leven van de Katholieken." In *Algemene Geschiedenis der Nederlanden,* vol. 8, pp. 344–57. Haarlem, 1979.

"Priest and Layman in a Minority Church: The Roman Catholic Church in the North Netherlands, 1592–1686." *Studies in Church History* 26 (1989): 287–301.

Stechow, Wolfgang. "Landscape Paintings in Dutch Seventeenth Century Interiors." *Nederlands Kunsthistorisch Jaarboek* 11 (1960): 165–84.

Stoichita, Victor I. *The Self-Aware Image; An Insight into Early Modern Meta-Painting.* Trans. A.-M. Glasheen. Cambridge/New York, 1997.

Stott, Annette. *Holland Mania: The Unknown Dutch Period in American Art and Culture.* Woodstock, N.Y., 1998.

Sumowski, Werner. *Gemälde der Rembrandt-Schüler.* 6 vols. Lindau, 1983.

Sutton, Peter C. *Pieter de Hooch.* Ithaca, 1980a.

"Hendrick van der Burch." *Burlington Magazine* 122 (1980b): 315–26.

"Life and Culture in the Golden Age," In Exhib. cat. Philadelphia, *Masters of Seventeenth-Century Dutch Genre Painting,* pp. lxvii–lxxxviii. Philadelphia Museum of Art, 1984.

A Guide to Dutch Art in America. Grand Rapids, 1986.

Swillens, P. T. A. *Johannes Vermeer; Painter of Delft 1632–1675.* Trans. C. M. Bruning-Williamson. Utrecht/Brussels, 1950.

Taylor, Paul. "The Concept of *Houding* in Dutch Art Theory." *Journal of the Warburg and Courtauld Institutes* 55 (1992): 210–32.

"Review of Celeste Brusati, *Artifice and Illusion. The Art and Writing of Samuel van Hoogstraten. Art History* 21 (1998): 140–5.

Tepe, W. *XXIV paepsche vergaderplaetsen: schuilkerken in Amsterdam.* Amstelveen, 1984.

Thiel, Pieter J. J. van. "Catholic Elements in Seventeenth-Century Dutch Painting, Apropos of a Children's Portrait by Thomas de Keyser." *Simiolus* 20 (1990–1): 39–62.

Thoré, Théophile. "Van der Meer de Delft." *Gazette des Beaux-Arts* 21 (1866): 297–330, 458–70, 542–75.

Französische Kunst im neunzehnten Jahrhundert. 3 vols. Ed. A. Schmarsow and B. Klemm. Leipzig, 1911.

Valentiner, W. R. "Paintings by Dutch Masters: Preface." In Exhib. cat. New York, *The Hudson-Fulton Celebration: Catalogue of an Exhibition Held in The Metropolitan Museum of Art,* pp. ix–xliii. The Metropolitan Museum of Art, 1909.

"A Newly Discovered Vermeer." *Art in America* 16 (1928): 101–7.

Veen, Jaap van der. "Review of John Michael Montias, *Vermeer and His Milieu.*" *Oud Holland* 106 (1992): 99–101.

"The Art Market in Delft in the Age of Vermeer." In *Dutch Society in the Age of Vermeer,* ed. D. Haks and M. C. van der Sman, pp. 124–35. Zwolle, 1996.

Vergara, Lisa. *Rubens and the Poetics of Landscape.* New Haven/London, 1982.

"*Antiek* and *Modern* in Vermeer's *Lady Writing a Letter with a Maid.*" In *Vermeer Studies,* ed. I. Gaskell and M. Jonker, pp. 235–55. Washington, D.C., 1998.

Verhelst, M. Verbeeck. "Madeleine dans les commentaires bibliques du dix-septieme siècle." In *L'image de la Madeleine du xve au xixe siècle,* ed. Y. Giraud, pp. 149–57. Fribourg, 1996.

Villiers, E. S. de. "Flemish Art Theory in the Second Half of the Seventeenth Century – An Investigation of an Unexplored Source." *South African Journal of Art History* 2 (1987): 1–11.

Vreeland, Susan. *Girl in Hyacinth Blue.* Denver, 1999.

Vries, A. B. de. *Jan Vermeer van Delft.* Amsterdam, 1939.

Jan Vermeer van Delft. Trans. R. Allen. London/New York, 1948.

Vries, M. de, et al., eds. *Woordenboek der Nederlandsche Taal.* The Hague, 1882–1995.

Waals, Jan van der. "In het straatje van Montias; Vermeer in historische context." *Theoretische Geschiedenis* 19 (1992): 176–85.

Wadum, Jørgen. "Vermeer's Use of Perspective." In *Historic Painting Techniques, Materials and Studio Practice. Preprints of a Symposium Held at the University of Leiden, The Netherlands, 26–29 June 1995,* pp. 148–54. Santa Monica, 1995.

"Vermeer in Perspective." In Exhib. cat. Washington, D.C., *Johannes Vermeer,* pp. 67–79. National Gallery of Art, 1995–6.

"Contours of Vermeer." In *Vermeer Studies,* ed. I. Gaskell and M. Jonker, pp. 201–23. Washington, D.C., 1998.

Wallach, Amei. "A Master of Silence Who Speaks in Grays." *The New York Times* (Section 2), September 5, 1999, 29, 31.

Waller, Edmund. *The Poems of Edmund Waller.* 2 vols. Ed. G. Thorn Drury. London, 1905.

Waller, Mary E. *Through the Gates of the Netherlands.* Boston, 1907.

Walsh, John. "Vermeer." *The Metropolitan Museum of Art Bulletin* 31 (Summer 1973): unpaginated.

Weber, Gregor J. M. "Antoine Dézallier d'Argenville und fünf Künstler namens Jan van der Meer." *Oud Holland* 107 (1993): 298–304.

"Vermeer's Use of the Picture-within-a-Picture: A New Approach." In *Vermeer Studies,* ed. I. Gaskell and M. Jonker, pp. 295–307. Washington, D.C., 1998.

Weber, Katharine. *The Music Lesson.* New York, 1998.

Weevers, Theodoor. *Poetry of the Netherlands in Its European Context.* London, 1960.

Weigert, Roger-Armand. *Inventaire du fonds français: graveurs du XVIIᵉ siècle.* Vols. 1–. Paris, 1939–.

Welu, James A. "Vermeer: His Cartographic Sources." *Art Bulletin* 57 (1975): 529–47.

"Vermeer's *Astronomer:* Observations on an Open Book." *Art Bulletin* 68 (1986): 263–7.

Weschler, Lawrence. "Inventing Peace." *The New Yorker,* November 20, 1995, 56–64.

Westermann, Mariët. *The Amusements of Jan Steen; Comic Painting in the Seventeenth Century.* Zwolle, 1997.

Wetering, Ernst van de. "Rembrandt's Manner: Technique in the Service of Illusion." In Exhib. cat. Berlin, *Rembrandt: The Master and His Workshop,* pp. 12–39. Gemäldegalerie SMPK at the Altes Museum, 1991.

Wheelock, Arthur K., Jr. "Constantijn Huygens and Early Attitudes towards the Camera Obscura." *History of Photography* 1 (1977a): 93–103.

Perspective, Optics and Delft Artists Around 1650. New York, 1977b.

"Review of A. Blankert, *Johannes Vermeer van Delft 1632–1675.*" *Art Bulletin* 59 (1977c): 439–41.

Jan Vermeer. New York, 1981.

"*St. Praxedis:* New Light on the Early Career of Vermeer." *Artibus et Historiae* 7 no. 14 (1986): 71–89.

"Pentimenti in Vermeer's Paintings: Changes in Style and Meaning." In *Holländische Genremalerei im 17. Jahrhundert; Symposium Berlin 1984 (Jahrbuch Preussischer Kulturbesitz, Sonderband 4),* ed. H. Bock and T. Gaehtgens, pp. 385–412. Berlin, 1987.

Jan Vermeer. 2d ed. New York, 1988.

"*Trompe-l'oeil* Painting: Visual Deceptions or Natural Truths?" In Exhib. cat. Hanover, N.H., *The Age of the Marvelous,* pp. 179–91. Hood Museum of Art (Dartmouth College), 1991.

"Vermeer and Bramer: A New Look at Old Documents." In Exhib. cat. Milwaukee, *Leonaert Bramer 1596–1674: A Painter of the Night,* pp. 19–22. The Patrick and Beatrice Haggerty Museum of Art, 1992.

Vermeer and the Art of Painting. New Haven/London, 1995a.

"The Story of Two Vermeer Forgeries." In *Shop Talk: Studies in Honor of Seymour Slive Presented on His Seventy-Fifth Birthday,* ed. C. P. Schneider, W. W. Robinson, and A. I. Davies, pp. 271–5. Cambridge, Mass., 1995b.

"Vermeer of Delft: His Life and His Artistry." In Exhib. cat. Washington, D.C., *Johannes Vermeer,* pp. 15–29. National Gallery of Art, 1995–6.

"Der Astronom und der Geograph." In Exhib. cat. Frankfurt, *Johannes Vermeer; Der Geograph und Der Astronom nach 200 Jahren wieder vereint,"* pp. 14–22. Städelsches Kunstinstitut, 1997.

Wheelock, Arthur K., Jr., and Kaldenbach, C. J. "Vermeer's *View of Delft* and His Vision of Reality." *Artibus et Historiae* 3 no. 6 (1982): 9–35.

Wichmann, H. *Leonaert Bramer, sein Leben und seine Kunst.* Leipzig, 1923.

Wiel, Kees van der. "Delft in the Golden Age. Wealth and Poverty in the Age of Vermeer." In *Dutch Society in the Age of Vermeer,* ed. D. Haks and M. C. van der Sman, pp. 52–67. Zwolle, 1996.

Wijsenbeek-Olthuis, Thera. *Achter de gevels van Delft: bezit en bestaan van rijk en arm in een periode van achteruitgang (1700–1800).* Hilversum, 1987.

Winkel, Marieke de. "The Interpretation of Dress in Vermeer's Paintings." In *Vermeer Studies,* ed. I. Gaskell and M. Jonker, pp. 327–39. Washington, D.C., 1998.

"Costume in Rembrandt's Self-Portraits." In Exhib. cat. London, *Rembrandt by Himself,* pp. 58–74. National Gallery of Art, 1999.

Woodall, Joanna. "Sovereign Bodies: The Reality of Status in Seventeenth-Century Dutch Portraiture." In *Portraiture: Facing the Subject,* ed. J. Woodall, pp. 75–100. Manchester, 1997.

Wright, Christopher. *Vermeer.* London, 1976.

Würtenberger, Franzsepp. *Das holländische Gesellschaftsbild.* Schramberg im Schwarzwald, 1937.

Ypes, Catharina. *Petrarca in de Nederlandse letterkunde.* Amsterdam, 1934.

Index

Note: Page numbers in *italics* denote illustrations